DASHBOARDS

DASHB

DAVID HOLLAND

O A R D S

Φ

Les voitures anciennes
c'est ma passion!

Contents Foreword by Gordon Murray **6** Introduction **8** Panhard et Levassor (1904) **14** Mercedes 37/90 (1912) **18** Bébé-Peugeot (1913) **22**

Foreword by Gordon Murray, Technical Director of McLaren Cars and designer of the 230 mph McLaren F1 Supercar, which went into production in 1993.

The dashboard of a motor car can be seen simply as one small element of a complex, technical machine. When viewed as a work of art, however, it takes on an altogether different role. The dashboard and controls – tactile, aesthetically pleasing and always in view – represent an area of car design where the designer has an opportunity to project and display the vehicle's innermost character. As a designer of over thirty motor cars I have obviously designed as many dashboards. For me, the dashboard must be a combination of ergonomic efficiency and style; even when it is part of an extreme vehicle such as a Formula One car, where function rules the design process, I find in the dashboard a deep technical beauty. During the evolution of the automobile an enormous variety of dashboard designs and levels of information have appeared – ranging from bland, plastic information-givers to examples that are truly works of art in their own right. But cars are about dynamics – driving – and driving is about the man and the machine. Here we find the dashboard's raison d'être: it represents the only link between the machinery and the driver – in short, nothing less than a visual lifeline of information transfer.

Opposite: Dashboard of the McLaren F1. Gordon Murray wanted to give the McLaren F1 dash a 'Formula One', businesslike feel, with a tight group of essential instruments and primary controls facing the driver. The high-tech specification was offset by 1930s-quality engineering with engraved instrument faces – chronometric needle movements and machined aluminium controls – to create a dash that is a blend of classic and modern design.

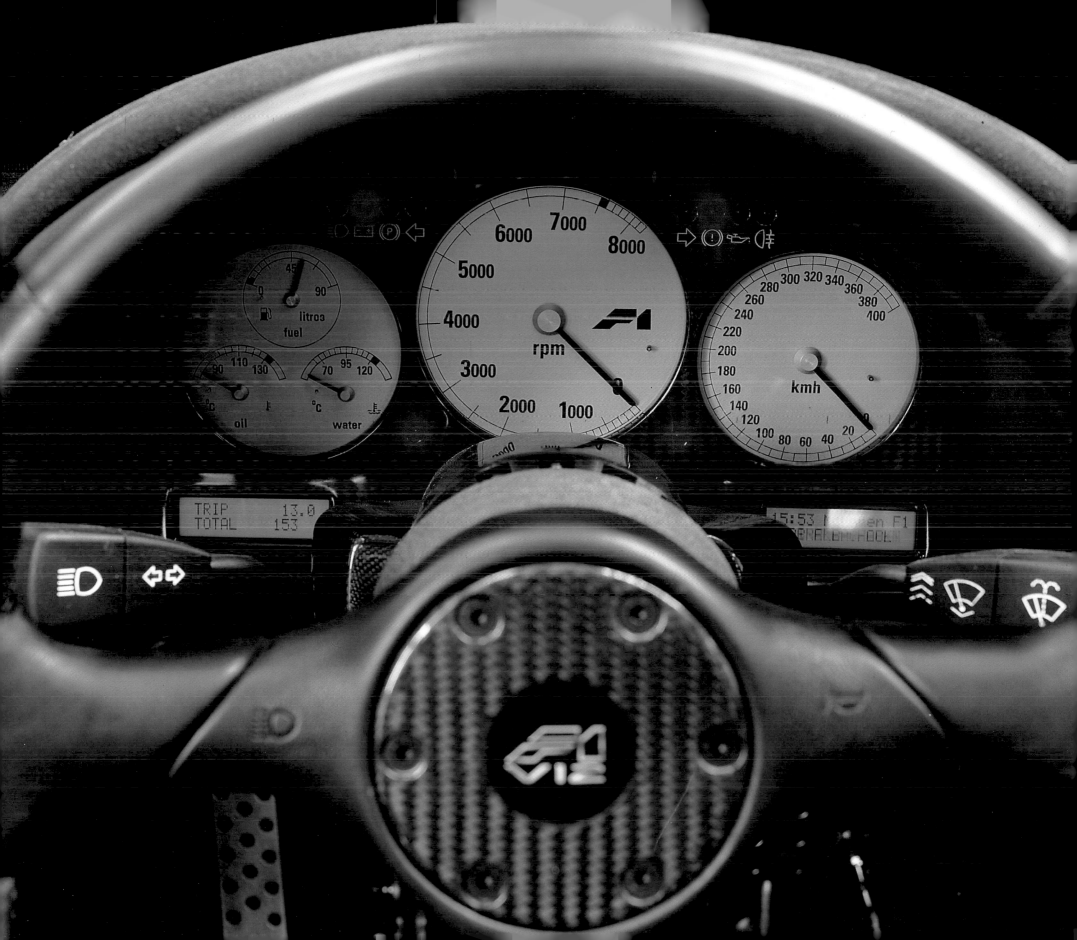

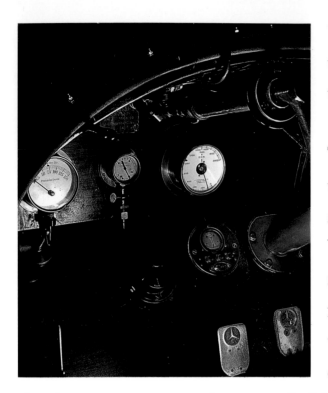

'**Dashboard** n. a board or leather apron in front of the vehicle, to prevent mud or stones from being splashed or flung up upon the interior.'

The above is a typical turn-of-the-century dictionary reference to the dashboard. A similar definition was seen in a letter from an Oxford coach- and carriage-maker half-way through Queen Victoria's reign, and other like references can be found as far back as the eighteenth century. The dashboard was, therefore, the foremost part of the horse-drawn carriage; it remained there in the early days of motorized transport, as these 'horseless carriages' concealed their motive power underneath or behind the occupants. As the century turned, a new fashion was set. The 'Système Panhard' arrived and was followed by almost all other manufacturers; that renowned French company decided to place the engine ahead of the occupants and drive the rear wheels through a cross-shaft and side-mounted chains; in time, the cross-shaft would become the rear axle and the chains would disappear. But the dashboard remained where it had always been, a division between the occupants and the power unit, once a horse, now an engine. Although for a time the steering column continued to come up through the floor, the dashboard began to provide a convenient structure on which to mount ancillaries – supports for hood straps and, later, for the glass windscreen. In due course, when such items as drip-feed oilers arrived to control the engine's lubrication, they found a natural place on the dashboard, combining the visually convenient with the mechanically practicable – a short run from control to engine. Soon, everything that mattered to the driver would be mounted on the now definitive dashboard.

By the end of the first decade of the twentieth century, sporting machinery was beginning to travel ever more rapidly, and it was becoming very uncomfortable for the drivers sitting up in the airstream with only goggles to protect them. Seats had to be lowered, so the steering column had to be angled to suit. Deflector cowls became longer and the dashboard was too far away for its instruments and controls to be seen or reached; they had to be moved nearer the driver on a subsidiary dash panel. The original structural dashboard became the bulkhead that remains to this day. In due course, the dash-panel spread across the width of the car and the 'scuttle' – scuttle-plates were removable for access – joined the bulkhead to the new dashboard. Although stately carriages were slow to lose their early perpendicular appearance, and steering columns remained more

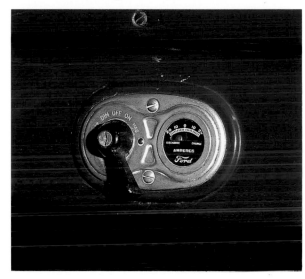

upright, we had, by the end of the second decade, the modern dashboard in all essential respects.

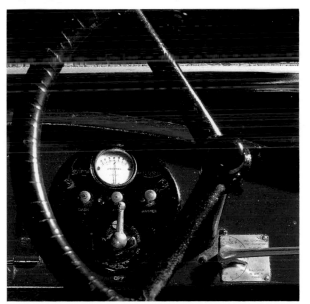

It only remained to make a feature of it, render it individual to the manufacturer and integrate it into the overall interior design. Naturally enough, the early instruments and controls tended to be a collection of unmatched items, each made by its specialist maker in the country of the car manufacturer. Speedometers would come from one source, while ammeters would come from an electrical specialist; clocks would come from a clock-maker, while drip-feeds and greasers would come from a pump supplier. But by the mid-Twenties, this equipment was frequently provided in sets, and sometimes the major items were grouped on their own sub-panel.

It was not long before such matching called for a certain amount of thoughtful placing, albeit by engineers more concerned with practicality than visual effect; it was to be decades before anyone thought seriously of ergonomics as a science for automobile design, but aircraft cockpit design certainly had some influence in the inter-war years. There are obvious examples, though, of early ergonomics, with instruments angled for easier reading and scales adjusted so that all needles upwards, easy to see at a glance, meant that all was well. Certain dials would take pride of place depending on priorities: the race driver would have the tachometer prominent together with the ever vital oil pressure gauge (the speedometer, if fitted, might be well over to the passenger's side), whereas the family motorist would be more concerned with speed (to avoid the police traps) and his speedometer would thus be nearest. Few such vehicles would have a tachometer. But intervention by the stylist could not be denied for long, and the Thirties saw cockpit design become as important to a manufacturer as the overall shape of the car. The external aura perceived by the by-stander had to be reflected in the view the driver saw: the dashboard. Sporting owners were given the full range of instruments, while family transport provided only as much information as was necessary: more aspiring family owners could add any extras they wanted by making another hole in the dash or by acquiring a sub-panel. That basic philosophy has not changed over the past sixty years as more and more functions have become available for the dash – all expected to be as visible or operable as possible. Styling, ergonomics and latterly legislation have all played their part in the gradual transition from the dawn of the dash, through staid or magnificent displays, to the functionality of the present day, where it is now very difficult to add instruments to integrated designs.

Meanwhile, instrument illumination has progressed from none at all, through separate and sometimes swivelling lamps proud of the dash and little lights set into instruments, to modern back-

lighting, rheostat-adjustable to choice. Radios became optional extras in the Thirties, as did heaters, cigar lighters and ashtrays; glovelockers too had to be accommodated in response to market demands. Now, air-conditioning, cassette/CD players and even televised route hazard displays have to be designed into ever more integrated presentations; in fact, the high-style modern dash is more reminiscent of a fighter cockpit built around the driver alone, like a single-seat race car. At the same time it is becoming ever more difficult to know what car you are in, as all seek to provide the same ergonomic optimum.

And what of steering wheels?

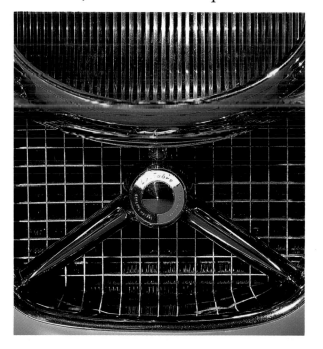

Once they had tillers – single levers atop the steering column. Since then, apart from such oddities as Citroen's single-spoke wheel (also seen in the very early days) and Austin's misguided quartic rim, the accepted method of directing the vehicle has been through a genuine round steering wheel with two or more spokes. Only the styling has separated them. Pre-Twenties ones were thick and quite small in diameter; vintage ones were large and unyielding to the touch, but competition cars often had the rims bound in cord to provide a better grip; in the expensive cars of the Thirties, the use

of coloured plastics could verge on the bizarre as the stylist's influence came to bear. Now the steering wheel has turned full circle; small wheels have been in vogue for sporting cars for some years, and have been enabled to remain so, despite ever wider tyres, with the advent of sophisticated power steering systems; early versions removed the feel of the road. Engine controls have moved from

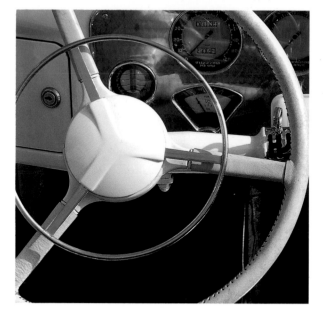

early dashboards, or cockpit sides, to the centre of the steering wheel – via concentric rods and tubes up the column – and back to the dash, thence to disappear with the arrival of automatic engine adjustments. Switchgear, likewise, started on dashboards – where less frequently used switches remain – and stayed there until the arrival of today's column-mounted stalks within finger-tip reach. Gear-levers too have had their dashboard moments; little switches on the dash or even in the centre of the steering wheel, levers sprouting through the dash, and steering column gear-changes, have all come and gone. Now we have 'four/five/six on the floor' whether manual or automatic transmission is employed, and only a horn in some wheel centres.

This simple history of the dashboard has outlined the trends. There has been a huge variety in style and form, and the components used, all concentrated on aiding the driver to maintain full control over the high-speed sports car or the family run-about. At the same time, the dash has had to reflect the image of the whole car, and be a perpetual reminder of the owner's unerring sense of value for money well spent. While the dashboards in this book have come from cars of all nationalities, my terminology is inevitably English. I have tried to avoid potential confusions but I am sure that our American readers will recognize that our bonnet is the American hood, our boot is a trunk, our hood is a top or roof, and our mudguard or wing is a fender; more technically, our manifolds are headers, two-stroke is two-cycle, capacity in litres becomes displacement in cubic inches if you multiply by 60 (accurate to within 1½ per cent) and our epicyclics are planetary gears. In the pages that follow, I have selected just some of the dashboards that have departed from the period norm, as such designs frequently point the way ahead for others. I have deliberately stopped at the point where natural evolution has brought all to the same bland conclusion – the padded facia containing near-identical instruments and controls in standardized positions. The dashboards selected for this book come from the days when a dash was still a dash. These dashboards have character.

Inset details are taken from the following cars: Mercedes 37/90 (page 8); Trojan, Ford Model T (page 9); Delage D8 (page 10); Cord 812, Mercedes-Benz 540K (page 11); Buick Le Sabre, Chevrolet Corvette (page 12); Cadillac Eldorado (page 13).

Panhard et Levassor (1904) France No manufacturer had a higher reputation in the early days of motoring than did Panhard, who won most of the great European long distance road races, following their pioneer adoption of the front-engined rear drive layout. The 'Système Panhard' set an example for all subsequent successful firms who had hitherto followed the original Daimler rear-engined layouts. Panhard's touring cars were well built, expensive and generally large, often with unusual coachwork dictated by the whims of a demanding clientele; this example is relatively small with a two-cylinder engine of 1.8 litres. Although the cockpit is fairly conventional for the period, it contains interesting items. Air pressure and water temperature gauges, at the lower left of the toe-board, seem as if from the steam-powered era; all the engine lubrication system is carried on a large console – two sight-oilers with regulating taps and a brass-capped oil reservoir incorporating two plungers to pump oil to the crankshaft bearings. The strong steering wheel, with its thick wooden rim, also carries an unusual set of hand-controls, a feature unique to Panhard; without removing his hands from the wheel, the driver can adjust ignition and throttle settings using light finger pressure to detach serrated locking rings and engage the linkage. This was a neat and ergonomically superior solution to engine management, achieved without a lessening of control. To drive a Panhard at that time, behind the intertwined P&L motif on the radiator matrix, showed knowledge and discrimination in your choice of car; in those days of space and elegance, Panhard had few equals and no superiors.

Opposite: Atop the entwined P and L is the badge of the maker of the closed circuit cooling system: GA of Paris.

Overleaf: The central oil reservoir features pressure priming pumps; ignition timing and hand-throttle are controlled by the finger tip wheels, while slight radial pressure unlocks the serrations.

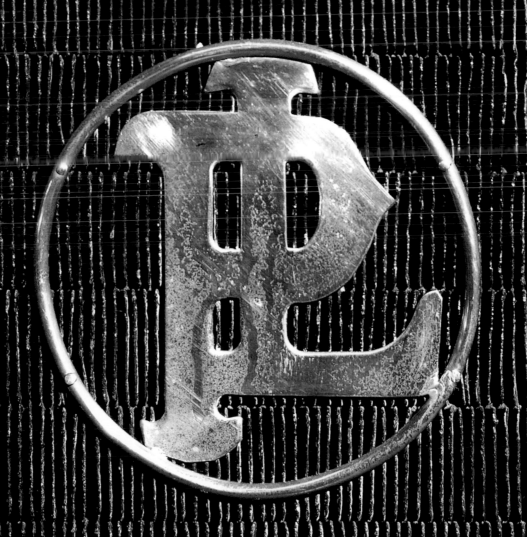
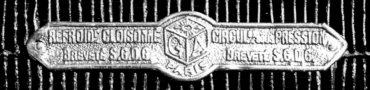

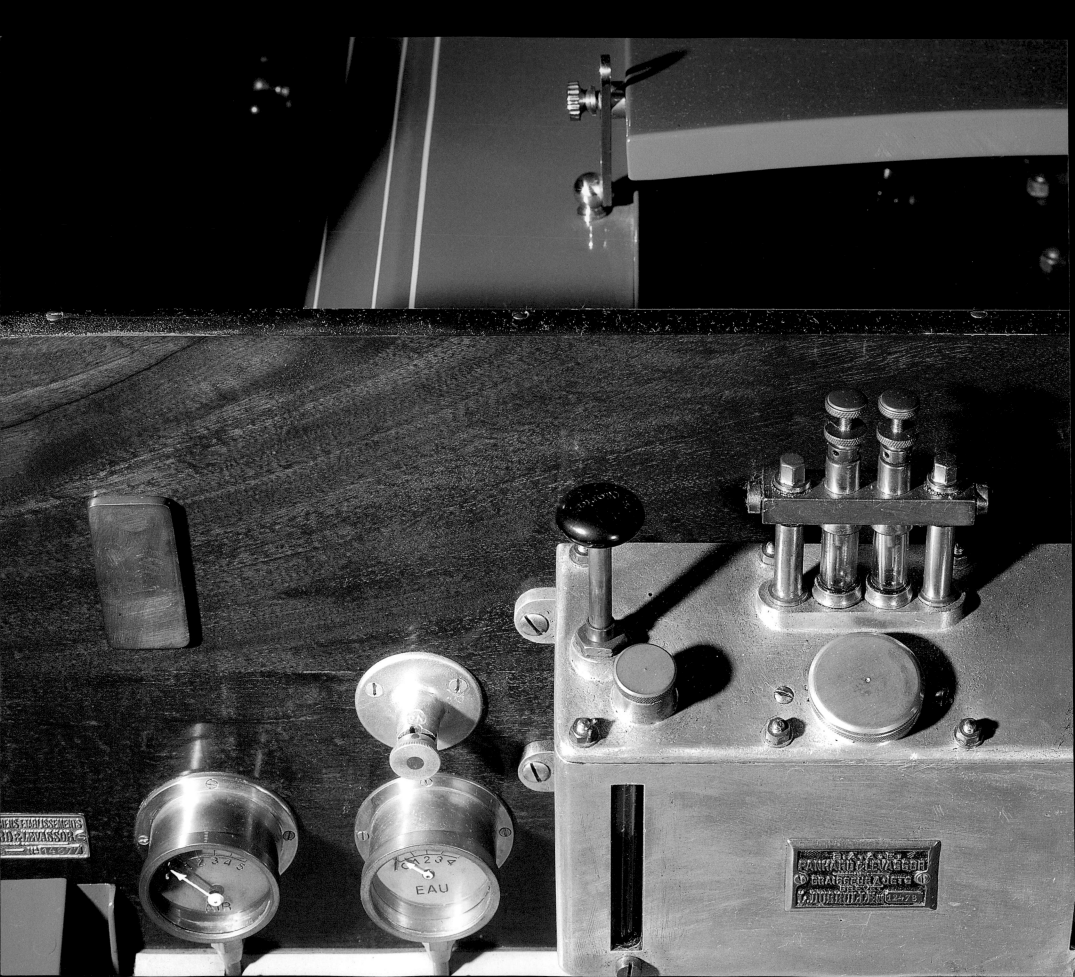

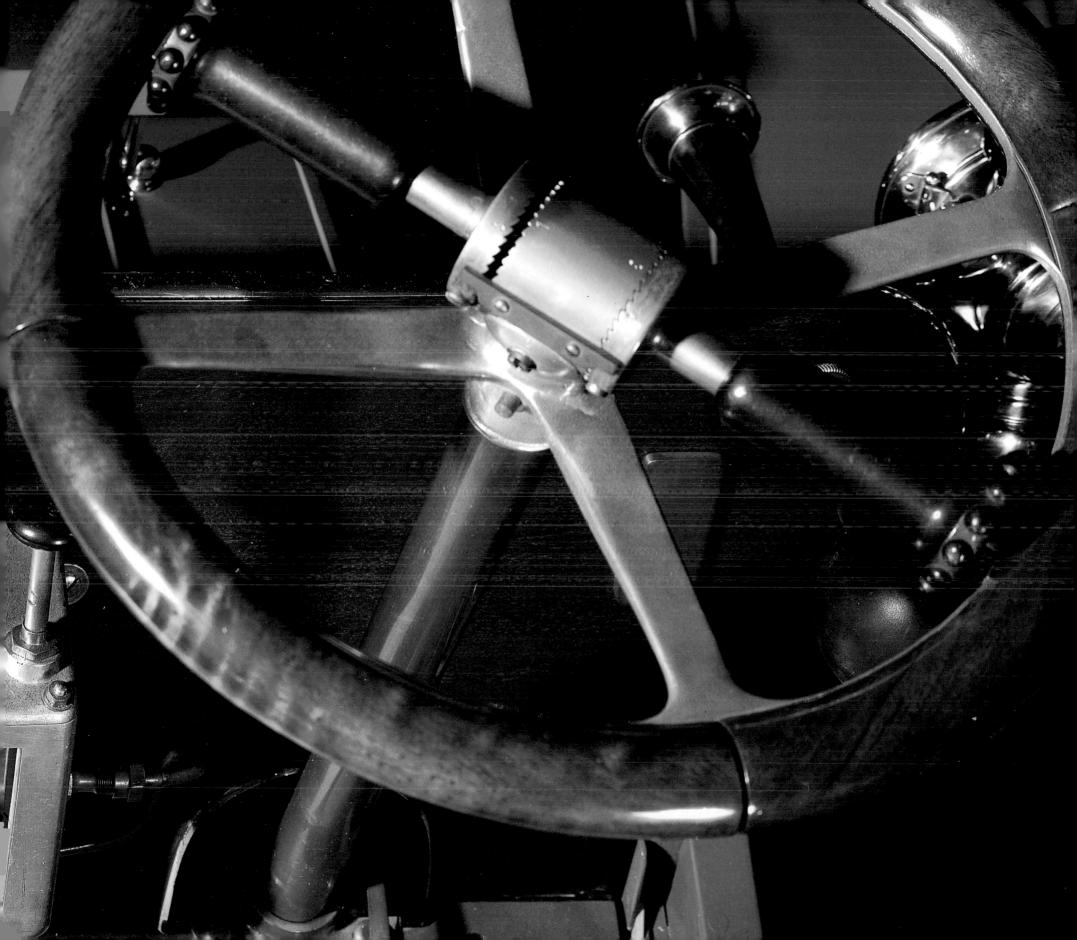

Mercedes 37/90 (1912) Germany If you had wanted to travel far and fast in 1912, you would probably have chosen a car from France or Germany; and with racing honours increasingly falling to Mercedes, the 37/90 would be a likely choice. With its big four-cylinder 9½-litre engine (using three valves per cylinder) it would out-perform most of the opposition in its expensive class. This is one of the last cars still to have its instruments in the original dashboard position ahead of the driver's feet, well below the scuttle. Hand controls were somewhat more conveniently placed,

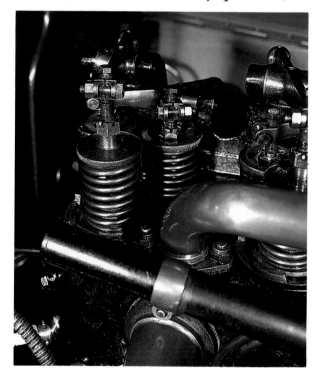

the usual ignition and throttle controls in the centre of the big wheel, external brake and gear-levers and, in the centre, a handpump requiring frequent operation to maintain fuel tank pressure. On the toe-board there are four instruments, a large steam-age oil pressure gauge on the left, a fuel pressure gauge, an ammeter and the tachometer reading to 1,800 rpm (1,500 rpm was useable giving 90 mph in top gear). The switches for magneto ignition and lights were rather out of reach. Unusually, there were four pedals, clutch, accelerator and two brake pedals – one for the rear wheels, another for water-cooled brakes on the countershaft which carried the front driving sprockets, with the water tank under the driver's seat. The exposed chains, one on each side, had a rudimentary guard, but sprockets were easily changeable to adjust the overall gearing for the open road or mountain climbing. It was a responsive car with light steering and easy driveability, but there was no windscreen – leather helmet and goggles sufficed. The era of convenience motoring was yet to come.

This page: The big 9½-litre four-cylinder engine had exposed valve-gear – two inlets and one exhaust.

Opposite: The heavy-section transmission chain is better equipped to transmit the torque than the narrow tyre.

Overleaf: All the instruments are still at foot level; the handpump for the fuel tank is within easy reach.

An extra pedal is provided for the water-cooled countershaft brakes.

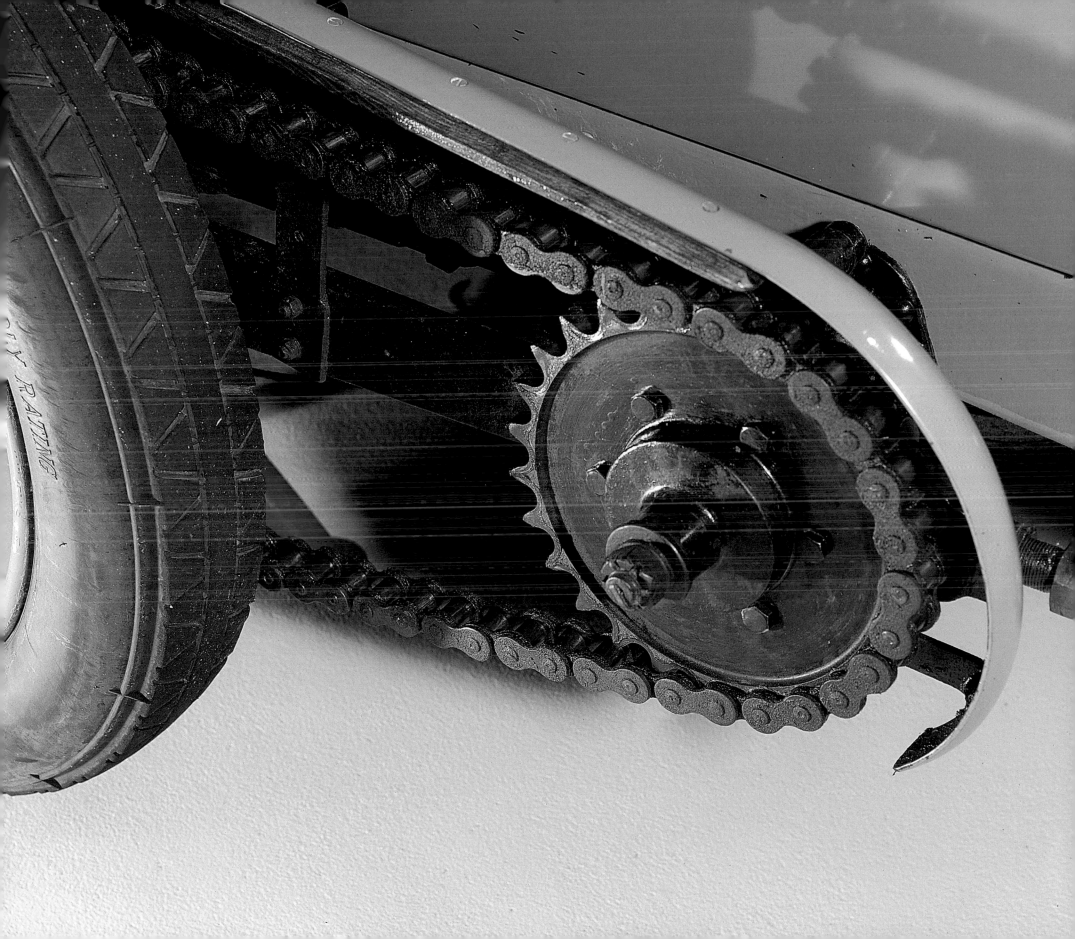

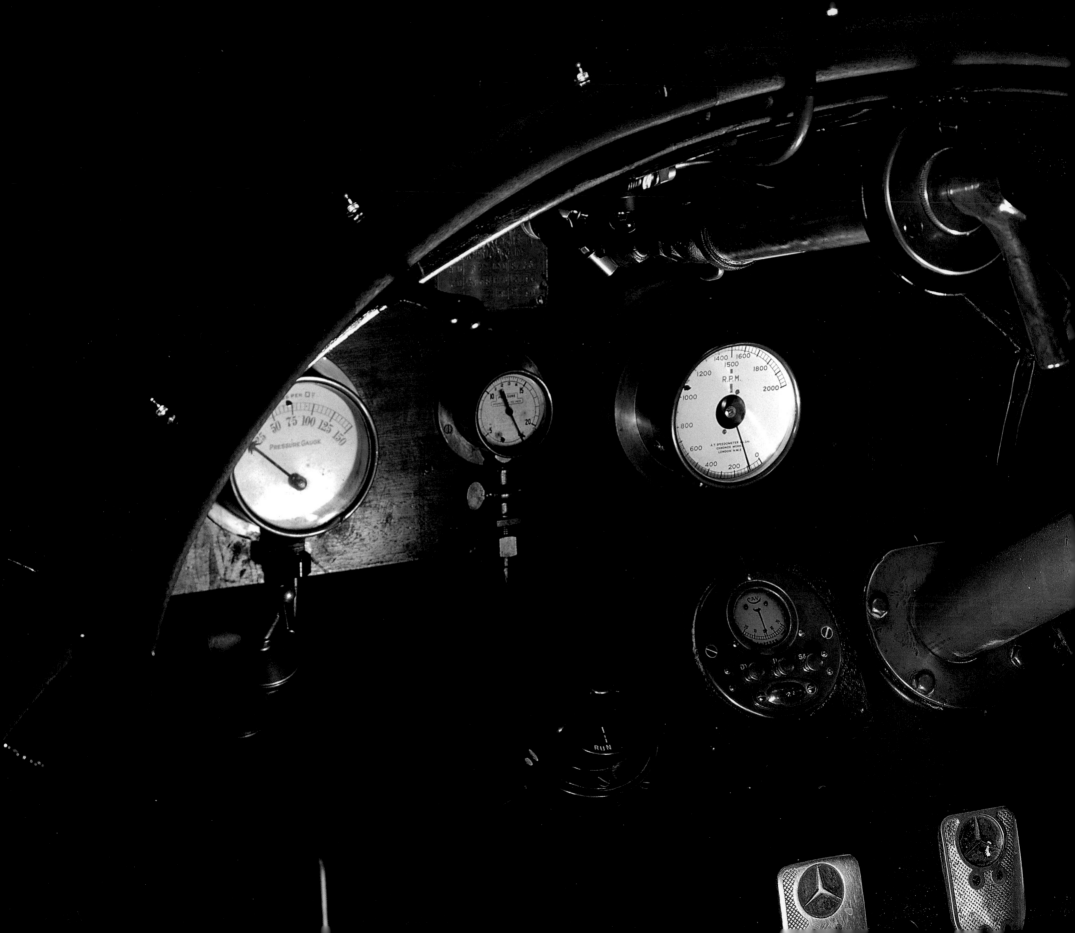

Bébé-Peugeot (1913) France In 1911 Ettore Bugatti, a brilliant young designer who was making his reputation with cars bearing his own name, designed for the prosperous French firm of Peugeot Frères a delightful little car whose diminutive name, Bébé, preceded the marque's title in a clever marketing ploy (this is shown on the chassis plate).

This was a thoroughly complete car in miniature, with a four-cylinder side-valve engine, a two-speed transmission and full equipment to allow a family to travel reasonable distances, though even Bugatti's mastery couldn't provide more than about 35 mph from the tiny 855 cc engine. This Bébé-Peugeot is a rare saloon version, expensively constructed in wood with tapestry furnishing, all making it somewhat top heavy. Its dashboard is typically simple but solid, and the instruments and controls are of high quality with no concession to the low-cost market place for which the car was designed. A beautiful Breguet 8-day clock is at the far left and a precision speedometer is mounted on a brass stalk – it has a knurled brass wheel to zero the distance recorder. Under the dash panel a double sight-oiler for engine oil is mounted in the centre of the toe-board; this incorporates an on-off tap which is interconnected with the magneto earth-switch to ensure that the engine cannot run if the oiling is turned off, thus providing a 'fail-safe' system to protect the delicate Bugatti mechanism, and to contribute to the driver's peace of mind by reducing at least one control. Some 3,000 examples of this loveable little motor car were built between 1913 and 1916.

This page: The form of the little 855 cc engine is reflected in the brass oil tank at the rear of the engine compartment.

Opposite: Although 'Bébé' was carried on the chassis plate, the radiator badge only attributes Peugeot.

Overleaf: Prominence is given to the speedometer, an American Stewart product. Sight-oilers are down on the toe-board. The hand-brake and gear-lever are on the right, alongside the bulb horn.

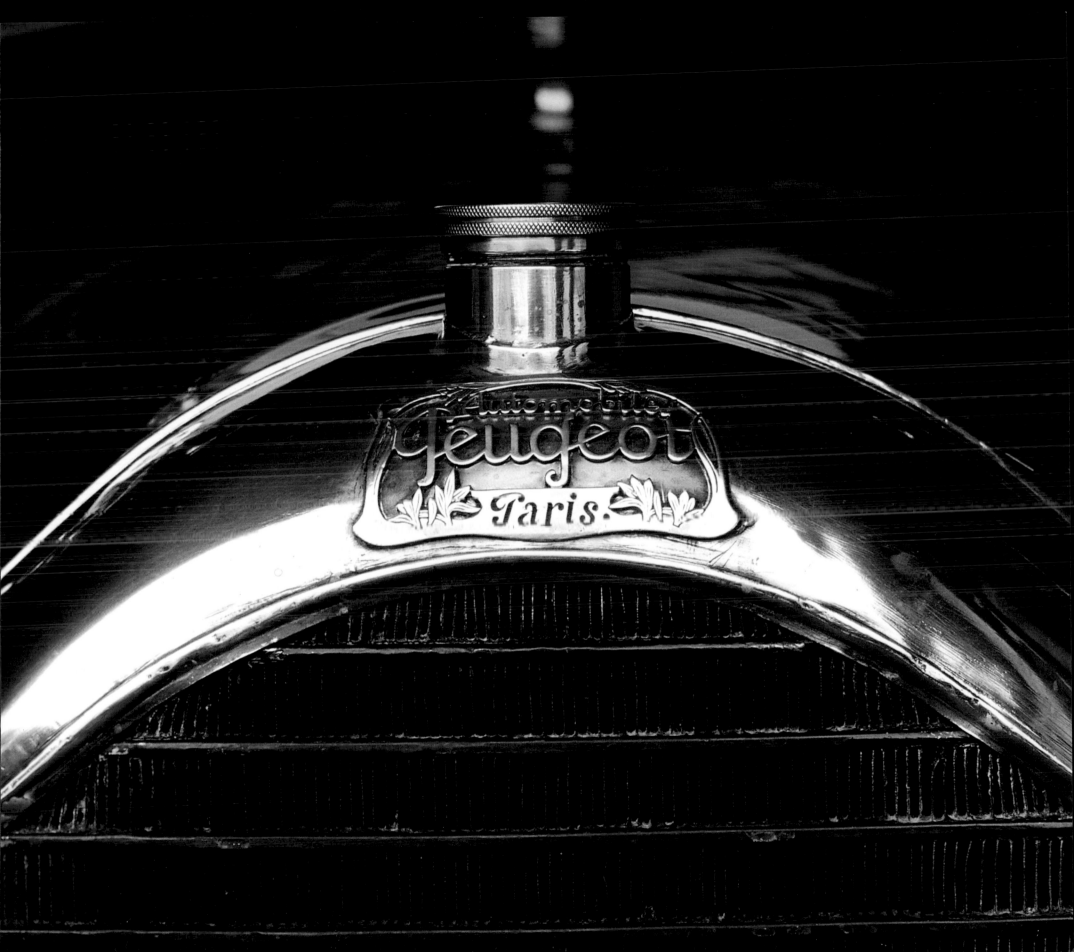

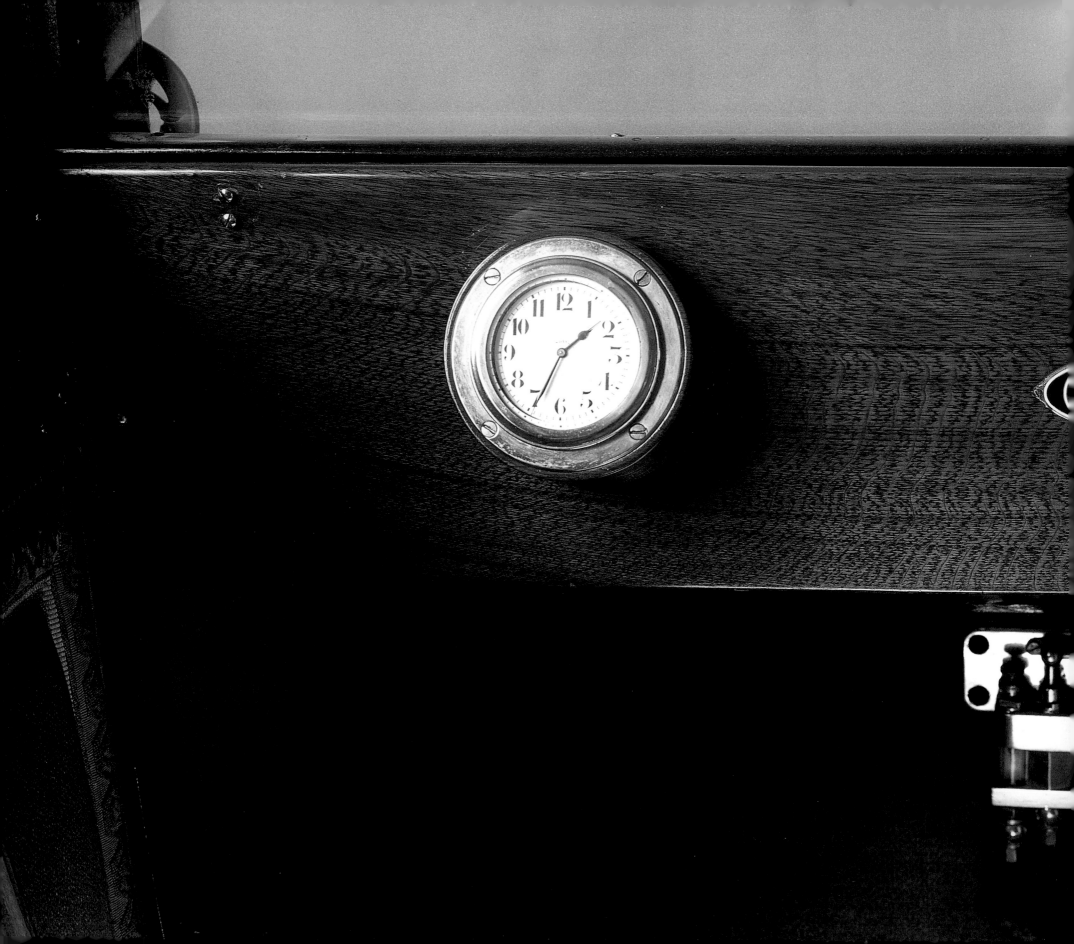

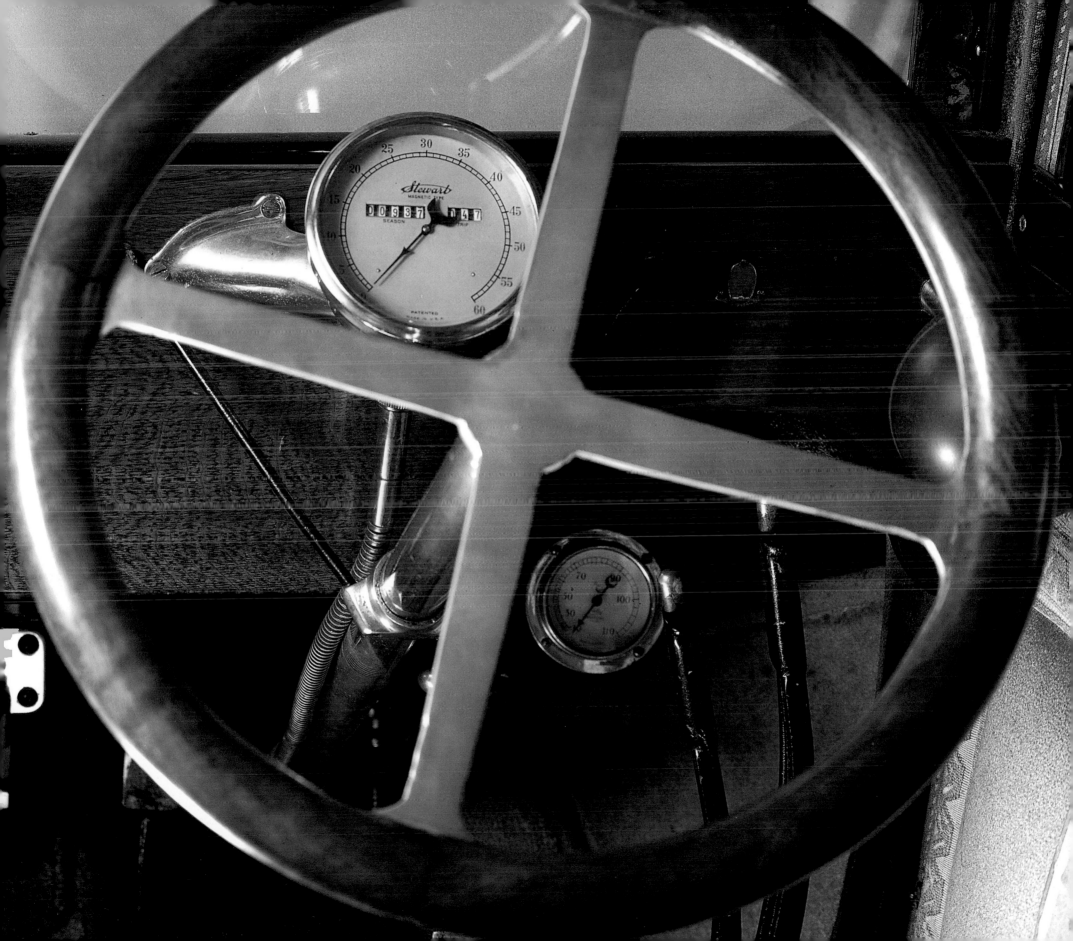

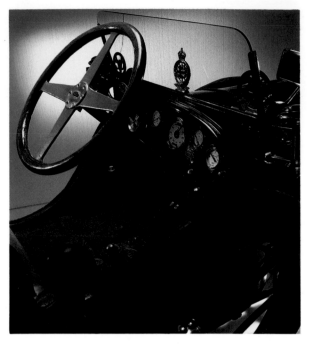

Bugatti Type 13 (1913) France The importance of this little car in our anthology lies in its two remarkable attributes: it was the first really small car (with a mere 1.3-litre engine) that could match the bigger machinery (with at least 5 litres) on any but the straightest of roads and, interestingly from our viewpoint, it had a dashboard with a full and well laid-out set of instruments at a time when these were at best rudimentary on others. The whole car is made on superb engineering lines. The little engine uses an overhead camshaft to operate its eight valves through Bugatti's strange 'banana' tappets and has full pressure lubrication; a fine four-speed and reverse gearbox allowed 40, 50 and 70 mph in second, third and top gears; and, like all Bugattis, the chassis gave superb roadholding with light and geometrically correct steering. The 1913 dashboard contains everything the keener driver would want, although Bugatti considered the eight-day clock (on the left) more important than a tachometer. Pride of place is given to the speedometer, with trip and total mileage recorders; dials for water temperature and oil pressure (with its red Bugatti emblem), and a fuel tank pressure gauge, complete the instrumentation – the hand-pump is on the floor to the driver's right. Push-pull controls are located below the latter gauges, reached under the steering wheel. The gear-lever and hand-brake are forward and to the right, with the Stepney patent spare wheel outside. Bugatti's gearbox sits on the floor with his name on the lid, which, like his signature cast into the engine's valve cover, proclaims his justified pride in making such a rapid little car, a prelude to the success to follow for Bugatti: Le Pur Sang.

This page: The Stepney spare wheel is a complete bolt-on tyre and rim assembly. The centre lever operates a clutch stop which helps quiet first gear selection at rest.

Opposite: This is the first use of Bugatti's hallmark horseshoe radiator shape. Blériot headlights dominate the frontal aspect.

Overleaf: Two paraffin-burning sidelights are mounted at each end of the unframed screen. The dashboard is very well equipped for the period with instruments familiar to the modern driver.

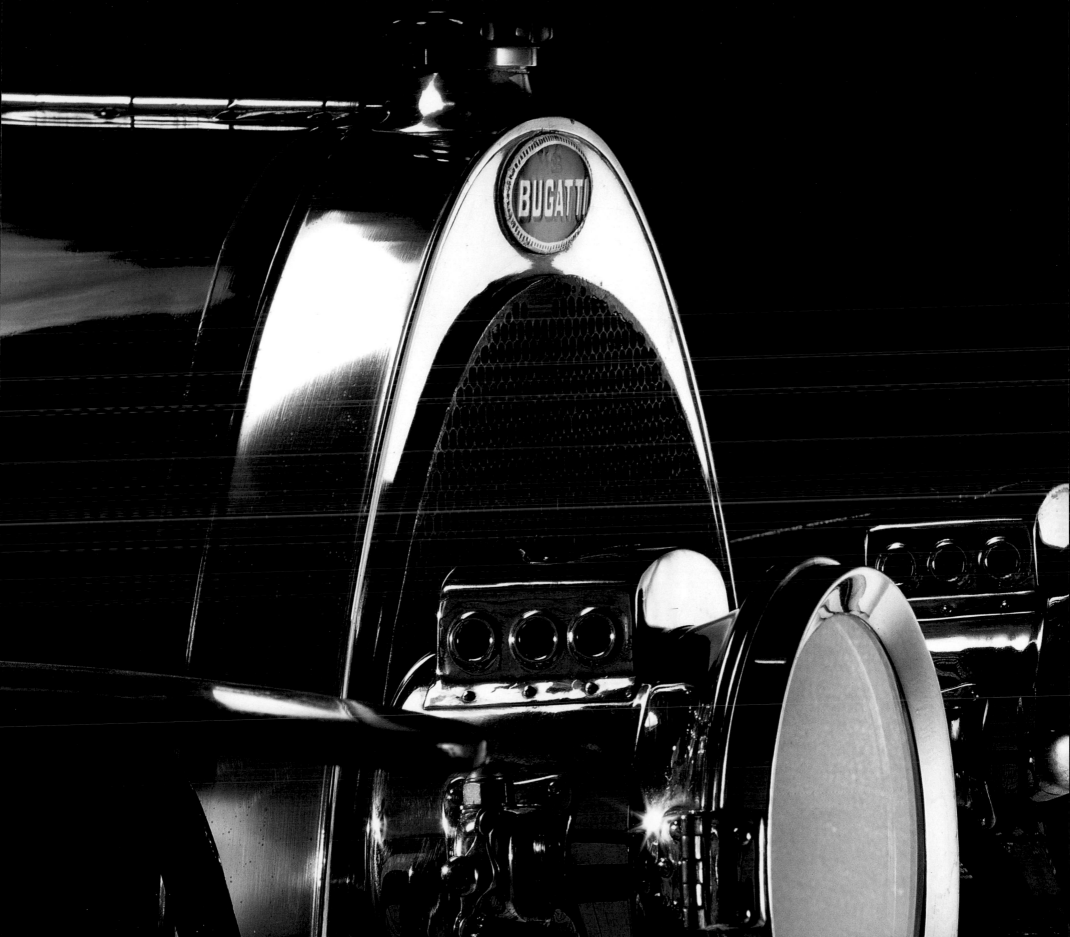

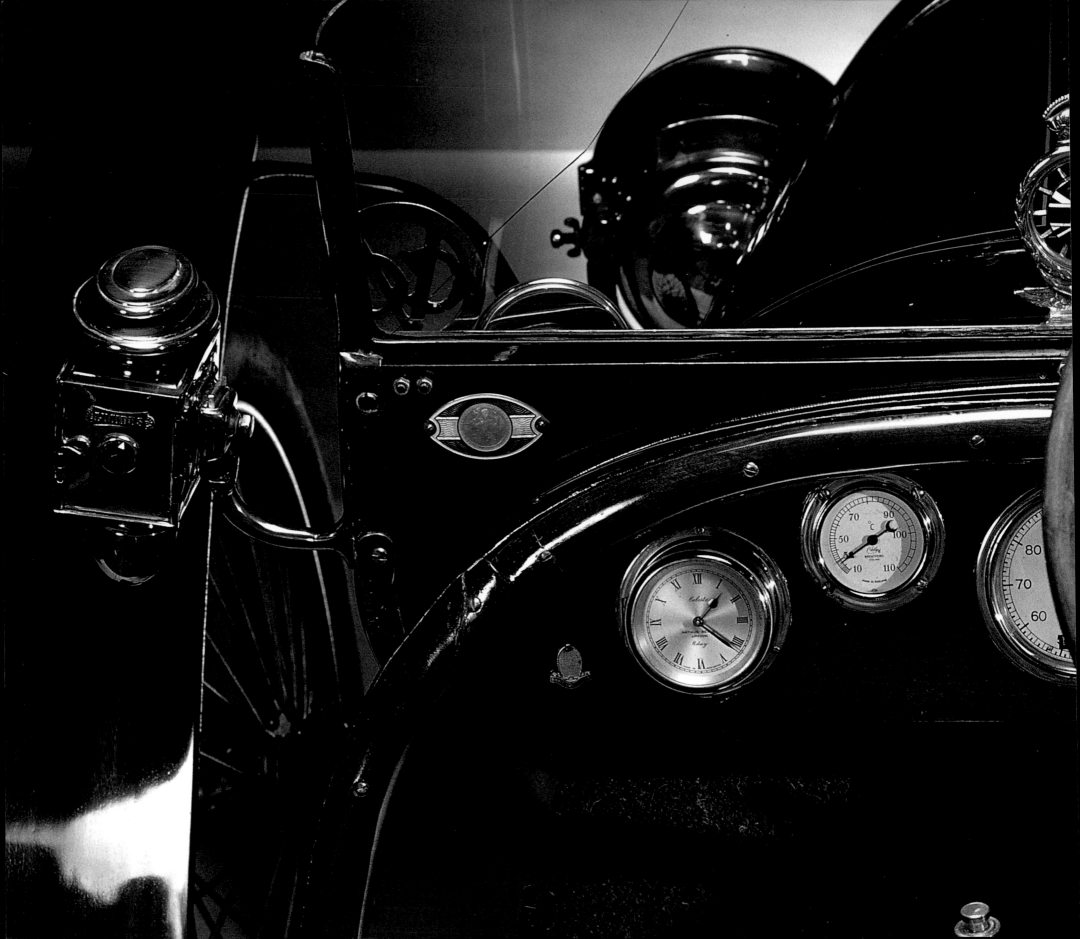

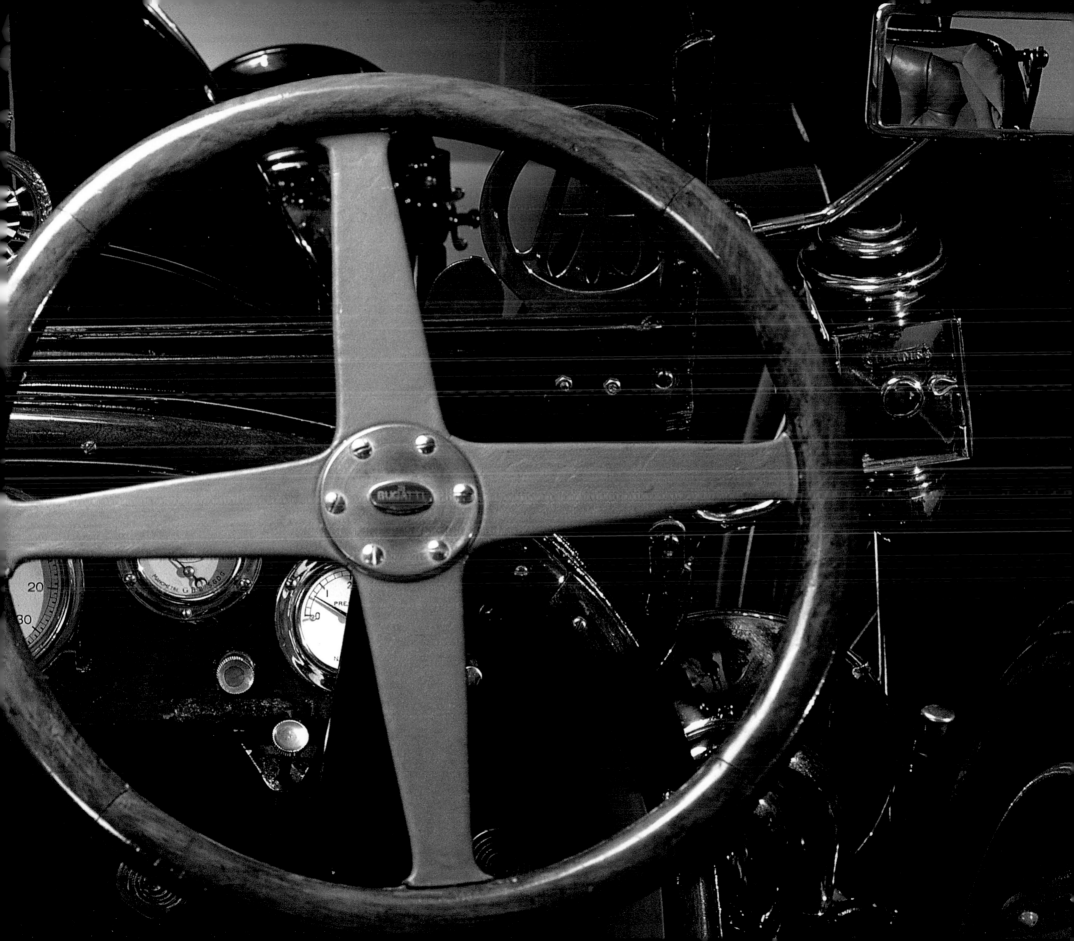

Newton-Bennett (1913) GB Manchester motor traders Newton & Bennett started their association with the Ceirano family around 1907, when Giovanni Ceirano was making SCATs in Turin. N & B began to import the cars and provided much technical assistance through their inventive works manager Robert Harper. Indeed, John Newton's nephew Cyril Snipe was sent to work in Turin, and won the 1912 Targa Florio in a SCAT. In 1911 Harper designed a new smaller twin-cylinder car for SCAT to build, but they only had time to produce two.

So Newton set up his own factory in Turin to build the four-cylinder NB from 1912. Over the next four years some 1,000 were built, before the factory was sold to Diatto in 1916. This car was owned by John Newton's son, Noel, and later presented to the National Motor Museum by Robert Harper's daughter. Well engineered, it also featured such Harper patents as detachable wheels and a cockpit lever starter. The simple dash is notable for just a single 60 mph speedometer, inscribed NB, Newton & Bennett, Manchester, and a brass choke knob.

On the toe-board, a fuel pressure pump has its own gauge, also labelled NB; the central brass pedal is for the accelerator. At the centre of its thin black steering wheel is a superbly crafted pair of quadrants, brass forgings bolted together, to provide ignition and throttle control. With its 2,155 cc engine the compact four-seater NB was an efficient little motor car, and was sold as far away as Africa and Australia. Newton continued his Italian association after the Great War with cars under the Newton-Ceirano name.

This page: The three-quarter elliptic spring is beautifully painted with its own coachlines.

Opposite: NB was the official name of this rare English-designed Italian-built hybrid, of which around 1,000 were made.

Overleaf: Only a speedometer with a mileage recorder was supplied, aimed more at the passenger, who also had to provide fuel tank pressure from the pump on the toe-board. The joined brass quadrants are nicely crafted.

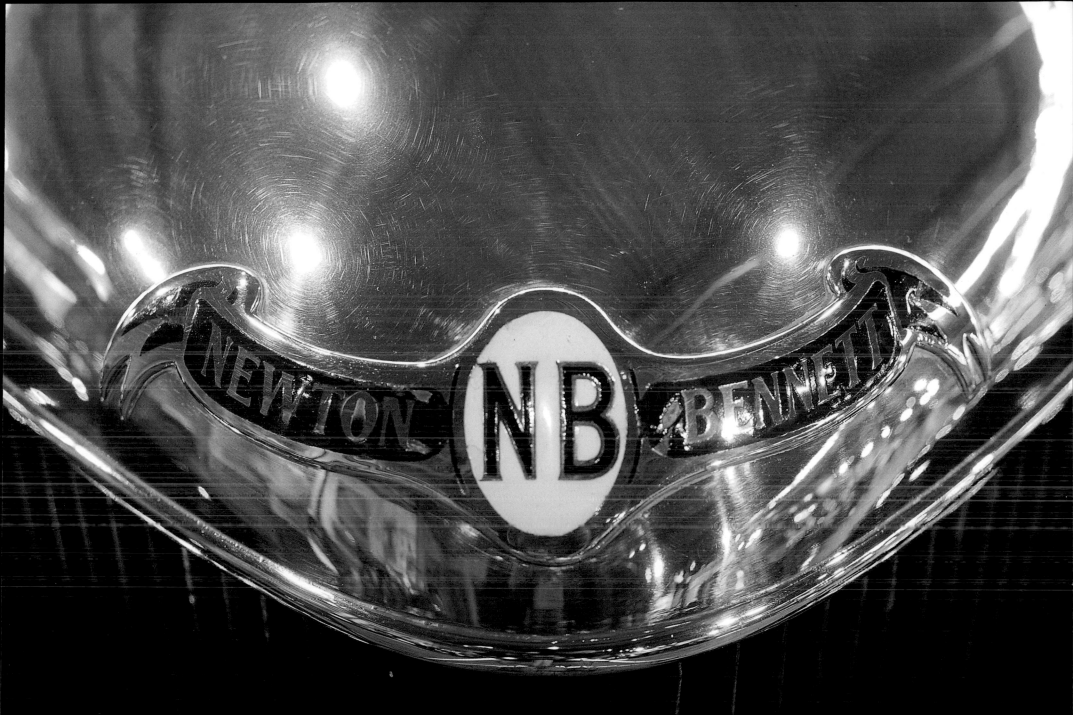

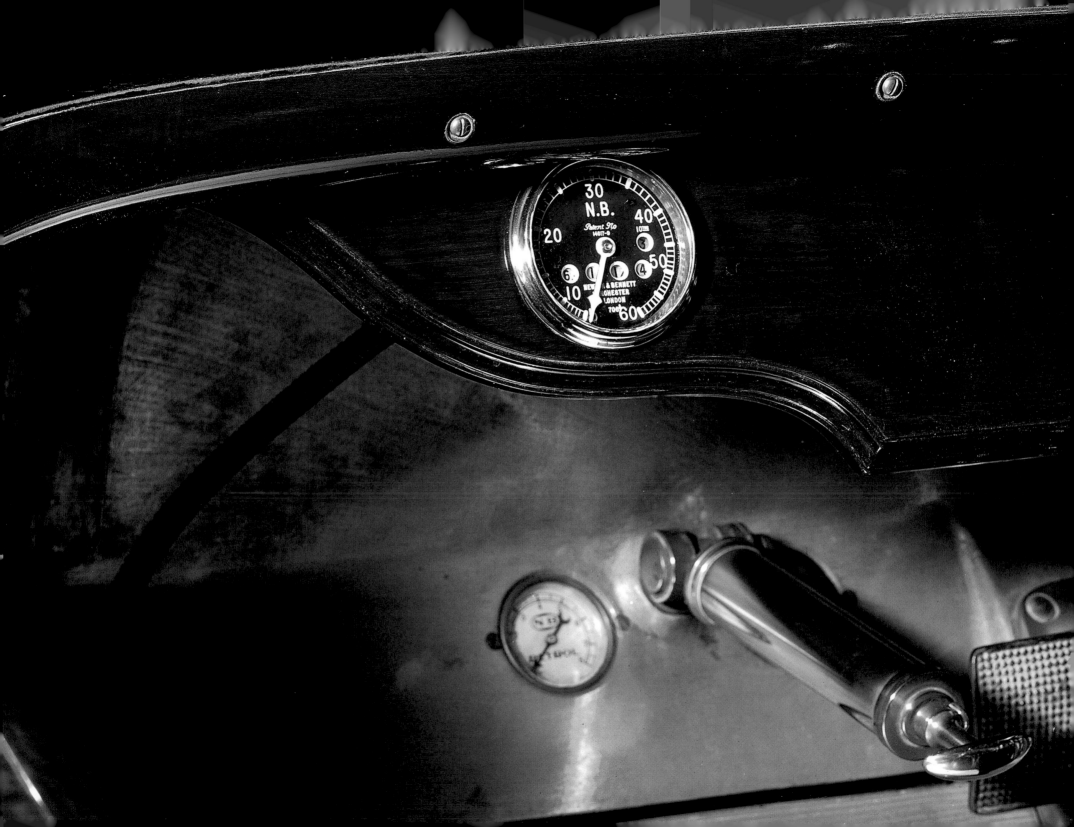

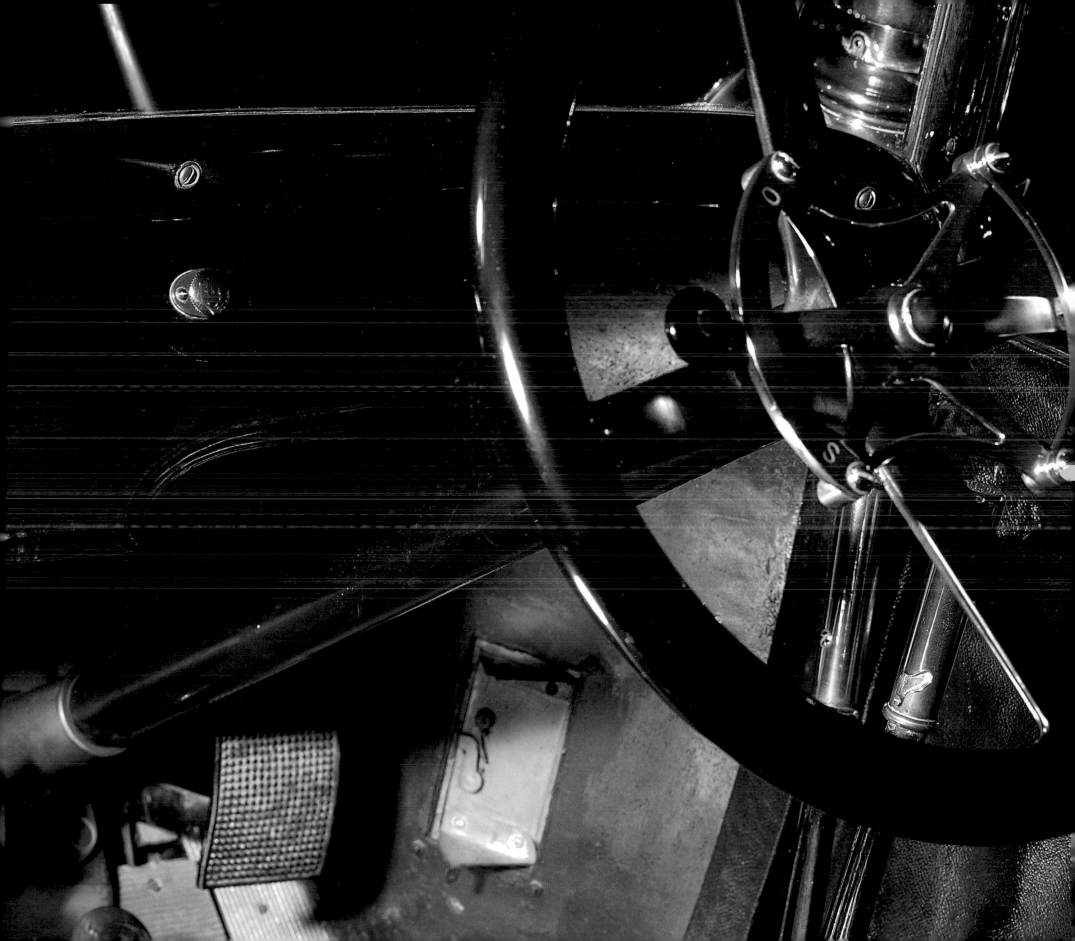

Morgan 3-wheeler (1920) GB The vogue for three-wheeled cars has come and gone over the decades, but the Morgan has retained a long-lasting niche in the automobile saga. Unlike many of its rivals, its chassis was sound enough to cope with real performance, instead of merely providing frugal upkeep; a backbone chassis carried innovative sliding-pillar independent front suspension with a wide track for stability, enhanced by a low centre of gravity. Outwardly similar to an early

Super Sports Aero, this is basically a Grand Prix model of which one was owned by the great air fighting ace, Albert Ball; this version used a Swiss MAG engine, with a two-speed transmission for its single rear wheel. Most notable in this fighter-like cockpit are the three controls on the steering wheel spokes – one for mixture control, another for ignition adjustment, the third being the only accelerator control; as the steering was geared at a mere half-turn from lock to lock, wheel-shuffling was unnecessary, so the lever would always be to hand, even when cornering hard. Pedals were provided for clutch and brake, while the handbrake was outside. On the dash are a speedometer, a small electrical switch panel with its ammeter and, very prominently, a sight-oiler with its regulating tap for the lubrication of the engine internals; this 'total loss' system ensured clean oil, but brought with it the penalty of a messy looking machine – with the rest of the oil dropping onto the road. If a bit primitive to modern eyes, the Morgan made for exciting motoring with all the flavour and the smells of adventurous earth-bound flight for the intrepid and young at heart.

This page: The single chain-driven rear wheel contains the car's only brake.

Opposite: The GP was fitted with a 1-litre water cooled MAG twin. Combined Swiss head and sidelights are mounted on the brass windscreen supports.

Overleaf: Simple instruments include a drip-feed sight-glass. Cable controls on the steering wheel can function as the steering wheel only moves a quarter turn each way; there is no foot accelerator.

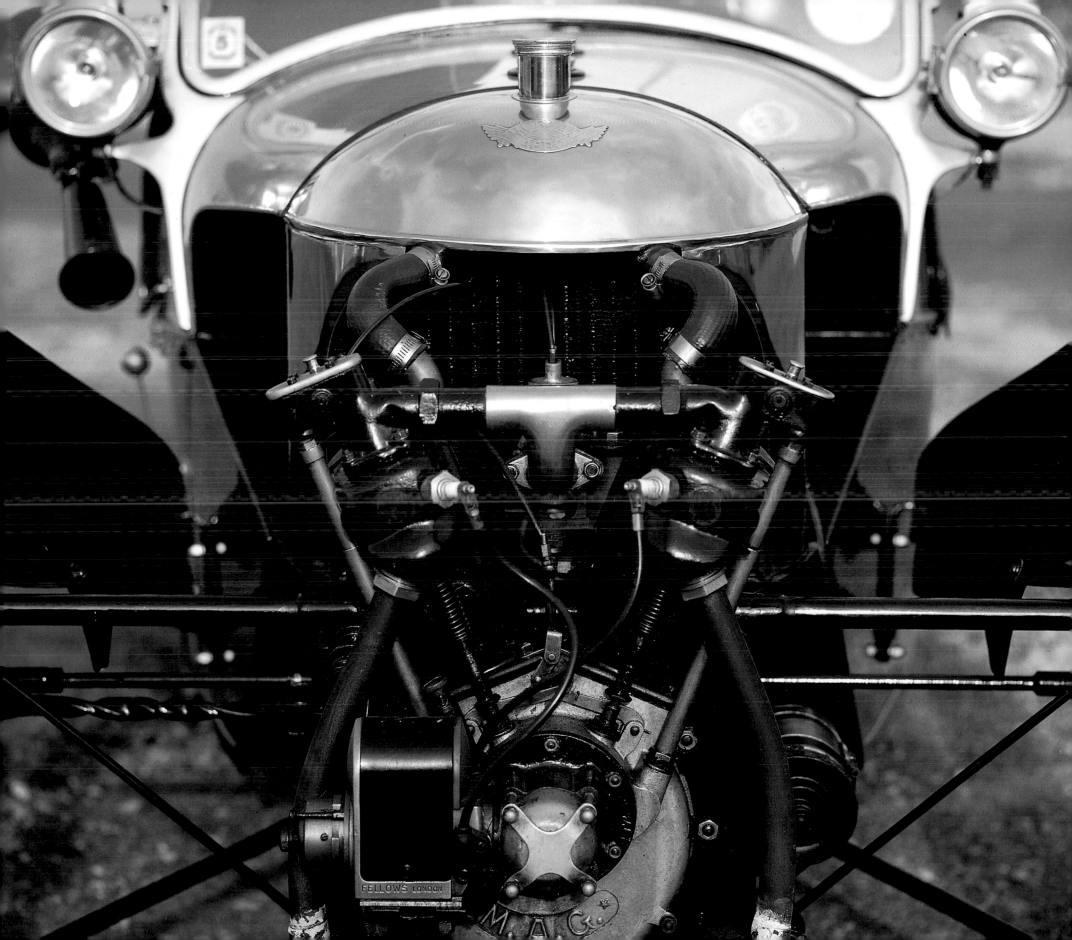

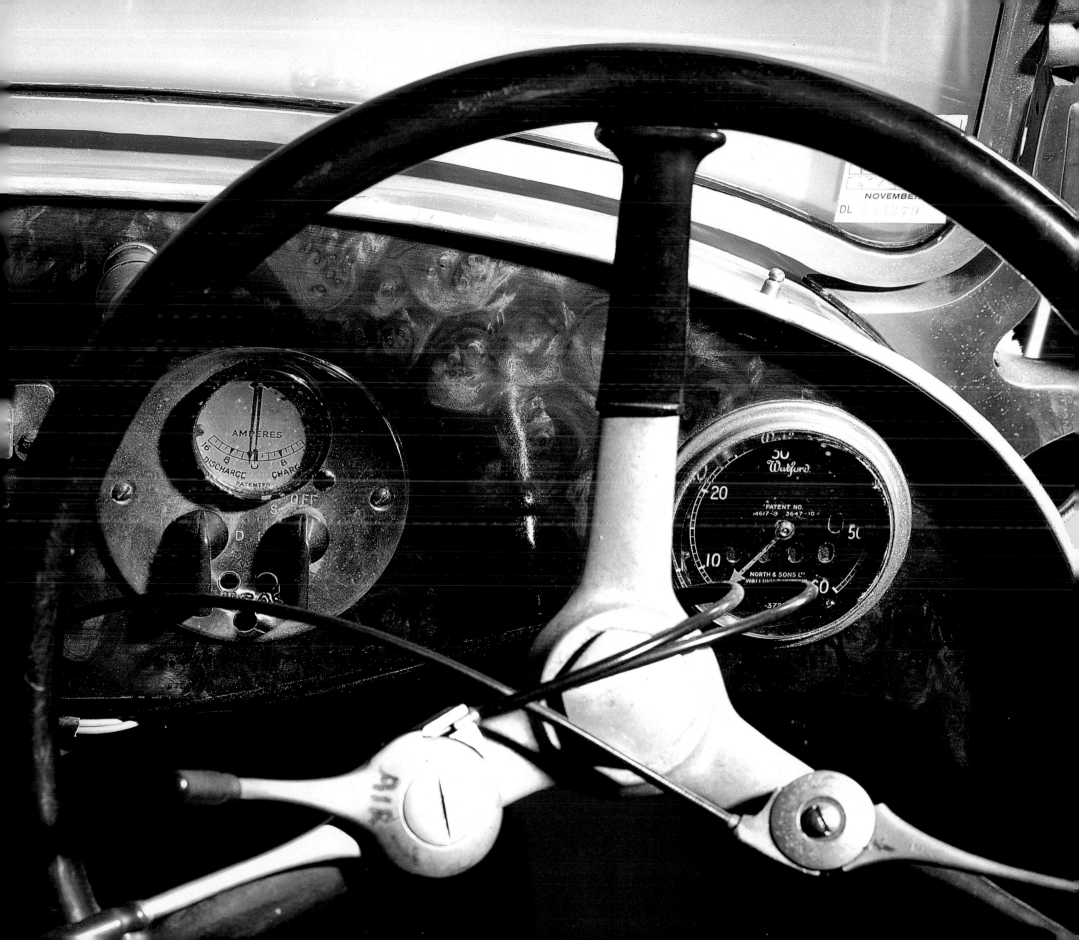

Aston Martin 'Razor Blade' (1923) GB A cockpit width of just 18½ inches gave this car its nickname. Built to attack world distance records at Brooklands, the main target was to become the first light car to exceed 100 miles in an hour. Using a 1½-litre twin-cam engine, designed by Gremillon for the Strasbourg GP, it needed to be as compact and streamlined as possible with the driver sitting well down and only his head above the bodywork; a metal panel covered his shoulders. The cockpit cowl, only just broader than the steering wheel, dominates our picture. The driver wouldn't see much of the dashboard when finally buttoned into the oyster-shell bodywork but, out on the banked circuit, he could duck down to check

dials and gauges. His main responsibility was to ensure adequate engine lubrication in continuous high-speed running – too little would ruin the camshaft bearings, too much would fill the sump and cause power-consuming drag. For this, he had sight-oilers and drip feeds with regulating taps; to control water temperature he had to adjust the radiator shutters; to maintain fuel tank pressure, he had to operate the handpump. The big Jaeger chronometric tachometer reads to 6,000 rpm, just 600 rpm above the engine's limit. Much Aston Martin apprentice time was spent in fitting everything in and around the minimal aluminium dashboard. Although tyre trouble prevented driver SCH Davis from taking the 100 mph record, the car went on to become a potent Brooklands contender in the hands of such as George Eyston. Davis, also an artist and journalist, designed the badge for the prestigious British Racing Drivers Club using Razor Blade as his model. It is a lasting tribute to an elegantly engineered, purpose-built unique little motor car.

This page: The slender radiator has driver-controlled shutters; wind resistance decreases as they are shut.

Opposite: Despite being out of sight, the toe-board was finely made. The magneto is driven from the rear of the engine.

Overleaf: Maximum information is squeezed into minimum space beneath the three sight-

oilers. There is little room for the left knuckles under the wind-cheating cowl.

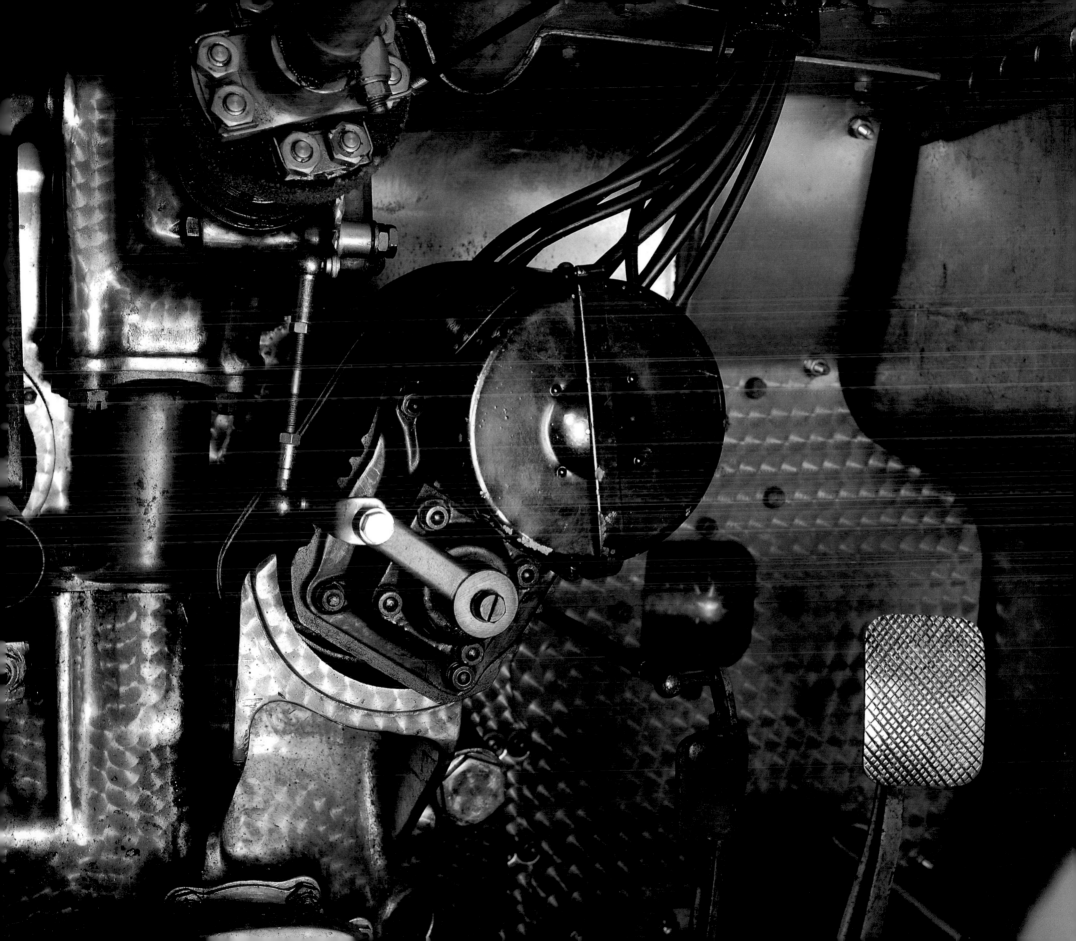

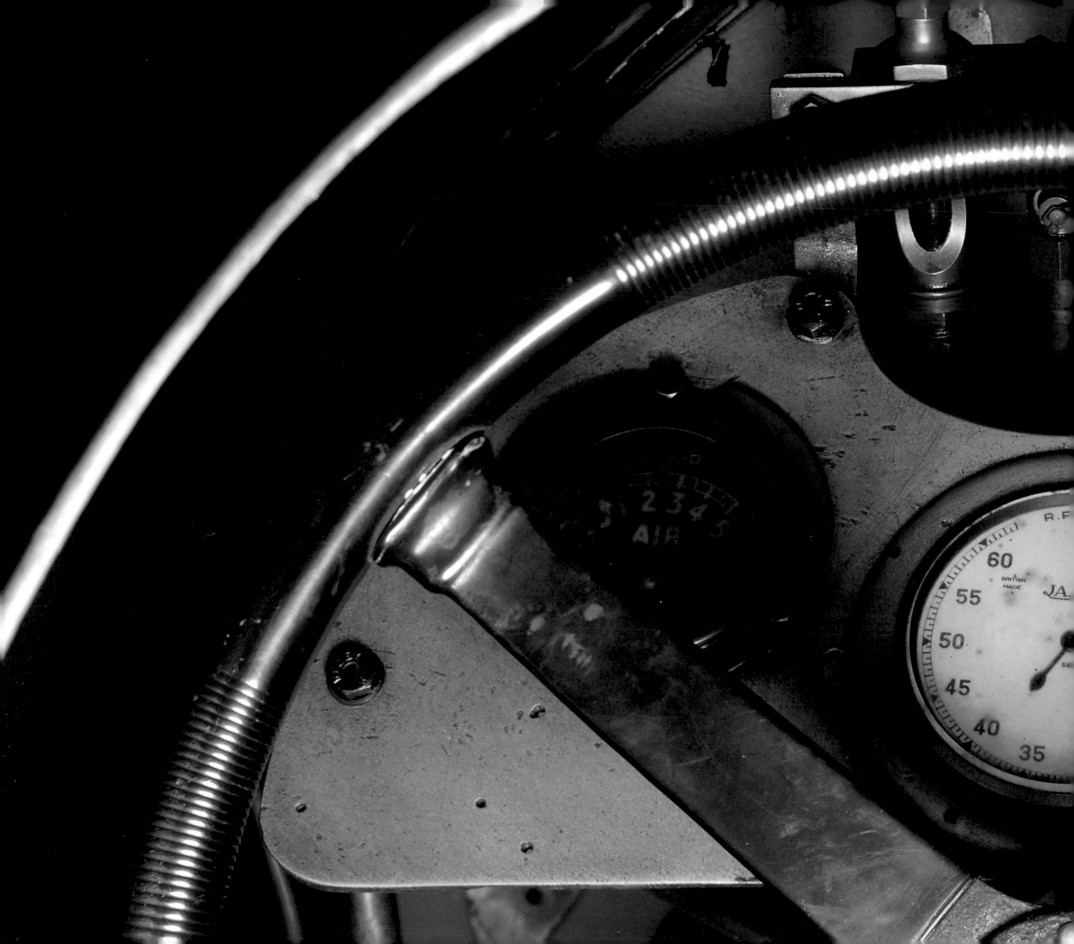

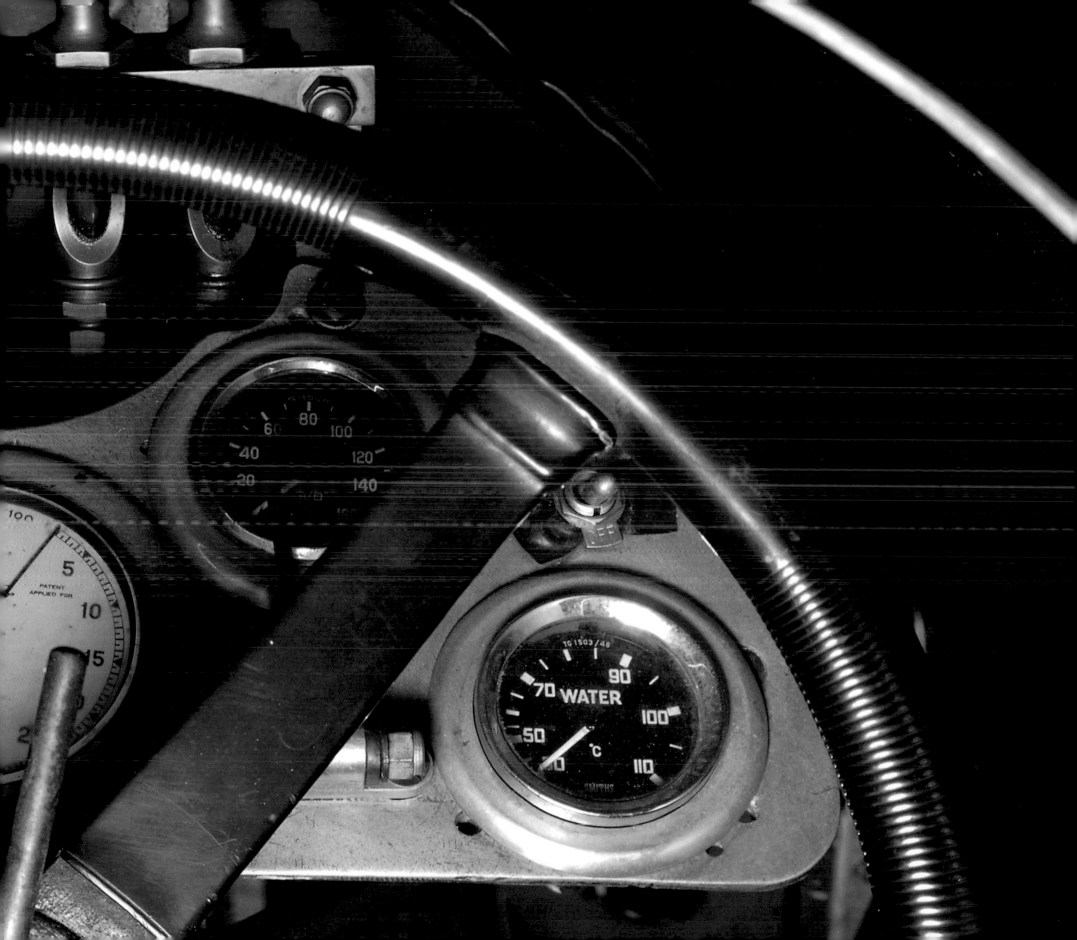

Rolls-Royce Springfield Silver Ghost (1924) USA

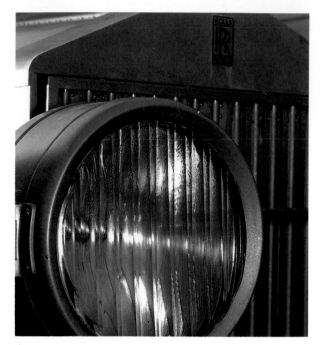

Springfield, Massachusetts was home for Rolls-Royce of America Inc.; from there some 3,000 American Ghosts emerged over a twelve-year period – many more than came from the Derby HQ. Springfield put an American body onto the English chassis, which differed only in such details as the special Dayton wheels, 6-volt electrics and some of the instruments. In the usual Royce buff colour, the thick-rimmed quite small steering wheel carries the twin levers for ignition (marked 'Early/Late' not 'Advance/Retard') and the hand-throttle, referred to as a 'governor', as well as a neat carburettor control above the horn button. Minor gauges and the Yale-locked electrical panel are English, but the Waltham clock and the ribbon-type speedometer are American. The dash is lit by two small cylindrical lamps, while the large knurled knob operates the scuttle-top air-scoop. On the floor are foot controls for Royce's starting carburettor and the novel chain-driven starter, permanently engaged with a built-in freewheel. On the driver's right are the long gear-lever moving around its massive gate, and an equal length hand-brake designed to act as an auxiliary brake, with its own separate rear brake shoes. This Springfield Ghost has a two-seater roadster body by the Smith Springfield Body Works; similar coachwork was later produced by Brewster, when Rolls acquired that company. American features include the large 'rumble seat', double-duck top with sidescreens, barrel-shaped headlights and the large side lamps with RR on the lenses, emerging from the scuttle on long swan-neck arms. With the 7½-litre six-cylinder Royce engine, it was a fast, reliable and silent motor car but its $14,000 price tag could have bought a fleet of lesser vehicles, if you wanted less than the Best Car in the World.

This page: The American barrel-shaped headlights have lenses with a slightly purple tint.

Opposite: Under the bonnet, everything has come from the Derby HQ, except the chassis plate denoting the Springfield connection.

Overleaf: Most of the finely engineered instruments and controls are as fitted to English-built Ghosts, except the ribbon-type speedometer from Waltham, who also supplied the clock. The ignition control quadrant is marked 'Early' and 'Late' instead of 'Advance' and 'Retard'.

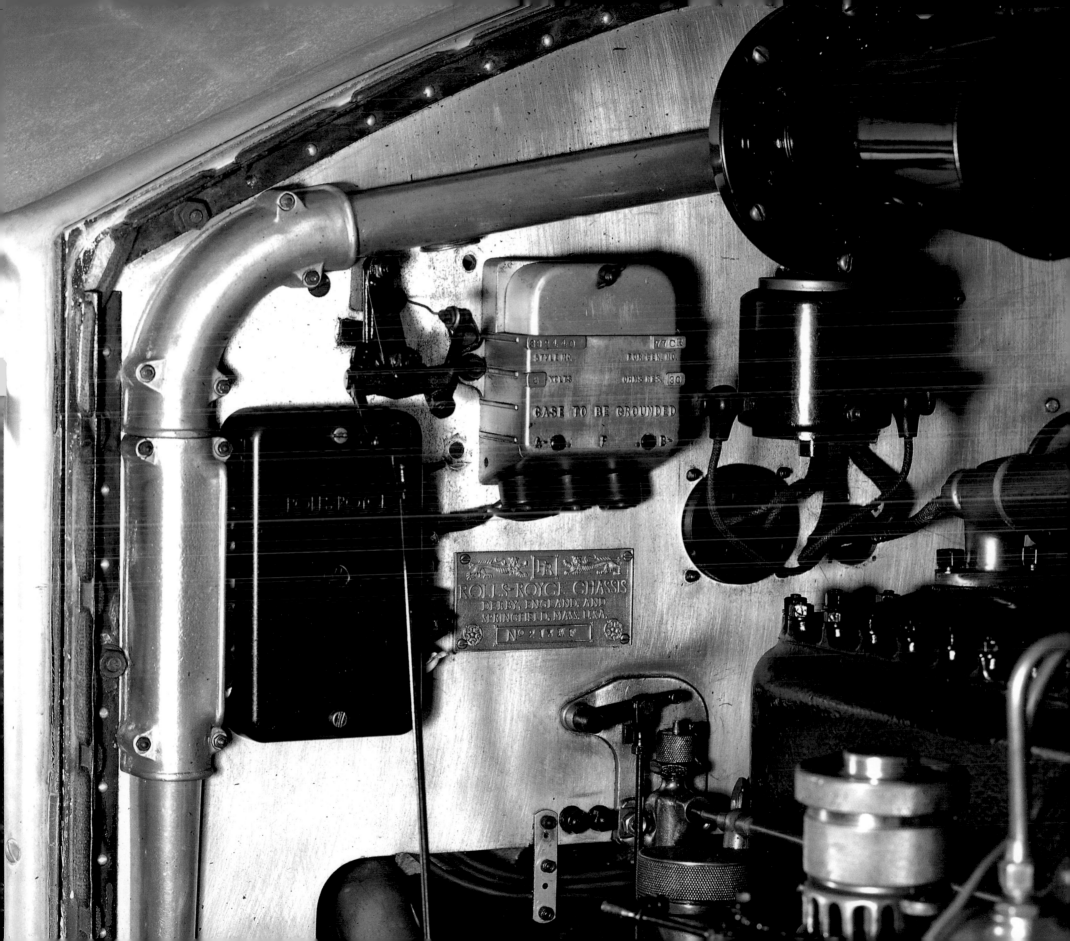

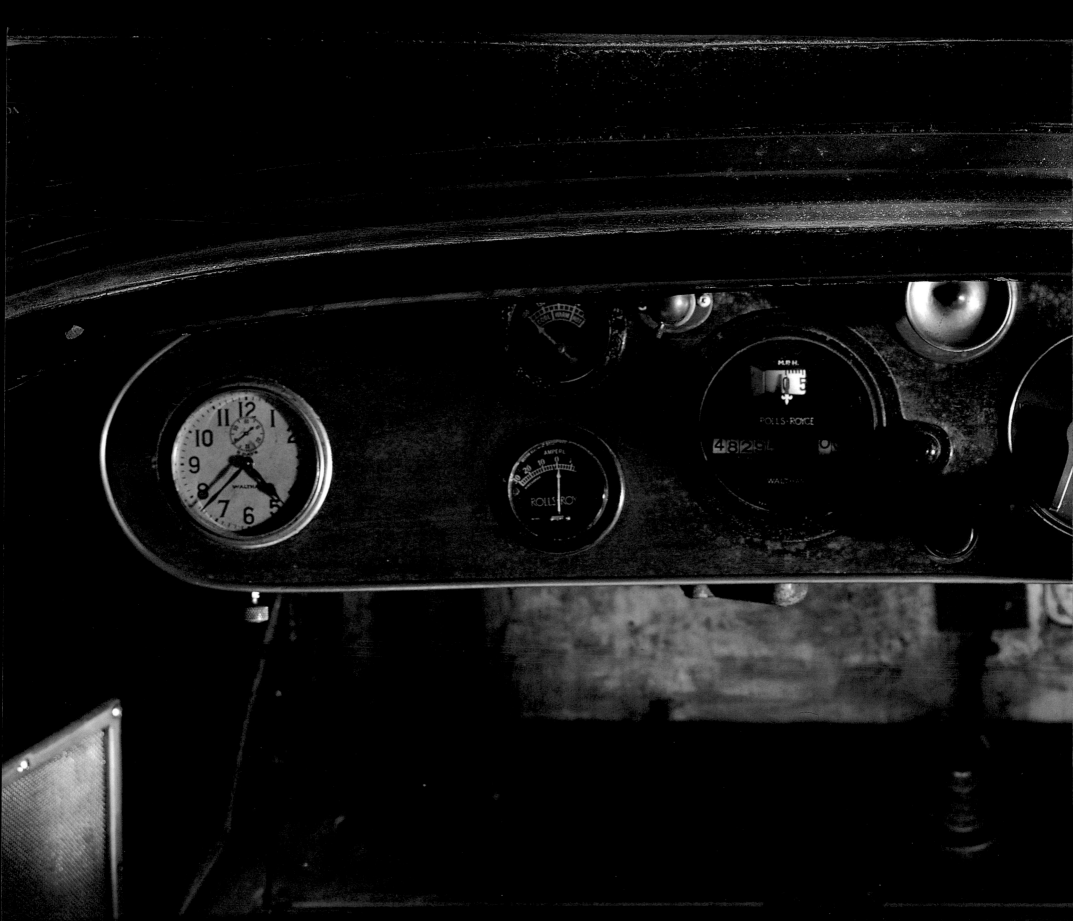

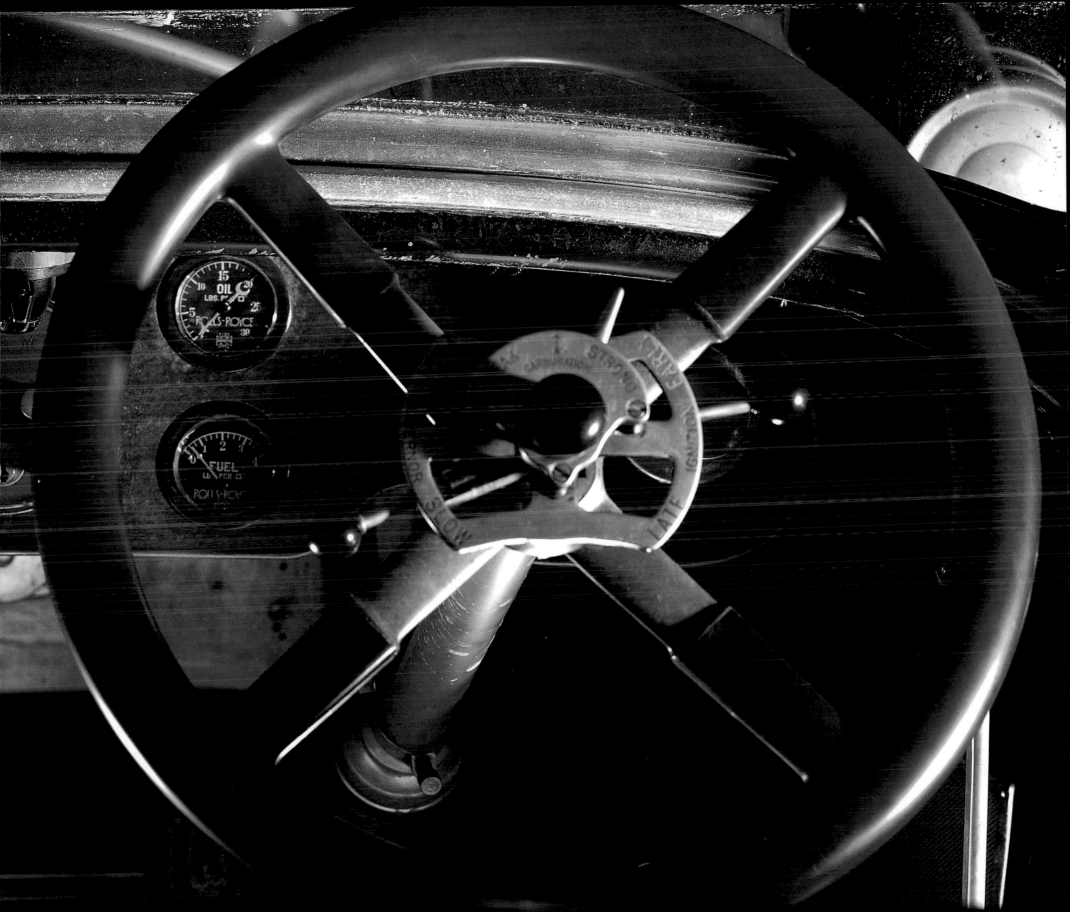

Trojan (1924) GB As a diversification from their prosperous commercial vehicle production, Leyland Motors launched the Trojan into the thriving and competitive market for the new generation of low earners in the early Twenties. Its completely revolutionary concept set it apart from the plethora of cyclecars and scaled-down motor cars, most of which quickly perished through feebleness of construction or inherent performance weakness in this critical market. For an owner prepared to put practicality and sheer value for money above any consideration of contemporary looks the Trojan offered extraordinary virtues in reliability, servicing simplicity, hill-climbing ability and in running costs – indeed its advertising line was 'Can you afford to walk?'. An epicyclic gear box, a chain drive, a single brake, a two-stroke engine with just seven moving parts and a rugged body all combined to create a highly individual vehicle. The

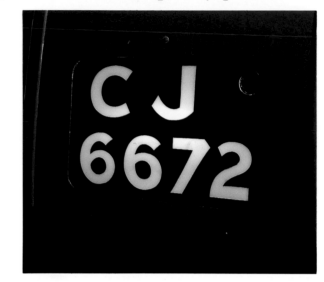

dashboard reflected the philosophy with a bare minimum of items – an ammeter, two switches and two levers; speedometers were not mandatory in the UK until 1937. A horn button in the wheel centre and a pull-up starting lever alongside the driver's seat completed the controls. As the petrol tank was fitted under the bonnet, a dipstick sufficed for a fuel gauge; fuel was supplied by gravity to the carburettor just under the tank, whence the mixture reached the under-floor engine through a very long manifold. For many years these Trojans, with their puffing exhaust note, trundled up hill and down dale, with complete reliability and little cost; they were just as much at home on the farmer's hill-side as on the open road.

This page: This back-lit number plate was a novel feature.

Opposite: Leyland Motors diversified into utility car production with the Trojan work-horse.

Overleaf: The painted dashboard only had a simple panel carrying an ammeter, switches and a petrol tap; the right-hand lever is for mixture control. Brass plates denote the Bromyard supplier and the chassis details.

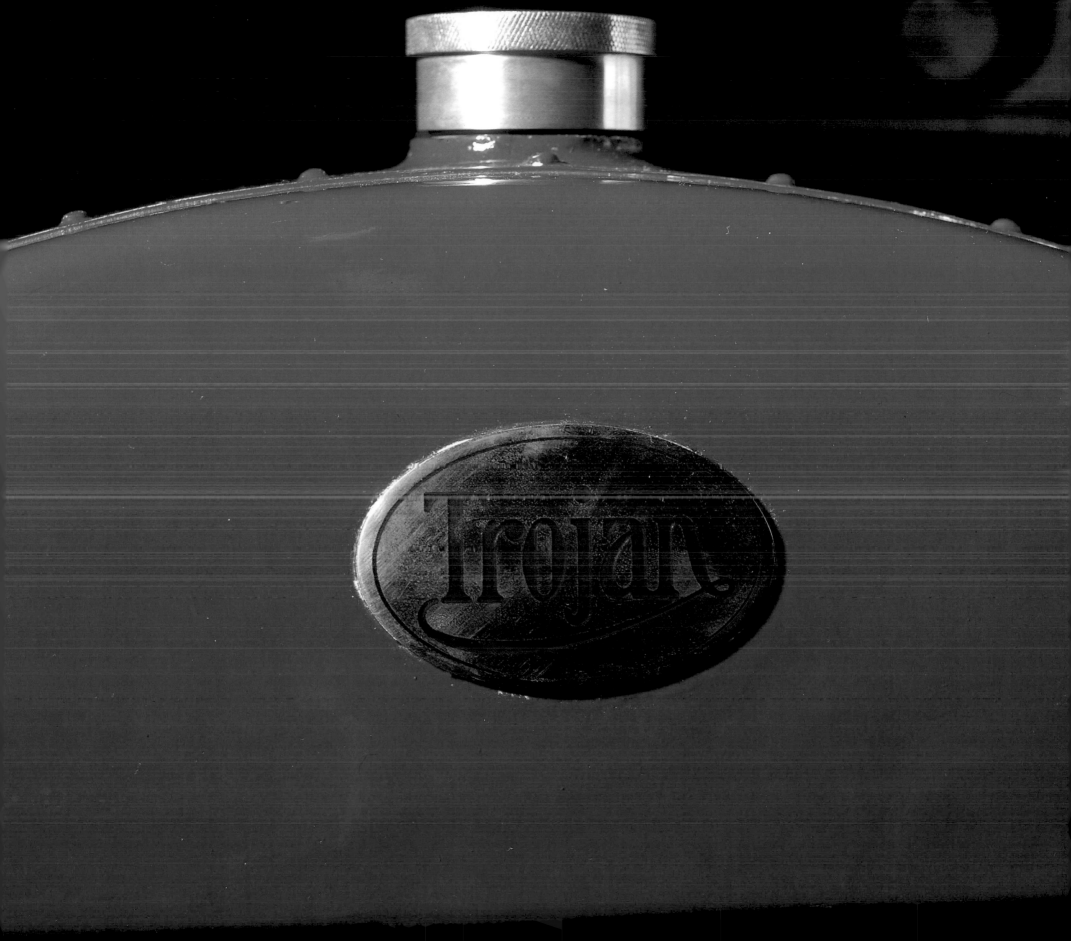

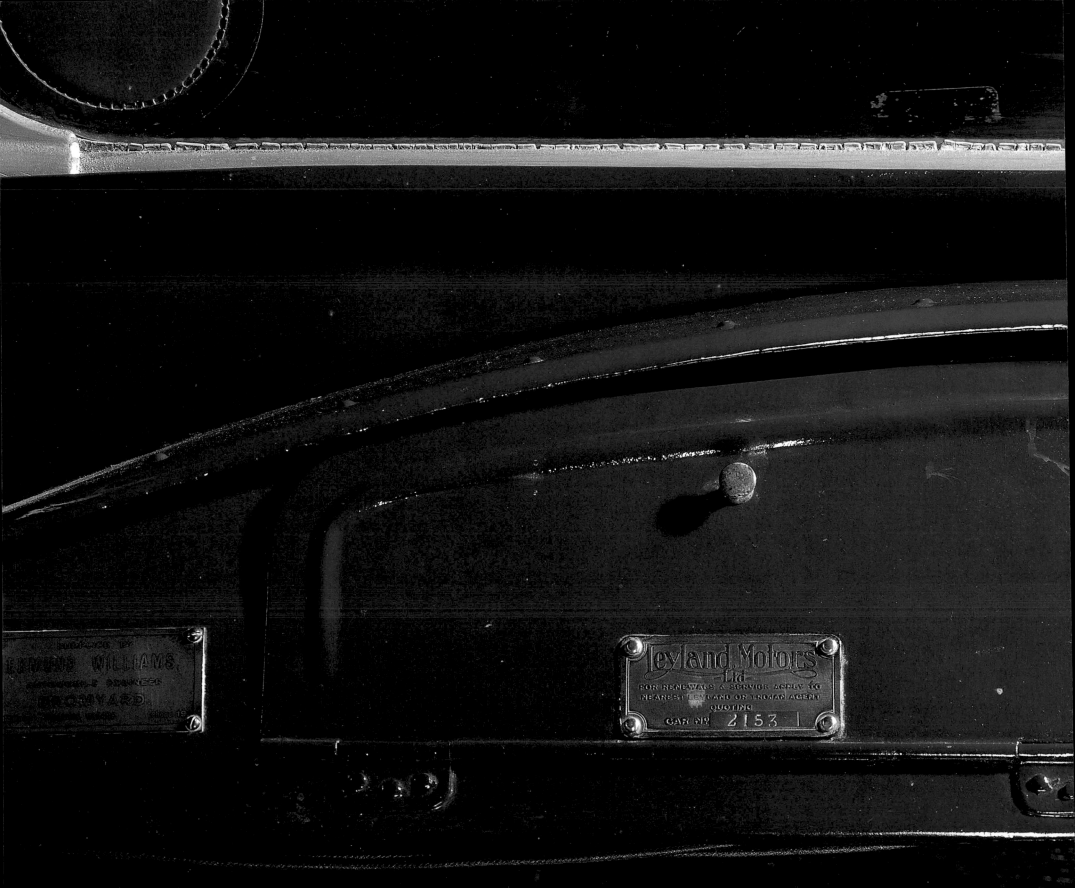

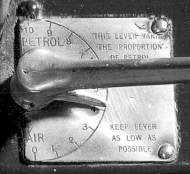

Austin 7 (1925) GB Following his early years with Wolseley, Herbert Austin set up on his own in 1906 making dull, dependable but well-engineered and quite costly motor cars which proved a hardly viable operation. However, he transformed his business, and the life-style of the nation, when he launched the Austin 7 in 1922; it was a thoroughly well-made complete car in miniature. Only the price was low, not the quality of materials used. The 7 opened up a whole new market

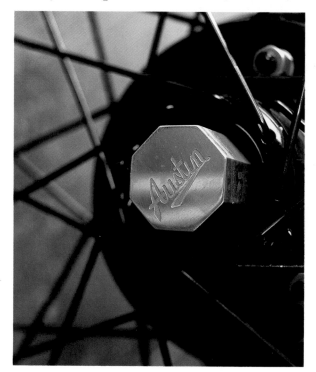

to first-time drivers and others who wanted practicality and convenience before performance and style. It gave them ease of control, reliability, just enough space for four, and minimal running costs. That simplicity is reflected in the dashboard. No speedometer was fitted in early cars, so the ammeter was the sole instrument, on its own panel with dynamo and light switches. Engine lubrication depended on small jets spurting at the crankshaft bearings; when there was enough pressure, a dash-mounted button popped out. A horn and a magneto switch completed the dash controls. In the centre of the steering wheel are two levers to control ignition and the hand-throttle, marked 'Gas'; this American term reflected Austin's recent visit

to the USA to study the art of mass production. Particularly unusual is the large printed and embossed plate on the dash, carrying patent numbers and references that applied to this design; Austin was always concerned to safeguard his commercial interests. He later licensed Bantam (USA), Rosengart (France) and Dixi (Germany) to manufacture their own versions. With its little 747 cc side-valve four-cylinder engine giving all of 50 mph, the Austin 7 was a true milestone design which continued in various forms until 1937, by which time a quarter of a million had been produced.

This page: The centre 'nut' is actually a bearing cap; the wheels are held on by the outer three nuts.

Opposite: Austin's stylized badge shows a winged tyre surmounted by a steering wheel.

Overleaf: On the dash is an electrical panel with adjacent horn-button. The oil flow indicator is above the impressive patent list with the magneto switch on the right.

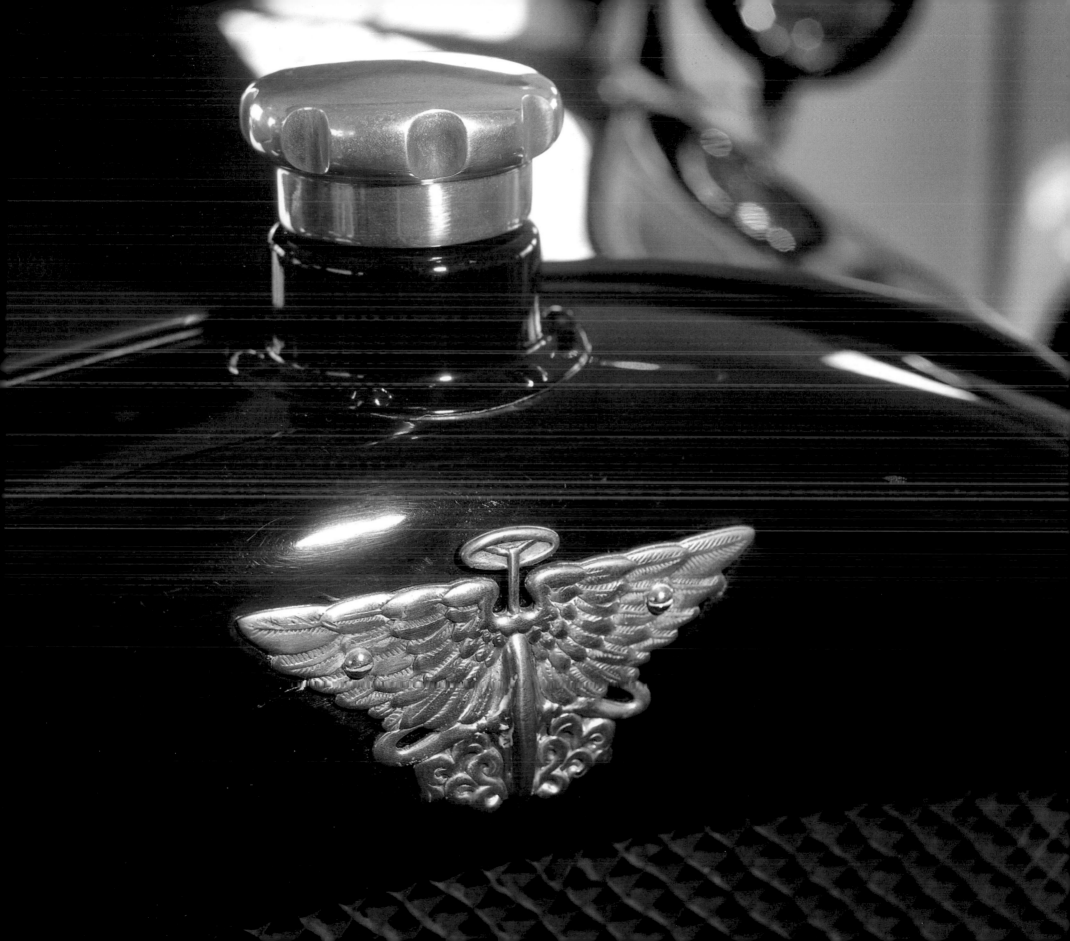

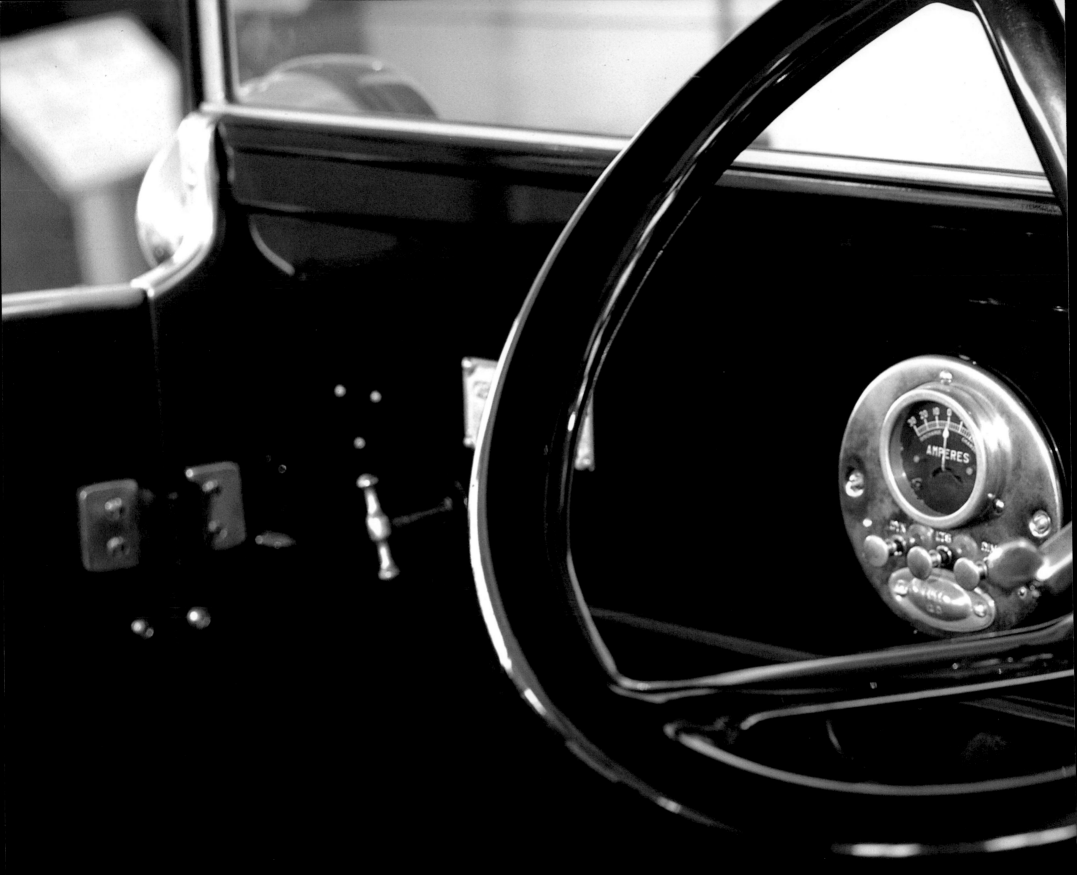

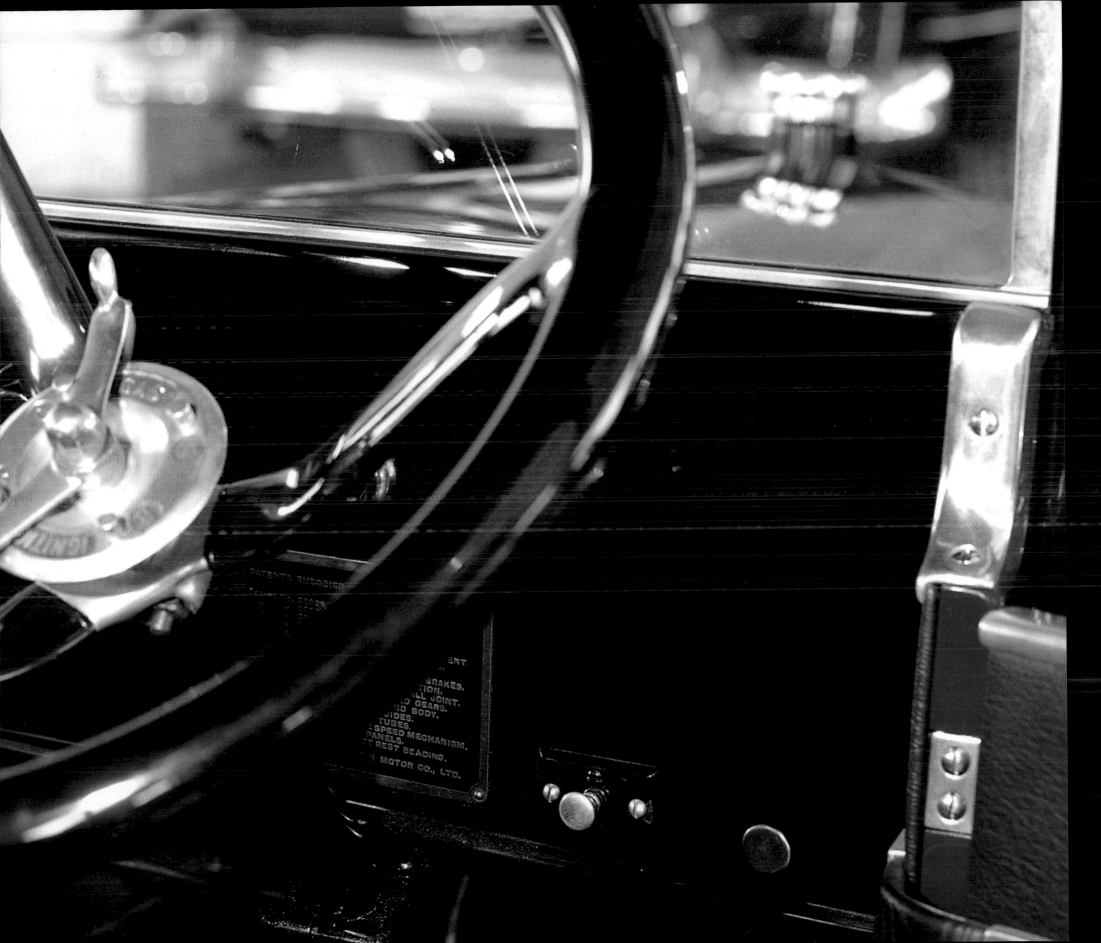

Rolls-Royce 20 'Howdah' (1925) GB Unmistakably a Rolls-Royce, this one was built in Sir Henry Royce's days, so the instruments are of the very highest quality – selected for their function rather than mere compatibility with adjacent ones – and the controls are superbly, even beautifully engineered. The body for this car was built for the Maharajah of Bharatpur by the small but highly respected coachbuilders, Wylders of Kew, and therefore contains some unusual features on its dashboard. Notable are the special switches along the lower edge for the owner's electrical gadgets, some of which were designed by the Maharajah himself: a massive electric bell at the front of the car to clear the way of animals and lesser mortals, a lamp for the State flag waving proudly above the bonnet when His Highness was aboard, additional lamps for the sides and rear, and an extra-powerful Stephen Grebel pillar-mounted spotlight essential for the tiger-shooting purpose of this car (hence 'Howdah' – the seat on the back of an elephant). A period cigar

lighter, a precision eight-day clock plus a vertical control for the radiator shutters complement the normal range of gauges and engine controls; those for throttle and ignition are mounted on the wheel while the mixture control (weak/strong) and starting carburettor (running/starting) share a central panel. The car is a beautiful, practical toy that well represents the Maharajah's insistence on the highest quality for all his motor cars, whatever their design purpose.

This page: The side-mounted spare is an original Dunlop Cord beaded-edge tyre on a Rolls split rim wheel.

Opposite: A pair of Stephen Grebel headlights flank the electric bell set under a powerful horn.

Overleaf: The original layout is standard Rolls 20, but switches under and to the right of the steering column were to the Maharajah's personal specification.

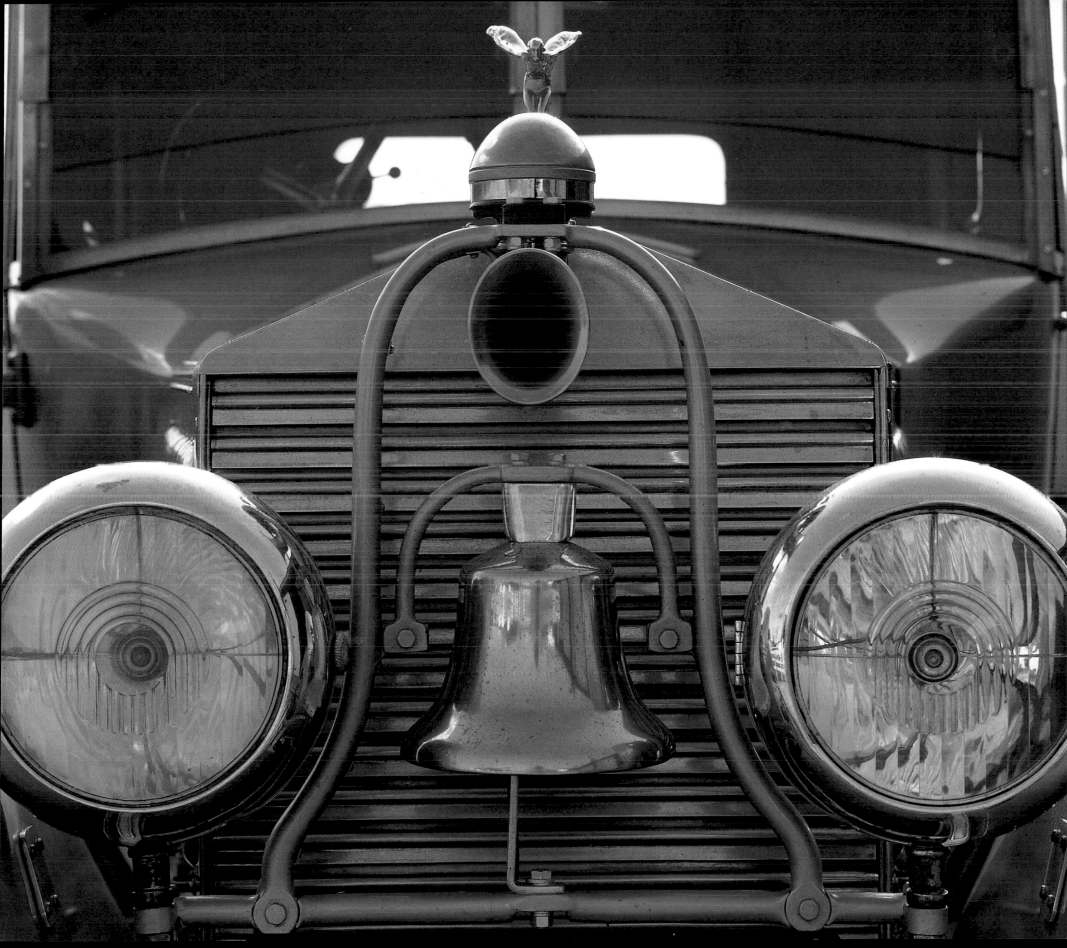

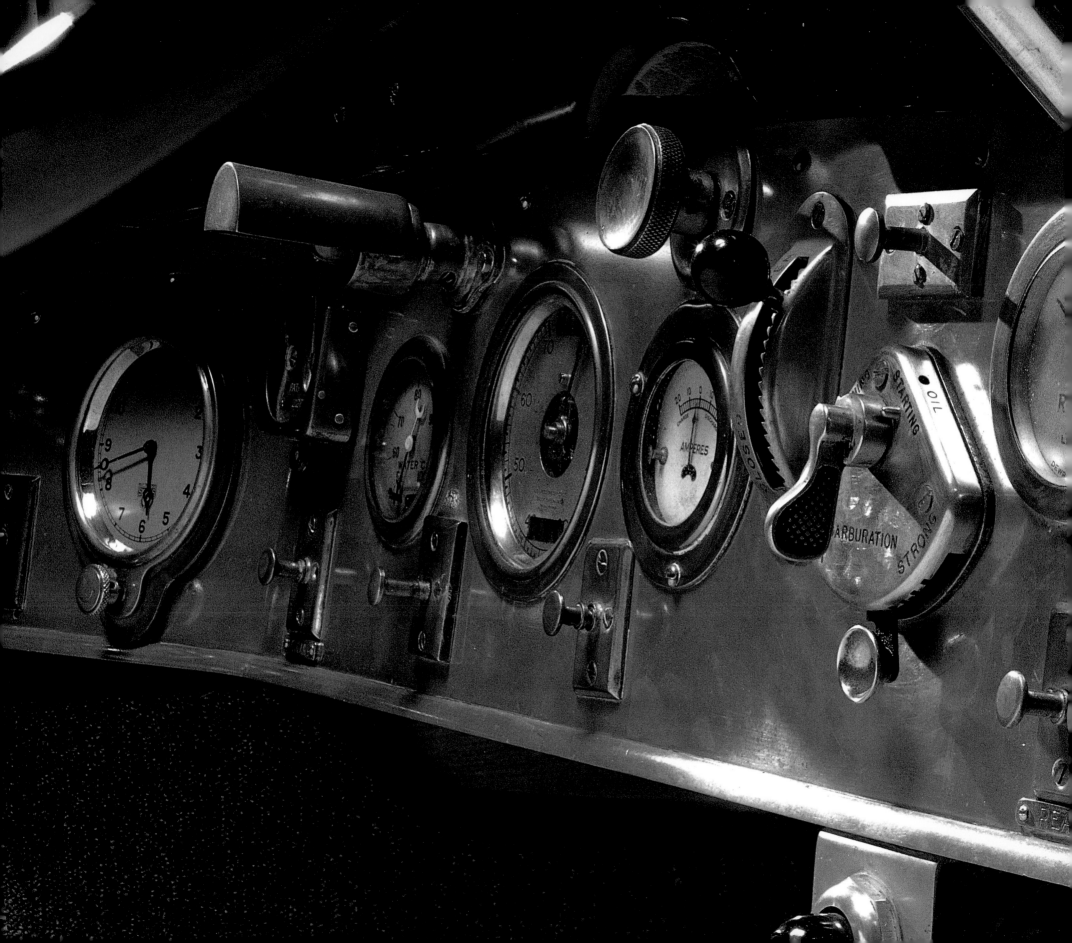

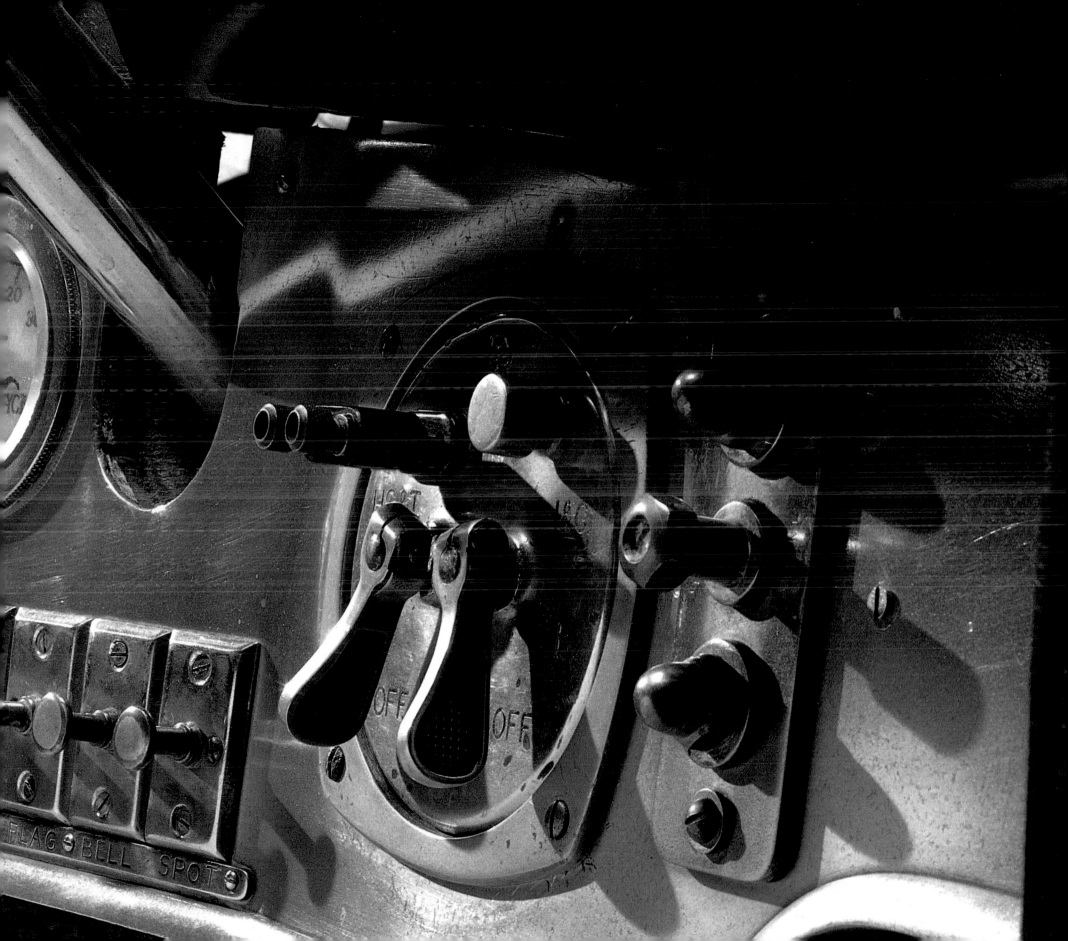

Bentley 3-litre (1926) GB The sight and sound of a vintage Bentley conjures up instant visions of glorious battle at the Le Mans 24-hour race, which the marque won on five occasions in the Twenties. This real warrior is a factory-entered Le Mans car, driven by Duller and Clement in 1926 – not one of the company's successful years as it retired after seventy-two laps with stretched valves. Subsequently owned and raced by Glen Kidston, one of the Bentley Boys, it has been kept

in original campaign-scarred condition, so the cockpit still reflects the special touches insisted on by W.O. Bentley, designer and Team Manager. Most of the instruments and controls were modified or replaced to ensure maximum efficiency rather than matching style. The most important dials – tachometer, oil pressure and water temperature – had luminous paint on their needles and at maximum or optimum readings to catch some light from adjustable but dim dash lamps. Two big household-type tumbler switches on the right control the two magnetos, while the three on the left operate side- and headlights with the innermost one used to signal to the pits via a low spot lamp. On the far left is a fuel-tank pressure pump with starter button adjacent. The gear lever is on the right, the hand-brake being outside the fabric bodywork. The steering wheel is spring spoked to absorb vibration and has Bentley's usual brass boss with twin levers for ignition and hand-throttle. The bonnet (with its compulsory leather strap spring mounted) and the wings still show the results of stones thrown up from that rough French track, partly obliterating the Union flag; but the German Silver radiator has been polished up bright and clear for a nostalgic picture some seventy years after the car rolled out of the Cricklewood factory.

This page: The famous winged B is topped by the standard filler cap, with its substantial tommy-bar for easy turning.

Opposite: The original Union flag is now a little faded. The obligatory leather strap has spring ends for quick release.

Overleaf: W.O. Bentley modified the dashboards of the works competition cars for durability and night driving. Luminous paint can still be seen on the tachometer scale. The big tumbler switches were strong and easy to find with gloved hands.

Three dash lamps can be seen under the top rail. The RR water temperature gauge is actually for engine oil.

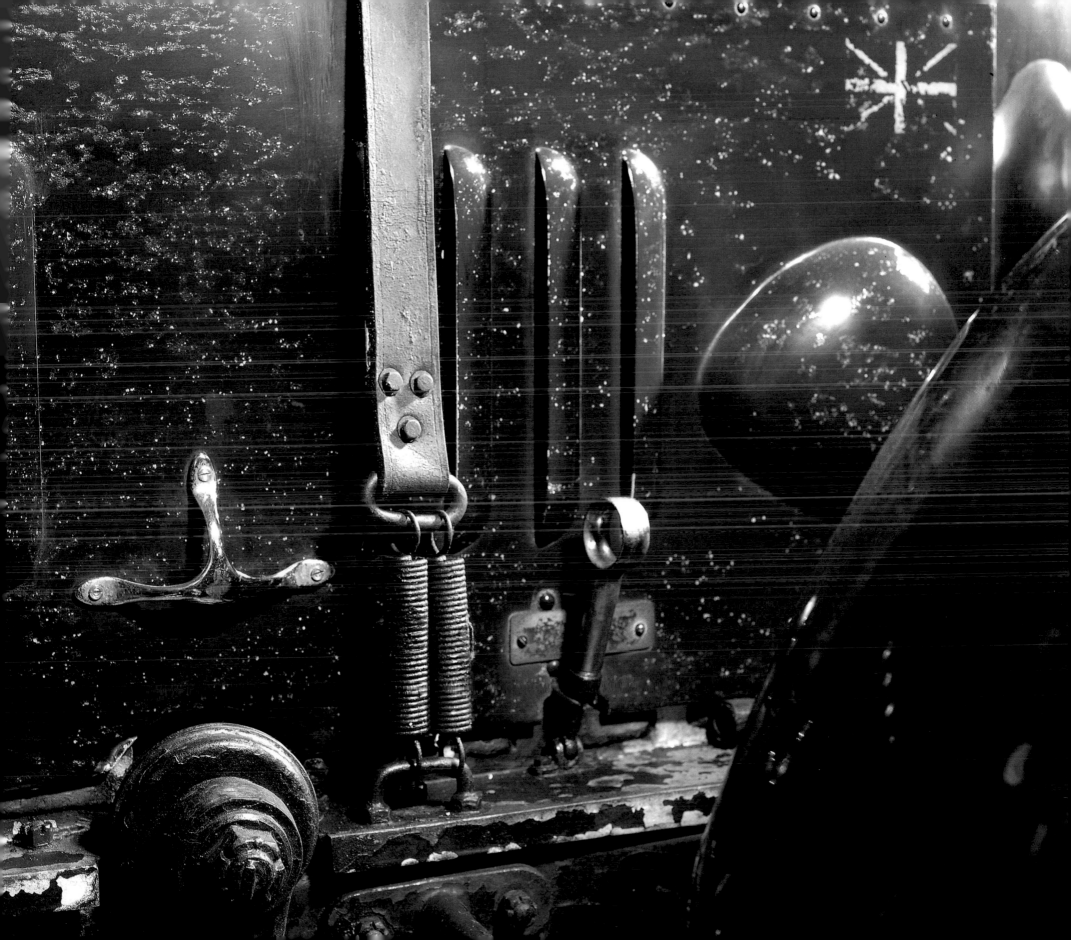

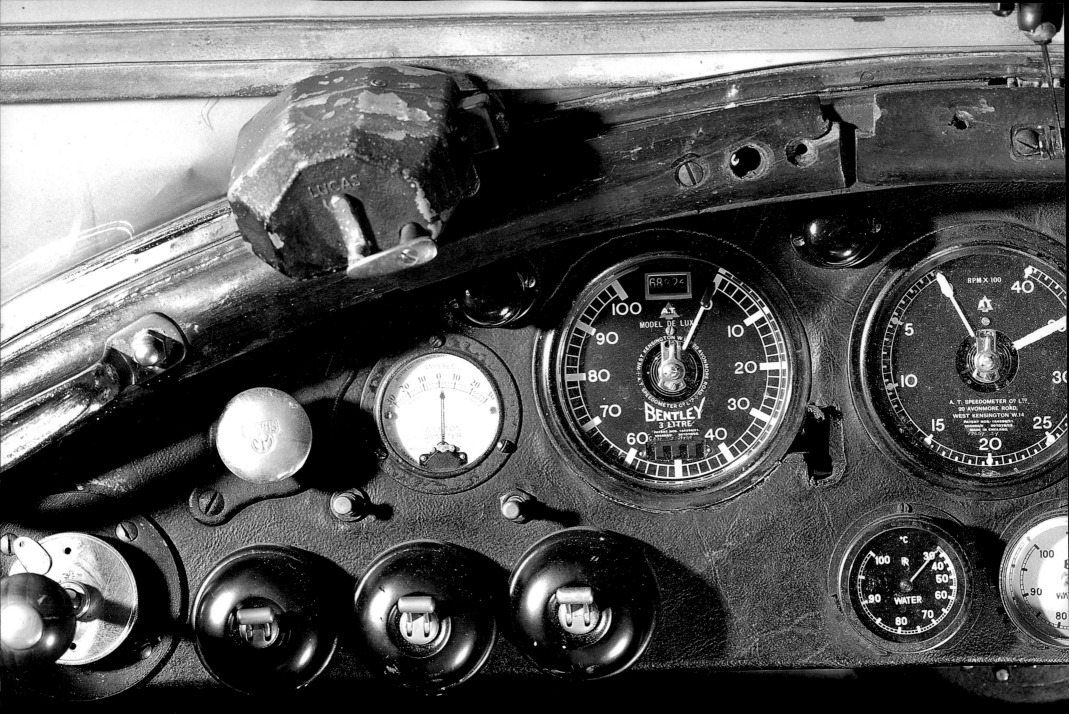

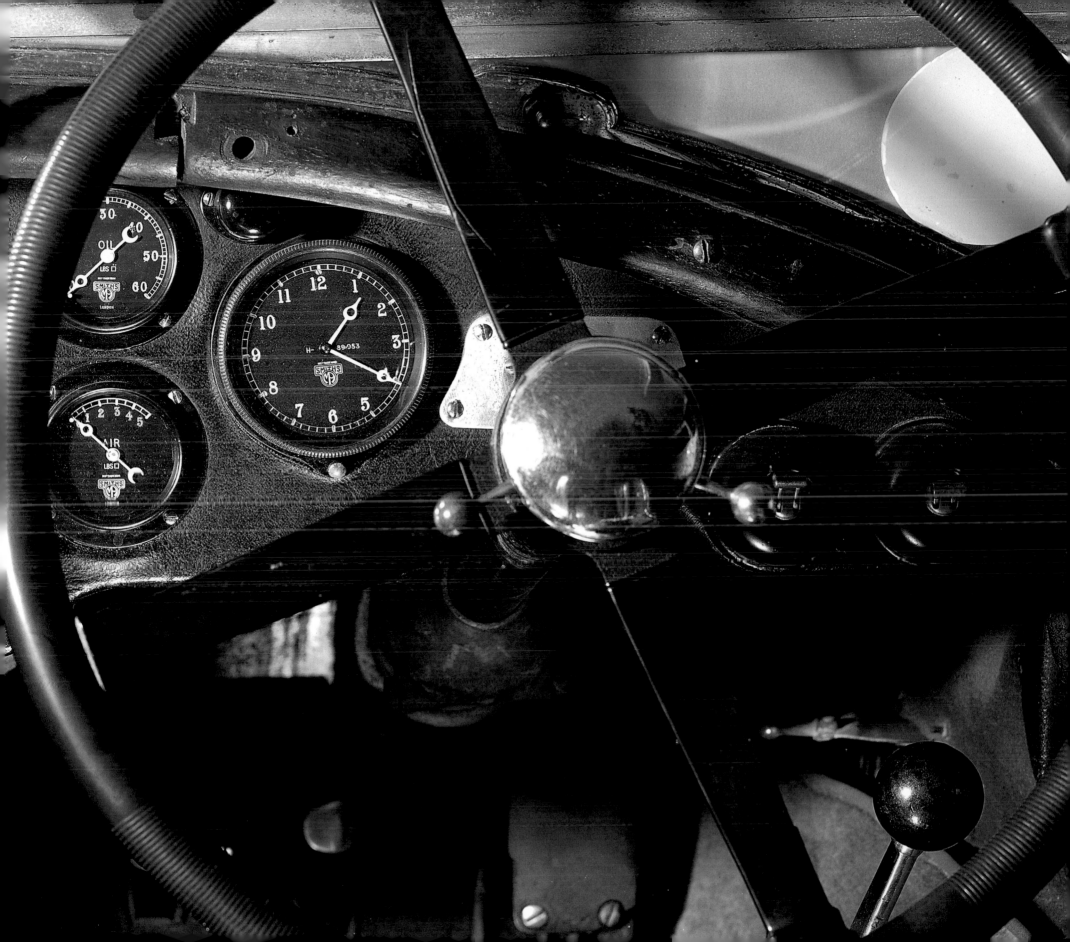

Ford Model T (1927) USA No dashboard anthology could ignore the view seen by millions of drivers for whom Henry Ford, with his immortal Model T, 'put the world on wheels'. Between 1908 and 1927, some sixteen million were produced with a large variety of body styles, but little change in the basic equipment; during this time it became a pioneer of moving-line mass production. Most of its buyers would have had no previous driving experience, so the need for careful gear-changing was eliminated by using an epicyclic gearbox controlled by pedals; largely foolproof, it could nevertheless display such odd habits as running over the person winding the starting handle on a cold day when the gear oil was thick. The dashboard reflected the somewhat rustic, but essentially practical, nature of a car for all types of first-time buyer; in the centre there was just a jet

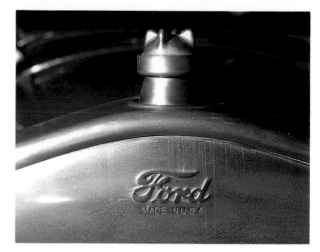

adjuster and a single combination electrical panel with an ammeter and a rotary knob for ignition and lights. The thick-rimmed steering wheel was dished away from the driver to make room for the unique epicyclic reduction gear in its hub. Two small quadrants below this had levers for hand throttle and ignition (a trembler coil system plus flywheel magneto). A speedometer was obviously considered an unnecessary distraction. The Model T was all things to all people, from the Keystone Cops to the outback farmer, from young to old. Idiosyncratic with endearingly unique features, it served its purpose. Our example is from the final production year; its steel radiator proudly proclaims 'Made in USA' – they were made in a great many other countries too.

This page: The ubiquitous Model T was built around the world – this one is clearly stamped 'Made in USA'.

Opposite: The steering wheel is, unusually, dished away from the driver to allow for the epicyclic reduction box under the boss. The paired quadrants can also be seen.

Overleaf: Designed for those with no previous motoring experience, the dashboard is perhaps oversimplified, with just a choke knob and an ammeter within the switch panel.

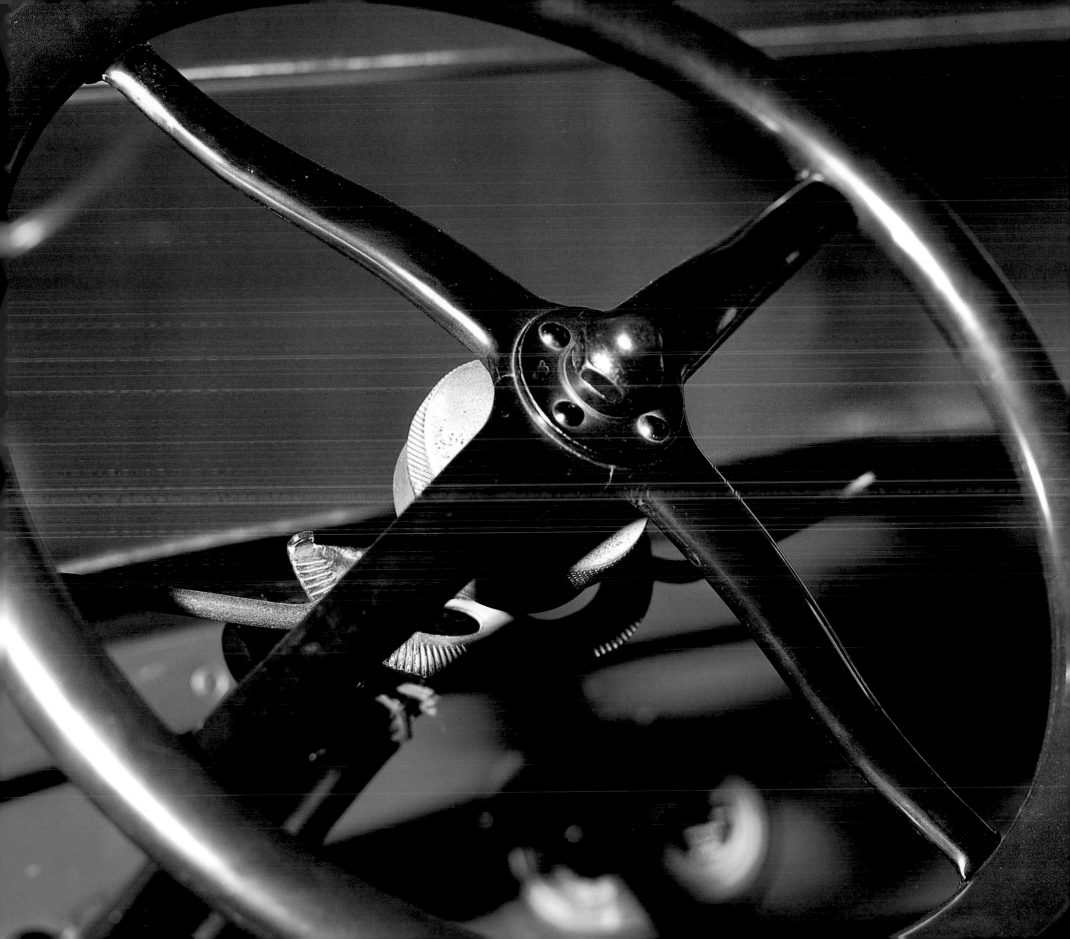

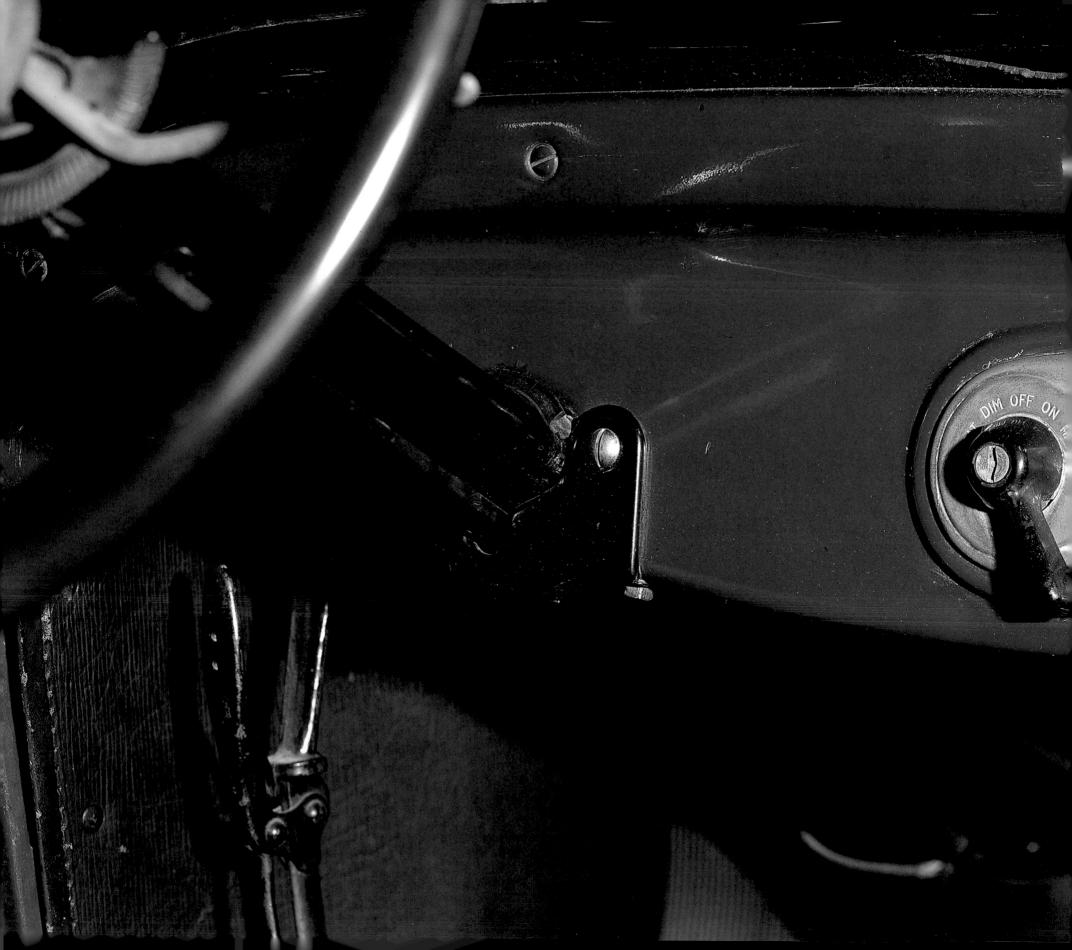

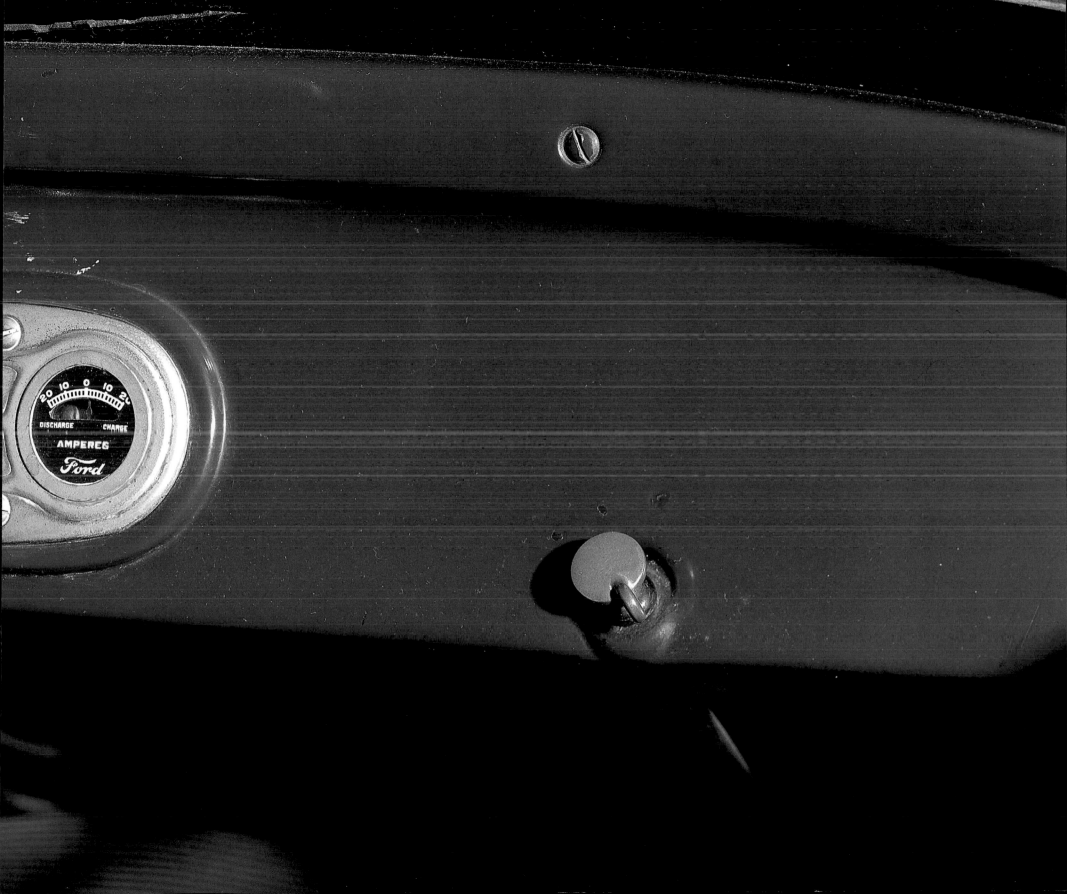

Voisin 3-litre (1927) France Everything that Gabriel Voisin designed was unusual; often unique in form and with no concessions to established practice, this applied as much in aviation, where he was a successful pioneer, as it did in making and racing motor cars. From their Issy-les-Moulineaux factory, Avions Voisin offered an extraordinary range of cars, from the purely practical to the totally luxurious. Always efficient, sometimes aerodynamically adventurous, occasionally bizarre, these cars appealed to connoisseurs who sought individuality and spirited performance. Joining the motor industry after the Great War, Voisin elected to use sleeve-valve engines. By the end of the Twenties, they were producing such fine automobiles as this 3-litre. Clothed in coachwork of a distinctive line, inspired by Le Corbusier's designs, it used lightweight panels and featured drop-windows and large integral aluminium luggage boxes on each running board. Inside, it is trimmed from roof-lining to floor, including the dash surround, in pure art deco materials with very eye-catching fabrics. The dashboard is relatively conventional as Voisin's aircraft background insisted on clear instruments placed close to the driver for easy legibility. The Lalique glass ash-tray for the passenger is redolent of Parisian chic in the jazz age. Intriguing in its visual impact, the futuristic Avions Voisin mascot depicts a stylized bird in strong flight; of aluminium, flat wings are rivetted to its body, epitomizing the Voisin design approach – evocative of the period but timeless in the purity of its form. A syndicate bought out Gabriel Voisin in 1936; after the war, he returned to the motor industry in Spain with the 197 cc 2-stroke Biscuter, purely practical transport for the public.

This page: The slotted wings of Voisin's stylized bird were bolted to its body. More realistic wings are in the radiator badge.

Opposite: Twin large and removable luggage boxes are an integral part of the body design.

Overleaf: Set within art deco fabric, the metal dash has a full array of instruments. A horseshoe earthing strip was required for the horn. On the left is a readily accessible fuse box.

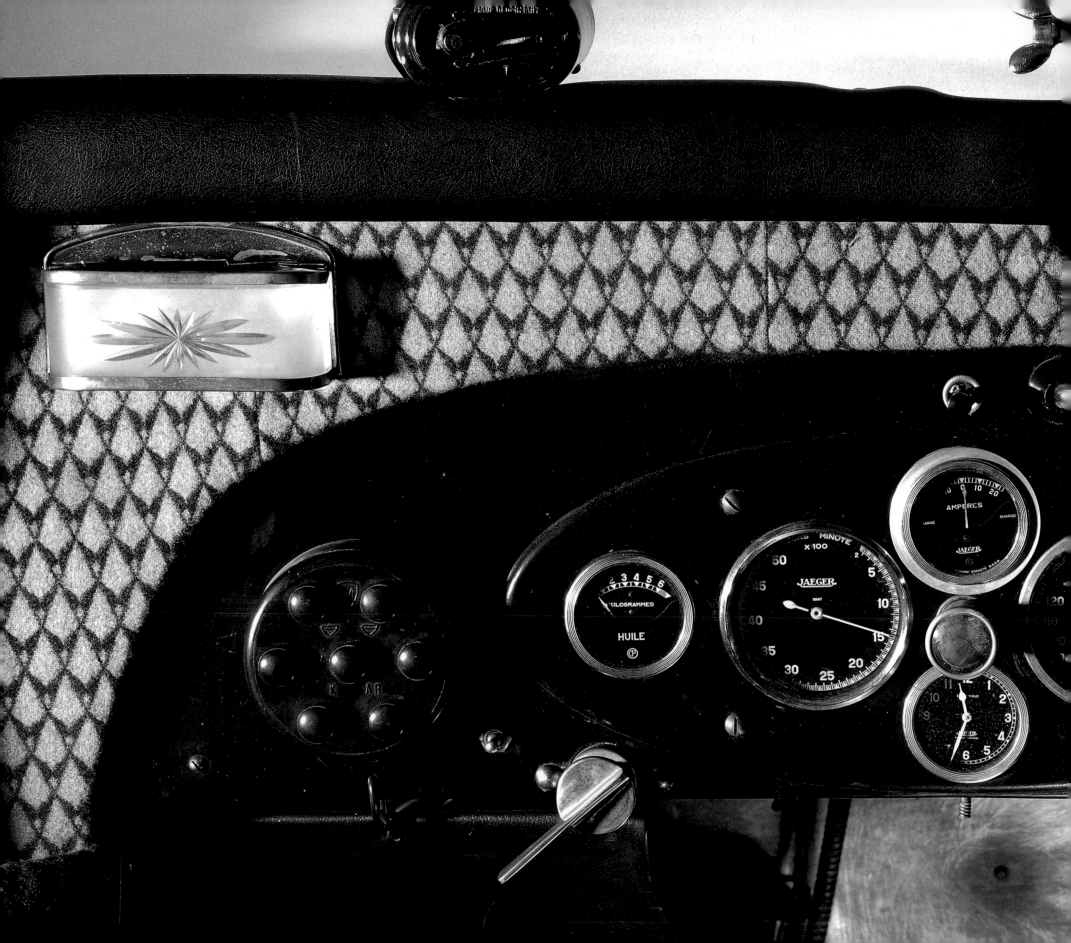

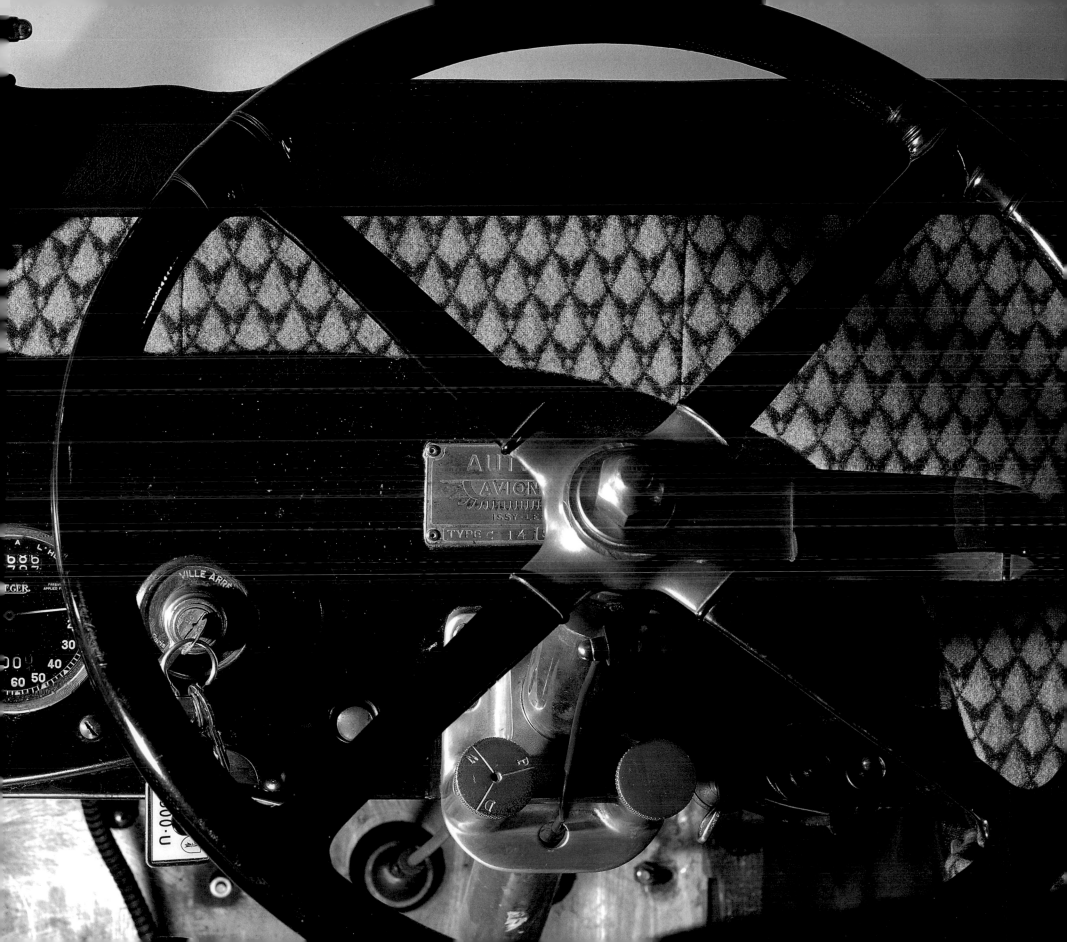

Hispano-Suiza H6B (1929) France/Spain While the name was the product of Swiss designer/ businessman Marc Birkigt producing cars in Barcelona from 1904, the legend of the Hispano-Suiza was built on the immortal H6B, which was designed and built in the company's French factory in Bois-Colombes, near Paris, from 1919. The renowned stork emblem came from the Escadrille des Cigognes ('Stork Squadron') whose SPAD fighter planes were powered by Birkigt's French-built

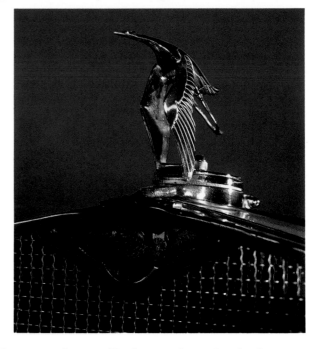

V-8 aero engine; the factory's road was renamed rue du Capitaine Guynemer after the squadron's leader. Powered by the six-cylinder 6½-litre ohc engine in a strong servo-braked chassis, the H6B was one of the fastest and most agile closed cars available anywhere when carrying sporting, lightweight coachwork (such as this from Million–Guiet). Its dashboard is exceptional for the degree of information and control carried on its aluminium panel. Tachometer, speedometer, clock, ammeter and voltmeter, with gauges for oil pressure and fuel contents (Le Nivex) gave very complete instrumentation. The complex Blériot electrical panel controlled two separate battery circuits, with two starters and twin-plug ignition, each of which could be operated alone or in tandem. Below the dash is a petrol cap with reserve position for the 24-gallon tank and its Autovac supply system. Alongside on the toe-board is a large fuse-box together with the chassis plate. Inclined forward to ease entry are the gear-lever and hand-brake, right-hand-drive befitting this grand'routière class. One of the world's finest automobiles, the H6B was built regardless of expense for a wealthy clientele who appreciated its engineering integrity, remarkable performance and grand style.

This page: A stylized version of the official Hispano stork sits above the colours of Spain and Switzerland set in the badge.

Right: Further tribute to the squadron is shown in the street name on the chassis plate.

Opposite: The correct stork, from the insignia of the Stork fighter squadron, is cast in aluminium for the door panels.

Overleaf: A shapely metal dash, set into the facia, contains all the instruments, symmetrically arranged with the oil pressure gauge

being most prominent to the driver. Under the dash is a fuse-box with a fuel tap on its left.

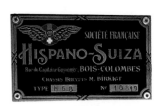

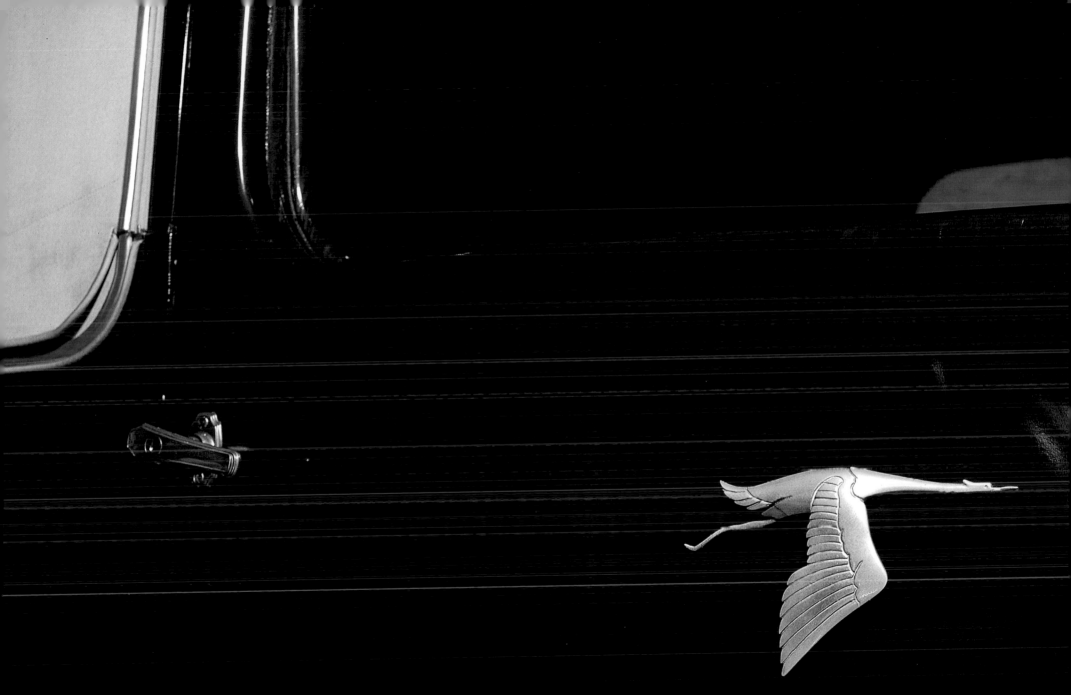

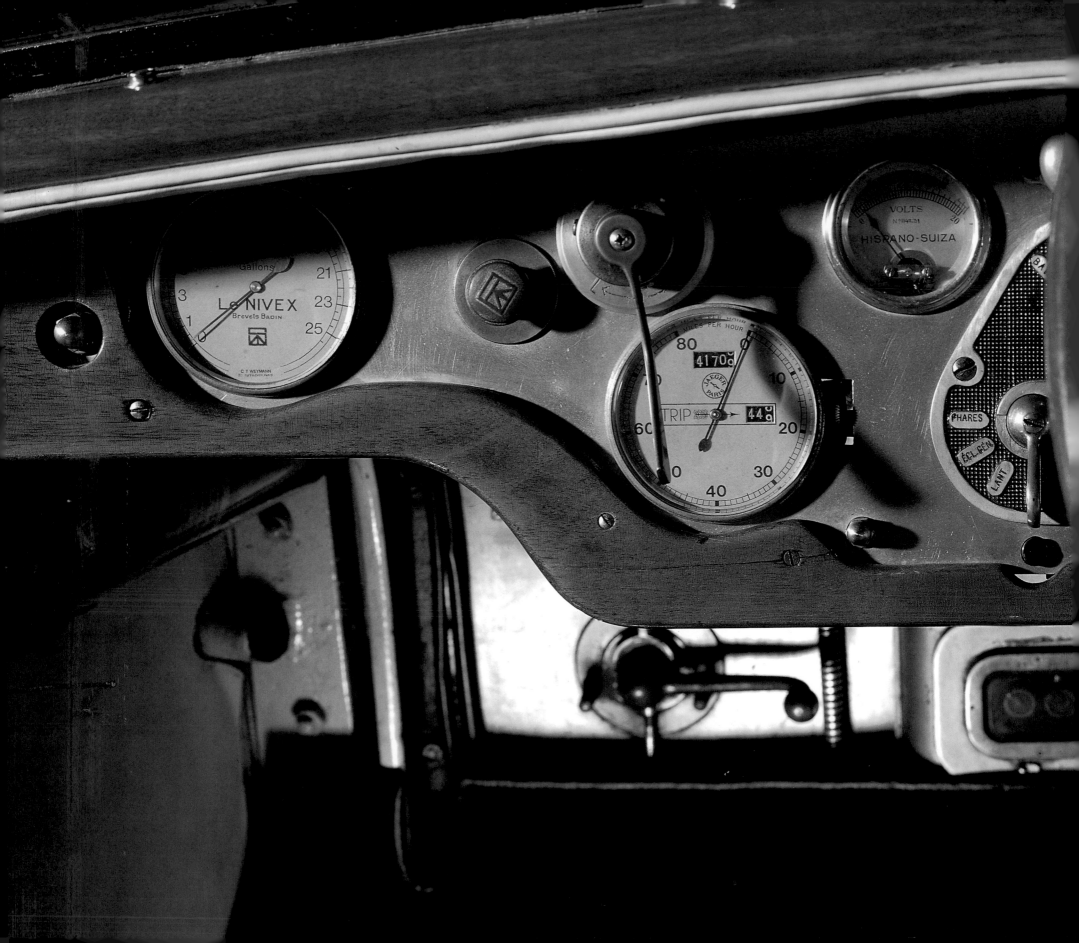

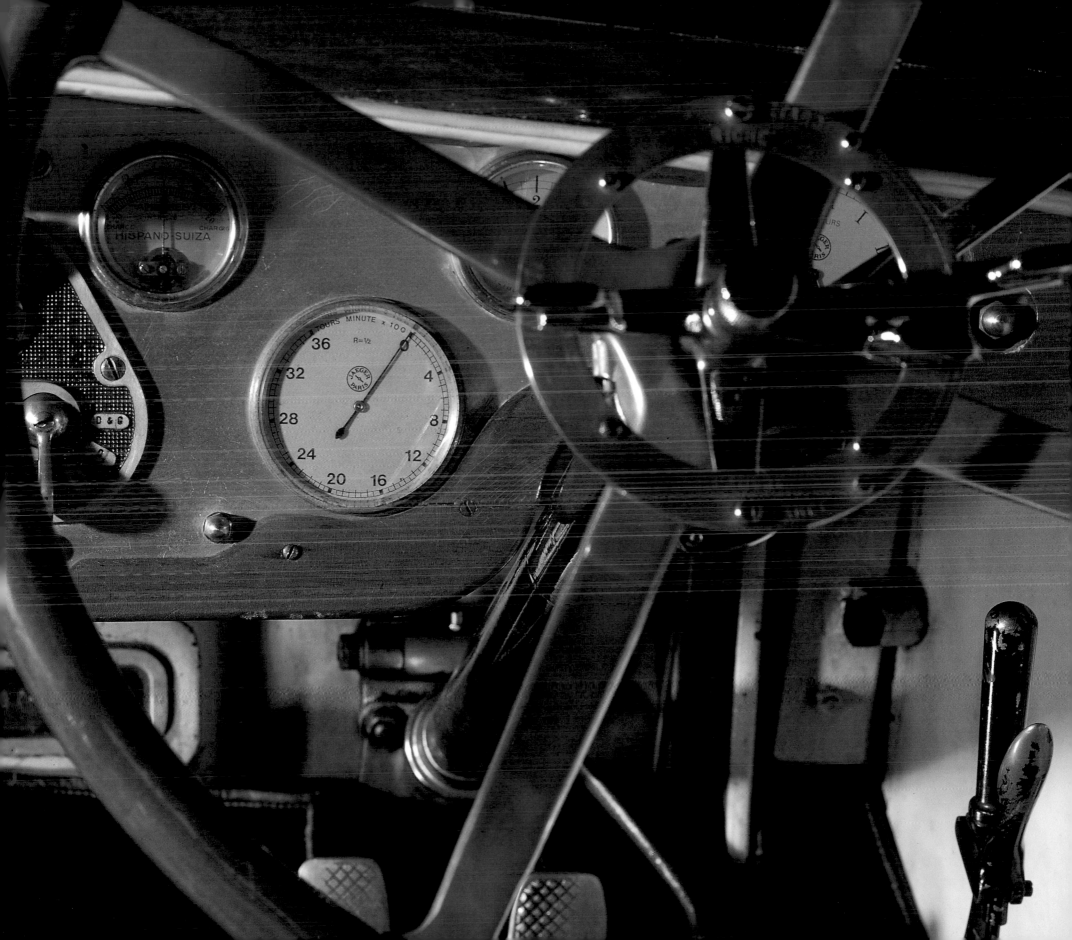

Mercedes-Benz 38/250 SSK (1929) Germany Following the prowess of their supercharged aero engines in the Great War, Daimler Motoren Gesellschaft applied supercharger technology to all the Mercedes high-performance cars for the next twenty years on road and track. The SSK was the ultimate production sports-racing version of the S Series, for which Ferdinand Porsche

had been engaged as designer – a few lightweight SSKL models were built solely for competition. With their 7.1-litre six-cylinder engines developing up to 250 bhp, the SS and SSK were very fast; the supercharger was engaged by clutch when the central accelerator was pressed to the floor, generating a characteristic and glorious mechanical wail. The SSK cockpit exudes serious intent; prominent is the 4,000 rpm tachometer flanked by a speedometer reading to 200 kph, which this model could reach in racing trim. The fuel tank is pressurised by the hand pump, below the pressure gauge with its fuel tap; alongside is a rotary magneto switch. To the left are oil pressure and water temperature gauges, a choke control and a combination lighting switch. The hefty steering wheel, with colourful indication for throttle and ignition lever positions, has the three-pointed star on its boss, although the radiator badge has the combined Mercedes star and Benz laurel wreath to signify the 1926 merger. Despite the theoretical thirty-second limit on supercharger use to preserve the cylinder sealing, there is no boost gauge – the noise was enough to show when it was working. Gear lever and handbrake are in the centre, set high for driver convenience without concession to space in the cramped two-man cockpit. With its huge leather-strapped bonnet through which outsize exhaust pipes protruded, and the Wagnerian roar from its exhaust, an SSK in full song was as awe-inspiring in sight as in sound.

This page: The painted back-plate hides the king-pin to give a very clean appearance; the large drum almost fills the wheel.

Opposite: The plated flexible exhaust pipes, standing out against the German racing white, were a Mercedes hallmark.

Overleaf: Despite the car's overall size, the cockpit is quite narrow; the passenger had to keep out of the way of gear-lever movements. Full instrumentation well suits the sporting purpose.

Delage D8 (1930) France Created in 1905, Delage became one of France's true grandes marques, but foundered in 1935 when Louis Delage, bon viveur and man of taste, had to sell out via Autex to Delahaye – both were to be lost within Hotchkiss in 1954. Throughout, competition had improved and promoted the breed, the highlight being the Grand Prix-dominating 1½-litre of 1926/7; road cars, sold from the Champs-Elysées showroom, ranged from durable sporting machines to luxury carriages with elegant coachwork from such as Franay, Chapron, Darrin or Figoni. This D8, bodied by the Parisian firm VanVooren for their 1930 Paris Salon stand, had the 4-litre straight-8 overhead valve engine with four carburettors and 120 bhp. Controls and the white-faced instruments, with Delage logos, are of understated high quality. The highly accurate Nivex fuel gauge, giving the gallons remaining only when the nearby knob was pulled, was a customary feature of high quality French and Italian cars. Uniquely Delage features include a colour-coded oil pressure gauge (no figures), warning red speedometer figures from 75 to 90 mph, rotary throttle and choke controls and the horizontal lever operating radiator shutters. In the steering wheel centre, the ignition lever augments an automatic distributor control; on the column are two typical grand'routière controls – town or country horns and a headlamp dipper. Set in walnut veneers and solid ebony, the dashboard was entirely appropriate to one of the world's top quality automobiles, and to the owners who appreciated such race-bred Delage hallmarks as the high quality chassis with light and accurate steering, the small gear-lever with short precise movement – reverse through first, curiously – and an engine that could lift the D8 comfortably beyond 100 mph.

This page: The water temperature is indicated by the calormeter on top of the radiator cap.

Opposite: The graceful curves of the front wings are typical of coachbuilders VanVooren and Figoni.

Overleaf: All the instruments on the central panel have Delage markings. Under the dash,

'Ouvert' and 'Fermé' denote positions for the radiator shutters.

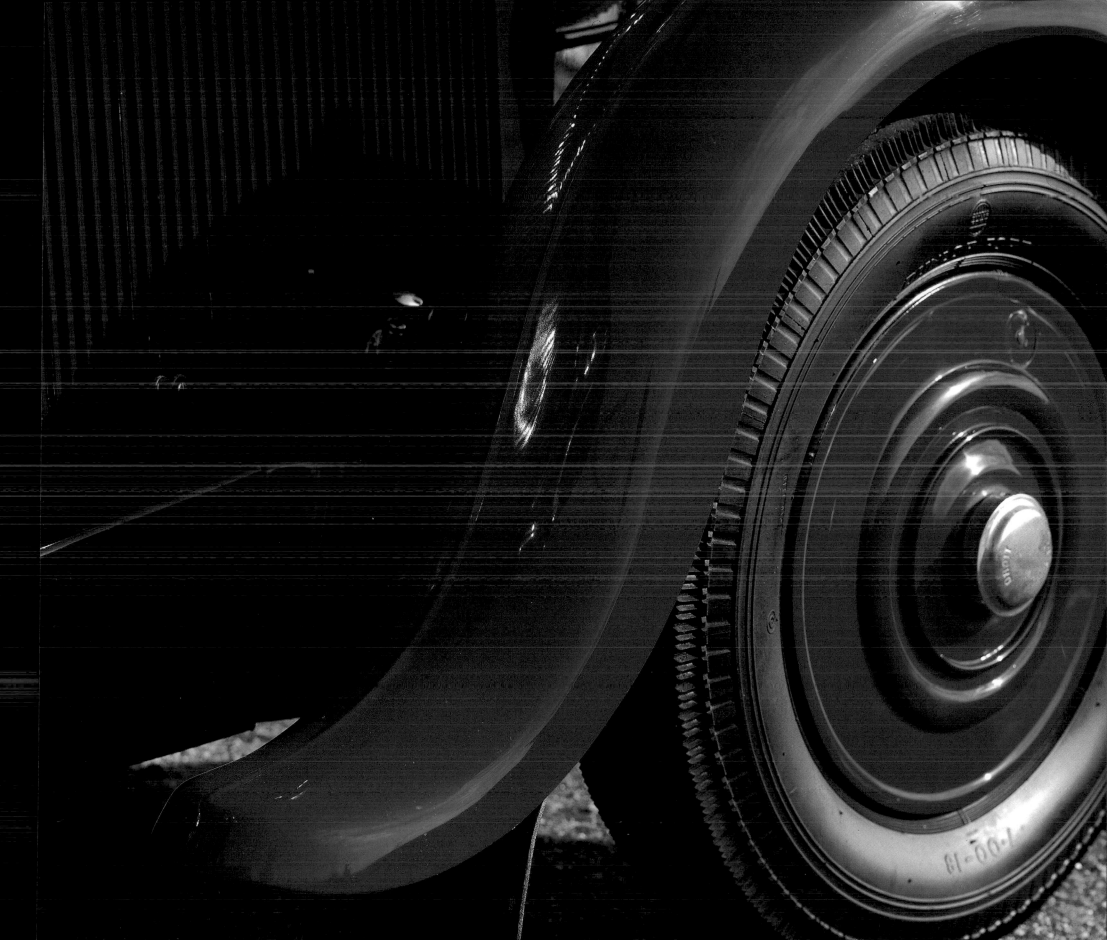

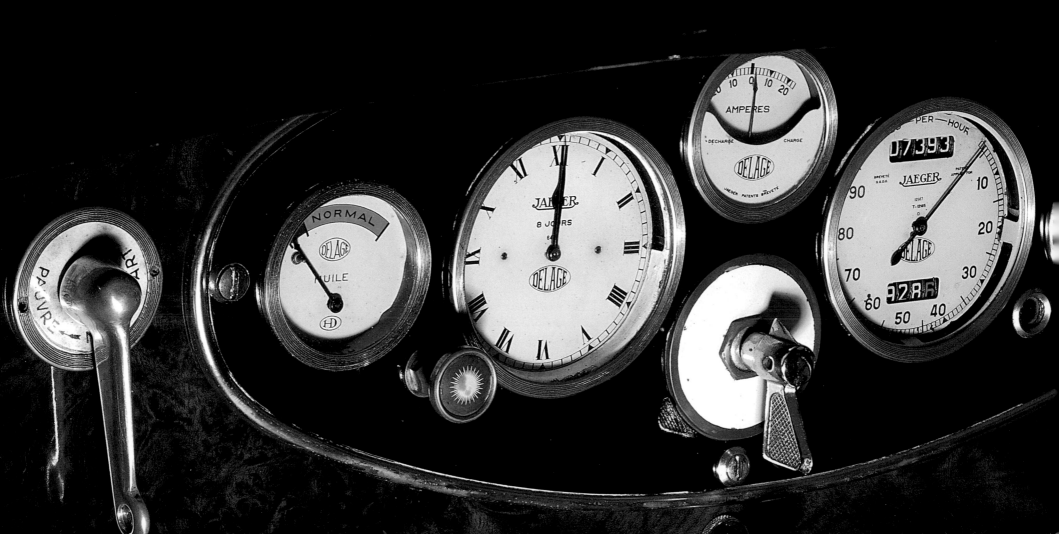

Duesenberg Model J (1930) USA Arguably America's mightiest automobile, and intentionally its most expensive, the Model J 'Duesie' was a blend of Errett Lobban Cord's financial clout and unbridled commercial ambition, with Fred and Augie Deusenberg's knowledge of high quality engineering and racing expertise. It had to be the biggest and the best; every component was of

heroic proportions, starting with the deepest, stiffest frame. The Lycoming-built 6.88-litre engine was a magnificent straight-8 with four valves per cylinder for which 265 bhp was claimed; as an example of the cost-regardless attitude, the crankshaft was balanced by capsules of mercury. In all its highly polished brazen style, the Duesie thundered through the Depression and only ceased in 1937 when all 480 equipment sets had been completed. In a car costing up to $20,000, the dashboard deserved the best and most comprehensive array available, stretching across the narrow cockpit. Its speedometer reading to 150 mph, 5,000 rpm

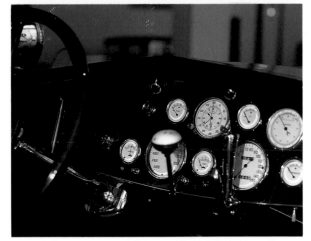

tachometer, and gauges for oil pressure and water temperature, ammeter and fuel were supplemented by an altimeter, a Swiss split-second chronometer, and a braking effort meter. Warning lights showed low battery level, and oil change and chassis lubrication requirements, with another confirming that the chassis lubrication pump was working. On the steering wheel were small button-shaped levers for ignition setting, hand-throttle and light beam adjustment. Surprisingly there was no boost gauge on the supercharged version of this chassis, but the ever deeper basso-profundo from the exhaust was enough indication.

This page: (Upper) Inset in the reversing lamp is a red brake light with a matching 'Stop' to enforce the message.

(Lower) The dash for the supercharged model (sometimes SJ) only uses analog instruments.

Opposite: The coloured Speedbird was an option, not found on all.

Overleaf: The anodized brass dashboard contains ribbon-type rev counter and speedometer among a full complement of analog minor gauges.

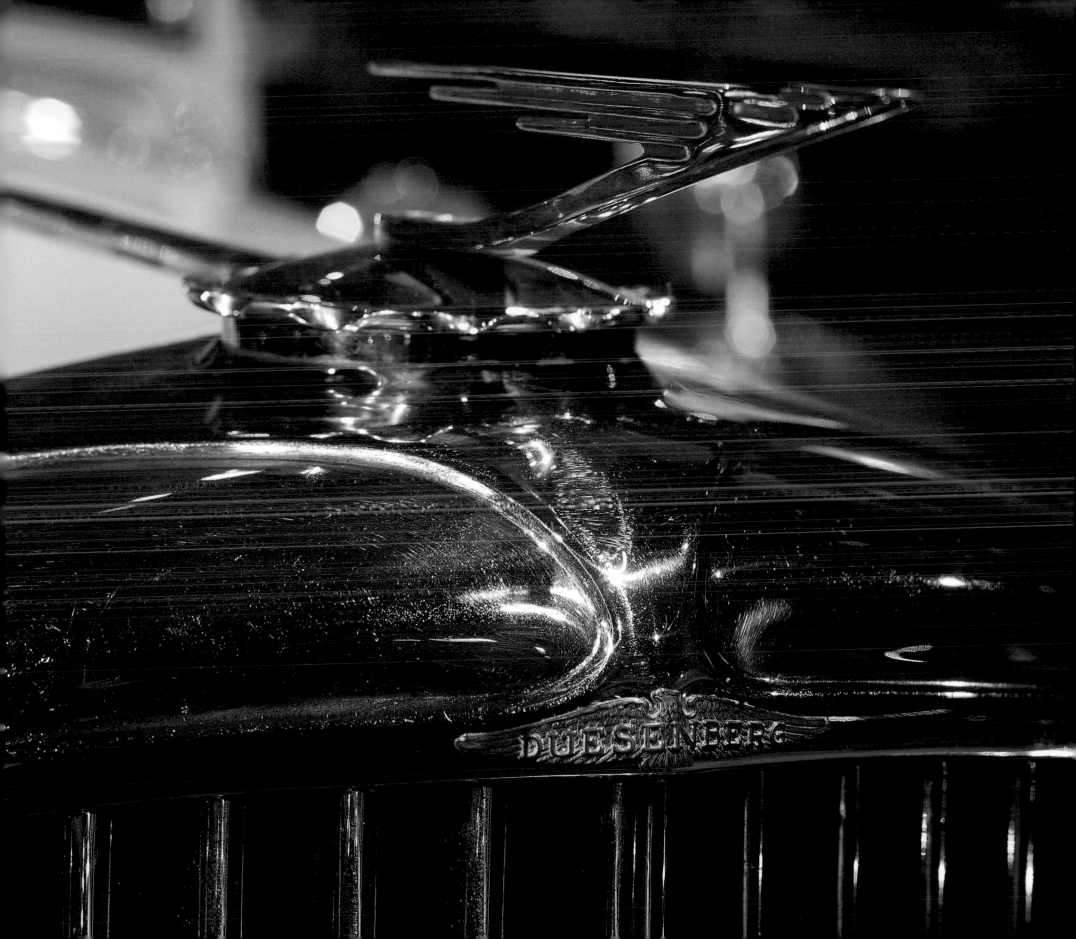

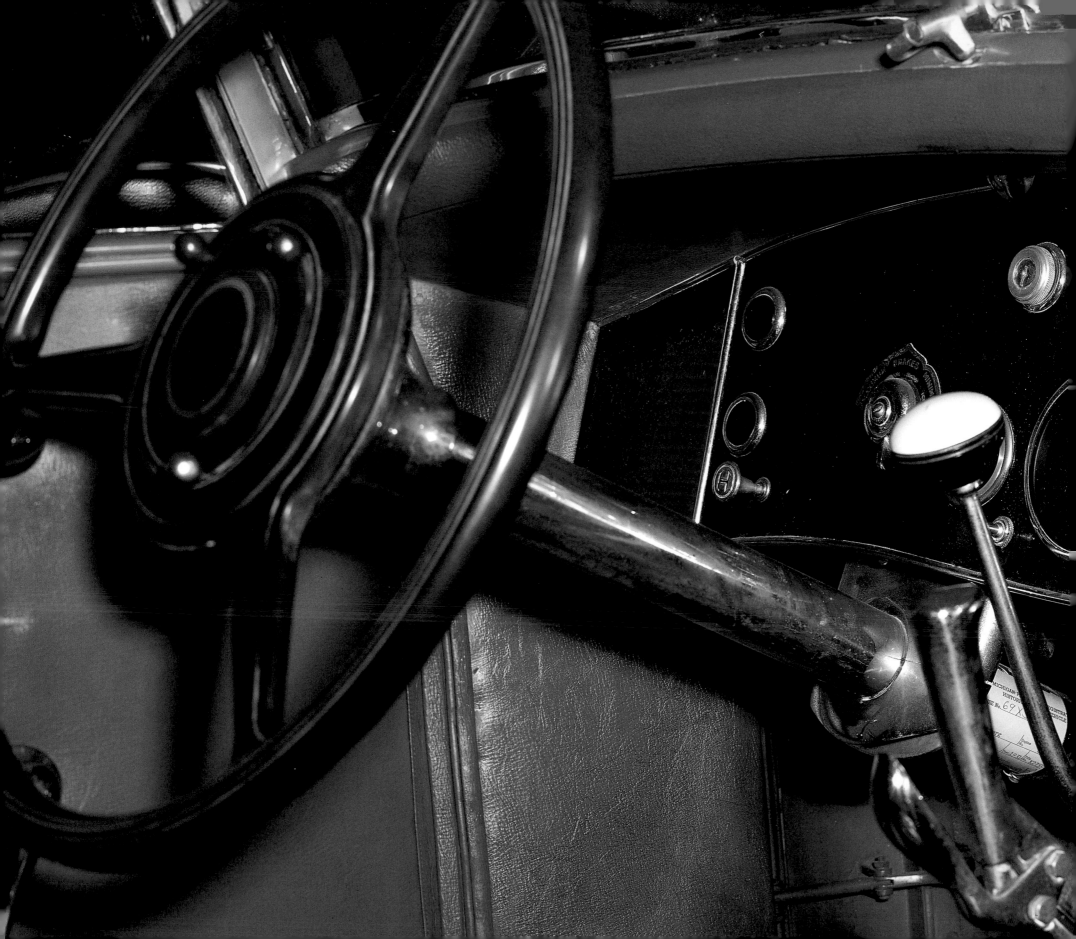

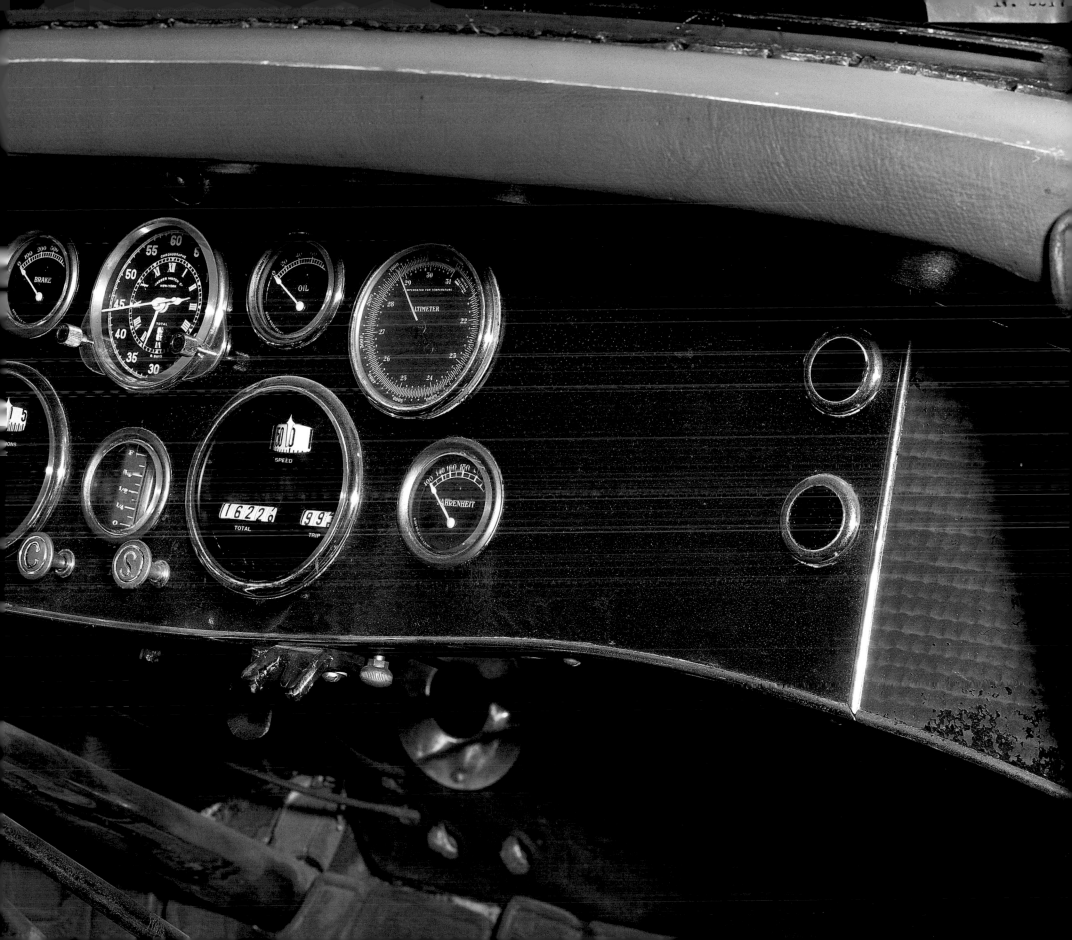

Isotta-Fraschini Tipo 8A (1930) Italy An evocative name, ranking in public esteem with Hispano-Suiza and Rolls-Royce for such aristocratic name-coupling, Isotta-Fraschini made great and glorious machines for princes, movie-stars and statesmen; designed by Giustino Cattaneo, these were invariably bedecked in the very best examples of the coachbuilders' art. A 7.4-litre straight-8 powered this regal two-seater cabriolet, reputedly commissioned by Rudolph Valentino from the Milanese house of Castagna, not far from the Isotta works. Artistically shaped, the metal dash panel is unusually coloured to match the car's paintwork.

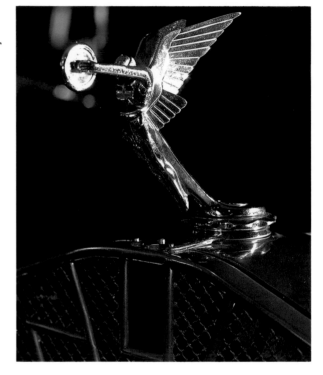

It contains the standard Bosch lockable ignition, as used by other superior models in that period, and dials of remarkable clarity with black figures on white ground with red lettering for their function – simple but effective. An electric cigarette lighter is set on the top rail of the dash, next to an ashtray, just beneath the centre of the opening V-shaped screen. A lever for the reserve petrol supply can be seen through the steering wheel, which carries the customary twin levers for engine control on its boss. But, possibly unique to this senior Latin manufacturer, there are a pair of apparent gauges at each end of the main dashboard; in fact, behind the glass there are enamelled plates with make, model and chassis number on the left, and opposite, Isotta's New York agency, who supplied this car. Of the 1,550 Tipo 8s built between 1919 and 1935, almost one-third were sold in America. They were certainly popular in Hollywood, where it would be easy to imagine this car gliding silently along under the street lamps on Sunset Boulevard, with the world's greatest lover ensconced in top hat and fur-collared coat and a perfectly peroxided companion alongside.

This page: Coachbuilder Castagna offered a variety of art deco 'stone-guards'; the Isotta goddess holds a symbolic wheel.

Opposite and Overleaf: The separate dash panel is colour-matched with the car, and contains very clear white dials.

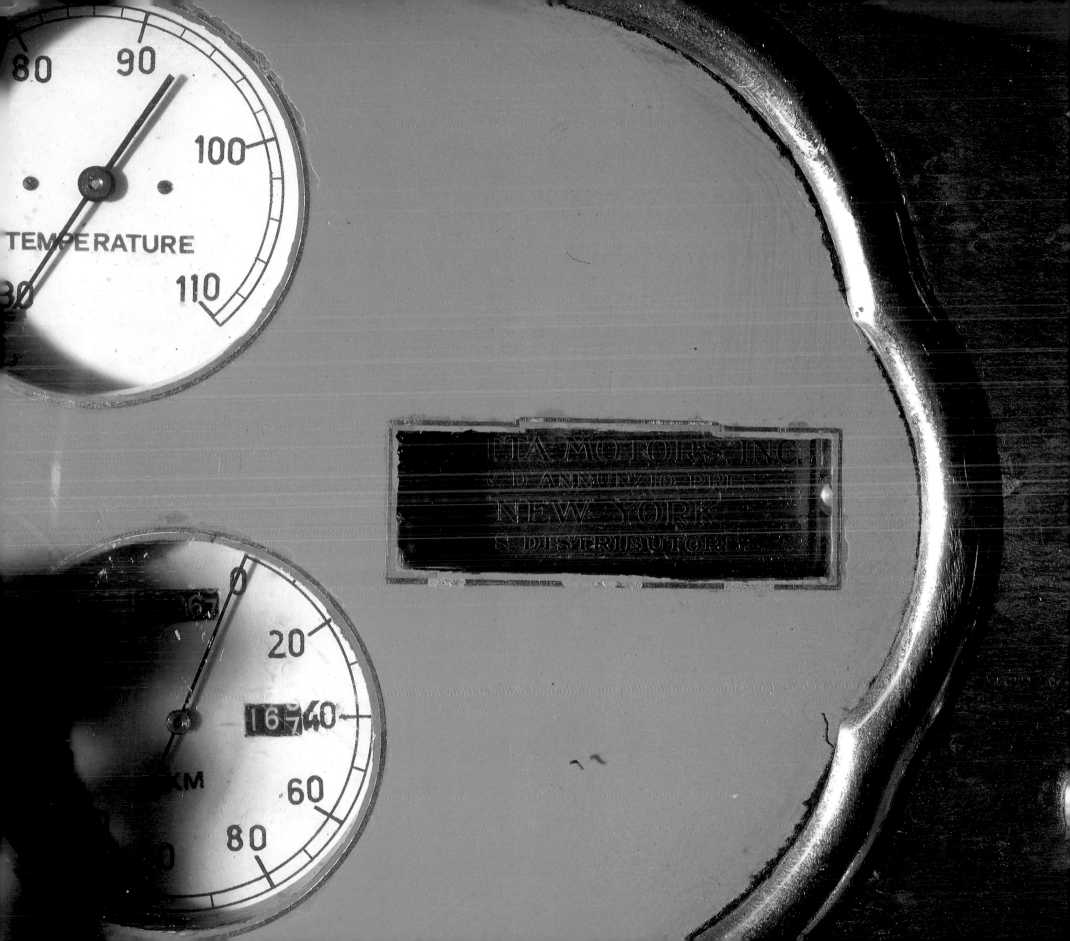

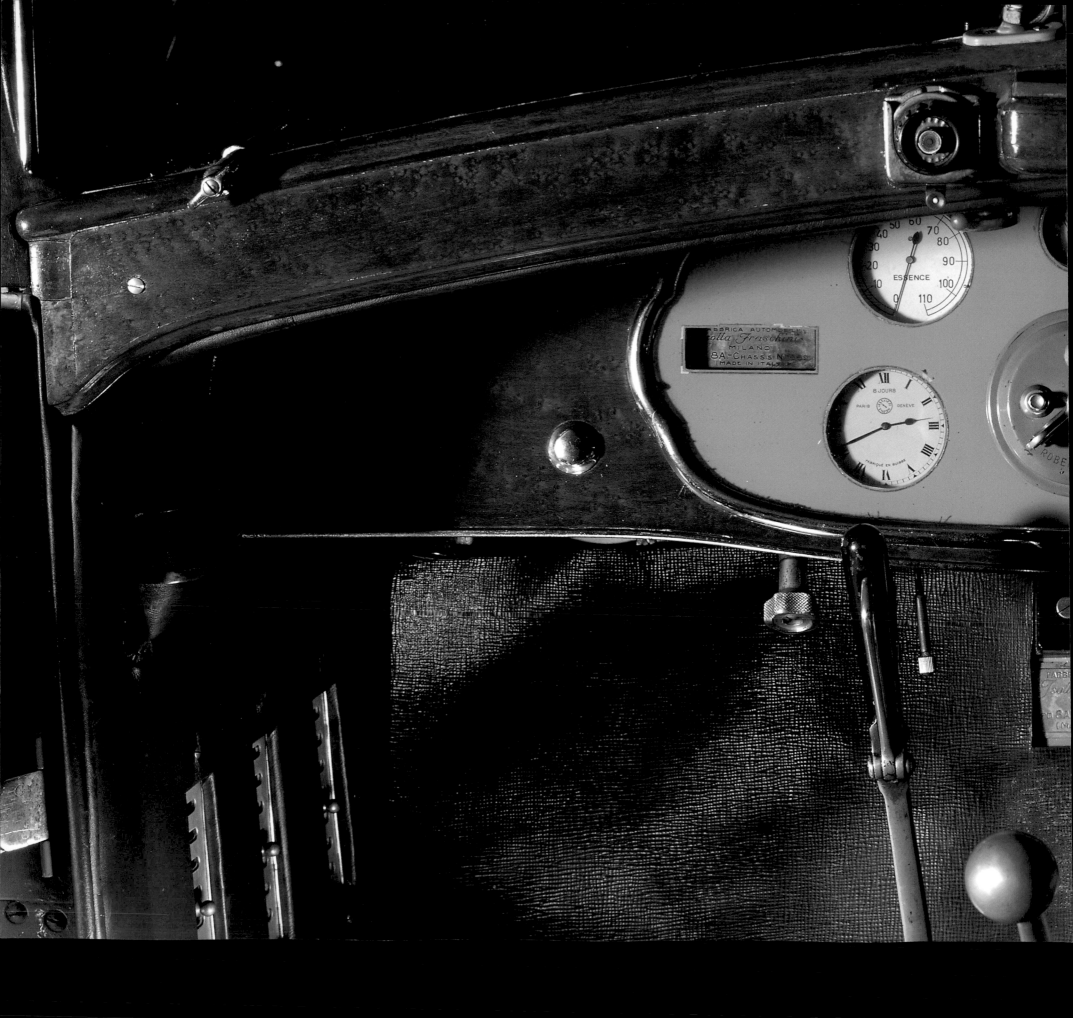

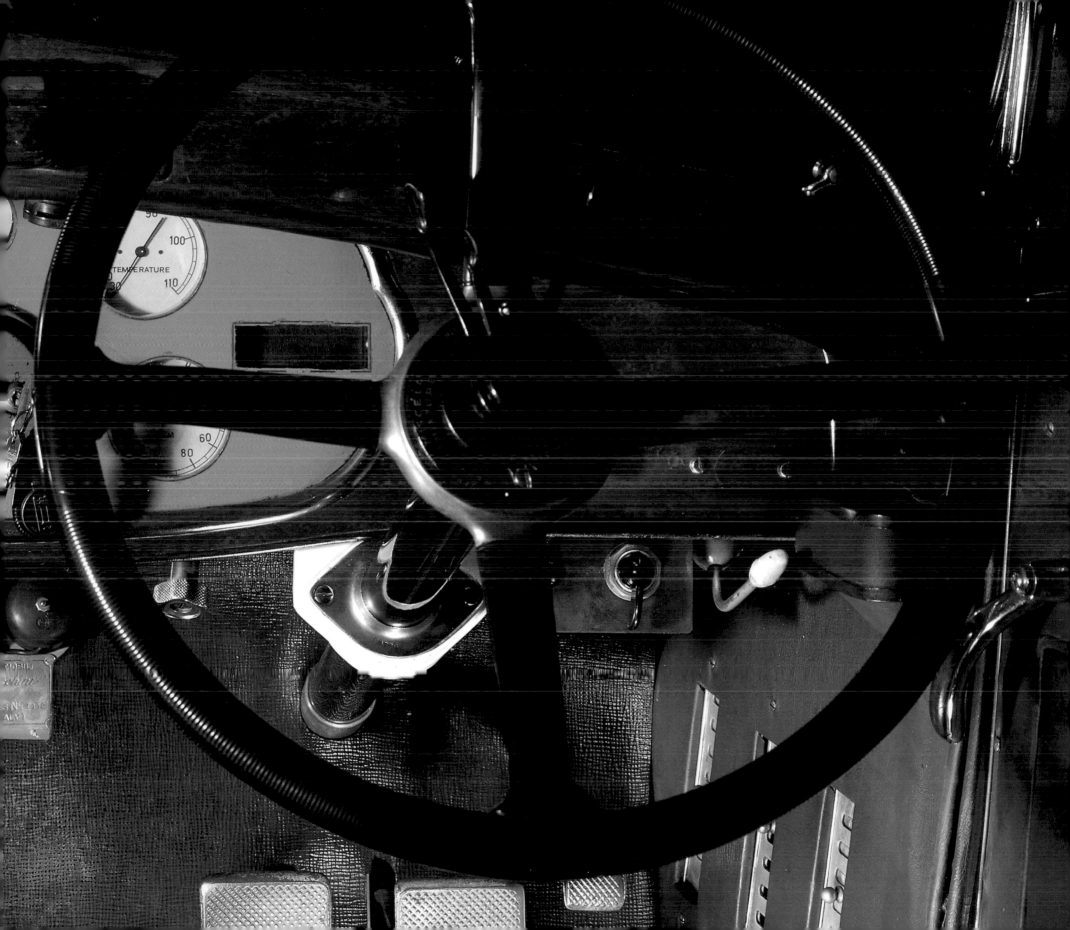

Minerva AK 'Torpedo' (1930) Belgium Sylvain de Jong made highly regarded motor cars in Antwerp from the turn of the century until the mid-Thirties, latterly using the famous Knight sleeve-valve engine patents which, with Daimler, he pioneered in Europe; the principle was used by several of the luxury trade makers for the unequalled silence and smoothness. The larger

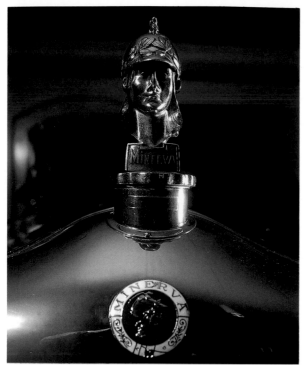

AL series, with a 6.6-litre straight-8, reached its pinnacle of aristocratic acclaim as the official choice of the Belgian King. This AK, with the slightly smaller 5.9-litre straight-6, is fitted with a distinctive open torpedo-style body – an unusually sporting Minerva of no mean performance. Ships' ventilators on the scuttle, a divided and angled front screen, a fold-flat rear screen and varnished wood rear deck show clear speedboat inspiration. The front compartment is splendidly appointed with its big wheel set high, and a full range of instruments set in the elegant facia; what makes it exceptional is the massive tachometer mounted separately on the far left, with its cable drive clearly visible beneath. The helmeted goddess Minerva adorns the regal radiator, with its unusual contours setting the style for that long, high bonnet, so evocative of the power and stamina that characterized these aristocratic vehicles. By the mid-Thirties, though, demand had waned, and Minerva merged with Imperia, whose smaller front-wheel-drive Trumpf-based cars sustained the company until 1949. But de Jong's Minervas had long gone by then.

This page: The helmeted Minerva, goddess of wisdom, sits on top of the cap and is profiled with the badge.

Opposite: Speedboat inspiration is shown by the ships' ventilators and the pronounced V-shape of the screen.

Overleaf: Despite the elegance of the engine-turned dash, the cockpit is dominated by the large rev counter angled towards the driver; sporting Minervas were a rarity, hence the afterthought.

Like most aristocrats of the road, the Minerva has right-hand steering.

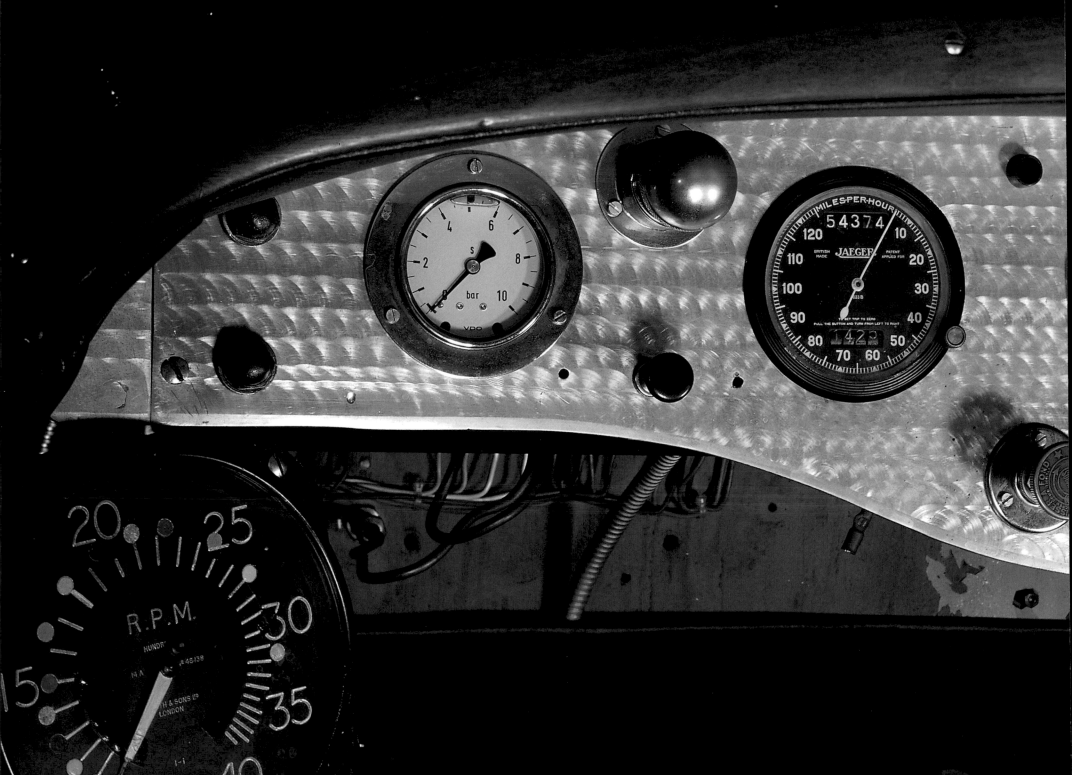

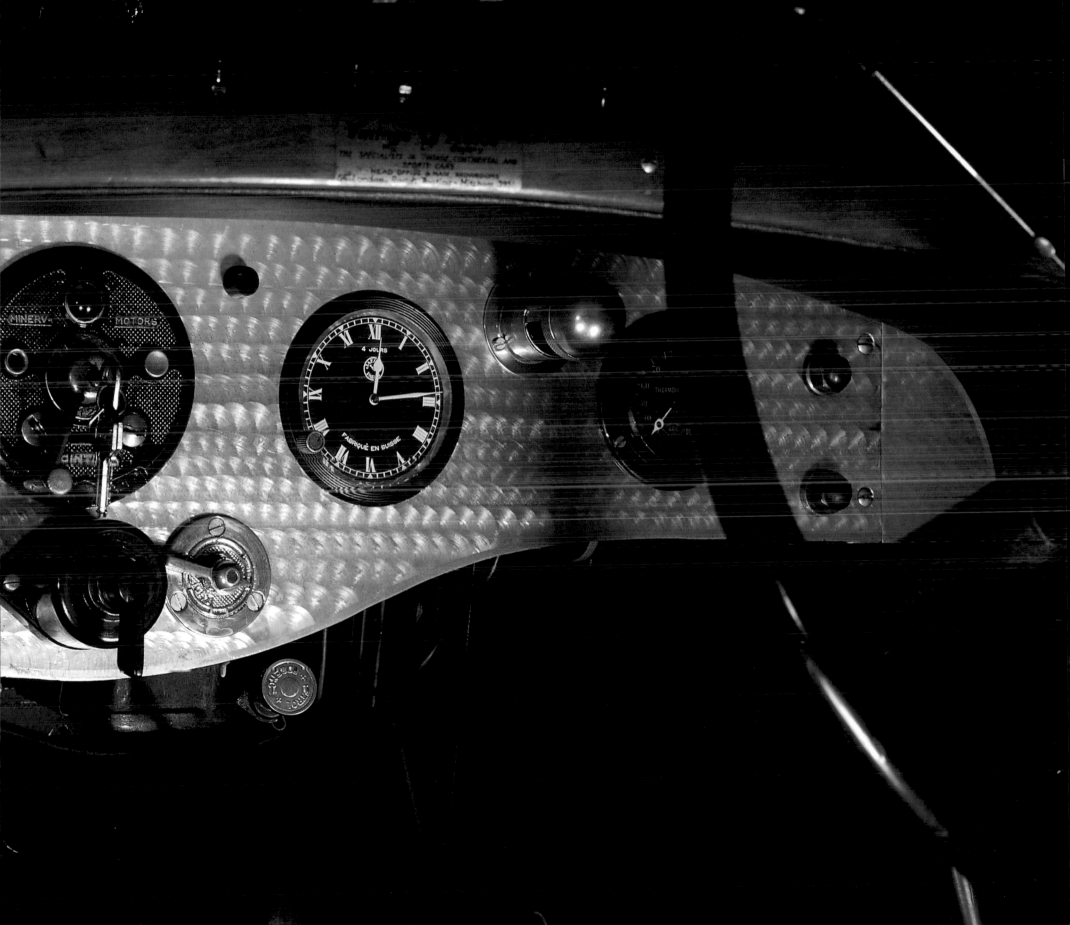

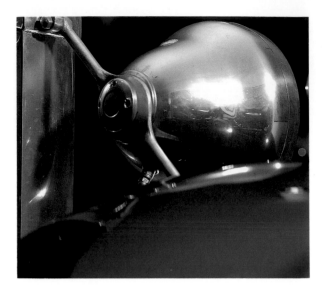

Daimler 35/120 (1931) GB Until the present Queen chose Rolls-Royce, Daimler had supplied automobiles for the British royal family from Edward VII onwards. From 1909, Daimler favoured the sleeve-valve engine built under licence from Knight of America; this gave a quiet but dignified performance, accompanied by a perpetual oil haze wafting behind. The 35/120 was one of the largest versions, capable of over 70 mph in spite of weighing 3 tons. This Barker-bodied chauffeur-driven limousine was commissioned by his friends for Winston Churchill, who used it for many years; his electric telephone for communication to the chauffeur was a very early example. It is better to appreciate this quintessentially upper-class Daimler dashboard from the Churchillian position behind the lowered glass partition. Set in fine solid wood by Barker craftsmen, the instrument panel is a complete assembly supplied by Rotax; unusual for the time are the two warning tell-tale lights – for oil pressure and dynamo charge – set in their own white roundel matching the other gauges. These include a vertical alcohol column engine thermometer. The switches are all beautifully made with clear white inscriptions on the black panel. To the upper right is a Ki-Gass pump to provide extra fuel spray for cold starting. The magnificent five-spoked steering wheel is crowned by two long levers for throttle and ignition settings in finely calibrated quadrants. The central gear-lever is ball-mounted but operates in reverse to the norm – first and third are to the rear. The chauffeur would have been trained to master this at the Daimler school.

This page: Rotax lights are mounted on the substantial wing stay, a Daimler feature.

Opposite: Daimler's patented fluted grille is surmounted by an appropriately Churchillian bulldog, added more recently.

Overleaf: Chauffeur's eye view; the high quality Rotax dash panel has one gauge devoted to a pair of tell-tale lights for oil pressure and dynamo charge; the stalk on the right carries a selector for town and country horns.

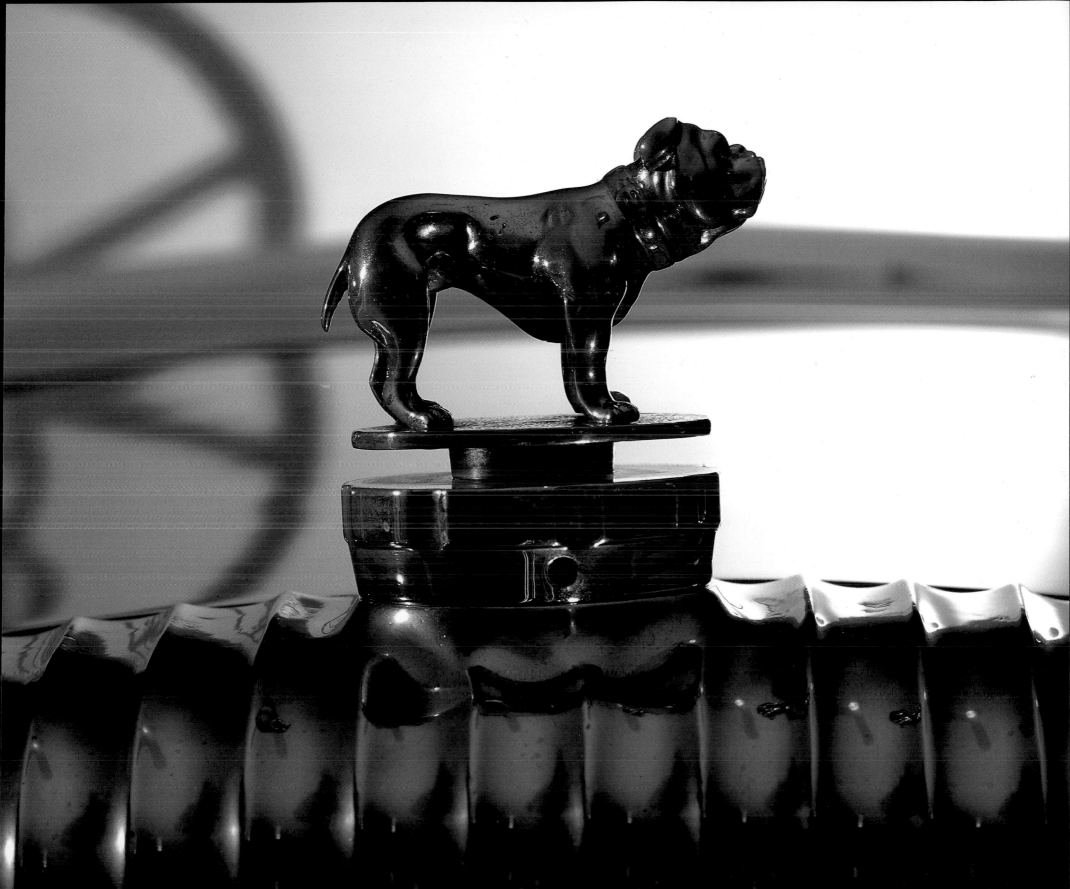

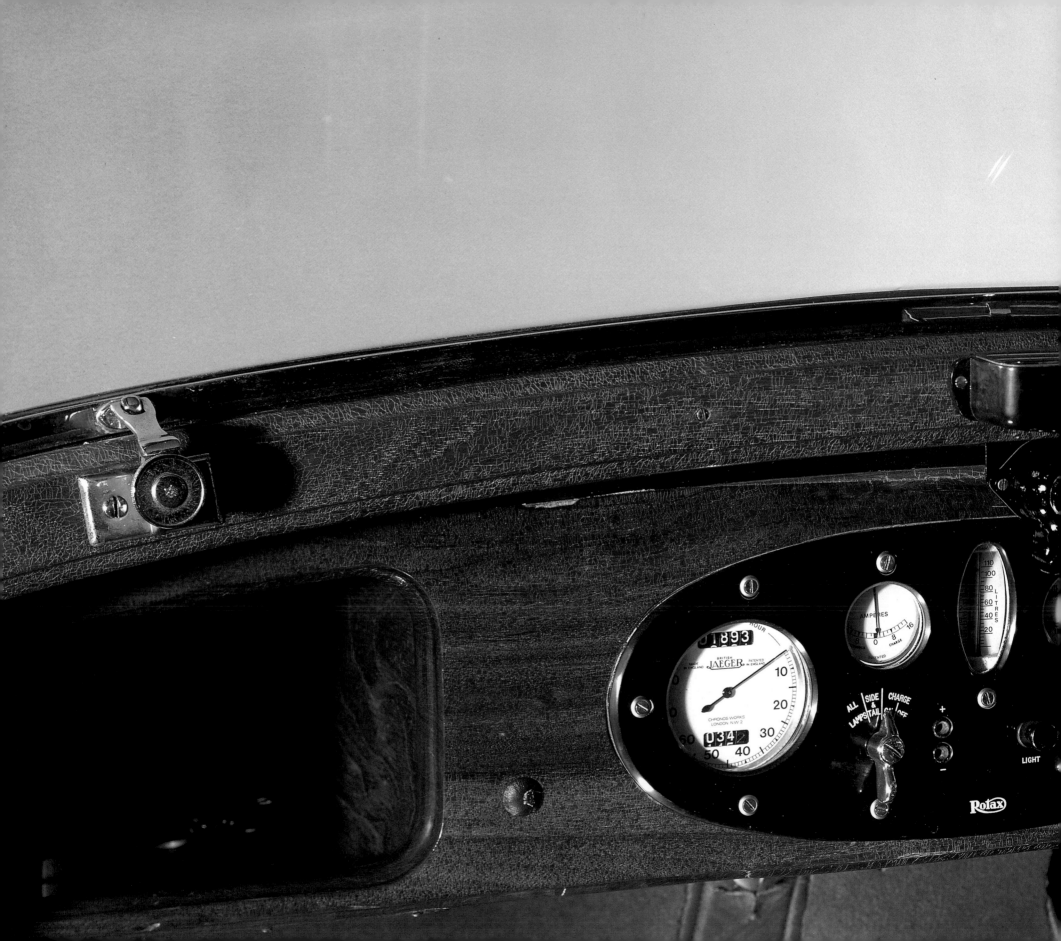

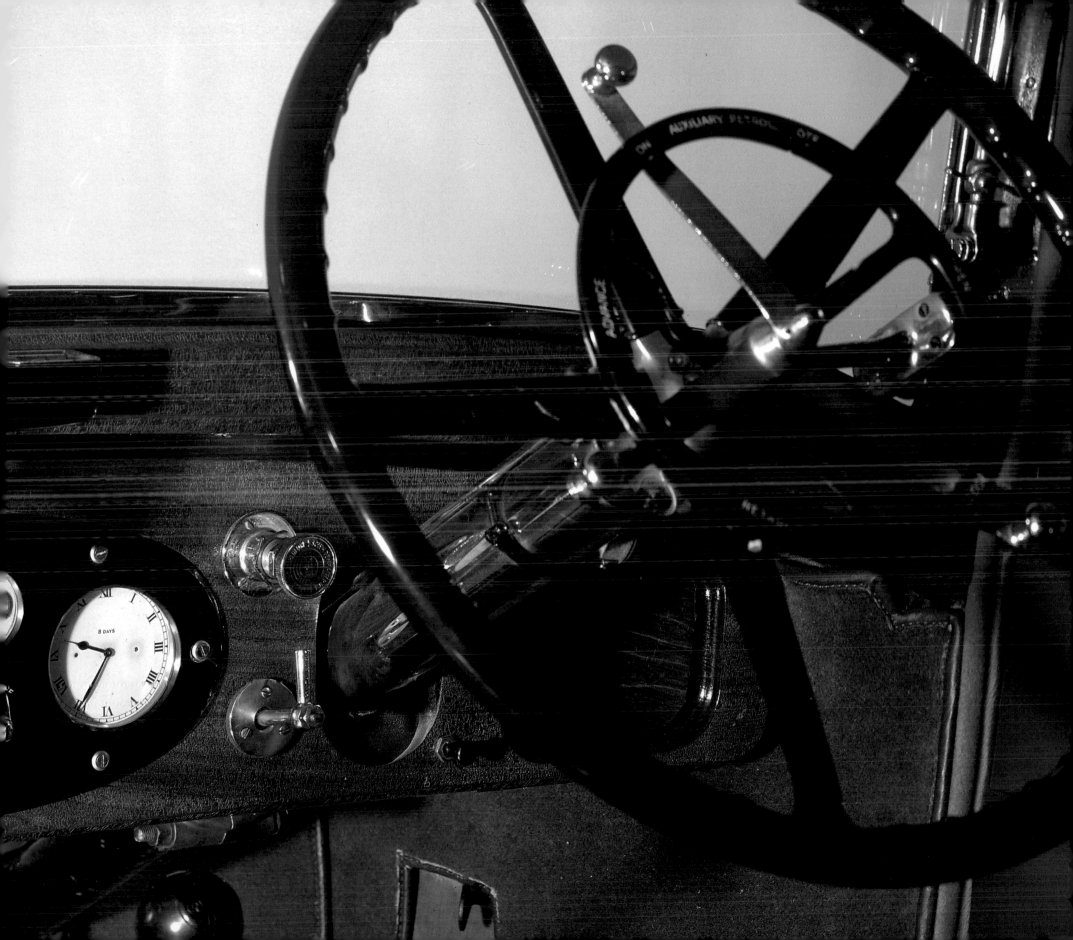

Bugatti Type 51 (1932) France Ever since the Type 35 arrived at Lyon in 1924, all Grand Prix Bugattis have had a beauty of line that owed everything to function and nothing to mere style: from the radiator to the wheels everything was drawn by an engineer with an artist's eye. Whereas this dashboard cannot aspire to beauty, it is still a model of functional efficiency, dominated by the big Bosch magneto protruding through the panel with its advance/retard visibly controlled by the plated lever – it is driven from the left camshaft of the supercharged 2.3-litre twin-cam straight-8. A tachometer is placed straight ahead with the oddly traditional (for a racing car) Bugatti clock replaced here with a speedometer for the car's road use. There is a Ki-gass control to aid starting, an oil pressure gauge and a fuel tank air pressure gauge alongside the T-handled air pump for passenger operation – this is augmented by an engine pump. Another pump handle, out of the picture on the left, takes oil from a reservoir under the seat into the engine when the level gets low on long distance races. Fine engineering detail extends to the bulkhead and pedals, and on the side, the Bugatti brake compensation chain system. The slender steering wheel is close to the driver's chest as high-geared steering demanded delicate

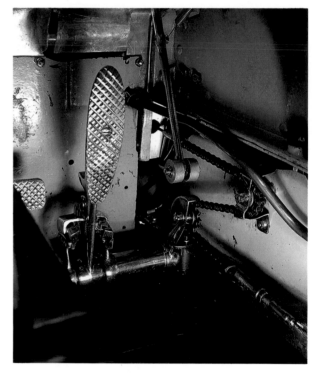

strength; the gear-lever and hand-brake are situated outside to keep the body frontal area narrow, at the expense of a cramped cockpit. Veteran of the 1931 and 1932 Tunis GPs, this car was also driven by Achille Varzi to victory in the 1933 Monaco race, famed for the epic duel against Nuvolari's Alfa Romeo which was resolved only in the final dash up to Casino Square.

This page: The front and rear brake cables join upper and lower ends of the chain; pedal movement pushes the lower sprocket forward to give equal effort to front and rear brakes.

Opposite: Narrow bodywork dictates that the gear-lever and hand-brake are outside the car.

Overleaf: There is nothing superfluous in this two-seater racing car. The customary instruments for the period are fitted; ignition timing is adjusted by the lever on the left alongside the magneto, driven from the back of the left camshaft.

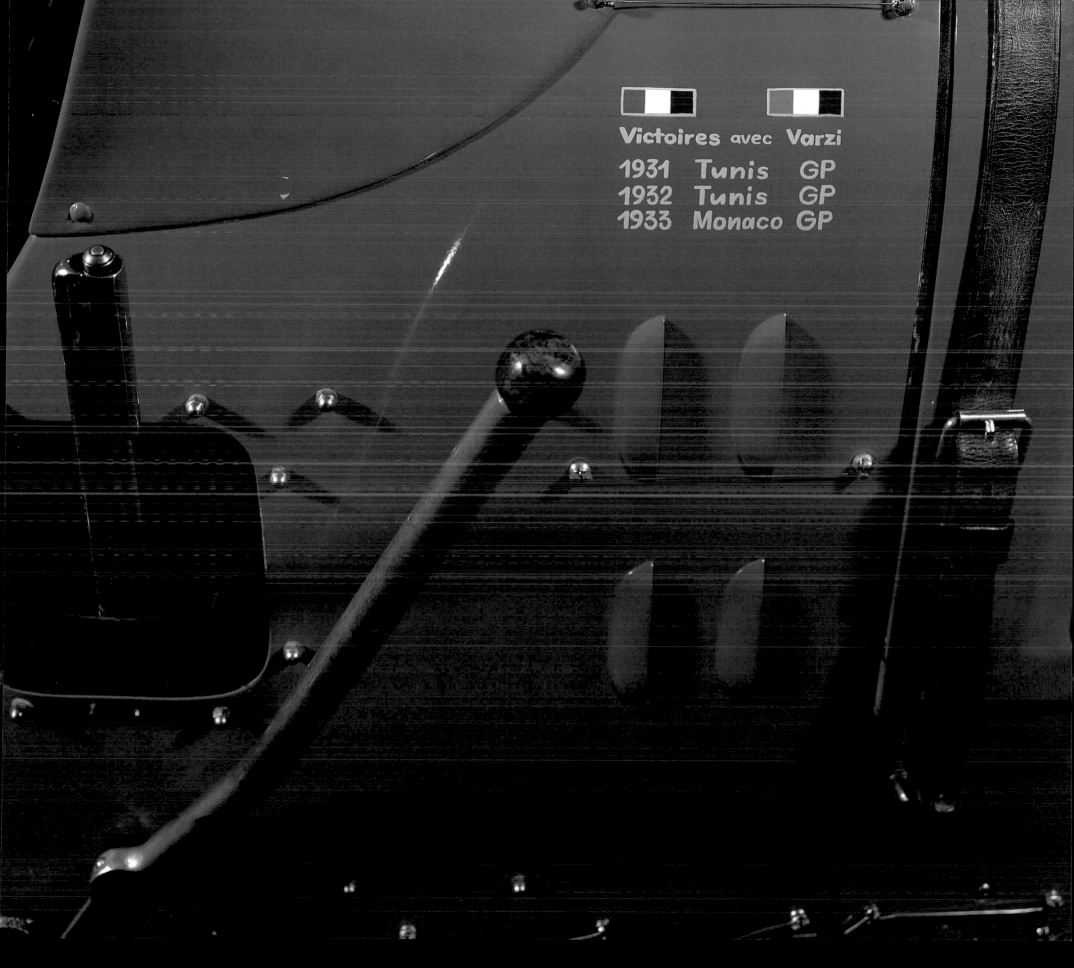

Victoires avec Varzi
1931 Tunis GP
1932 Tunis GP
1933 Monaco GP

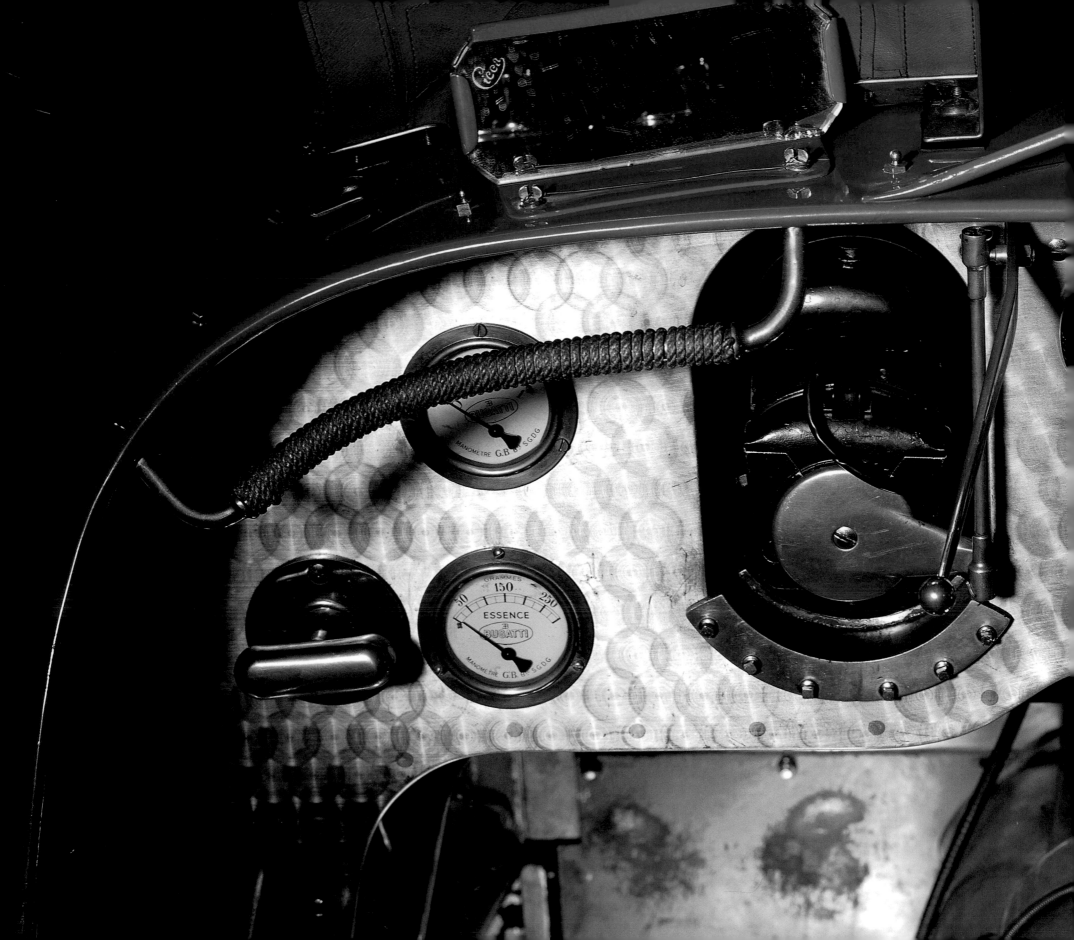

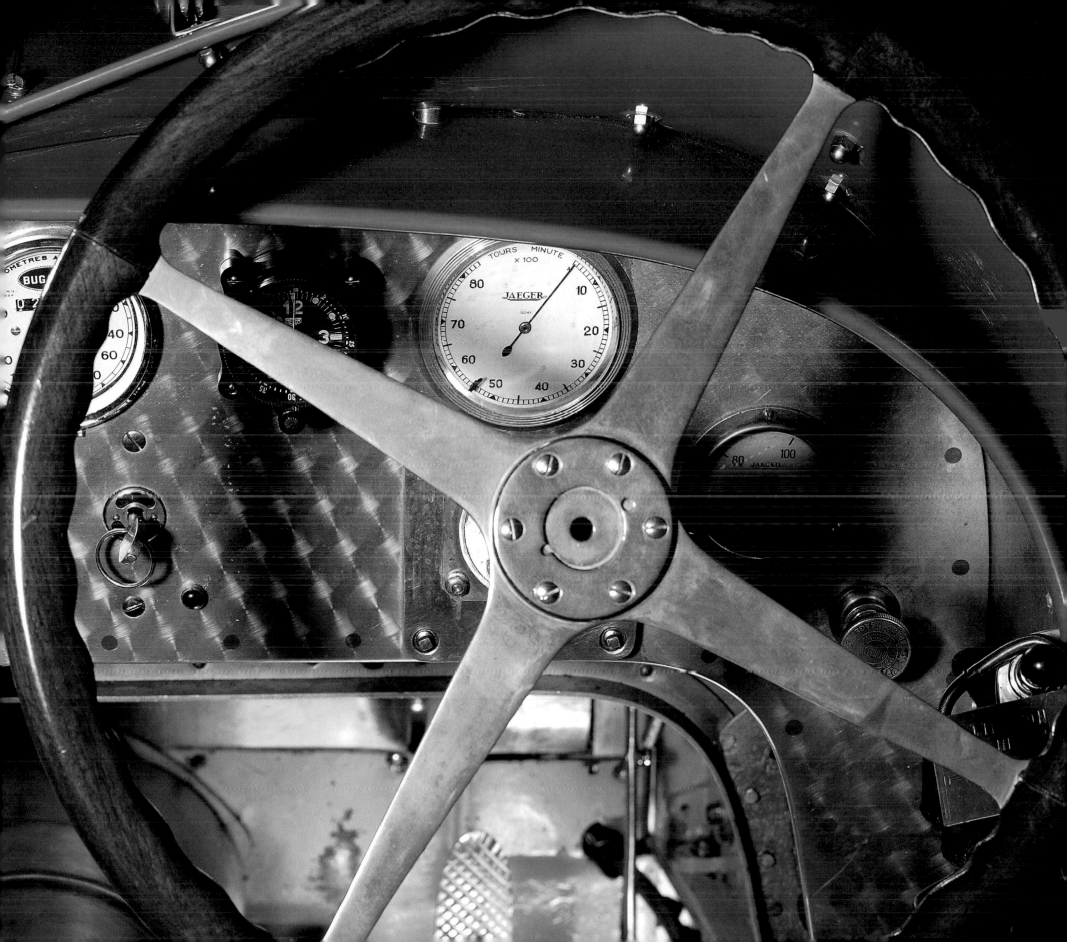

SSII (1932) GB As forerunners of the famous Jaguar name, the lesser-known SS cars have a special place in history. Starting as a builder of Swallow motorcycle sidecars in Blackpool, William Lyons moved onto four wheels with Swallow coachwork on Austin 7s; when he moved to Coventry, the Swallow Coach-building Company began to furnish other marques, including nearby Standard. In 1931, Lyons launched his own SS range, using modified Standard chassis and engines under his own extremely elegant low-slung bodywork that rivalled many more expensive machines. Surviving ridicule at his claim of £1,000 looks for £310, Lyons persevered and set the benchmarks for future Jaguar value for money. The 16 hp SSI cost £310 and the 9 hp SSII was £210. The interior of this SSII is remarkable as an example of the firm's devotion to style; full of fanciful shapes and colours, it embodied the Lyons philosophy that every component seen and touched by the typically middle-class buyer, was deliberately over-engineered to exaggerate the sense of well-being. The style of these early cars was more striking than their performance. The instrument panel is certainly suggestive of a pedigree beyond the class of this small low-priced car. The dials, which are set in a wooden dash built by furniture makers, are balanced in layout, comprehensive and easy to read. The large steering wheel has a prominent horn-boss, while the gear-lever is well placed and the windscreen can be opened to help driving in fog. Real leather is used throughout the interior, and the sun-burst effect of the door pleating was later to become an SS hallmark. Symbolized by the stylistic SS motif atop the radiator filler, this car was an attractive machine in every respect.

This page: An SS feature, the pleated leather sun-burst motif can be seen on all the door trims.

Opposite: The SS mascot sits above the hidden radiator, and is here reflected in the shiny yellow paintwork.

Overleaf: The brown instrument panel is set back from the wooden facia; some of the gauges are marked 'Standard', indicating the chassis ancestry. The handle on top is to open the windscreen.

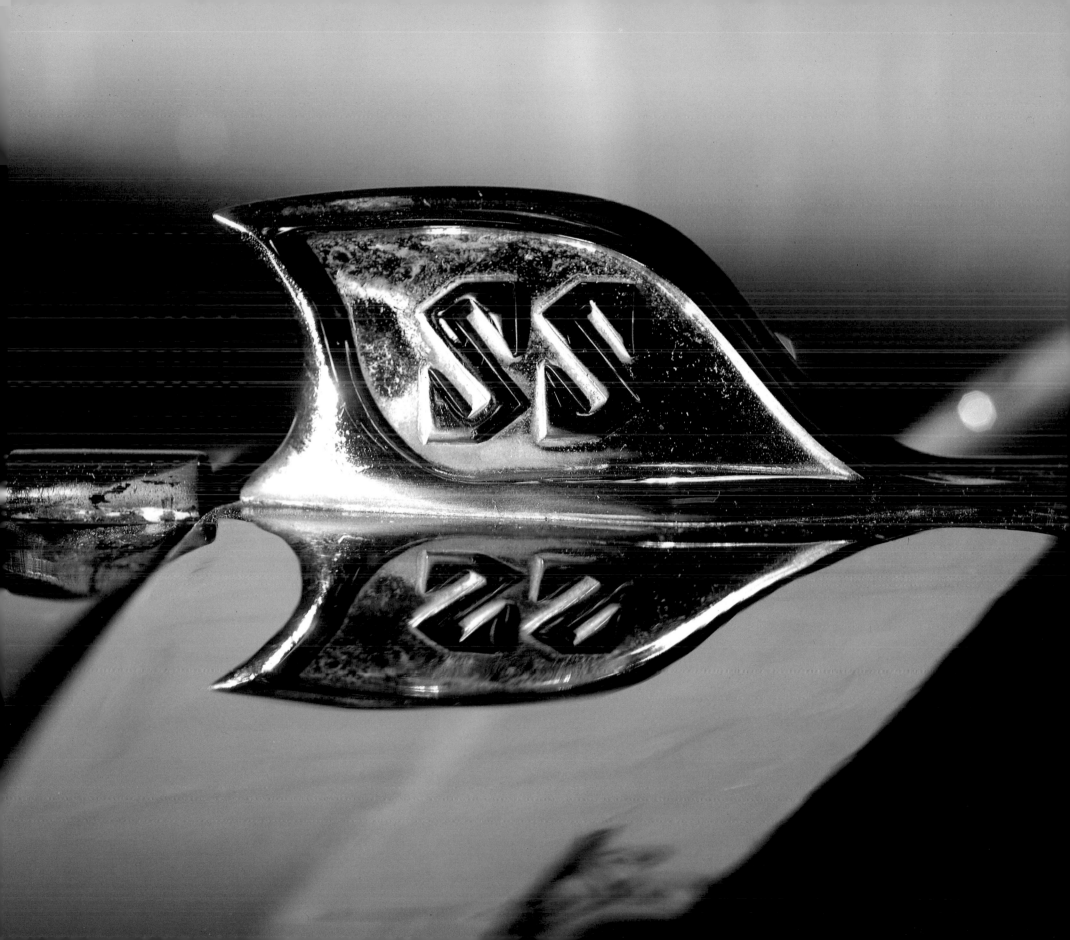

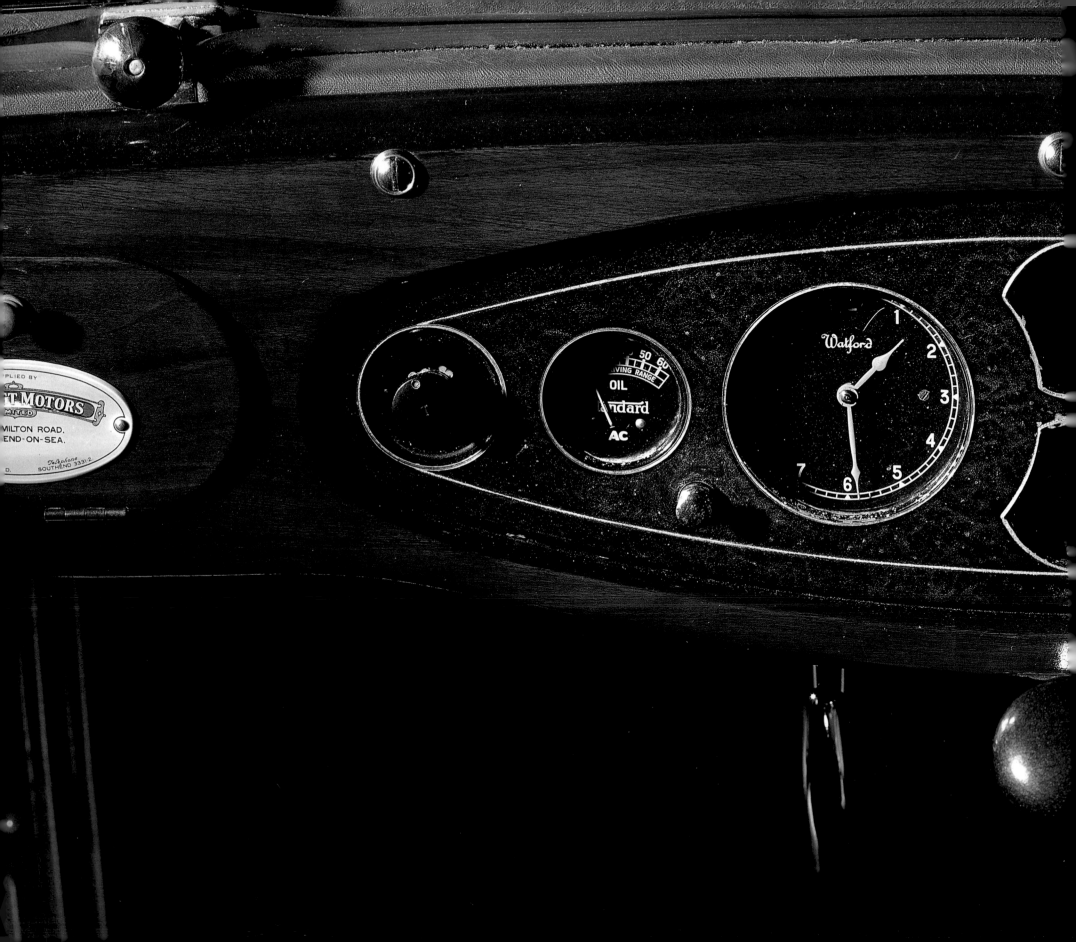

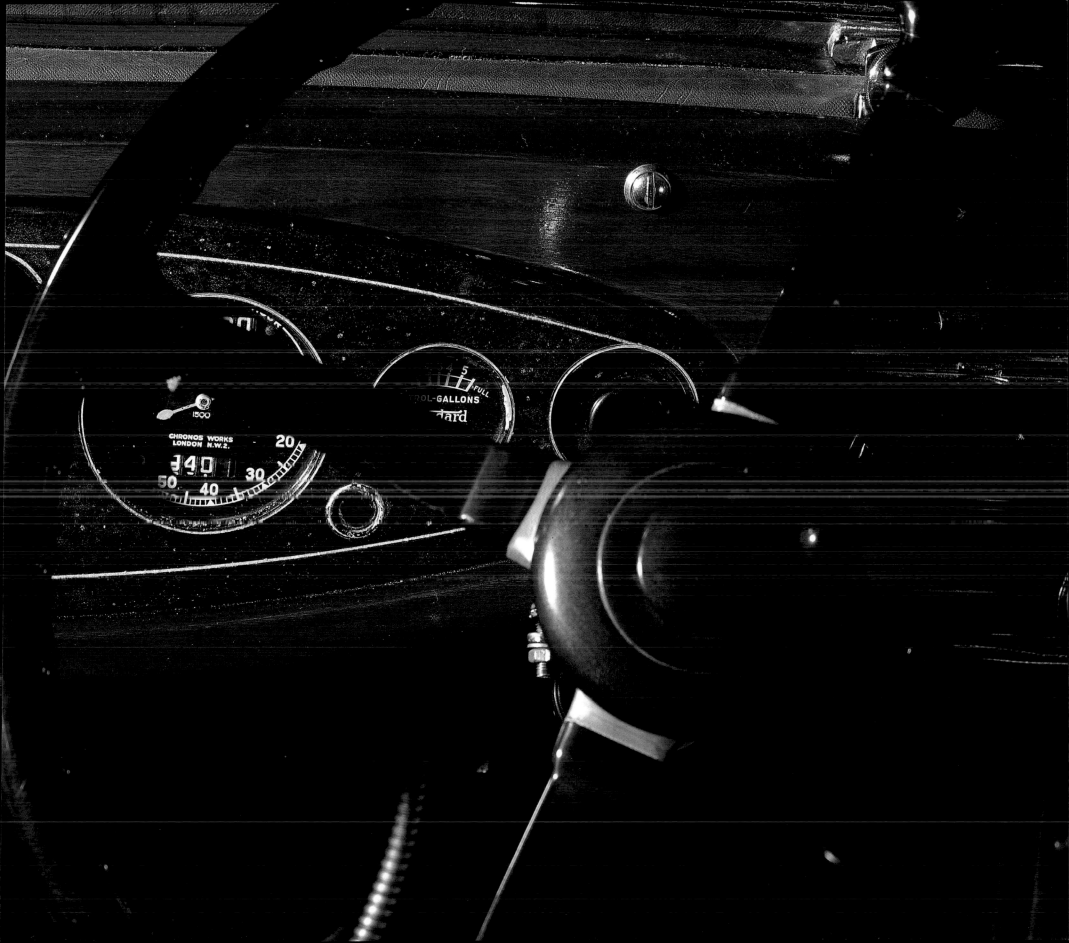

Alfa Romeo 8C-2300 Le Mans (1934) Italy The eight-cylinder Alfas enjoyed considerable success in road events from 1931 until war stopped play; Heldé and Stoffel finished second in the 1935 Le Mans 24-hours, just 5¼ miles behind the winning Lagonda, in this car. A fully equipped four-seater, it was powered by a Jano-designed supercharged twin-cam straight-8, and was well

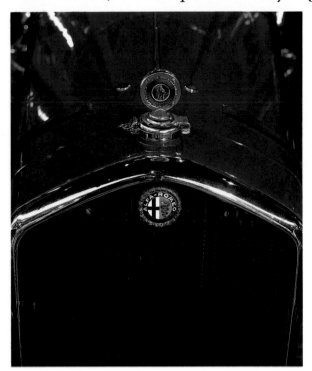

able to cope with the rigours of long-distance racing with good brakes and light, accurate steering. Leslie Hawthorn, father of Grand Prix champion Mike, was a subsequent owner, and the dashboard reflects the casual way in which out-of-date racing cars were treated before restoration became a religion. The large tachometer, mounted correctly on the steering column, has been replaced by a British unit, and the combined water temperature/oil pressure gauge is also not original. However, these little changes do not detract from the overall patina and genuine history of this racing machine. Next to the Alfa chassis plate on the left is a Tapley acceleration meter, a later fitment used to provide a regular check of accelerative urge; there was no boost pressure gauge as this was considered of academic interest only. Alfa Romeo always fitted a very plain black steering wheel, with the ignition lever working from the central boss. The dash panel has a nice curve on its lower surface, a typical Alfa practice which also provided extra knee room. Very fast for their time, these Alfas had a strong following in the top Thirties drivers – Nuvolari, Campari, Varzi, Lord Howe, Louis Chiron and their like – and only Bugatti challenged them. In Britain Triumph produced the Dolomite copy, but it never fulfilled expectations.

This page: The Alfa badge shows the cross of Milan and the serpent of the Visconti family.

Opposite: A little corner of detail showing the hood mounting, door locks, dry sump oil tank and streamlined battery box.

Overleaf: The slender curved dash follows the scuttle contours; Alfa's four-spoked wheel has the advance/retard on its boss, but the giant rev counter dominates the cockpit scene.

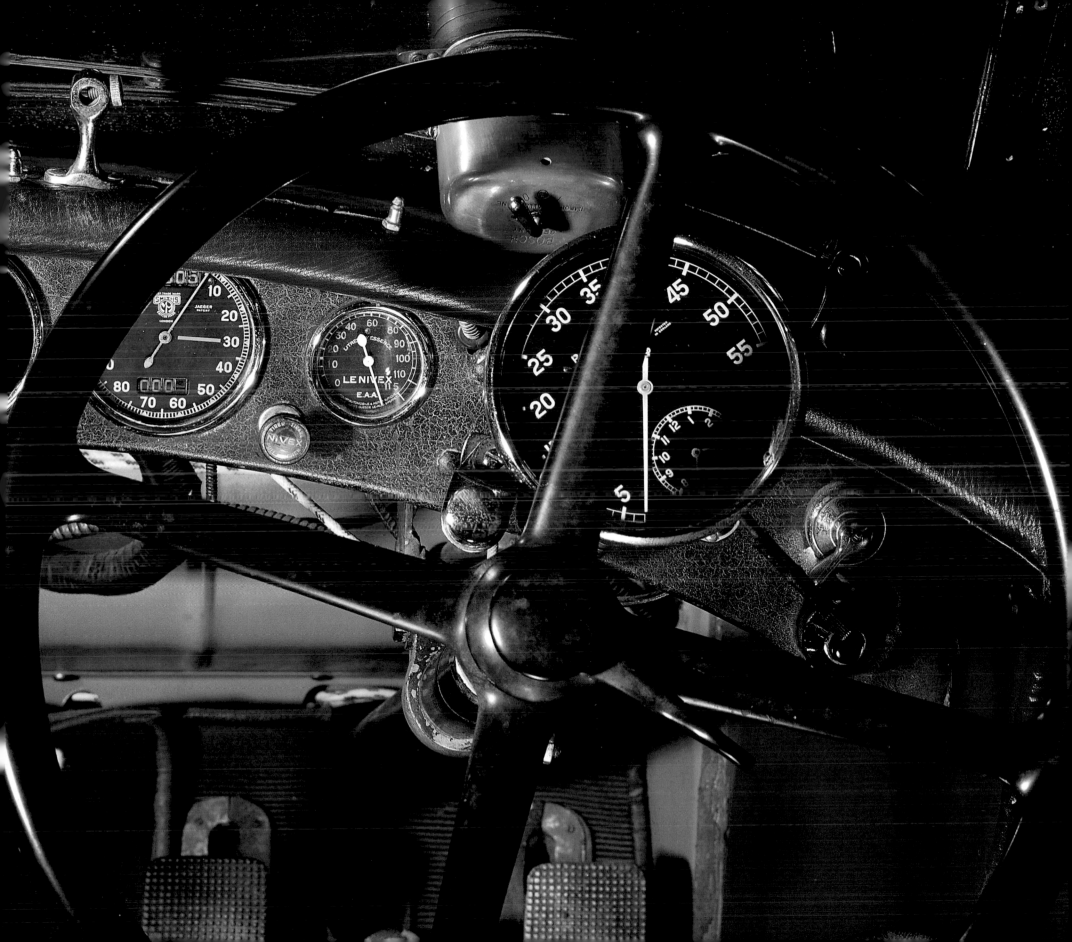

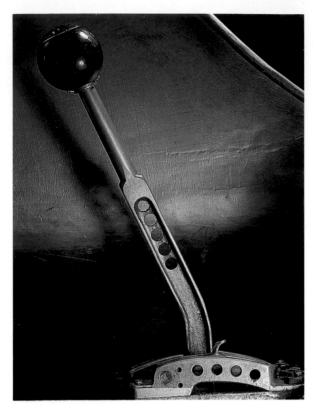

Mercedes-Benz W25 GP (1934) Germany Through the Twenties, international motor-racing had largely been the happy playground of wealthy amateurs who bought their own racing machines, usually French or Italian, sometimes British. Factory teams were then a rarity, but all was to change in the Thirties, when the Italian entries started to sweep all before them. Hitler, seeking to outdo Mussolini, decided that motor-racing would provide an ideal propaganda medium for Germany; Mercedes would share with Auto Union the task of upholding German honour. Mercedes' response was the W25 designed for the 750 kg (max) formula. Joining late in the season, the beautiful W25 was powered by a supercharged straight-8 with around 350 bhp from 3.36 litres. At its first race to GP regulations, the car was fractionally overweight, so team boss Neubauer decreed that the white paint be removed; that was enough, and the German national colour became silver ever after. The racing world was astounded by the performance of these new and noisy projectiles. Neubauer was not impressed by the mechanical knowledge of most of his drivers, so decreed a bare minimum of instruments, which is apparent on this dashboard. Mounted against the drilled frame surrounding the panel is a central oil pressure gauge, flanked by tachometer and temperature gauges for water and oil with a switch for the magnetos. A gear-lever working in a fool-proof gate, and a small hand-brake to comply with the regulations, completed the controls. Not the most successful of Mercedes' Silver Arrows, even by the time the engine had been enlarged to 4.31 litres and 430 bhp, the W25 set the scene of German domination that was to hold until war broke out.

This page: The H-section gear-lever and its gate have been drilled for lightness in unstressed areas.

Opposite: Many competitors saw this view as 3.36 litres of supercharged straight-8 blared past emitting acrid fumes.

Overleaf: Engine-turning everywhere shows tool-room attention to detail. Highly stressed engine bearings demanded an oil temperature gauge as well as a pressure gauge, positioned with more prominence than the rev counter.

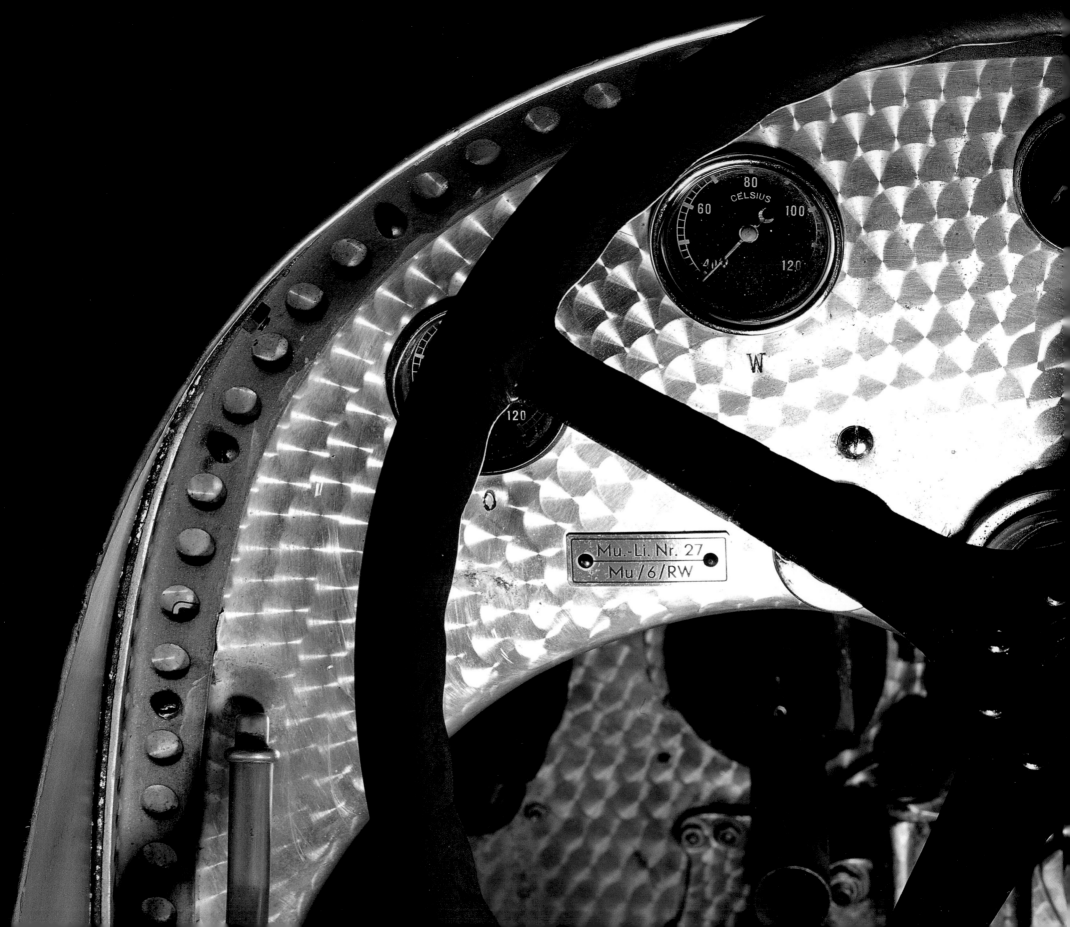

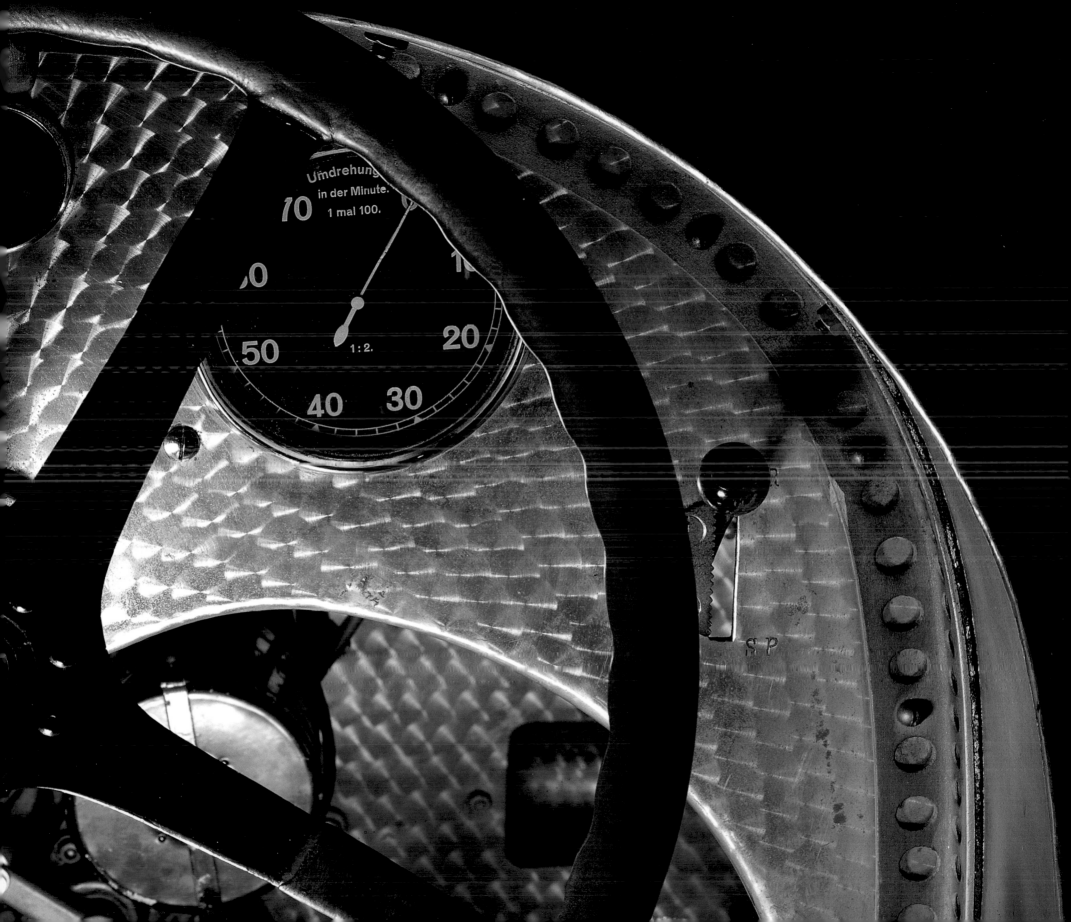

MG Midget PA (1934) GB The creator of MG, Cecil Kimber, had that rare ability to use basically simple, standard components and create highly attractive cars that dazzled in the showroom and generated strong marque loyalty. That the parts came from Morris and the engines from Wolseley never caused Kimber to deviate from his crusade to make affordable

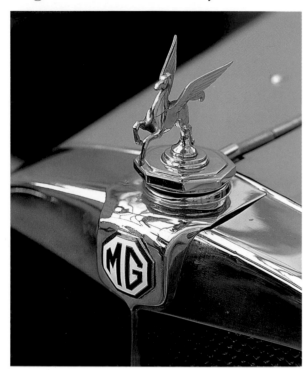

sports cars in large numbers; factory competition, whether in trials or circuit racing, did much to improve the breed and promote the products. Although the range included six-cylinder sports and touring cars, it was the Midgets which were for the young. The PA arrived in 1934 as a refined replacement for the stark J2; still with the same little four-cylinder engine, it could achieve nearly 75 mph with the screen folded flat and the driver ducking down behind the twin-cowled scuttle. The MG trademark was the octagon which surrounded the initials in the badge; this geometric form can be seen in almost every part that could feasibly be made to conform – from side-light shells to the instrument surrounds and control knobs. Just ahead of the short-travel gear lever, sitting in its exposed gate, can be seen octagonal knobs for throttle and mixture control. The large instrument ahead of the driver was unusual in combining speedometer and tachometer; its brown face was reflected in the whole interior colour scheme – even the switches. For the passenger, a matching dial gave ammeter, oil pressure and the ignition key; the battery point was a period expectation for the home mechanic owner. It was, as Autocar said at the time, 'a most desirable little sports car'.

This page and Opposite: Octagons are everywhere, from the radiator badge and cap to the choke and hand-throttle knobs above the octagonal gate casting for the four-speed gearbox.

Overleaf: Matching octagons for the major instruments include the rev counter with inset speed scales for third and fourth gears, an interesting speedometer alternative.

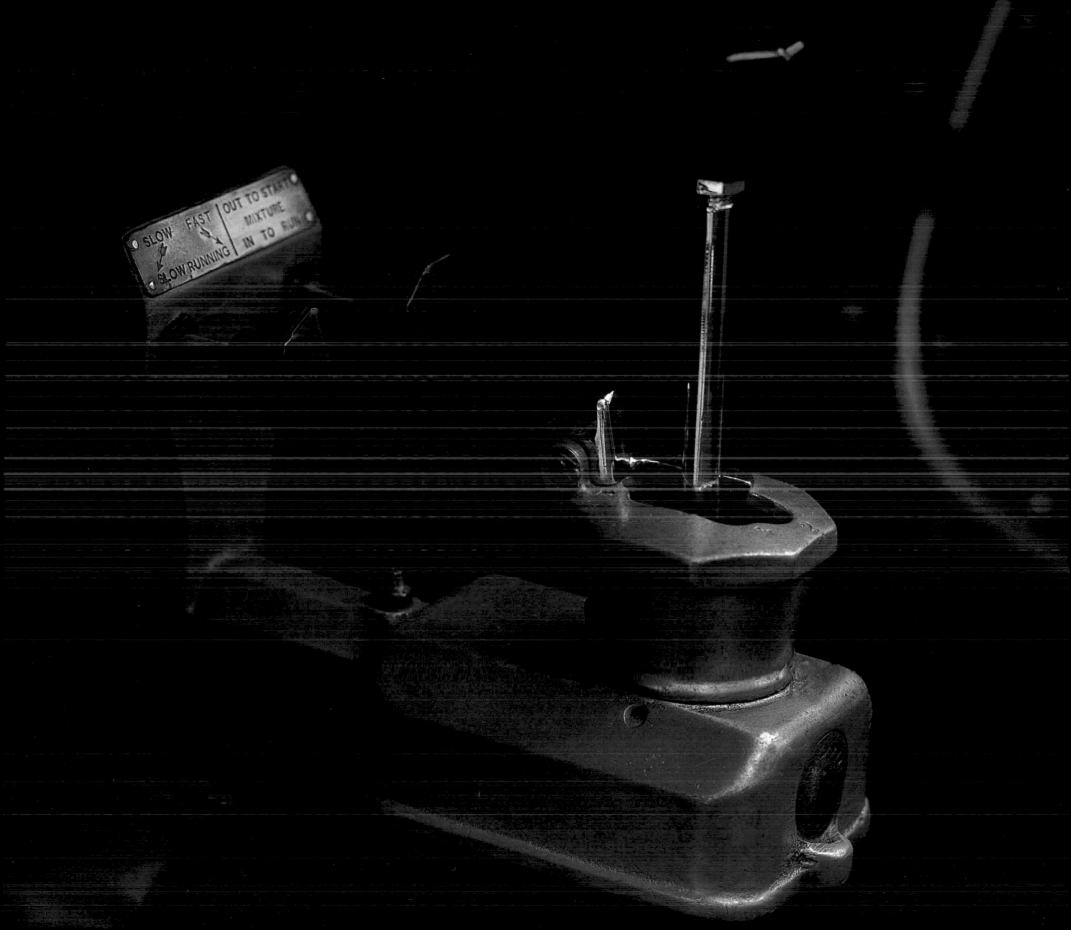

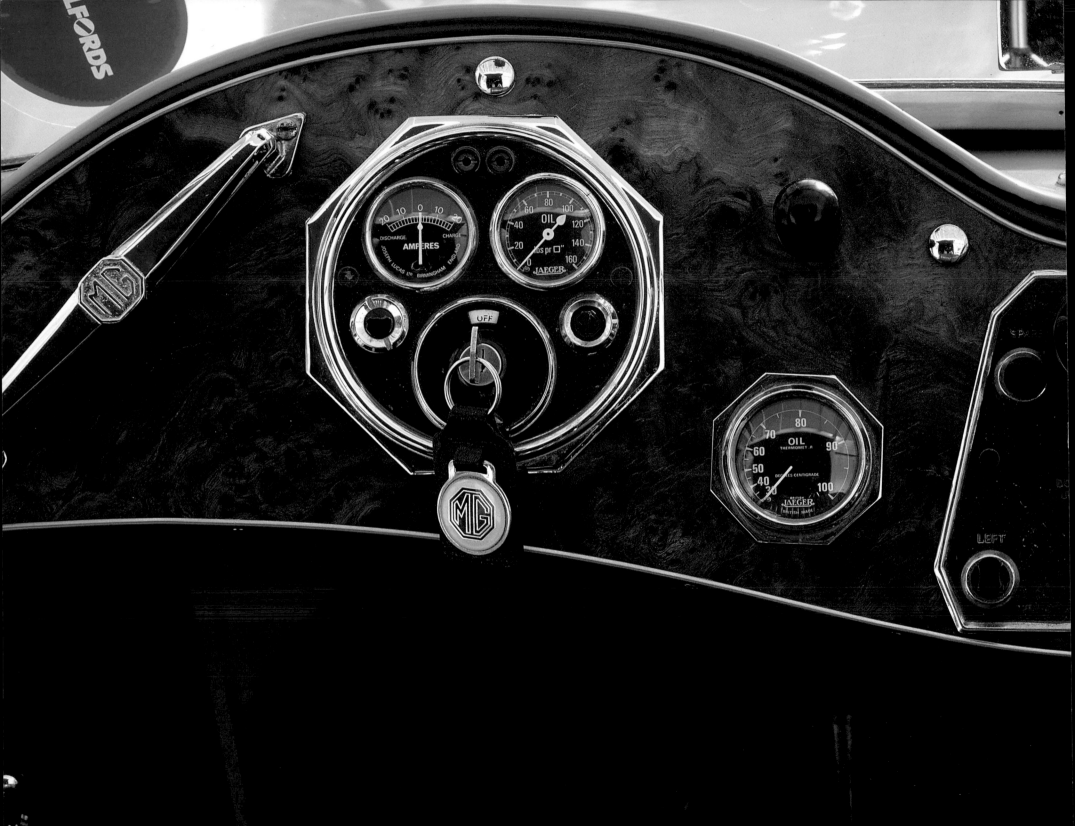

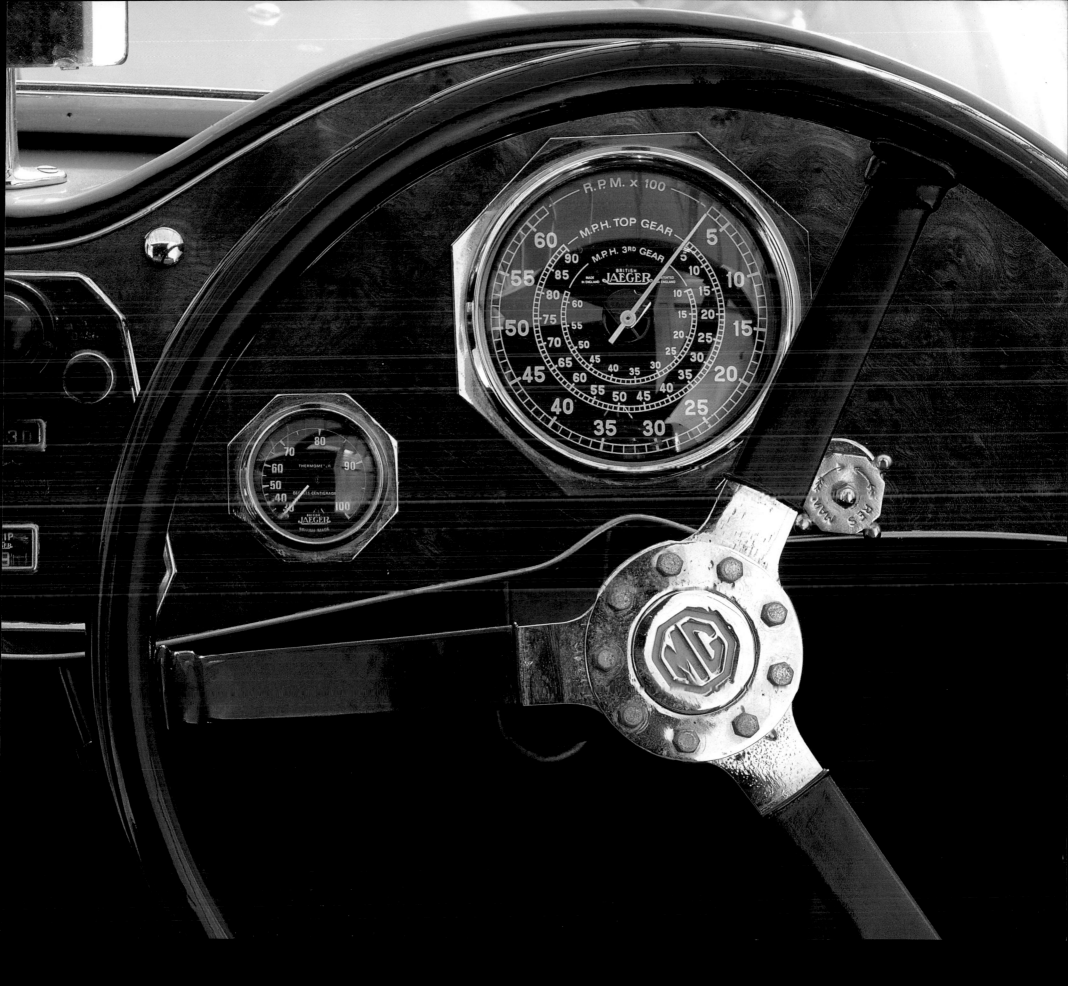

Aston Martin Ulster (1935) GB The Ulster was many a British sporting driver's dream in the Thirties, but only a few could ever realize that dream as, apart from the ten factory racers, only twenty-one were built for sale at the cost of quite a substantial house. Very few cars of any engine size could genuinely attain 100 mph, but the Ulster achieved this with only 1,500 cc. This was largely due to its beautifully engineered overhead camshaft four-cylinder engine which gave a remarkable 85 bhp at 5,250 rpm, but it was also aerodynamically efficient with low overall height, a full-length undertray and cycle-type wings attached to the back-plates allowing very little clearance between tyre and wing. Its race-bred chassis was clad in a superbly styled body with a uniquely shaped tail carefully beaten with compound curves to cover the horizontally laid spare wheel. The cockpit is admirable in its functional simplicity with a full quota of essential instruments and a battery of individual aircraft-style switches, a separate one for each electrical circuit. The gear-lever, working

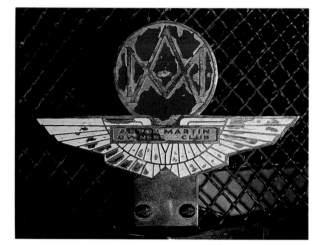

in a visible gate, has the traditional Aston Martin rubber knob, kinder to the driver's hand in rapid mountain driving, while the vital ignition setting is controlled by a large lever in the centre of the spring-spoked steering wheel. This car carries the distinguished badge of the Aston Martin Owners' Club; it combines the radiator badge of the original Bamford & Martin cars with that from the Bertelli period in which the club was formed in 1935. Italian racing red reflected Bertelli's native country and his love of motor racing; the works Ulsters were also red.

This page: The battle-scarred AMOC club badge incorporates old and new radiator badges set in the national racing red of former company owner/designer Augustus Bertelli.

Opposite: Placing the spare wheel flat under a pointed tail generated this superb example of the panel-beater's art.

Overleaf: Designed for competition, with all the information and control the keen driver needs, this dash owes something to aircraft practice; night lighting is directed at the important oil pressure and water temperature gauges.

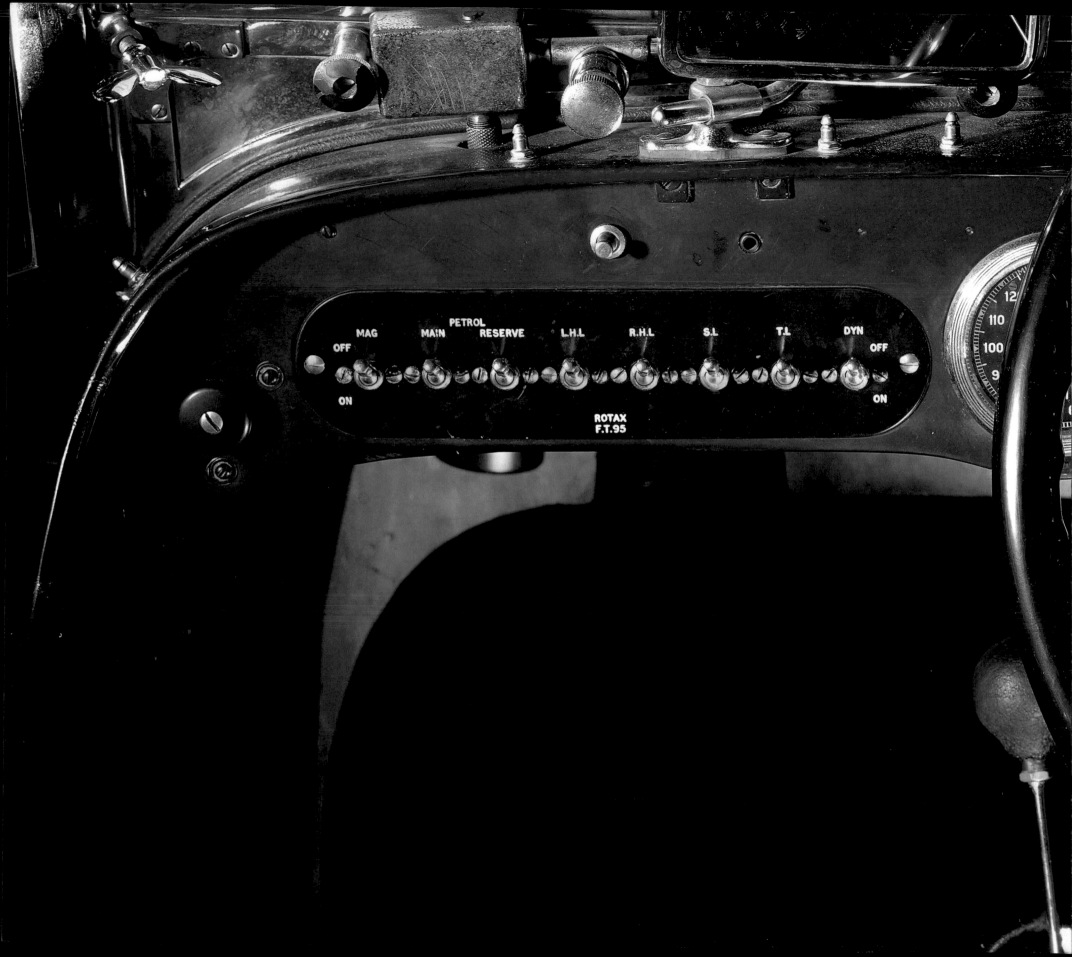

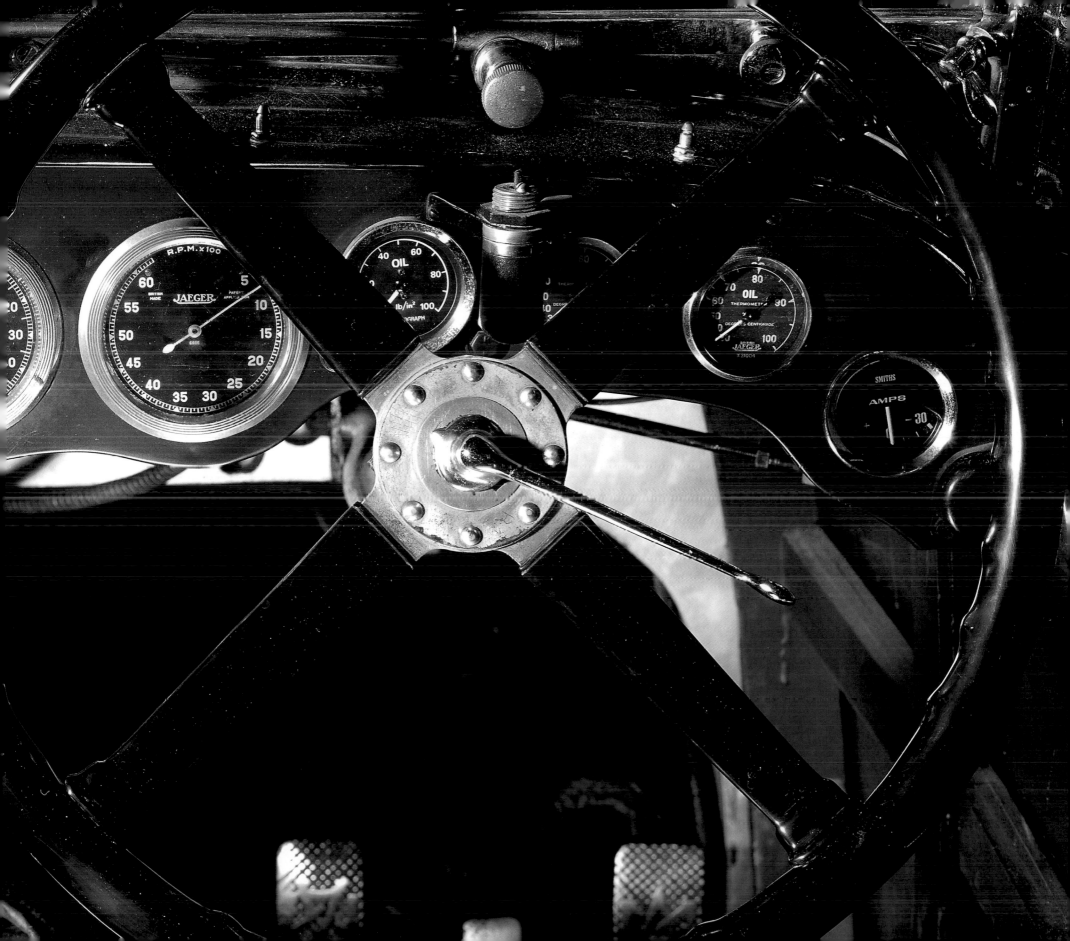

Austin Twin-Cam (1936) GB Single-seater Austins had gained some 3,000 wins in various events from 1923 to 1935, but this exciting machine, designed by Murray Jamieson to attack MG's 130 mph flying mile and other records, was the first Austin designed from scratch for the purpose. While the chassis was recognizably similar in concept to the A-frame of the little 7, the twin-cam engine was completely new. Using RR50 high-duty alloys where possible, this watch-like 750 cc

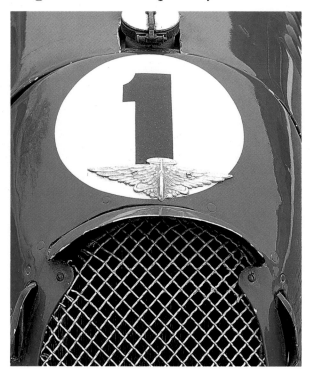

unit was developed to produce 116 bhp at 9,000 rpm, using 20 psi supercharging with special fuels – over 150 bhp per litre was a formidable achievement. Clothed in attractive miniature GP bodywork, it was incredibly fast on tight circuits and took many international records in 1936 and the British flying mile at 121.2 mph. MG's record at Frankfurt remained intact – but the sponsors were happy. The dashboard is remarkable for the complexity of its instrumentation; very few other racing cars could boast so many dials, and it is doubtful whether the driver would have had time to look at some of them, or even see them behind the sporting Bluemels steering wheel – multi-spoked to absorb vibration. To ensure attention, the dominant 12,000 rpm rev counter and the most important dials (oil pressure and water temperature) had yellow needles. A hefty sized air-pump can be seen, as well as the brass plate added later to ensure that the car remained the property of the Austin Motor Company. Sadly, designer Murray Jamieson was killed in a freak accident while spectating at Brooklands in 1938, but he had seen the vindication of his remarkable design, which continued on its winning ways until war broke out.

This page: Austin's staid badge sits uncomfortably on the functional air intake of this successful little racing machine.

Opposite: The tall tail, profiled to the driver's shoulders, held a 25-gallon tank – sprint fuel was consumed at 3½ mpg.

Overleaf: Seven gauges were squeezed into the smallest space, with yellow needles denoting those to be carefully watched – the oil pressure gauge and the large rev counter reading to 12,000 rpm. The supercharged 750 cc engine would use 10,000 rpm when running on racing fuel.

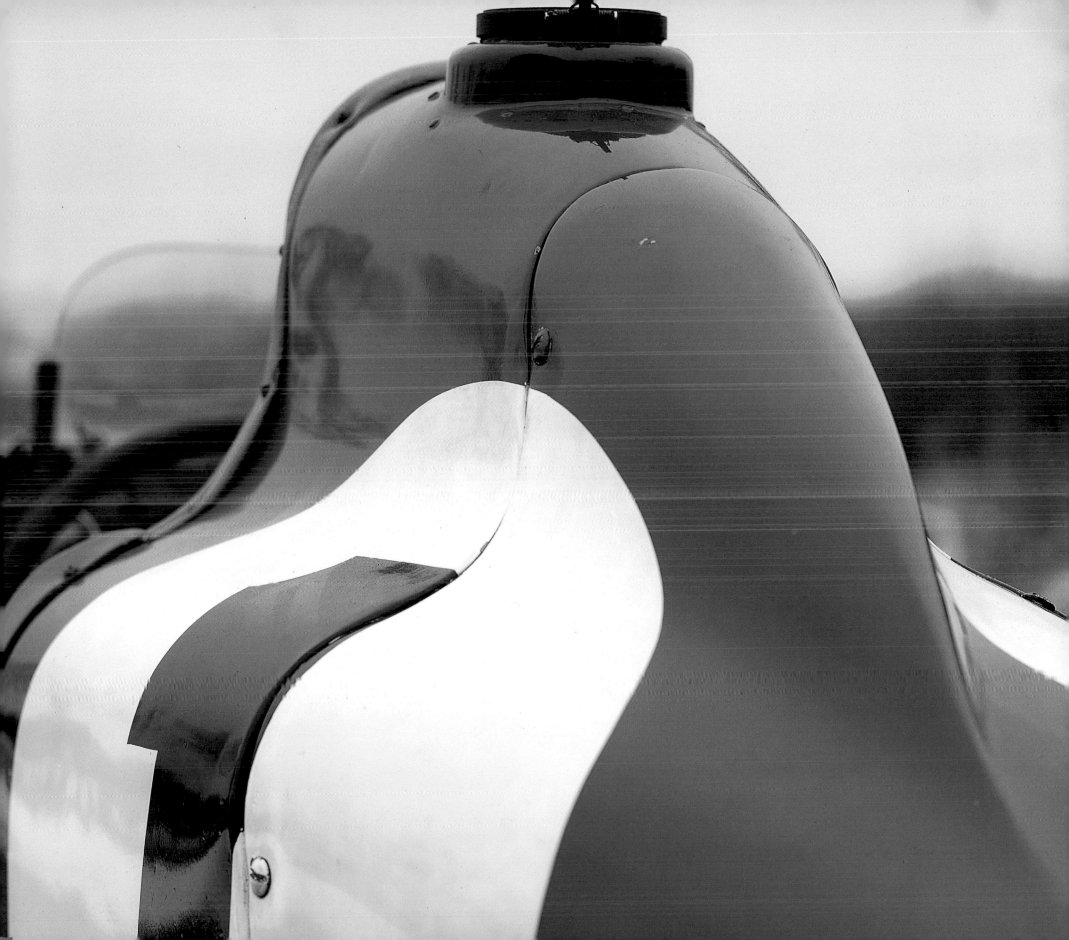

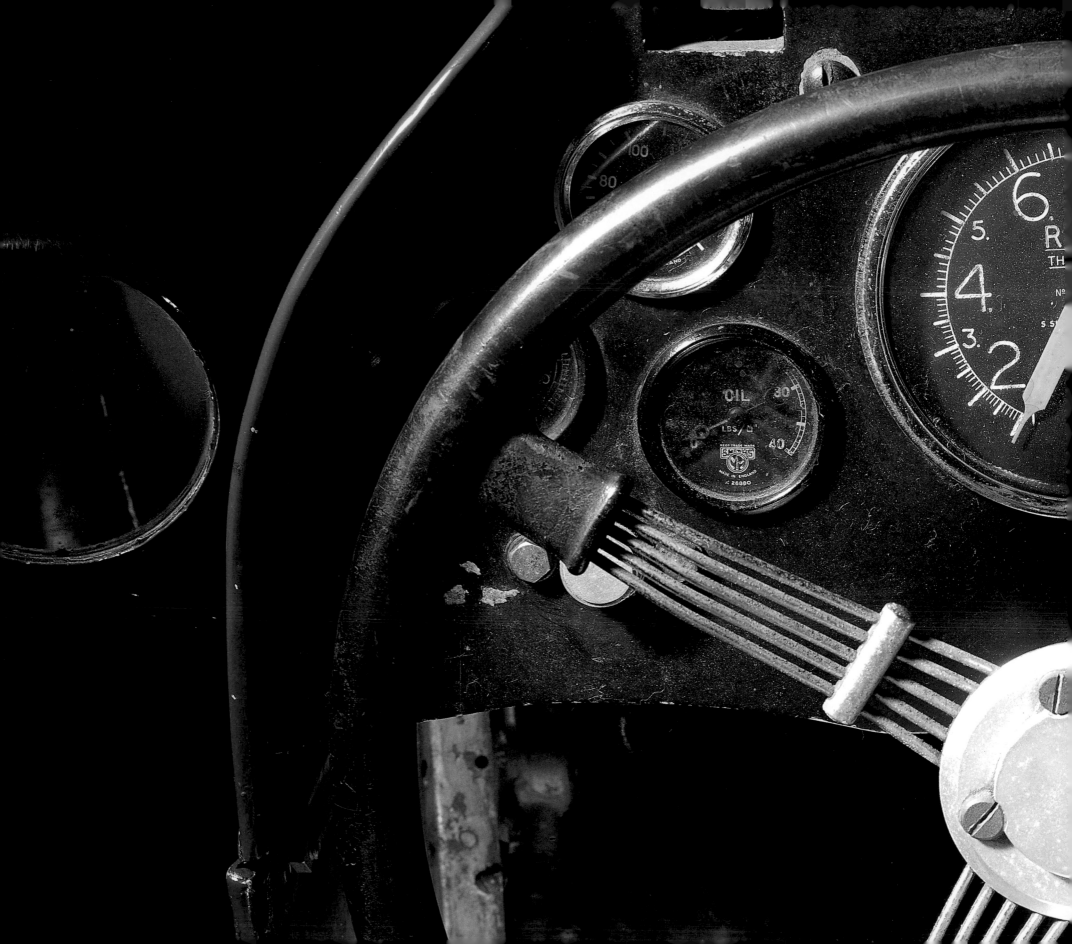

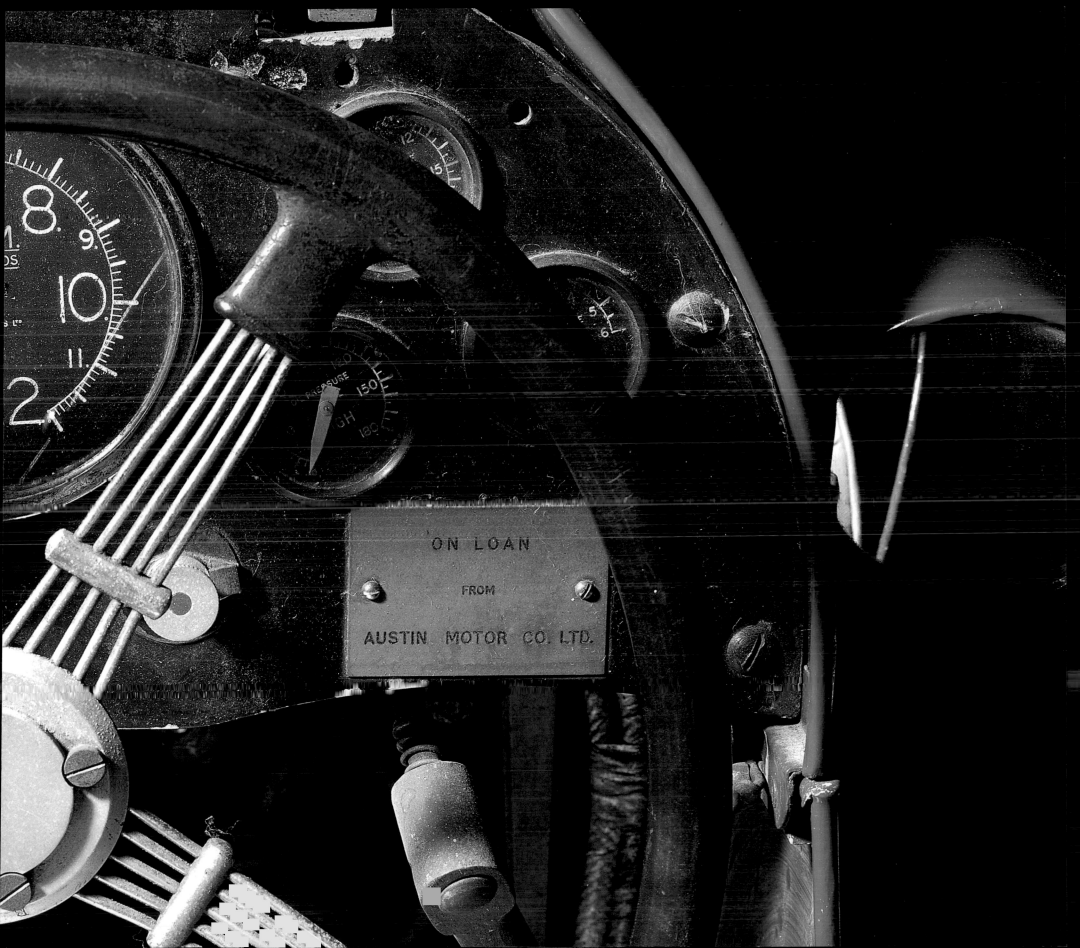

Chrysler Imperial (1937) USA As befitted the flag-ship for the Chrysler group, the Imperial became a marque in its own right. Although not quite in the Peerless, Packard or Pierce Arrow class, the Imperial was nevertheless a fine carriage for the wealthy; its long and elegantly proportioned chassis carried some of the finest bespoke coachwork by such American specialists as LeBaron, Murphy or Hibberd & Darrin. The Depression had killed off some of the more luxurious marques, leaving such as Chrysler, Lincoln and Packard to profit from a smaller market with fewer contenders. The coachwork on this 1937 example was made by LeBaron and termed a Town Sedan, with the emphasis on space and luxury appointments for the passengers. It therefore has a winding glass division behind the chauffeur, who received instructions by microphone through his own loud-speaker; the rear compartment even had its own dashboard to show the time, and to check that the speed and distance covered

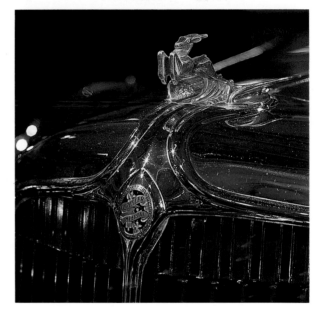

conformed to the owner's orders. All these dials and controls are set in handsome walnut, beech and other fine veneers to match those surrounding the passenger compartment; they continue through to the front area where, however, the driver's dash panel is of more down-to-earth engine-turned metal. Although the provision of a dashboard for the rear passengers is not unique – it was included in other examples of prestige coach building – it was an attractive period innovation, and one that was no doubt greatly envied by lesser mortals.

This page: 'Chrysler Imperial' on the badge shows that this was a separate marque.

Opposite: The chauffeur's dashboard is comparatively restrained but still informative.

Overleaf: The miniature dash – speedometer with trip recorder and a clock – for the rear occupants reflects opulence.

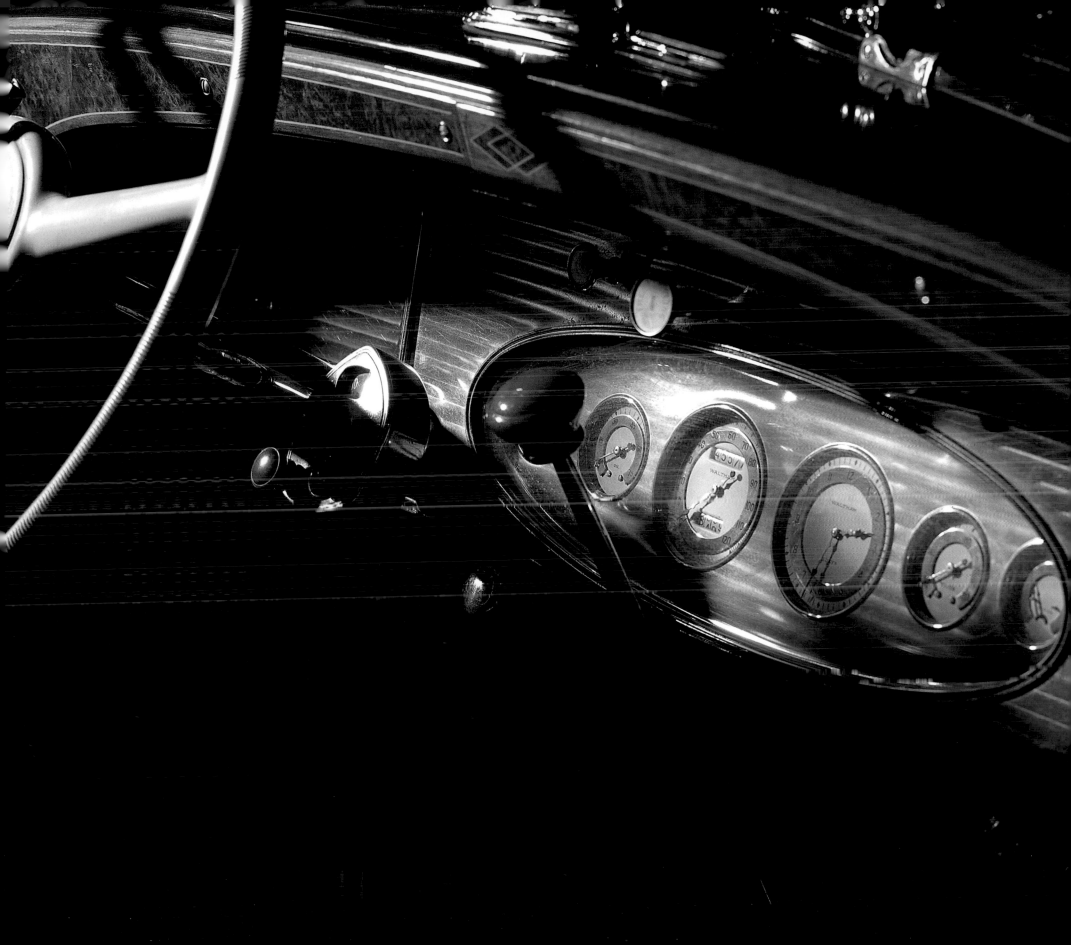

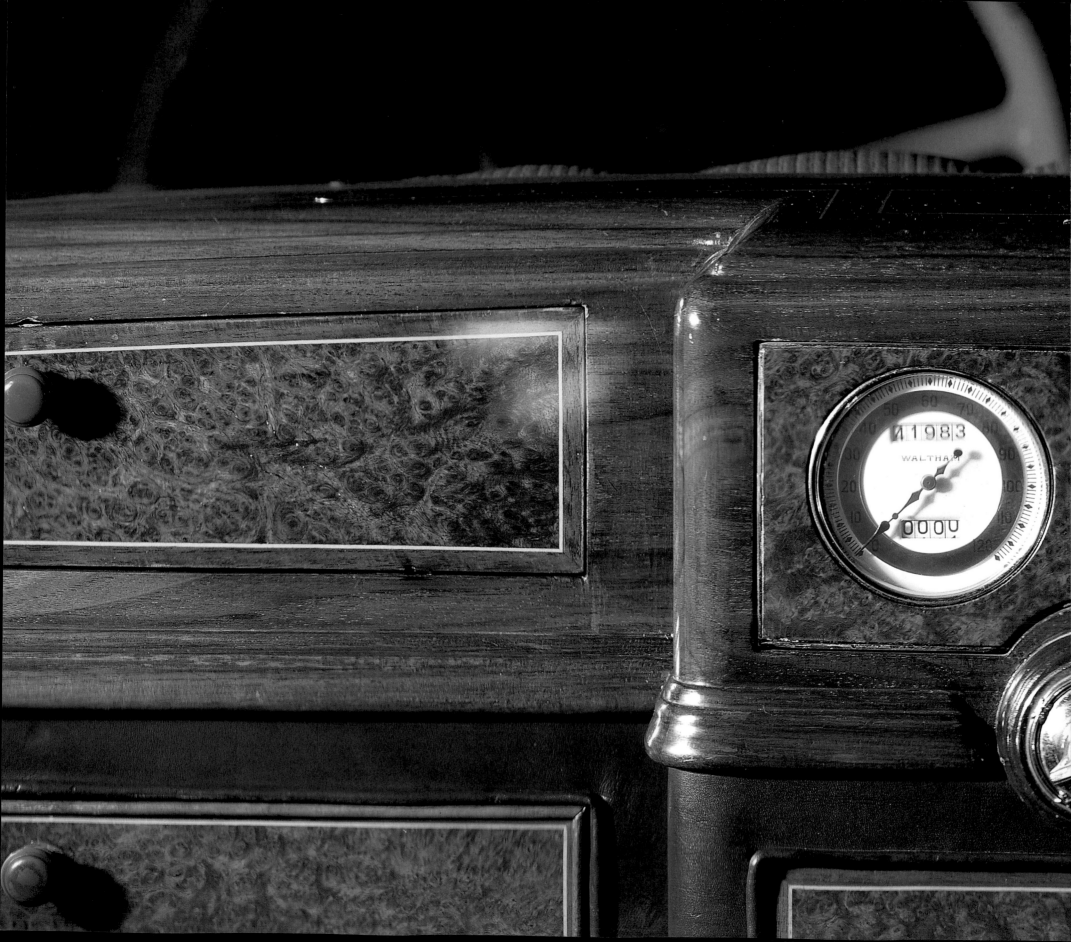

Cord 812 (1937) USA Most of the products of the Auburn-Cord-Duesenberg empire were designed to impress, but none looked more dramatic than Gordon Buehrig's Cord 810/812, its striking trend-setting front disposed of separate radiator and headlights in one clean sweep. It was equally impressive underneath with front-wheel-drive, a Lycoming V-8 and gear selection via vacuum cylinders and electric solenoids. With many unusual features, the dashboard

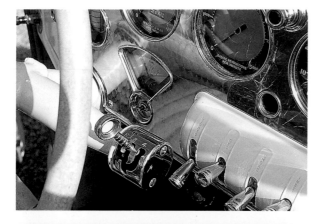

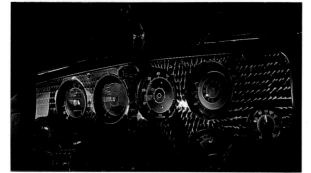

had tremendous visual effect with its full range of matching instruments and controls set in an engine-turned panel. On a stalk behind the leather-bound steering wheel was a miniature gearbox gate; moving its little lever engaged different solenoids. On the dash behind, aircraft-style vertical levers controlled choke, throttle and exterior lights. Pressing a button gave oil level on the fuel gauge. There was even a rheostat to dim the dash lights, giving an unusual indirect green and gold glow. Vacuum-operated wipers had separate controls above the dash panel; hot air flow was provided by a variable speed heater fan, while levers opened twin ambient air ventilators. The built-in wireless had its own lighting. There was no starter button, as this was combined with the clutch mechanism, complete with an automatic cut-in if the engine stalled in traffic. And the innovative 'pop-up' headlights were raised from the wings by handles at each end of the dashboard. Despite and because of all its novel features, the high performance Cord was sadly a commercial lemon, which brought none of the expected joy to owners faced with unreliable transmissions; warranty claims were high. The end came in 1937 for both the 812 and the Cord empire.

This page: (Upper) This detail shows the miniature gear-lever gate which engaged vacuum operated selectors on the gearbox ahead of the engine. (Lower) Night lighting was green and gold.

Opposite: Buehrig's coffin-nose Cord set new styling trends. The badge on the front apron is the only visible Cord insignia.

Overleaf: The stylish engine-turned dash shows contrived symmetry – the small 'gauge' at far right is a radio with volume/station knobs underneath. The central bank of aircraft-style levers includes a control to lift the headlamps.

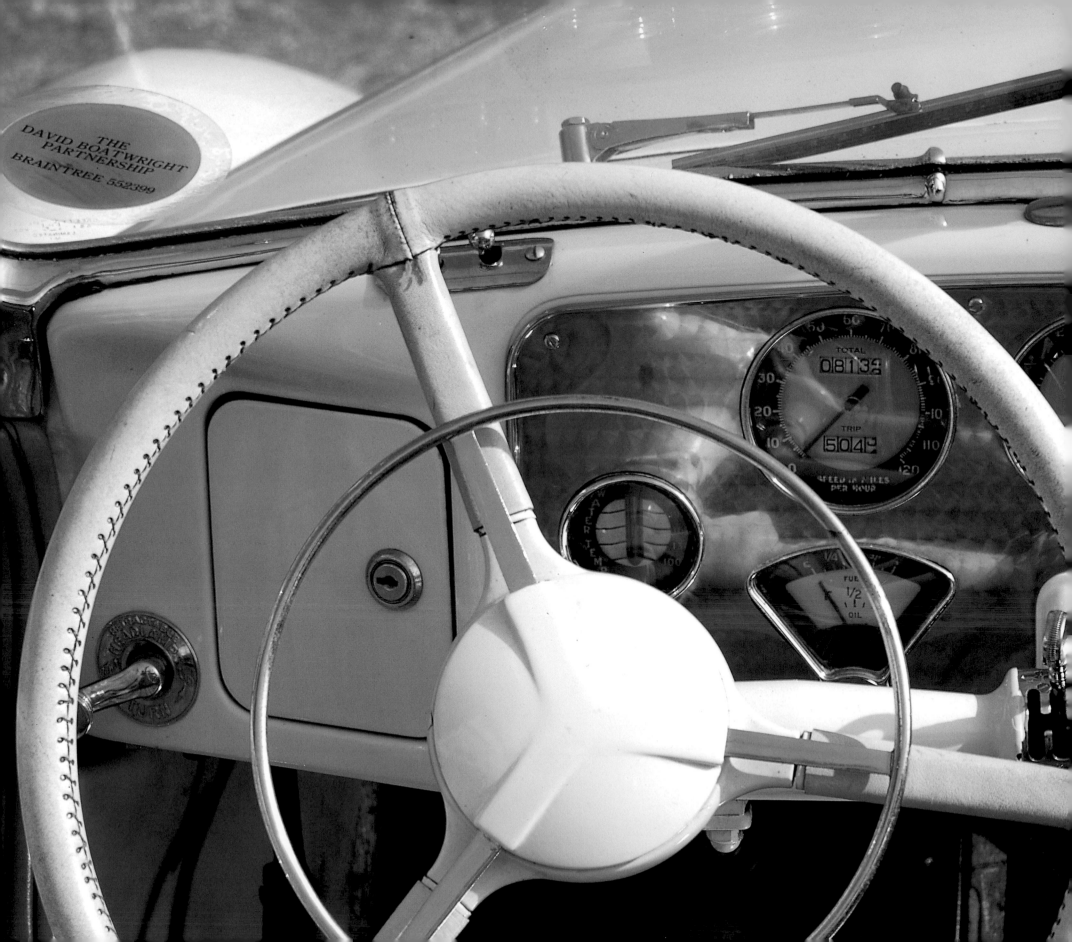

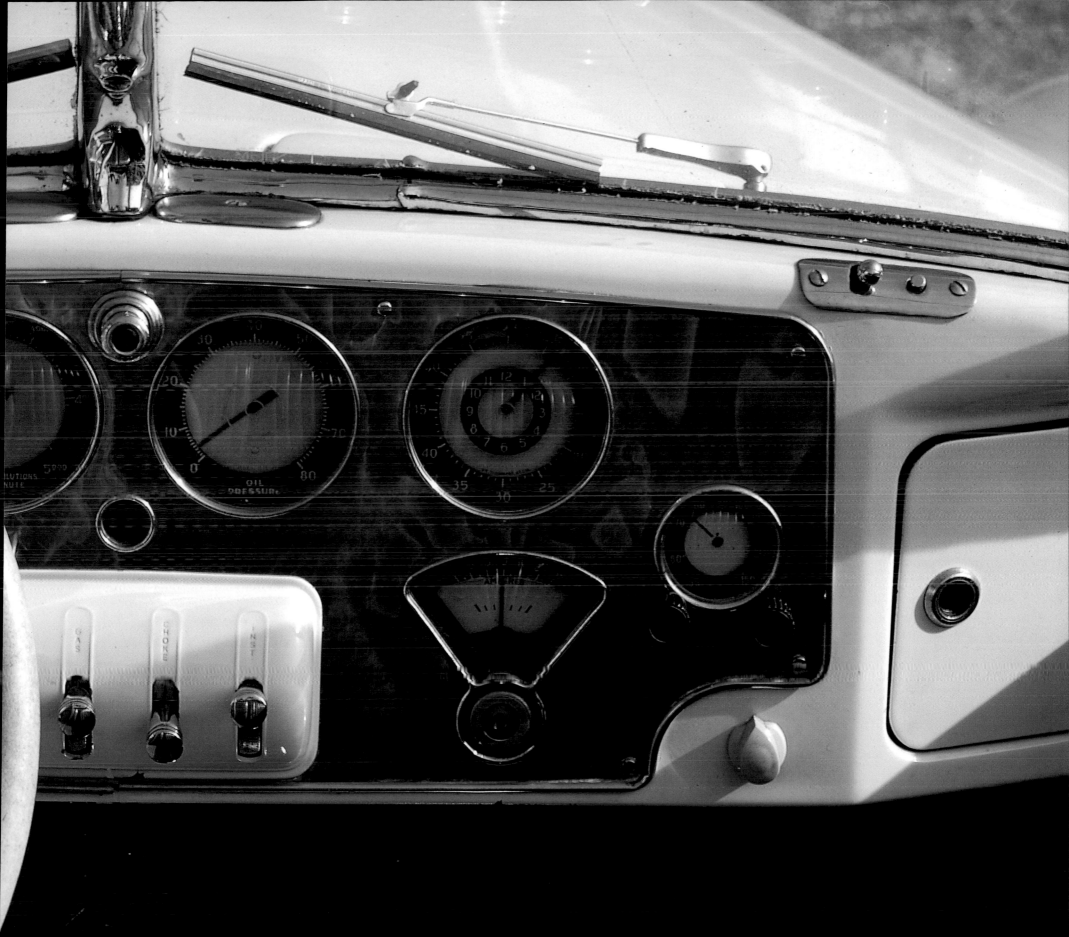

Packard V-12 (1937) USA In its greatest days, Packard was synonymous with precision and performance for the patrician. Together with Peerless and Pierce-Arrow, the Packard enjoyed the patronage of a discerning and wealthy clientele from the first Twin-Six – so good that it inspired Enzo Ferrari to create his V-12s – to the carriages used by Eisenhower and Patton in the European war. Seven litres of meticulously engineered V-12 gave to this factory-bodied convertible performance and utmost reliability in near silence, despite carrying high quality coachwork of prodigious weight; here it would waft just two people (and an occasional third in the 'rumble seat') in magnificent luxury behind that long bonnet topped by a typical winged radiator mascot, the famous Packard pelican. Underneath it, the well-finished and handsome engine complemented the magnificence above. The aristocratic dashboard, with symmetrical dials, included the built-in radio console that was customary in the high-class cars of America; Europeans had yet to integrate the wireless into the dash. The steering wheel is delicately formed, featuring the Packard crest in the central horn boss. Gear selection still used a long lever, but in those days three-abreast benches had not arrived; despite their overall size, these cars were surprisingly narrow, so the driver had priority of the available space while his passenger was squeezed against the side.

This page: The Packard pelican was an option, seen here silhouetted against a tiled wall illustrating a Bugatti T35.

Opposite: The covered side-mounted spare wheel has the Packard Twelve in chrome, set in red glass enamel.

Overleaf: Centrally placed in the metal panel is the standard Packard radio. Twin glove lockers in the veneered facia each carry a different St Christopher. Slender swan-necked spokes give an elegance to the steering wheel.

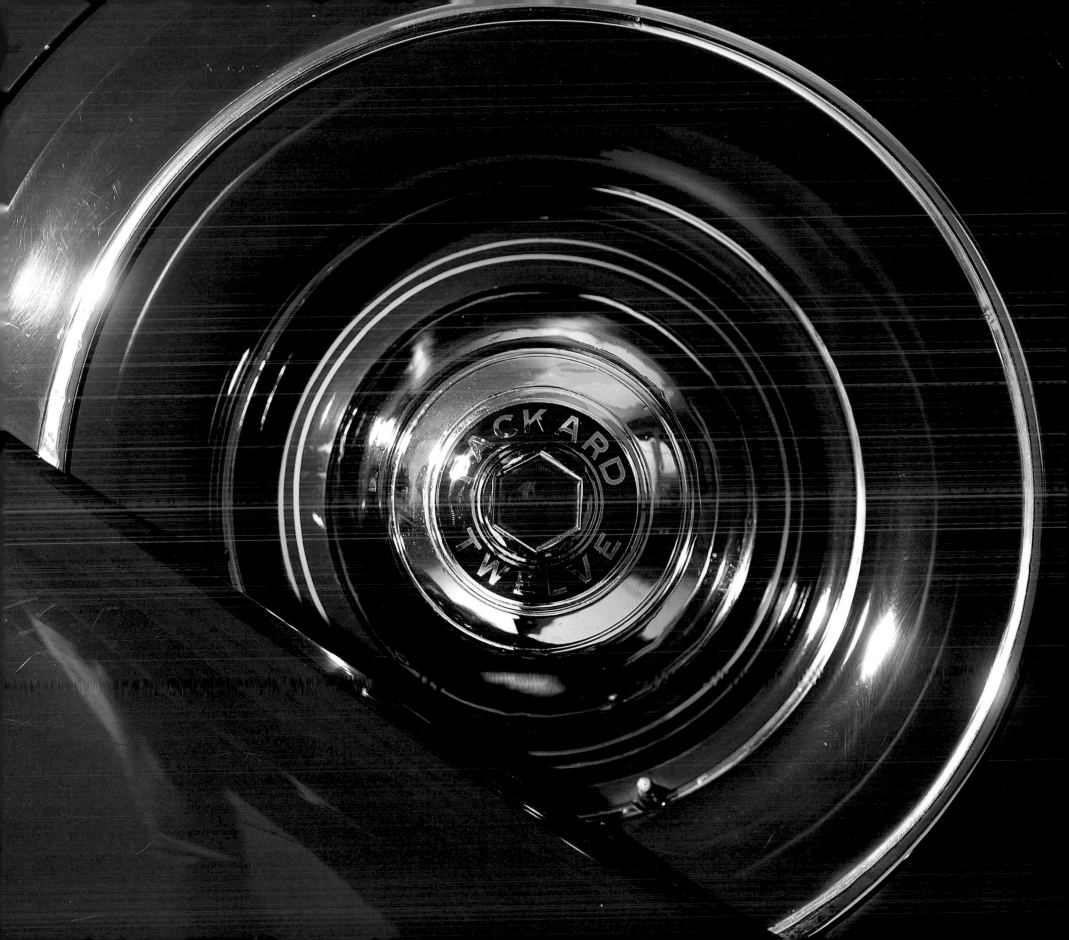

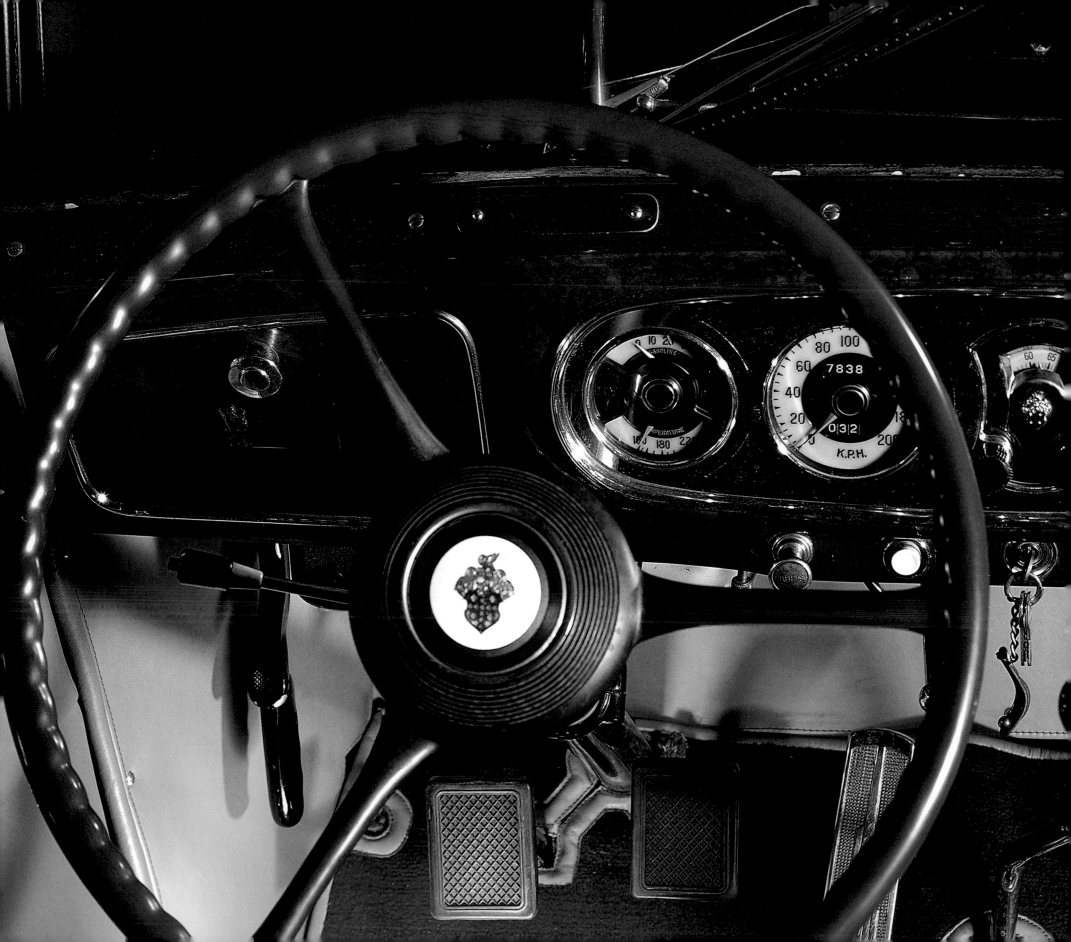

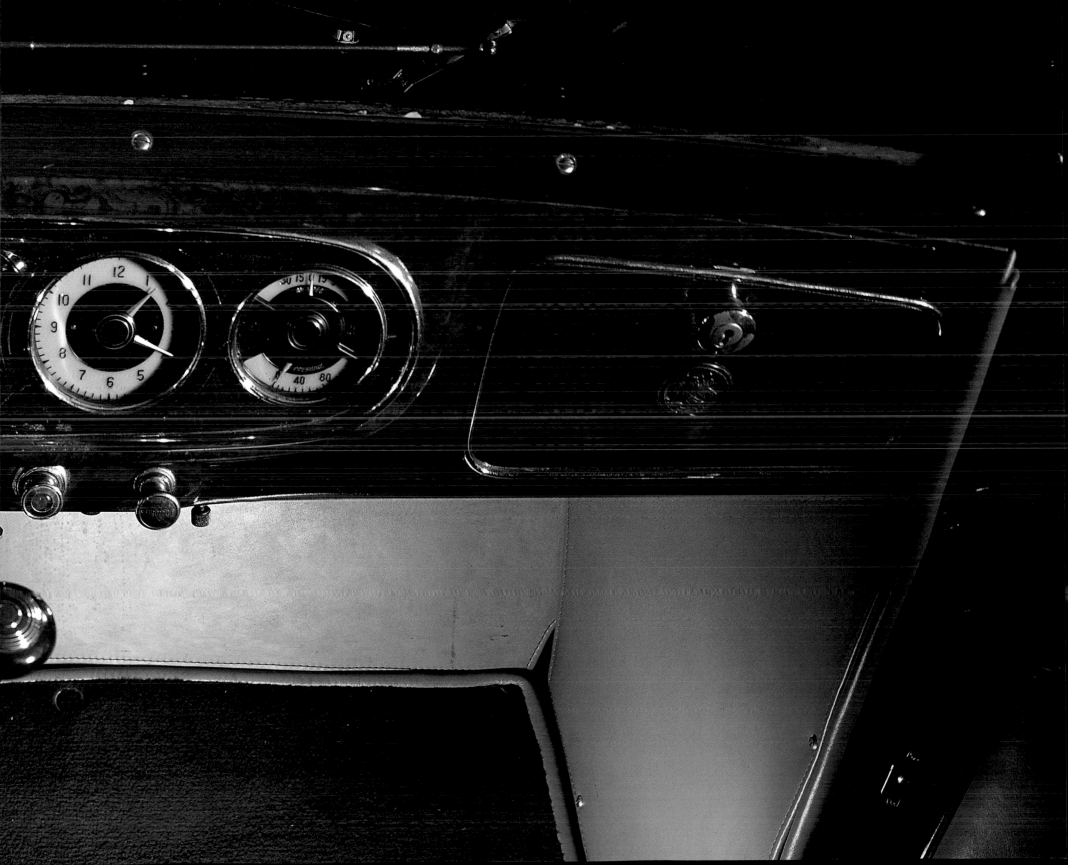

Mercedes-Benz 540K (1938) Germany Developed by the remarkable Hans-Gustav Röhr from Hans Nibel's 500 series, all under the aegis of the great Max Sailer, the 540K was top model in a range of fast, luxurious motor cars that followed the departure of Ferdinand Porsche. It was expensive, large and complex in its chassis which carried some of the finest coachwork ever seen;

its 5.4-litre straight-8 engine was a relatively lazy and heavy unit, requiring added boost from the driver-controlled supercharger to take its normal 115 bhp up to 180 bhp and reach its advertized position as the fastest five-seater production car in the world. Nevertheless, its massive independently sprung chassis allowed it to maintain high speeds on the new Autobahnen and lesser roads alike. With the radiator set well behind the front axle line, its sweeping curves displayed marvellous proportions, with lots of chrome and some finely detailed workmanship all helping to justify the high price tag. The flavour of all this is mirrored in the dashboard and controls. The symmetrically planned panel is centrally sited, its five dials conveying more than enough information; with metal finish, it is set against a backing of leather which follows the upholstery. The thick white steering wheel with a chrome horn-ring is matched by the white gear lever knob, controlling four (later five) speeds through a whippy wand. If it lacked the finesse of its French or Italian equivalents, and needed the muscles to drive it, the 540K was nevertheless a fine creature of its time.

This page: The Mercedes star and Benz laurel are joined in the badge. Bosch provided horns, foglights and headlights.

Opposite: A multi-spoked wheel has a large knock-on spinner and seven covered balance-weight capsules. Two adults can sit in the occasional 'rumble seat'.

Overleaf: The elegant symmetry of the informative dash panel, set off by the padded leather surround, is beginning to show some styling influence.

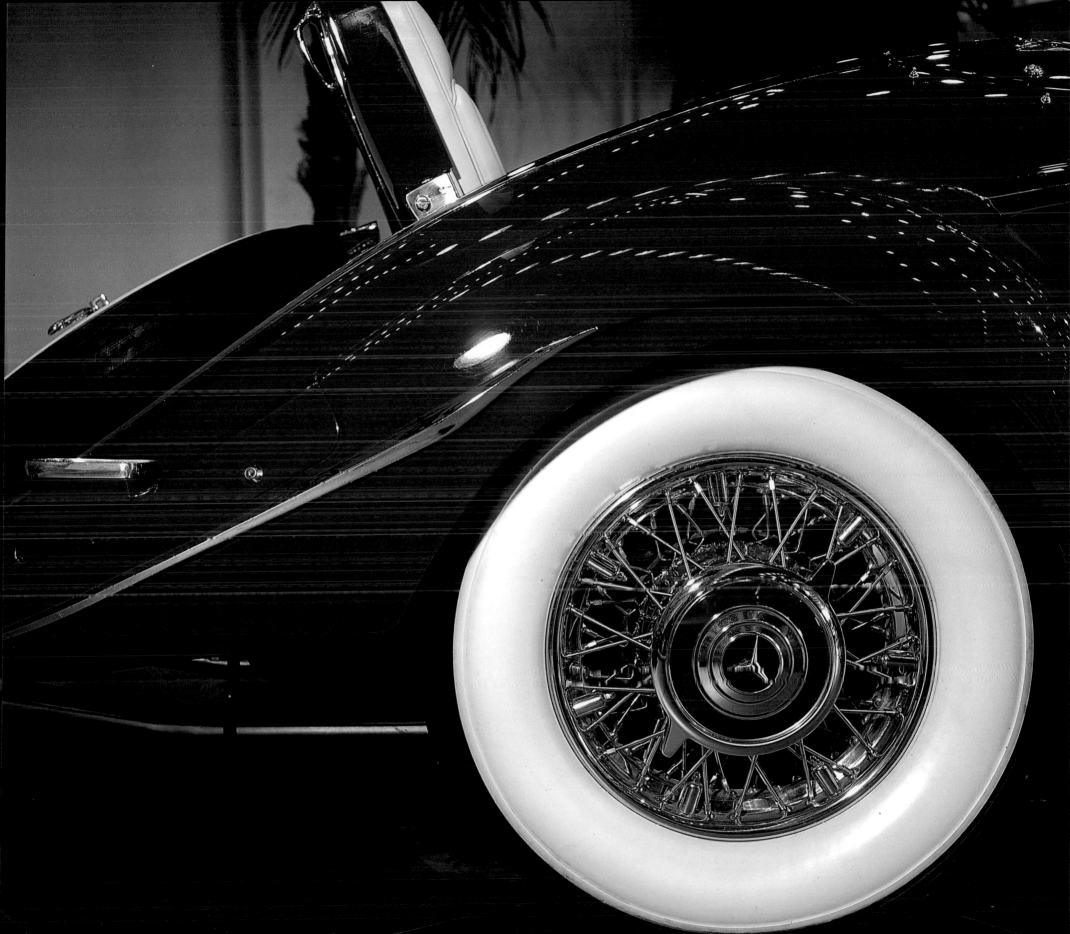

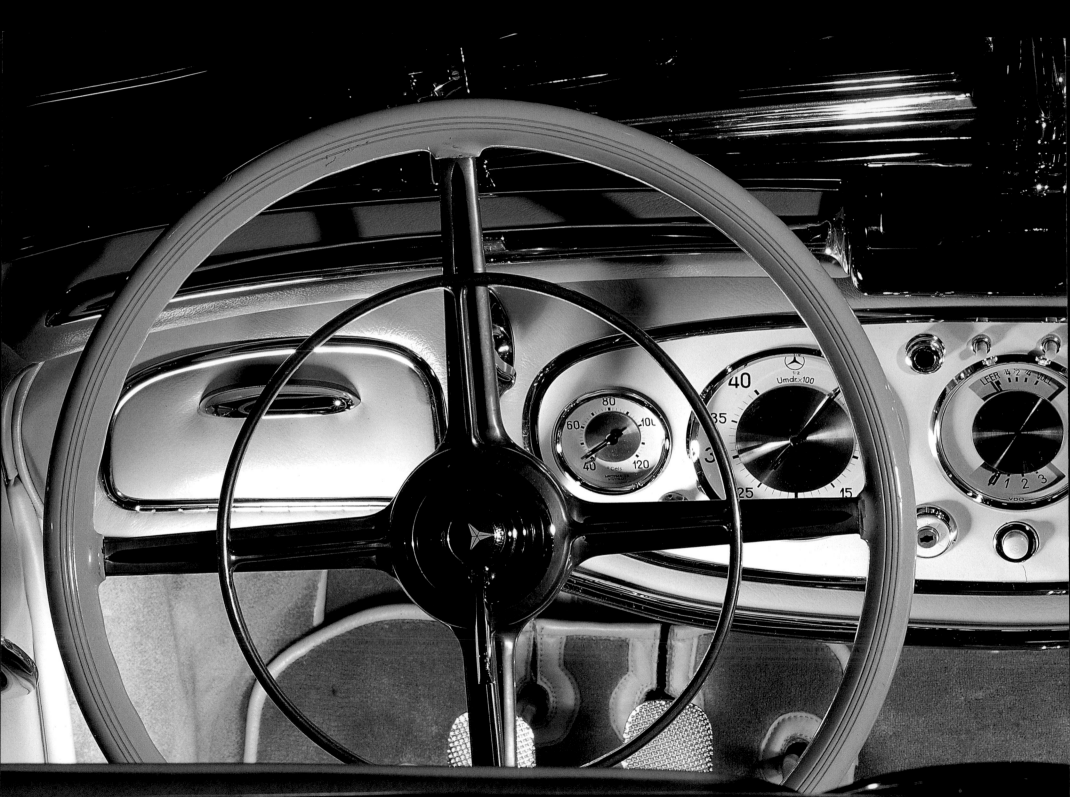

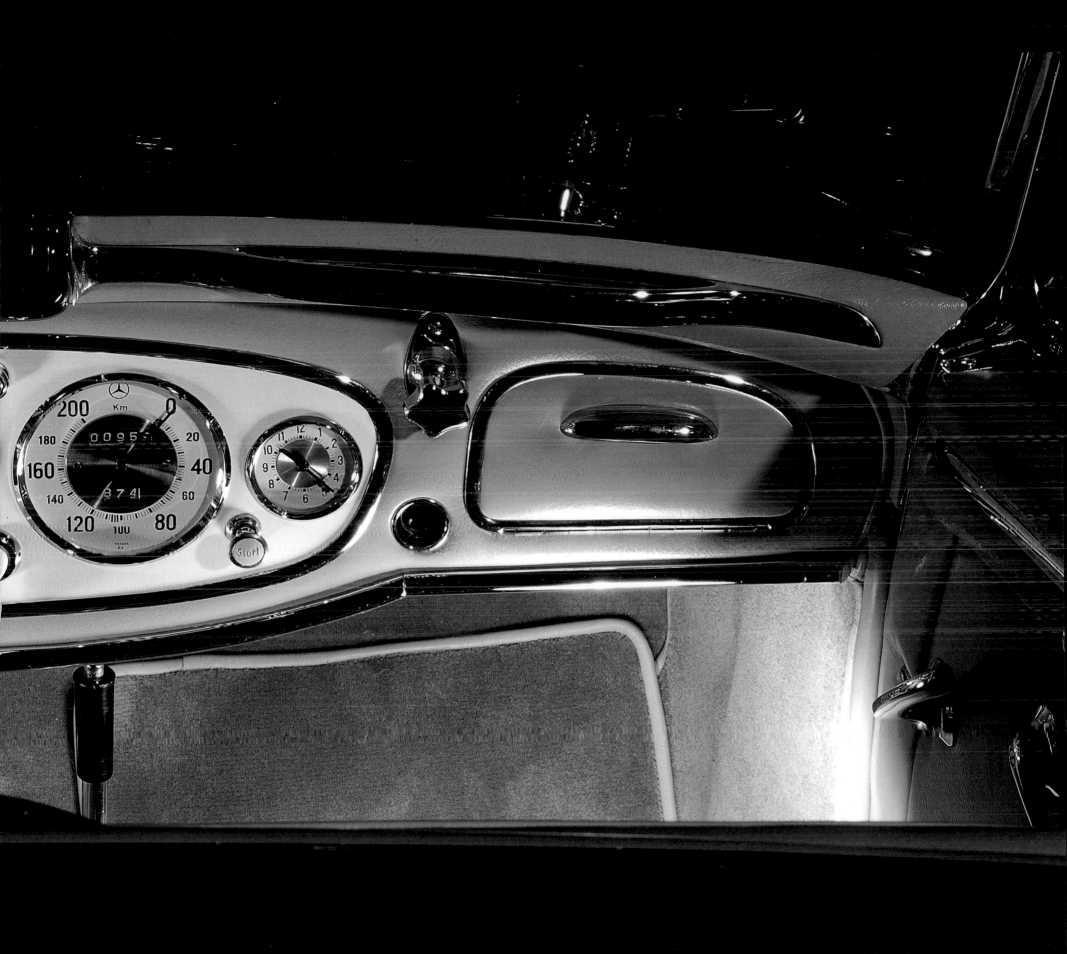

Ford V8 USA When the legendary Model T 'Tin Lizzie' was finally replaced by the Model A, after fifteen million had helped put the world on wheels, the Broadway songster who came up with 'Henry has made a lady out of Lizzie' was absolutely right. Clothed in a creditable scaled-down version of Ford's recently acquired upmarket Lincoln – even down to radiator shape, side lights and other features – it adopted all the creature comforts by then expected of a family car, and had a conventional gearbox. But performance didn't match the looks; even doubling the output of the four-pot engine failed to attract enough customers from rival makes. So Ford's engineers worked hard on Henry's new dream: a low cost V-8 for the masses. Putting this into a lightweight Model AB chassis created a road-burner that out-gunned all rivals in its class and set the enduring American tradition of power for the people – including Bonnie and Clyde. The V-8 may have overheated if

used hard for long periods, and used oil at an increasing rate, but it brought a new performance dimension to Ford's reputation. The dash remained fairly austere throughout the new series, but the steering wheel soon reflected the fashion for new shapes, colours and materials, including Henry's innovative processed soya products; this late example was in the envied 'banjo' style with a mock wood facia. Florida fads and the availability of bolt-on accessories brought the addition of a driver-controlled spot-lamp, adding style to this $800 automobile. The Ford V8 was almost as ubiquitous as the Model T, but came in greater variety; it was just as successful as a speedway hot-rod or a doctor's coupé as it was in providing a comfortable saloon with surprising acceleration.

This page: A Firestone 5.50-18 tyre sits on Ford's ingenious welded-spoke wire wheel with its prominent V8 insignia.

Opposite: The vulnerable V8 mascot with its trailing air stream is a complicated little casting.

Overleaf: Banjo-style spokes are used on this De Luxe steering wheel. Pull-type choke and throttle knobs are set

between the pairs of vertical chrome strips on this later type dash. The 'Charge-Master' is a period addition.

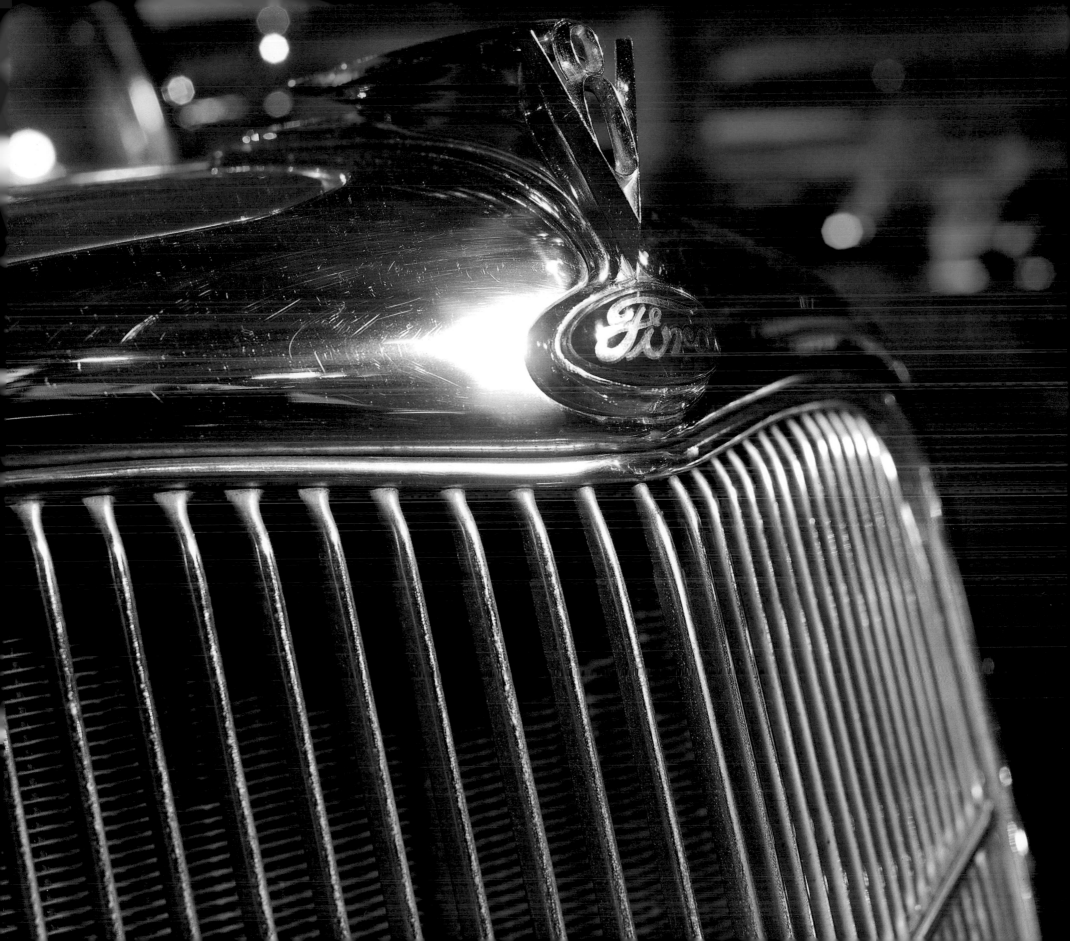

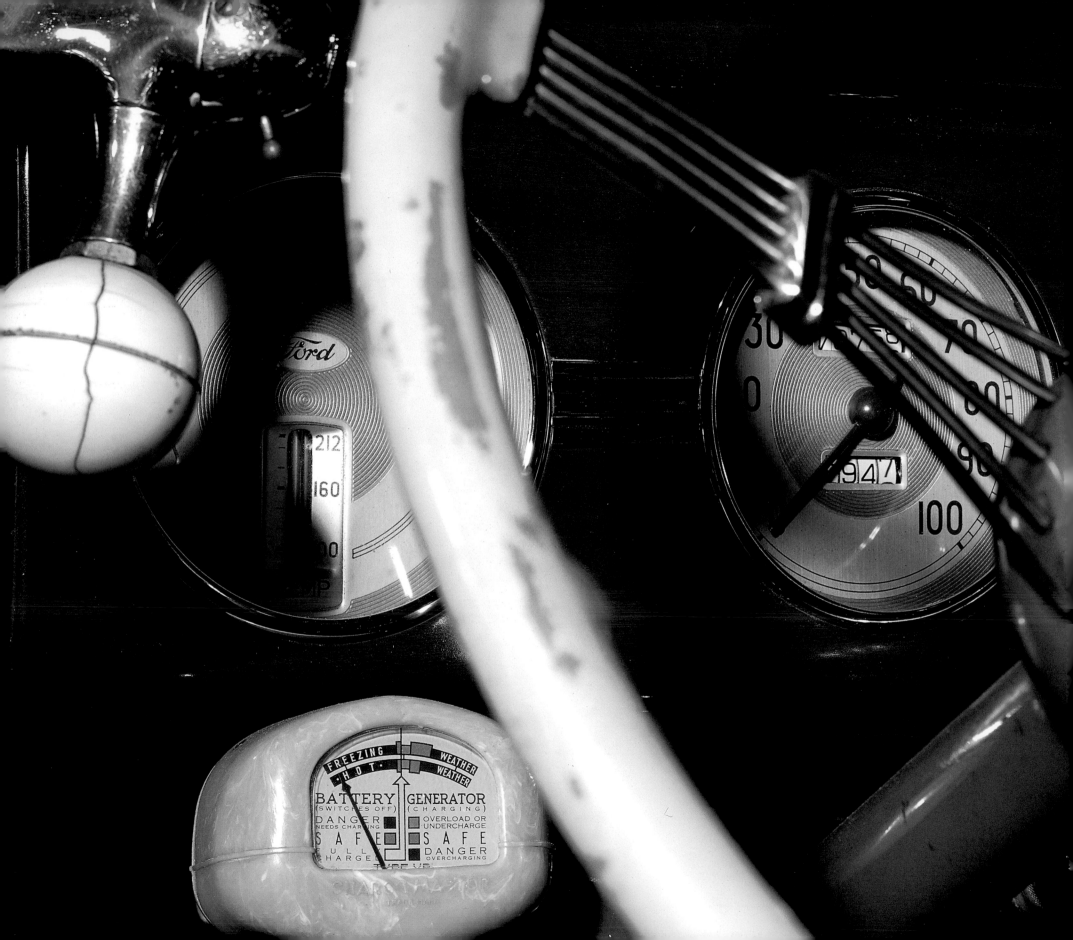

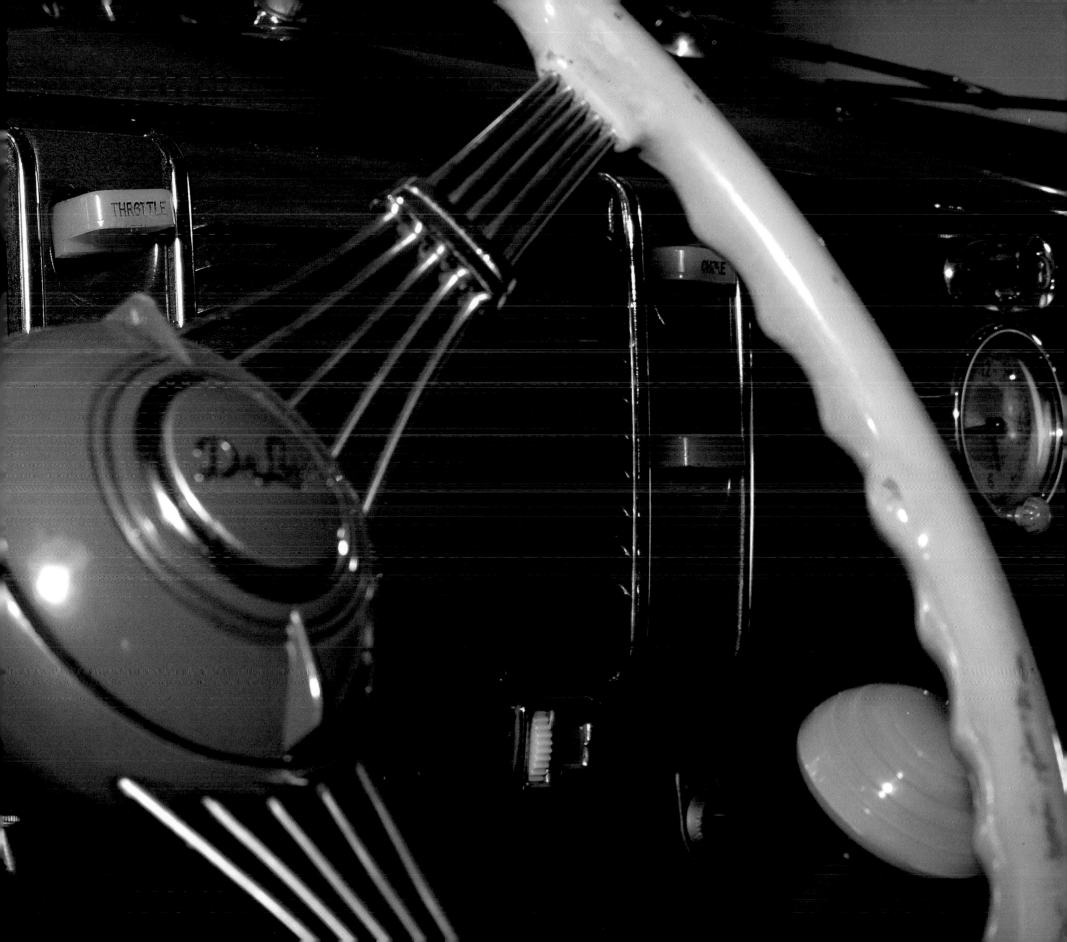

Maybach DS8 Zeppelin (1939) Germany Gottlieb Daimler's partner in the first days of the horseless carriage was Wilhelm Maybach, who later worked with Count Zeppelin, making the engines for the giant airships constructed on Lake Constance, before forming his own company to produce cars and aero-engines. Always expensive, and massive in construction, Maybach cars tended to be the choice of bankers and nobles rather than actors or politicians. The rising stars

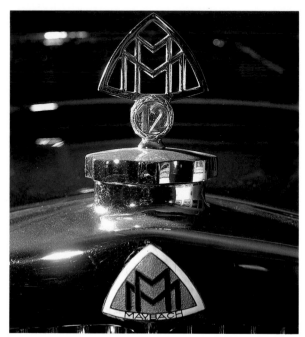

of inter-war Germany preferred the more affordable Mercedes-Benz and Horch so the Maybach gradually declined into a dinosaur existence, but not before the company had created its magnificent swan song, the Zeppelin. The DS8 designation indicated the capacity in litres of the single camshaft V-12; this heroic power plant was coupled to an unusual transmission, which provided no less than eight forward gears and four reverse, with some 200 horsepower to overcome all the inertia and achieve speeds up to 100 mph – or more for the few special Autobahn models. The Maybach depicted here is one of the final series, with superb coachwork by Spöhn; the vividly coloured dashboard

shows a dedication to quality and detail, complemented by those two tiny levers on the steering wheel boss to control the numerous gear variations available in the infamous 'Doppelschnellgang', from a tree stump-pulling 14-to-1 bottom gear to a relaxed overdrive ratio of 2.5 to 1. With a seven-foot-long bonnet and three tons of motor car, the necessarily strong-armed driver needed all his concentration to conduct this formidable example of one of the greatest motor cars of its era.

This page: Two Ms, for Maybach Motoren-Werke, are repeated on the badge and in the mascot above a laurel-wreathed 12.

Opposite: The big 8-litre V-12 developed some 200 bhp, which made these big cars surprisingly fast.

Overleaf: The red leather interior trim is continued across the facia top; the metal dash panel contains the customary range of instruments. Twin levers on the steering wheel centre control gearbox ratios, while floor lever has a choice of final drive ratios – two forward, one reverse.

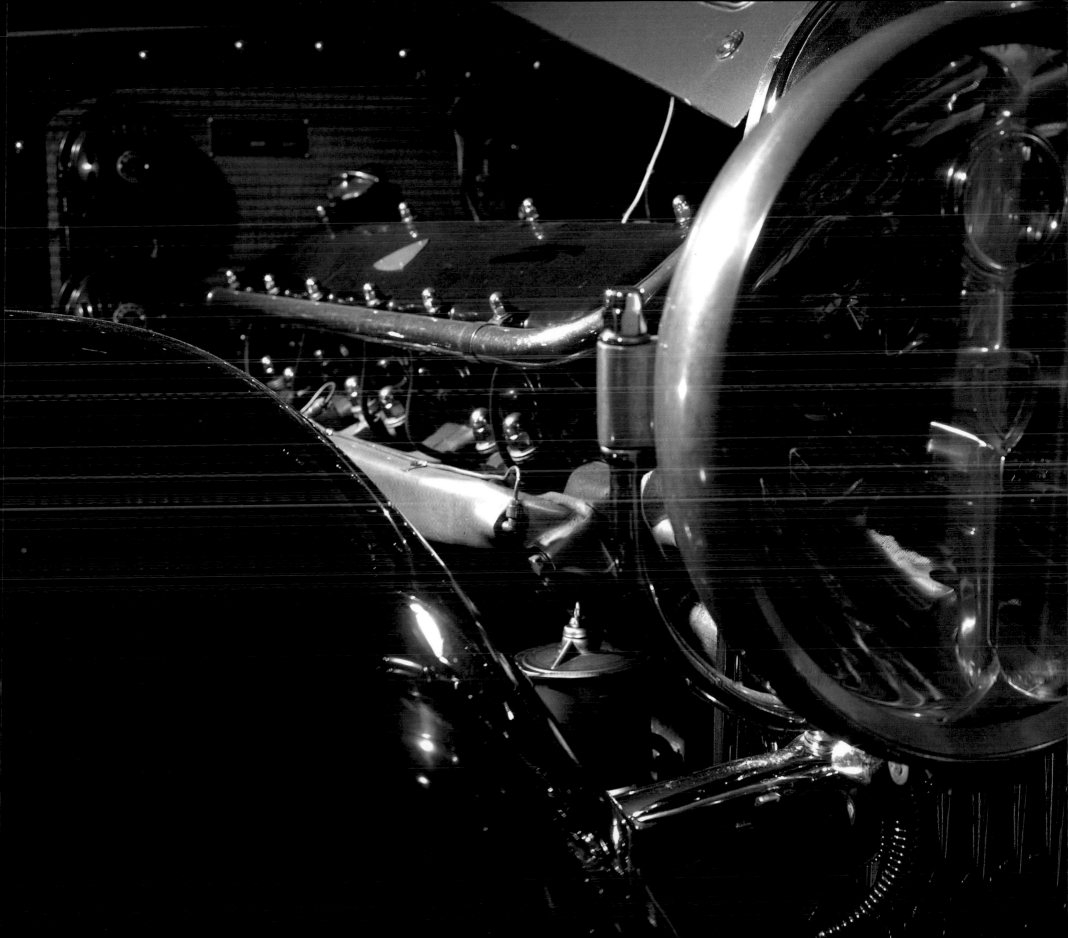

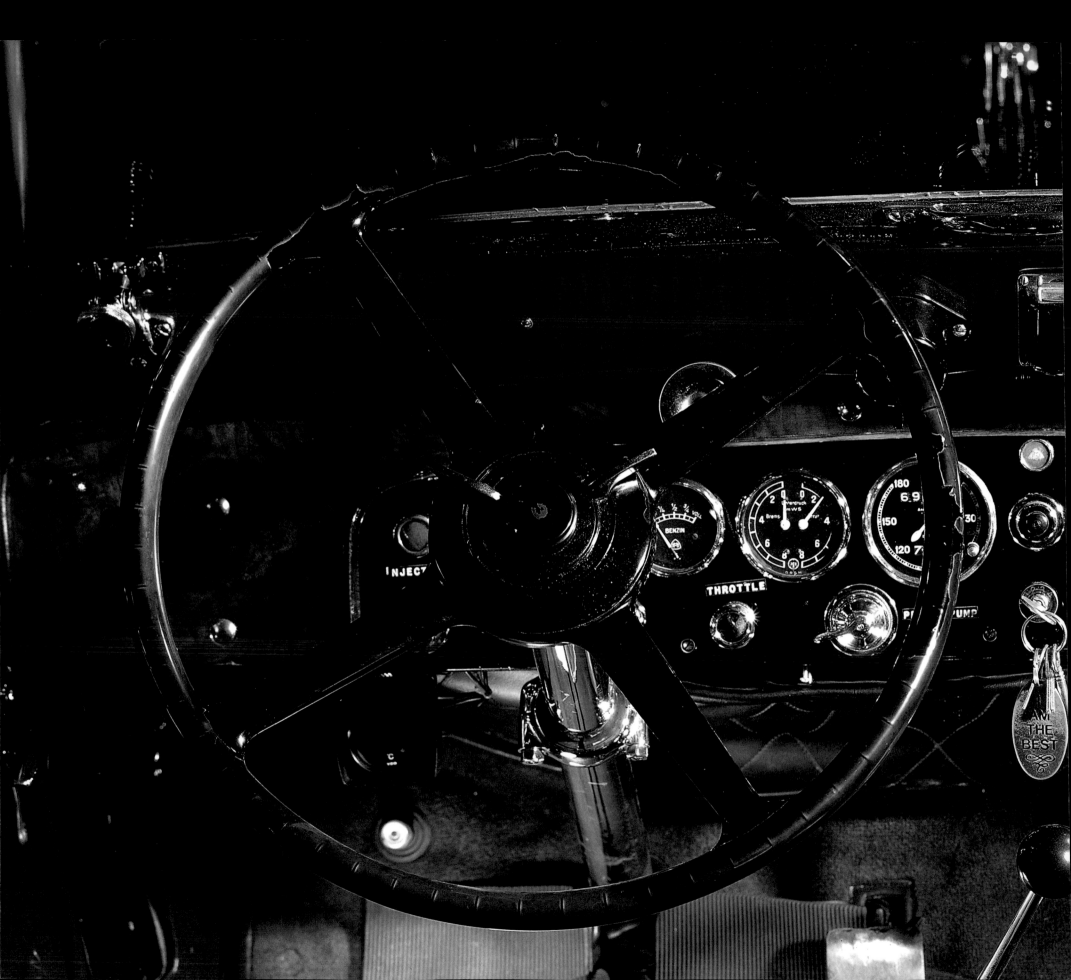

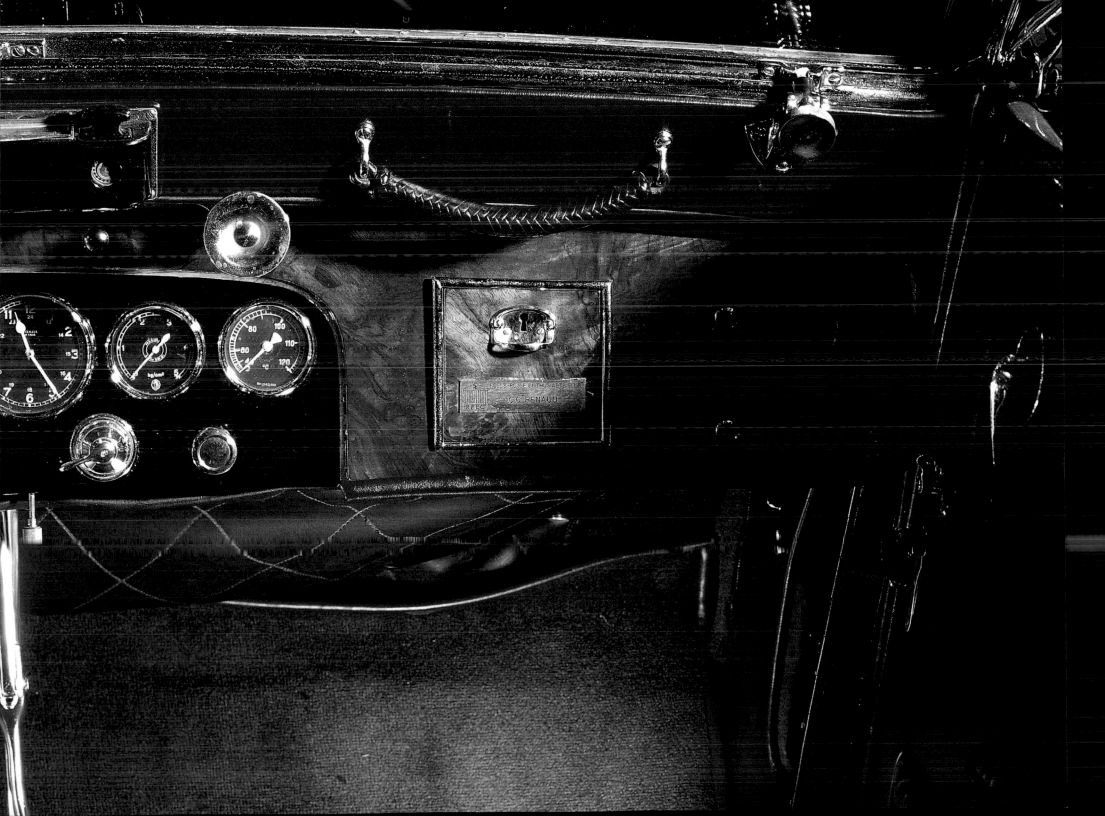

Willys Jeep (1943) USA Archetypal off-road 4x4, the Jeep was originally developed by the American Bantam Car Company, who had previously built a version of the Austin 7 under licence; however, the onset of war in Europe required a production volume much greater than the little firm could provide, so the crash programme demanded by the US War Department was taken up by Willys-Overland, and later supplemented by Ford who produced the majority.

The Jeep's name came from the US Army designation GP – General Purpose – and it became the most successful of all the cross-country vehicles of any army, radically transforming battlefield transportation and subsequently setting a fashion for future leisure vehicles. Easy to drive and service, simple to repair, the Jeep was designed to be purely functional with no frills. Thus all equipment was practical: the carbine holder beneath the folding windscreen (with hand-operated wipers), the plain seat cushions, the rudimentary canvas roof, and the fuel cans on the back. All controls had perforce to be simple and strong, easy to see and use, so the dash held a full set of well-made instruments with clear inscriptions – these were later to become standard accessories for future generations of sports car and hot-rod enthusiasts seeking more information than their standard sets gave. Like cars from previous eras, the dash was set well forward of the driver. With 60 bhp from its Willys L-head engine to power a 1-ton vehicle, the Jeep was quick off the mark; and with four-wheel-drive, additional low ratio cross-country gears and all-independent suspension, it would go anywhere. The Jeep gave noble service, and a lot of fun too in its dual roles as battle-wagon and GI's sports car.

This page: The spare fuel can, strictly an 'American', is strapped to the back panel.

Opposite: A wartime night mask is used on the wing-top convoy lights; sprung T-handles hold the bonnet and a lowered windscreen.

Overleaf: The functional dashboard has simple clear gauges; instruction plates are fixed to the locker lid.

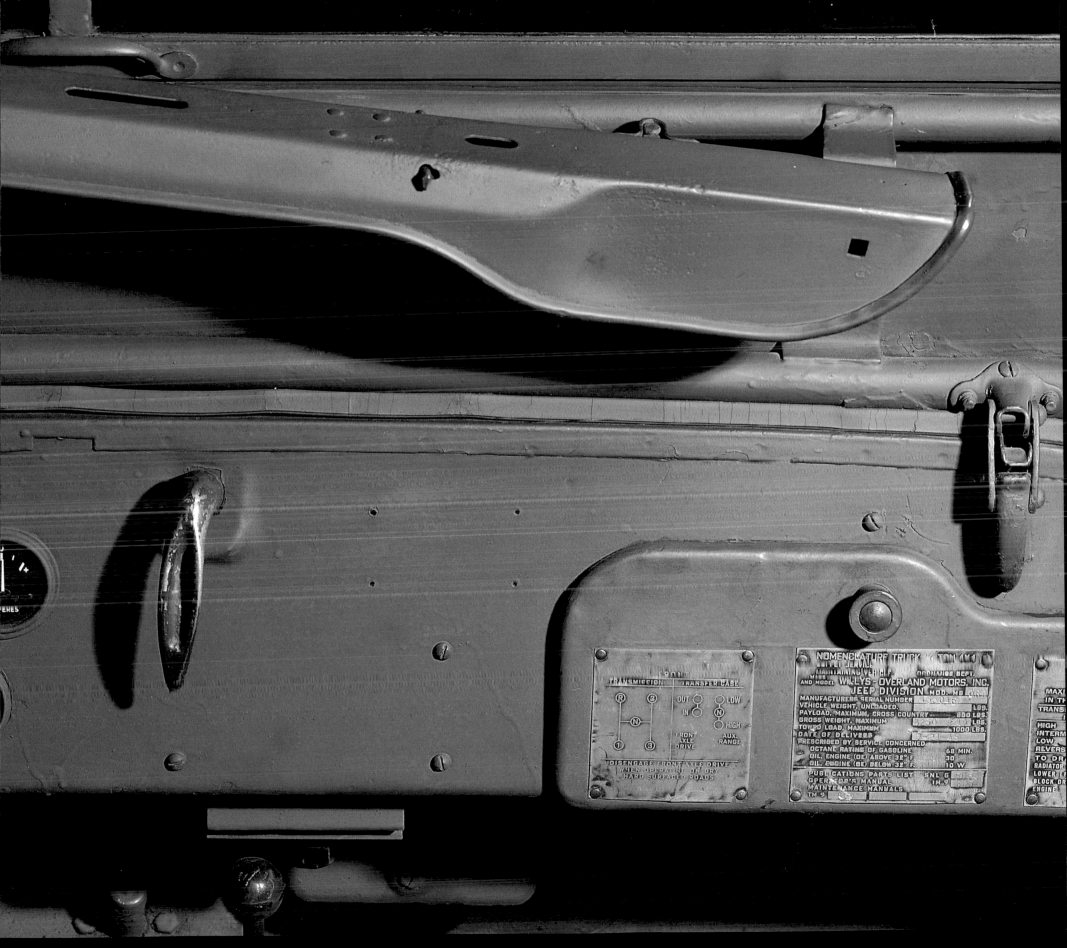

Talbot Lago Record (1947) France Anthony Lago had acquired the Paris end of the ill-fated Sunbeam Talbot Darracq combine before the war, together with the overseas rights for the Wilson epicyclic self-changing gearbox – a highly successful approach to gear selection, which also found favour with the racing fraternity. Using the Talbot name, Lago became a manufacturer of

powerful racing and sports cars, the latter renowned for high performance from their competition-proved components. The theme continued after the war, Talbot gaining track successes with Grand Prix and sports cars. Before the French government effectively ruined their luxury car makers with extortionate taxation, the company also produced some remarkably powerful and handsome, if costly, Grand Tourers which earned a solid reputation for speed, strength and reliability. This Lago Record, using a de-tuned version of the 4½-litre GP engine, was clothed by Talbot's in-house coach-makers to give fast, untiring travel over long distances. The purposeful dashboard shows the maker's priorities; Jaeger, the best of the Thirties instrument makers, supplied the large speedometer and tachometer. Behind the leaf-spring spoked steering wheel – a Talbot hallmark – is the quadrant for the Wilson gearbox indicating PM ('Point-Mort', for neutral) and MA ('Marche Arrière', for reverse); balancing this are the very Gallic stalks for headlamp dipping and horn selection. A roll-down sun-blind was provided for the driver, who could just see, over that long bonnet, the exclusive mascot on the cap for the radiator, which bore the same badge that the racing cars proudly carried on the European circuits.

This page: The racing cars used the same Talbot badge; the mascot above carries 'TL' for Talbot Lago.

Opposite: The chrome fillet on the rearmost part of the wings was a feature of Talbot's in-house bodywork.

Overleaf: Jaeger instruments are set in a pale leather-faced panel between veneered wood sections. The sprung

steering wheel and the Wilson pre-selector quadrant are identical to those of the racing cars.

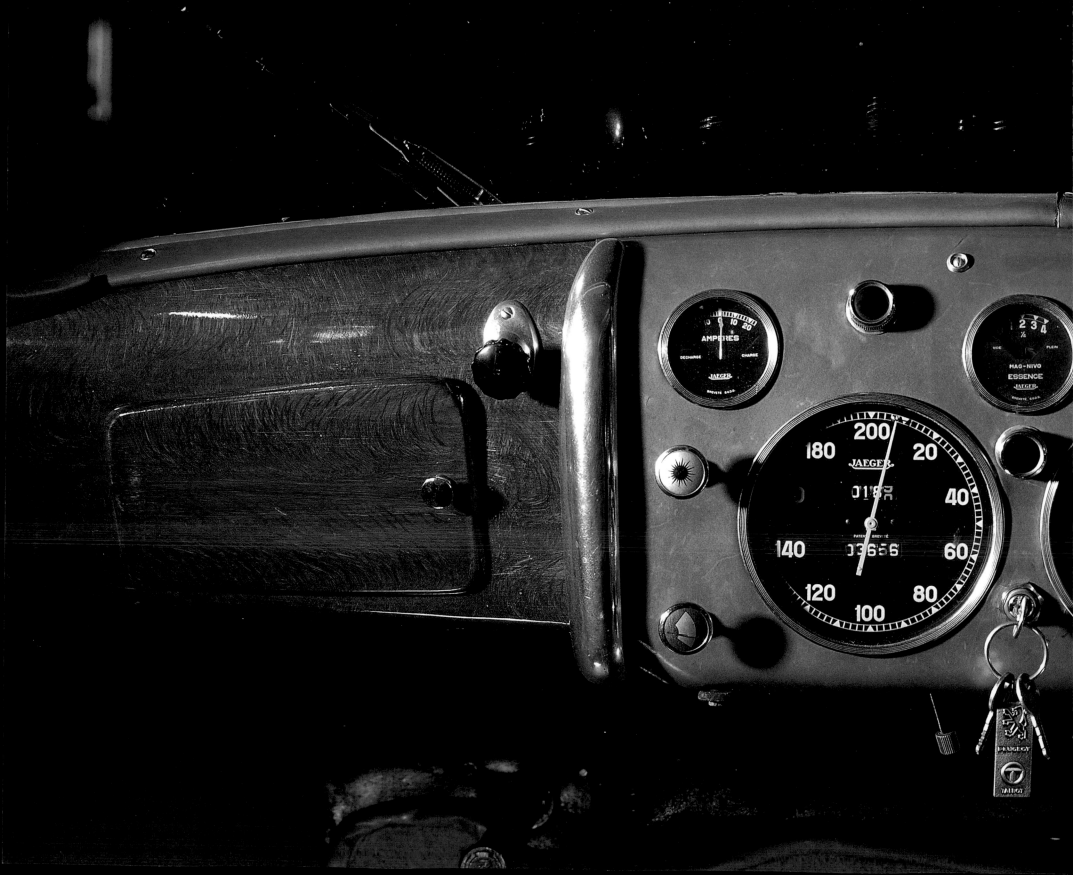

BRM V-16 GP (1949) GB Brainchild of Raymond Mays and Peter Berthon, British Racing Motors was formed to take Britain back into the forefront of international motor racing by using the motor industry to fund its construction and produce its parts. The two had previously created ERA (English Racing Automobiles) in the Thirties; privately funded, that team had been successful in Voiturette racing (Formula Two) so they had a good track record – Mays being the driver and fund-raiser, Berthon the clever engineer. An exciting concept, the V-16 suffered all the problems of design by committee, as well as the difficulty of finding the right materials and machining ability in post-war England. But it was beautiful, and its 1½-litre engine, with tiny 57 mm diameter pistons and Rolls-Royce centrifugal supercharger, sounded magnificent when producing up to 580 bhp and using a hitherto unheard-of 12,000 rpm. Like most pure racing cars, this has only the minimum of instruments: engine oil temperature and pressure gauges to left and right behind the wood-spoiled wheel, and a cluster of switches on the left, coupled so that all four ignition sets could be operated together. But it is the tachometer which distinguishes this dash from all others; with the power band awkwardly in the 8-12,000 rpm range it had to be purpose-built, so Berthon called in Smiths to produce this novel device with its horizontal scale. Throughout the rest of the formula for which it was designed the car failed to justify the enthusiasm of its many backers – industry magnates and the enthusiastic supporters' club. By the time the bugs had been sorted out, its chance was over, but the high frequency scream of its exhaust will live forever in the memories.

This page: The carefully contoured cut-out is to provide space for the driver's elbow.

Opposite: No other racing cars had disc brakes at this time. The disc almost fills the space inside the wheel, with just enough clearance for the Girling 6-piston alloy brake caliper.

Overleaf: Many British companies contributed parts and money to the BRM project. Smiths produced this novel rev counter as the engine speed was beyond the range of normal period instruments.

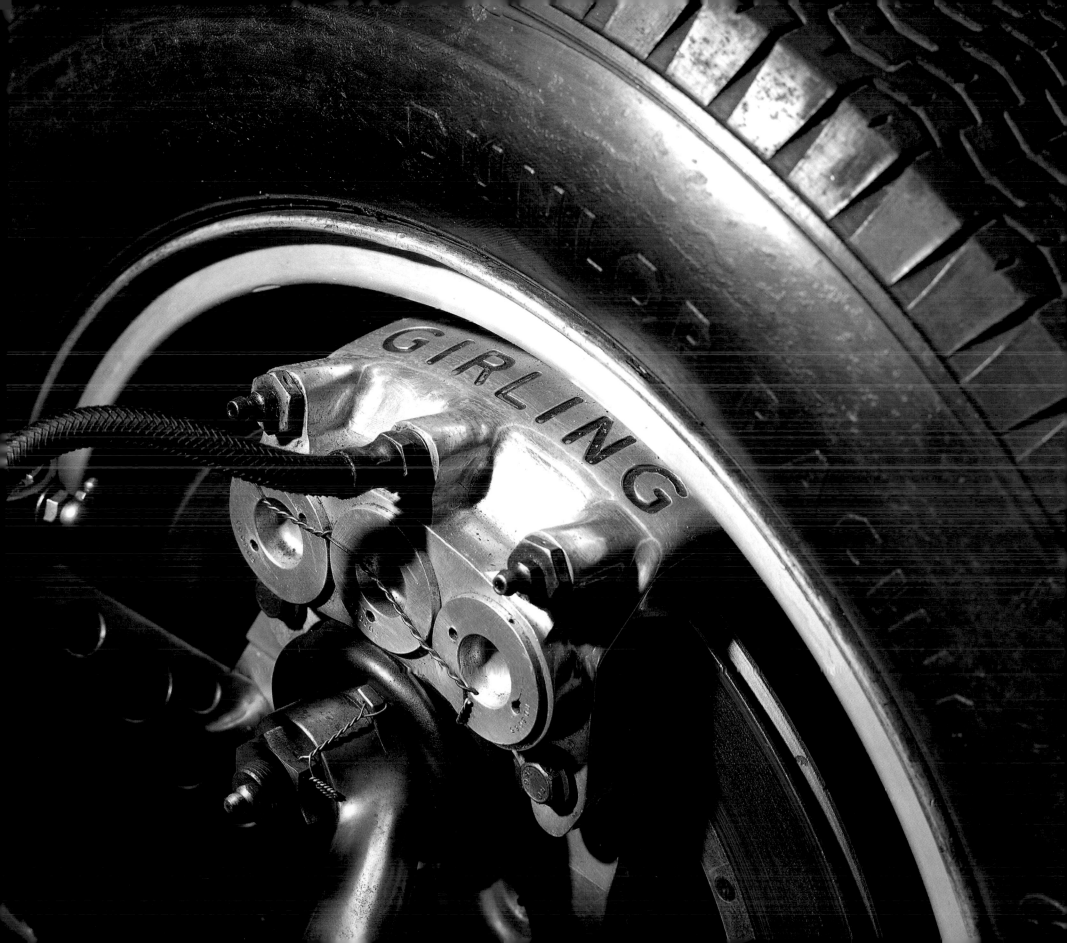

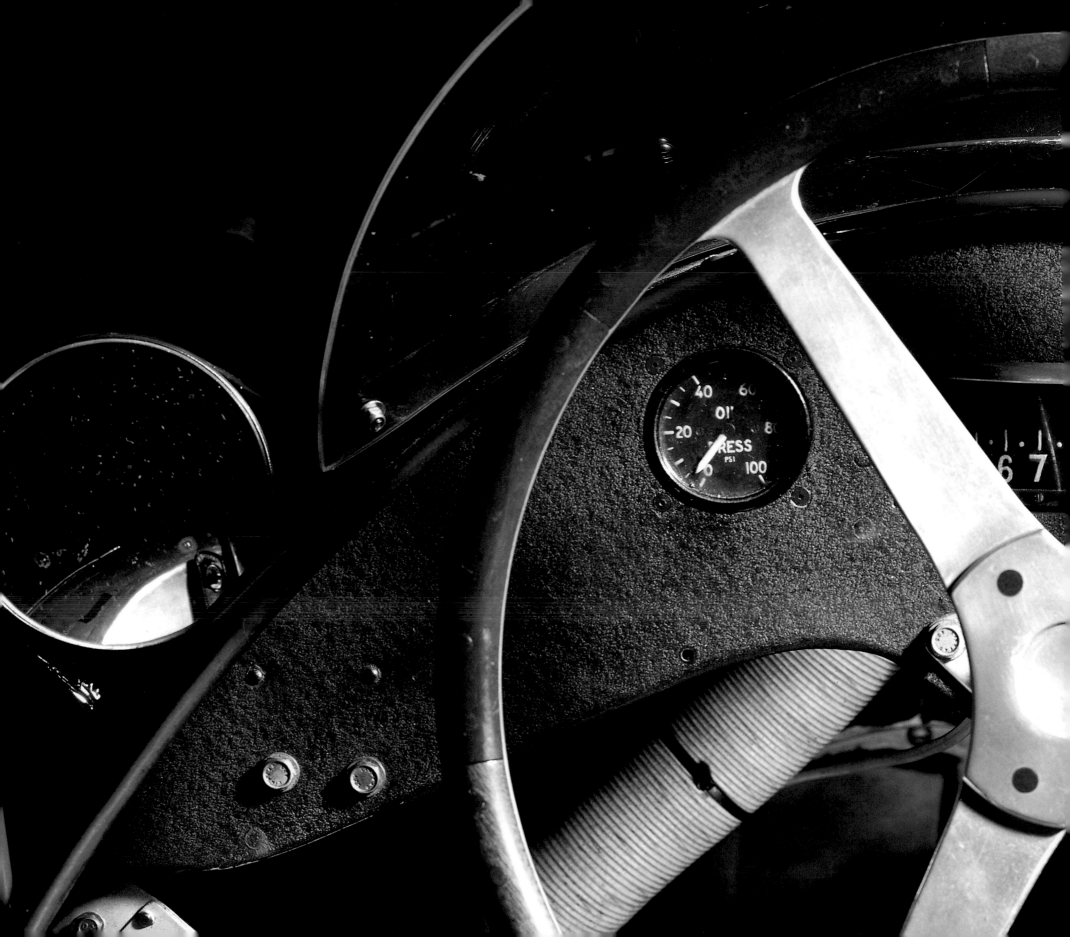

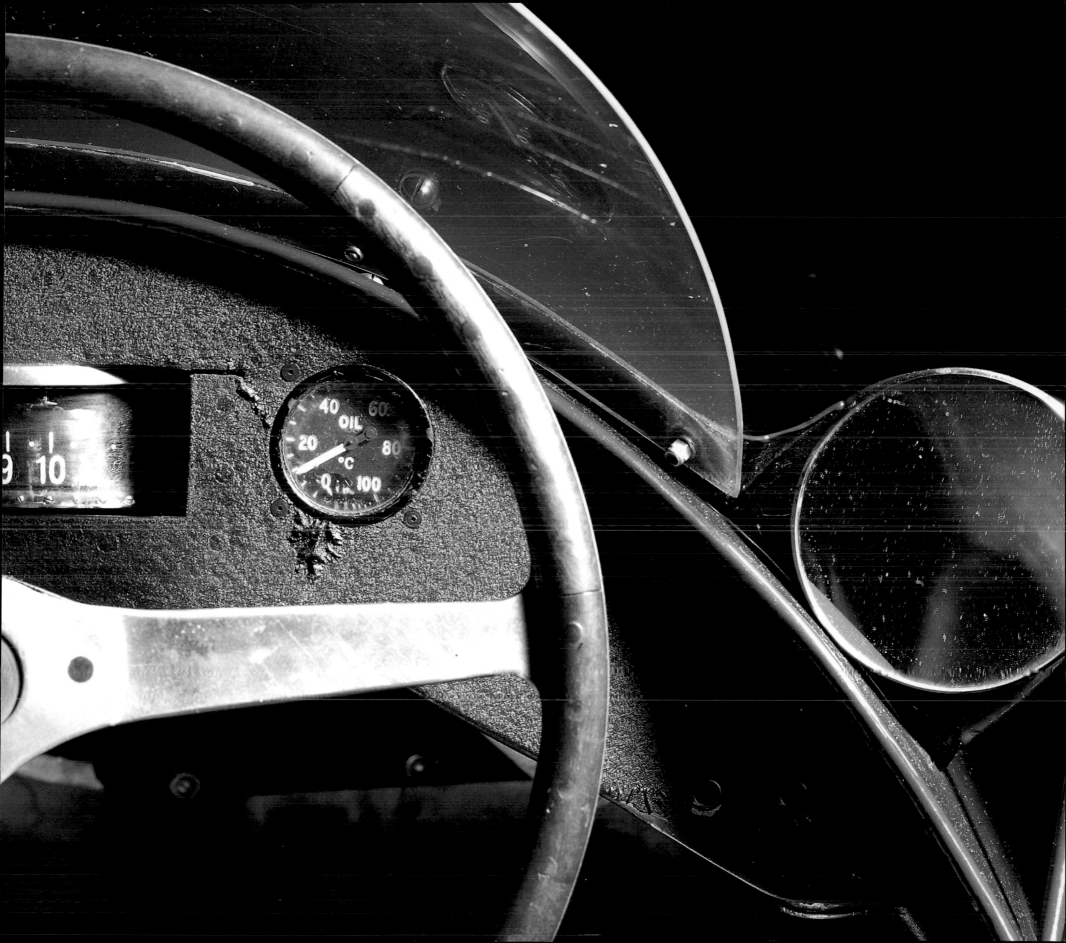

Chrysler New Yorker (1950) USA This interesting Town and Country estate version came at the top of the New Yorker price range, and provided one of the last examples of wooden craftsmanship to embellish bodywork with unusual and impressive lines – many subsequently used wooden strips on metal panels to create a similar effect. Combining the practical aspects of a hatchback station-wagon with the flowing lines of a sedan, it boasted all the traditional carpenter's methods in its construction. The dashboard displays the care that Chrysler took

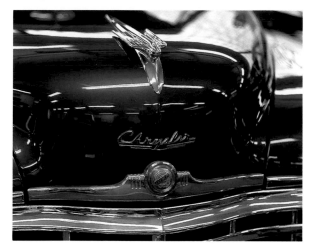

in designing a panel that combined novel presentation and sound ergonomics; thus the instruments are all in the large hooded binnacle in front of the driver, with the semi-circular speedometer ringed by the minor gauges. Lesser controls are still within reach behind the steering column auto transmission gear-change; switches for lighting, wipers, washers and panel lights are just to the right while the radio, with the tuning scale separated from the controls, is set in the chromed surround that extends over to the passenger, for whom an ashtray with internal cigar lighter is provided. Just below the radio, and still within easy driver reach, are the heater and de-mister controls. The steering wheel, all knobs and lever ends, including that for a scuttle vent, are made in amber-coloured Xylonite, the hard 'plastic' which the American auto industry's design studios pioneered to provide colour to their interiors. With contrasting wood panels between the solid ash main members, all varnished to enhance the grain, this 'woodie' was a smart dual-purpose automobile combining new-world craftsmanship and modern styling with plenty of honest Detroit power.

This page: Set in heavy Fifties chromium plate is the original Chrysler badge with period script above on the 1949 model.

Opposite: The Town and Country used quality wood and carpentry – note the mitred joint.

Overleaf: On the 1948 Town and Country model all the minor gauges are placed around the large semi-circular speedometer under the hooded

binnacle straight in front of the driver – an impressive example of early ergonomics borrowed from the racing world.

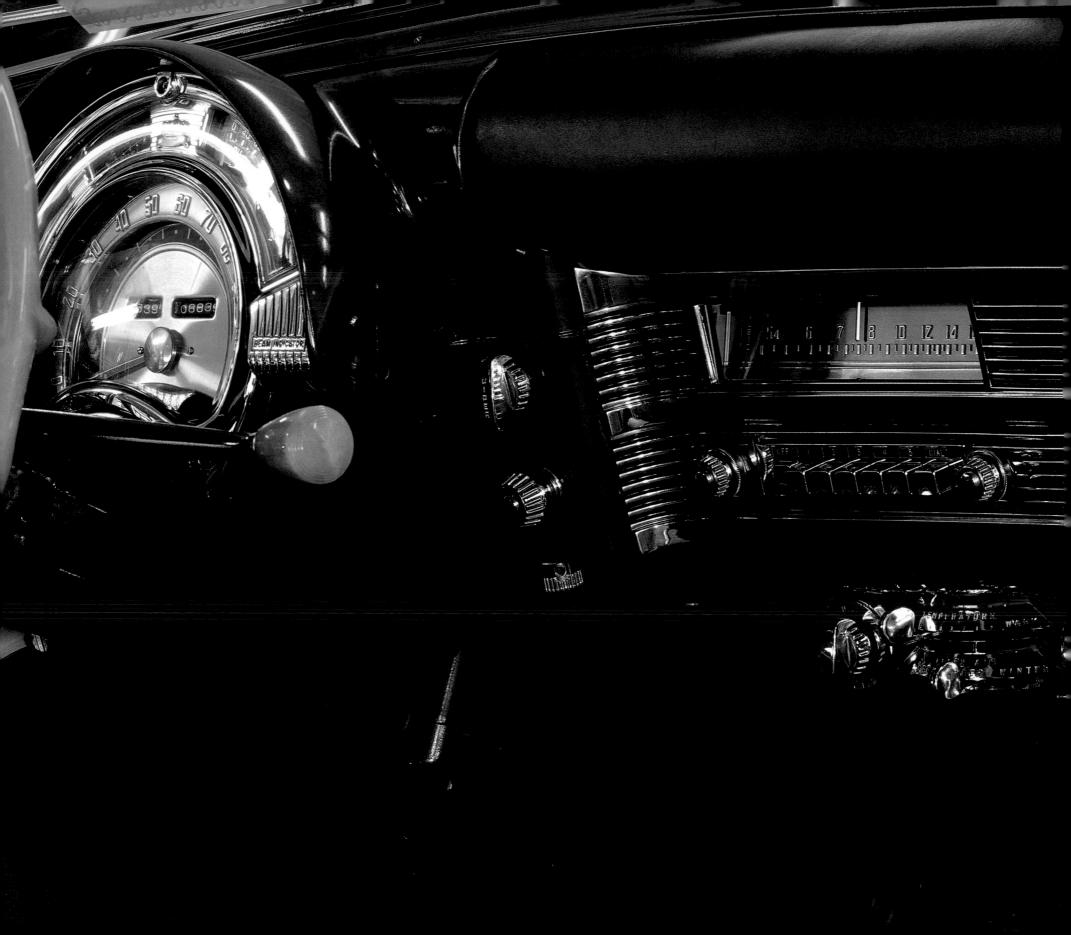

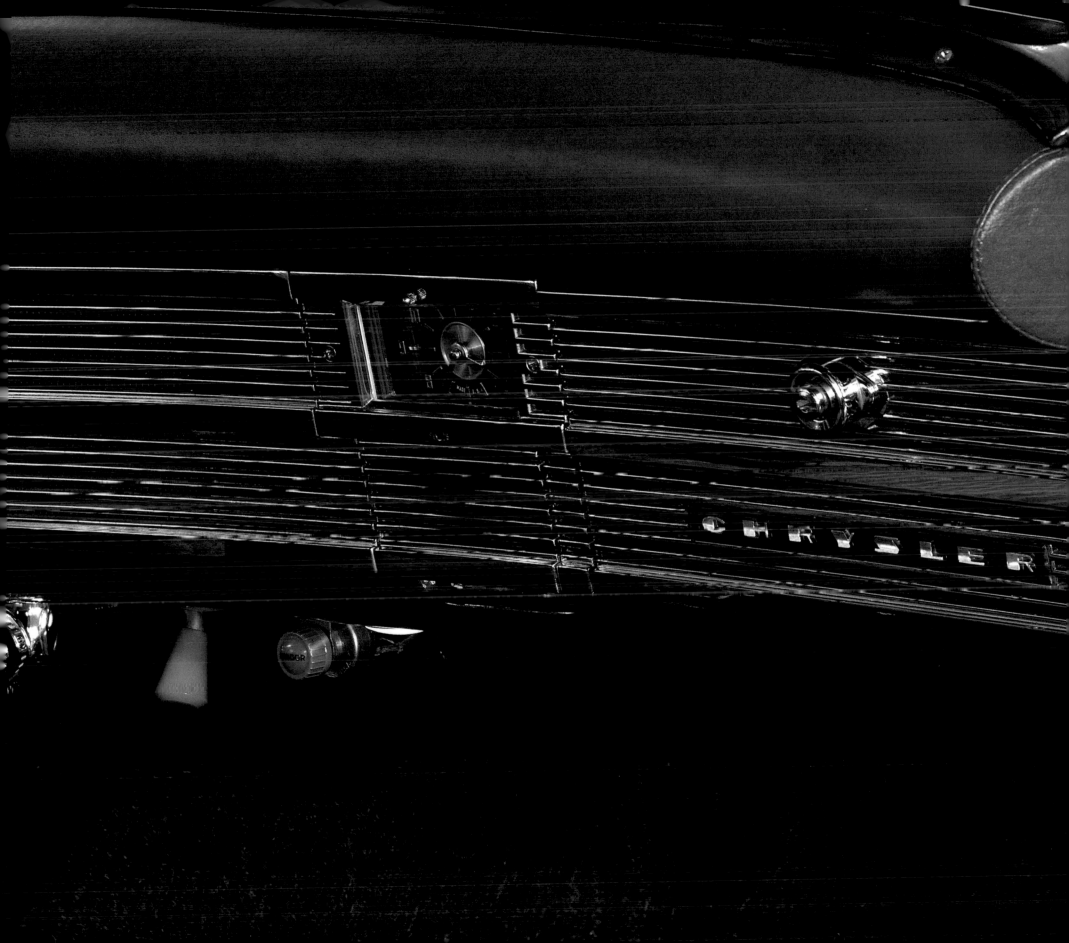

Cooper 500 (1950) GB When racing started again after the war, a new low-cost formula was launched for racing cars with engines limited to 500 cc, usually motorcycle units. The Cooper succeeded by having all-round independent suspension for its light and well-balanced chassis; fitted with either the tuneable push-rod JAP engine, or the more expensive but stronger Norton overhead camshaft unit, it took most of the prizes around the European circuits, except when it was up against the Kieft driven by Stirling Moss. Using methanol fuel, these little engines developed up to 50 bhp which, as with motorcycles, was transmitted to the rear wheels by chain.

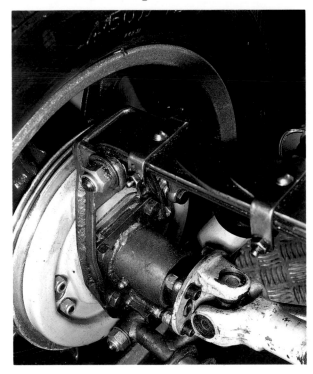

The whole car was neatly proportioned and, with the engine in the rear, allowed good visibility and enough room even for a tall driver within its short wheelbase. Cooper made their own steering wheel with a leather rim on a three-spoked alloy frame set behind the wind-cheating perspex screen. The single instrument was the tachometer, with a tell-tale needle for the cynical mechanic to see the engine revs actually used, and a single on-off switch for the magneto ignition – marking tape is a modern requirement to guide race marshals in the event of an accident. Motorcycle engines didn't have starter gears, so manpower replaced the starter button. The whole car only weighed around 590lb ready to race, lightweight wood being used for the gear and hand-brake levers, for example. With the wheels in sight outside the ultra-short bonnet, it was possible to place the car extremely accurately, and they provided very close racing.

This page: Light and simple, the independent rear suspension used a transverse leaf spring.

Opposite: Cooper had their own wheels cast in magnesium alloy for ultimate lightness.

Overleaf: Behind Cooper's leather-rimmed wheel there is just a rev counter and a magneto switch for the JAP V-twin, all that was necessary in this racing lightweight.

Jaguar XK120 (1950) GB This is the sports car that shook the early post-war world, generating admiration from Los Angeles to Turin; it set a bench-mark for post-war design with its timeless, beautiful lines and superior, but refined, performance from the magnificent XK engine. William Lyons' pre-war agreement with aircraft engine manufacturer Armstrong-Siddeley had allowed him to use the Jaguar name. With its registration number, NUB 120, this is an XK with a difference; the Brown's Lane factory built it for Ian Appleyard, scion of an established Yorkshire motor trade family, who pursued both a successful international rallying career and the boss's daughter, Pat Lyons. Driven by Ian and Pat Appleyard, NUB 120 won rallies throughout Europe, gaining much acclaim for the Jaguar name. Many more British manufacturers would follow Jaguar into the rallying scene. Jaguar's museum staff have kept the car in its original state, so its dashboard gives an interesting insight into the period rally scene; there were deliberately very few alterations

to the standard specification, as Lyons sought to maintain the appearance of the catalogued model as far as possible. The standard dash was already well equipped, so the instruments and the Jaguar-badged four-spoke steering wheel, with pronounced finger ridges on the back of the rim, are from the production model; the speedometer is appropriately calibrated in kilometres for continental use. On the left, a Halda 'Speed Pilot', virtually obligatory for the serious rallyist, marked the sole departure from standard specification, but it was enough to bring considerable success to this highly professional team in their brilliant career together.

This page: The elegant V-windscreen held the soft-top with simple catches at its top corners. On the back is a luggage rack.

Opposite: The rally plate is the proud mark of a successful competition career. Headlamp stone-guards were vital with the rough roads used on such an event as the Alpine rally.

Overleaf: Jaguar's comprehensive instrument panel could be hinged down for access. The only non-standard item is the Halda unit – a pair of identical split-hand stop-watches, necessary when one timed stage follows immediately after another.

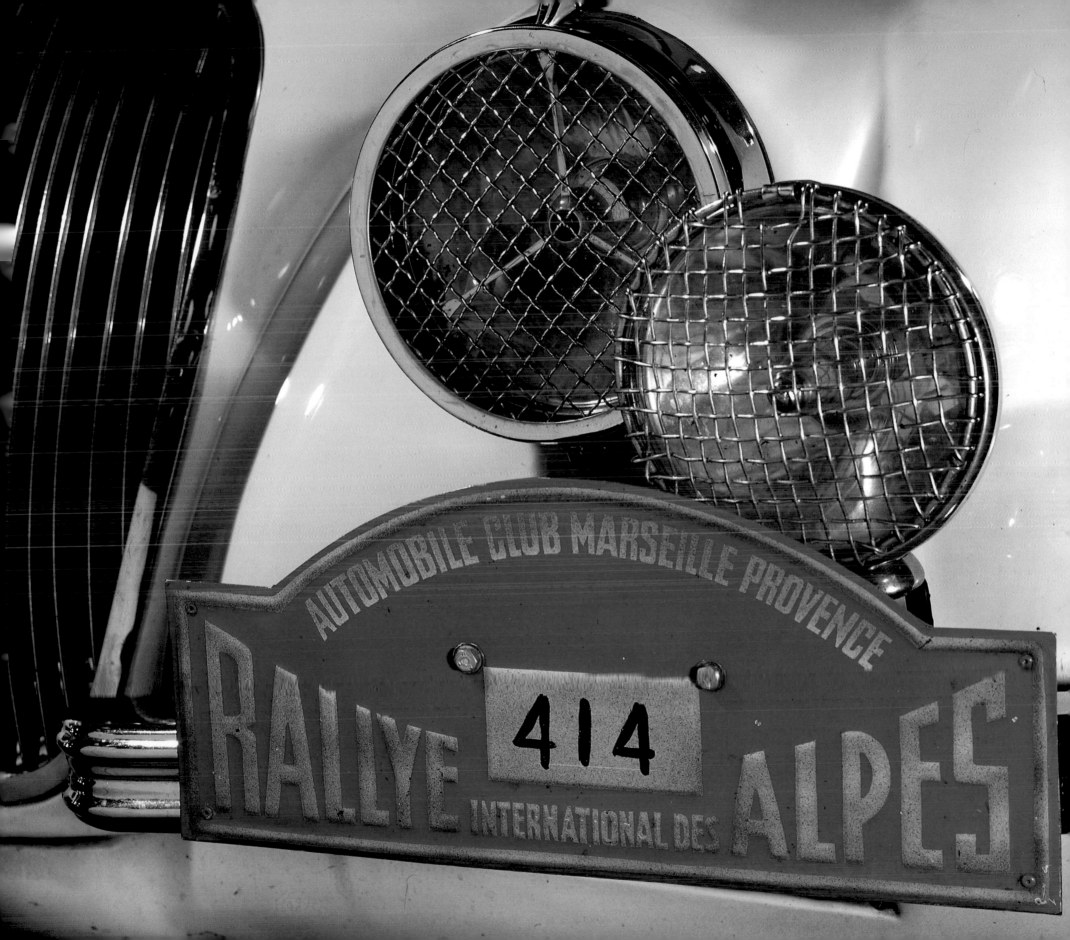

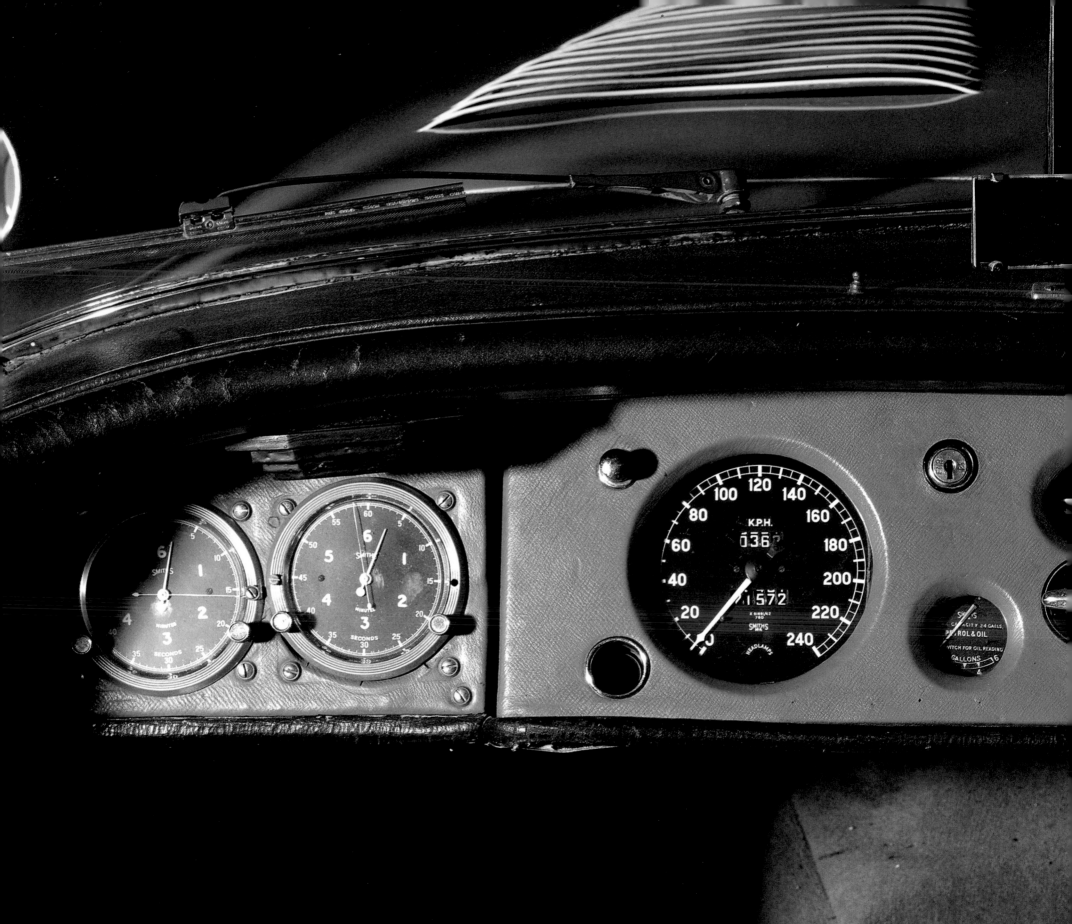

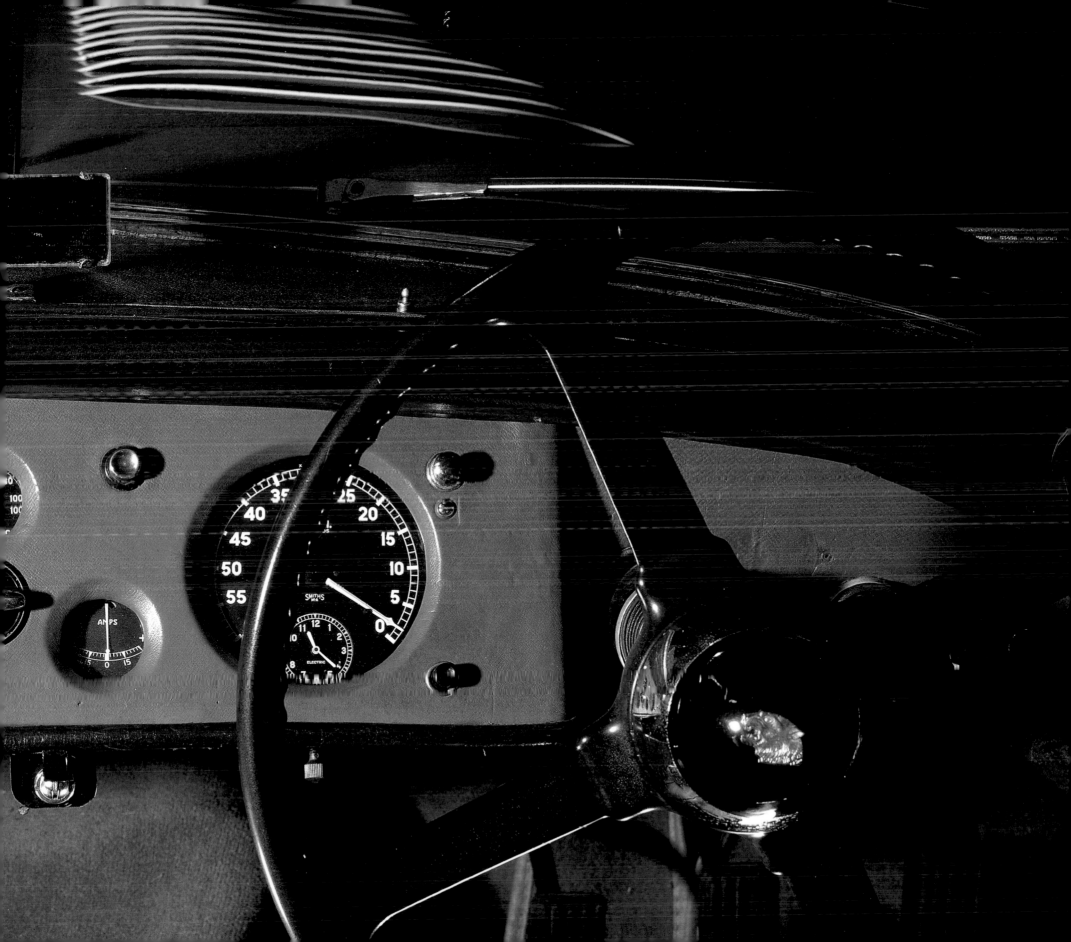

Buick Le Sabre (1951) USA Harley Earl, General Motors' celebrated stylist, created the Buick Le Sabre at a time when all the leading US car makers were experimenting with new shapes and new concepts in automobile design. Some of these 'dream cars' were just glamorous skins over well-tried chassis; others, like Le Sabre, were commissioned by more adventurous companies to demonstrate forward thinking in novel details under brand new styling themes, with budgets to match. Beautifully crafted, Le Sabre reflected all of Earl's aspirations in a visual tour de force

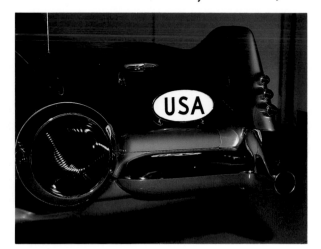

of grand proportions, raising 'dream cars' to a new art form. Although it remained undeveloped and uncopied in its original form, Le Sabre was to remain as an inspiration to another generation of stylists, and some of its innovations sired elements of later Buick production. The dashboard mirrored Harley Earl's personal love of exciting automobiles. Dominant is a large circular console, containing a battery of gauges and switches, surrounding the steering column. In the middle of the dash itself is a 10,000-ft altimeter flanked by gauges for manifold vacuum, fuel level, alcohol level and pressure (Earl fancied methanol injection) and a small rectangular mileometer. Surprisingly there was no speedometer – a tachometer sufficed, mounted on its own below the main panel. For the trendsetting GM Dynaflow automatic transmission, there is a modest selector lever to the left of the wheel; the two large pedals are marked 'Brake' and, somewhat whimsically, 'Power'. For all the extravagance of its sheer size, and the sweeping expanse of its voluptuous panels, Le Sabre was a car to be enjoyed for its dynamic performance; Harley Earl did that on many occasions.

This page: The finny tail has a single central stop light; exhausts exit through each end of the bumper.

Opposite: Two grilles of contrasting shapes sit between pairs of slanted headlights.

Overleaf: Any instrument you could ever want, and a few more, for Harley Earl – notably altimeter, contents and pressure gauge for methanol injection – but no speedometer. Unusual is 'Power' on the accelerator.

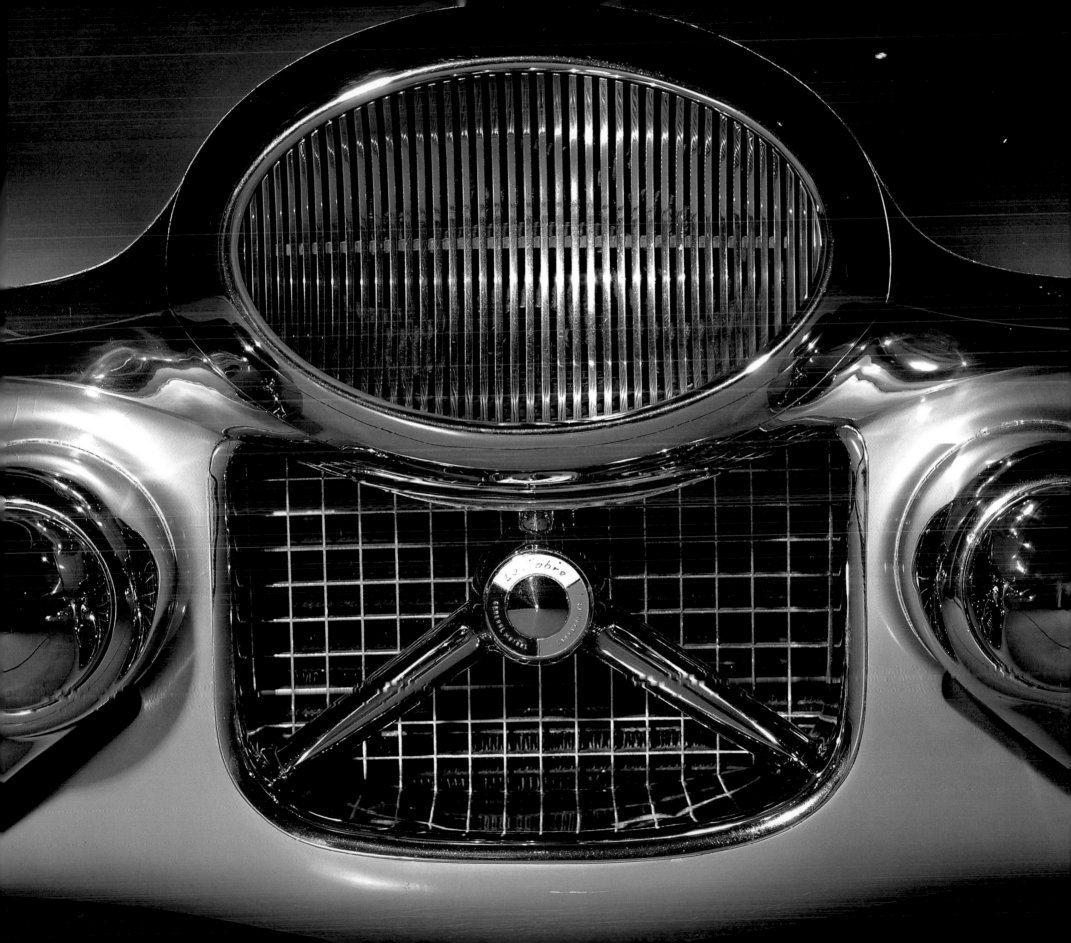

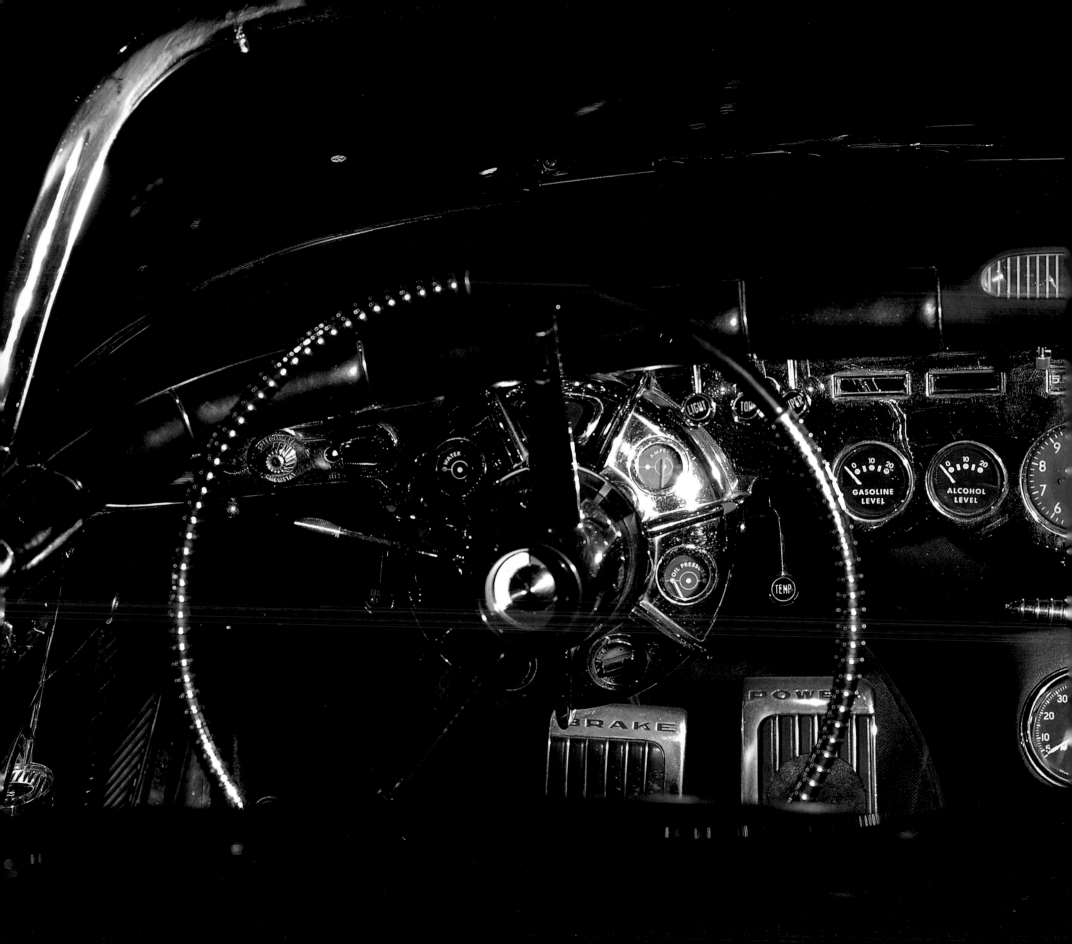

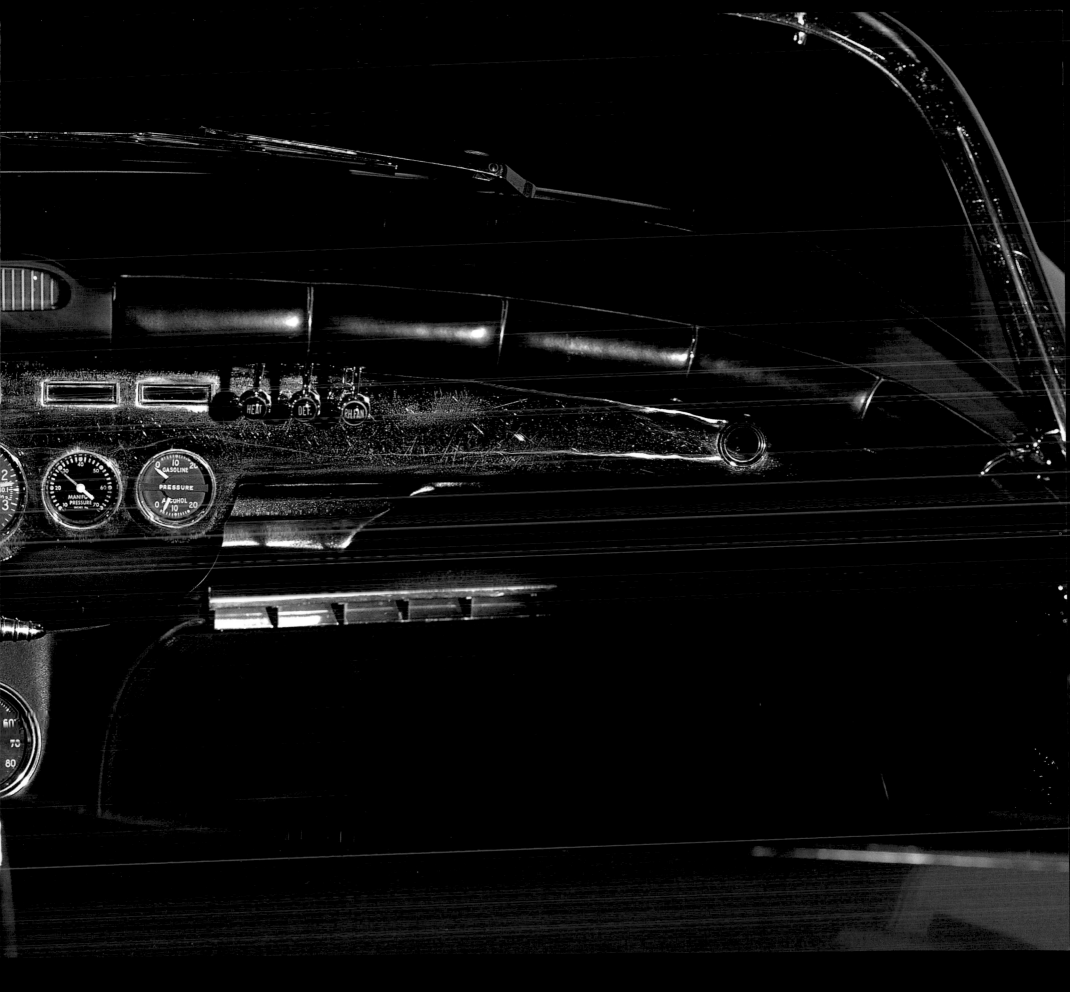

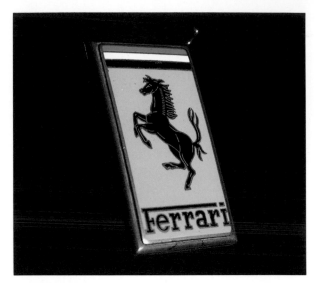

Ferrari 212 Inter (1952) Italy Common though it may be in Italy, the name Ferrari everywhere means speed, glamour, excitement and automobile artistry, coupled with the thrilling sound of twelve cylinders and the vision of vivid red sports-racing cars displaying the prancing horse badge – the product of Enzo Ferrari's connection with the Great War air-ace who inspired him in his career. This Vignale-bodied convertible is an early 2½-litre Tipo 212, built five years into Ferrari's post-war Modena operation. Painted in body colour, the metal dashboard is dominated, like most sporting Italian cars at the time, by two large dials – a 240 kph speedometer and an 8,000 rpm tachometer, red-lined at 6,500 rpm. Within both are lesser gauges for oil pressure, water temperature, fuel contents and a clock with small warning lights for dynamo charge, oil pressure and direction indicators, not universal in the period. The steering wheel could have come from a racing car, with its slim riveted wooden rim and the famous badge on the centre boss. One of Vignale's individualistic touches is shown in the deep red Xylonite used on the indicator stalk and gear-lever (with its tiny reverse gear detent button) as well as in window winders and door handles. The dark glass sun visors, very useful against low sunlight, can move over a large arc to be used as auxiliary windscreens. Just above the fresh-air grille and to the right of the lockable glove-box, the St Christopher badge reminds us that we are all mortal, even – or particularly – when driving such a dream on wheels as this classic Ferrari.

This page: The famous prancing horse showing the Italian colours at the top.

Opposite: Vignale liked the Xylonite-type material used here in window winder and sliding door handle.

Overleaf: The painted metal facia contains just two Jaeger dials, speedometer and rev counter, each with smaller

gauges and warning lights inset. The switches were originally unidentified but have modern indication.

Dark glass visors are useful in low sunlight. Note also the red Xylonite gear-lever knob.

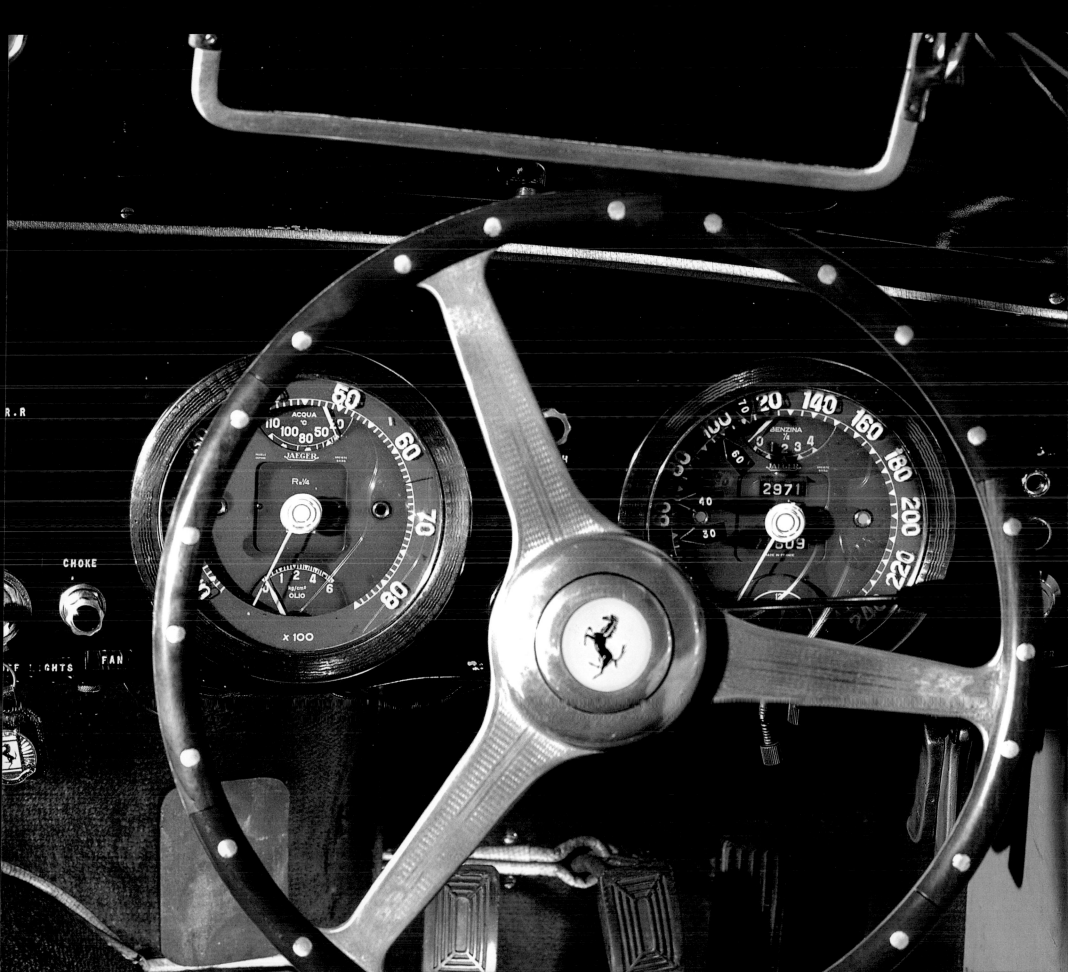

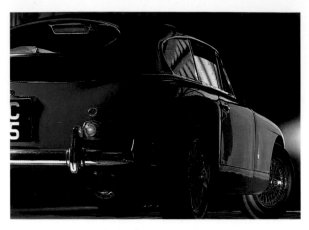

Aston Martin DB2/4 (1953) GB Having bought Aston Martin just after the Second World War, David Brown took the best from his subsequent acquisition of Lagonda to make a range of sporting Grand Tourers that would challenge the world. From Lagonda came the 2.6-litre straight-6 twin-cam engine, and gifted body designer Frank Feeley; from Aston Martin came the design fruits of many years of sporting competition. The result was the two-seater DB2. In adding a second row of seats for the DB2/4 with an opening rear door, Aston Martin pre-dated the 'hatchback' without affecting the model's 120 mph performance. Pre-war Aston Martins were essentially sports cars. Lagonda experience in producing sporting carriages for the connoisseur was used to good effect in the interior appointments. The DB's dashboard had to provide every bit of needed or desired information to the keen driver in as elegant a layout as one would expect from the Feltham craftsmen. Symmetrically laid out, instruments and controls were contained in the four 'dials'. Of full size are the 140 mph speedometer and 6,000 rpm tachometer; four instruments are squeezed into a third – ammeter, oil pressure, water temperature and fuel level, the latter becoming an oil level gauge at the press of a button. The final 'dial' contains various switches and the ignition key – naturally there is a separate starter button. Along the bottom of the dash are more switches with tell-tale lights – interior light, under-bonnet light, dash and map-reading lights – and a fuel reserve which gave a useful three gallons. In addition, and very up-to-date, there was a two-speed wiper switch and a windscreen washer button. Even now, forty years on, you could expect nothing more complete than this.

This page: Black and dark blue were the racing colours of the first owner, Earl Howe.

The DB2/4 was arguably the first coupé with an opening rear window, or hatchback.

Opposite: Lucas headlights form part of the strong Aston Martin face that carries through to the present day.

Overleaf: This night picture shows how effective is the instrument lighting for this very comprehensive dashboard,

which is as delightful for its symmetry as its clarity. The radio was a factory-fitted option.

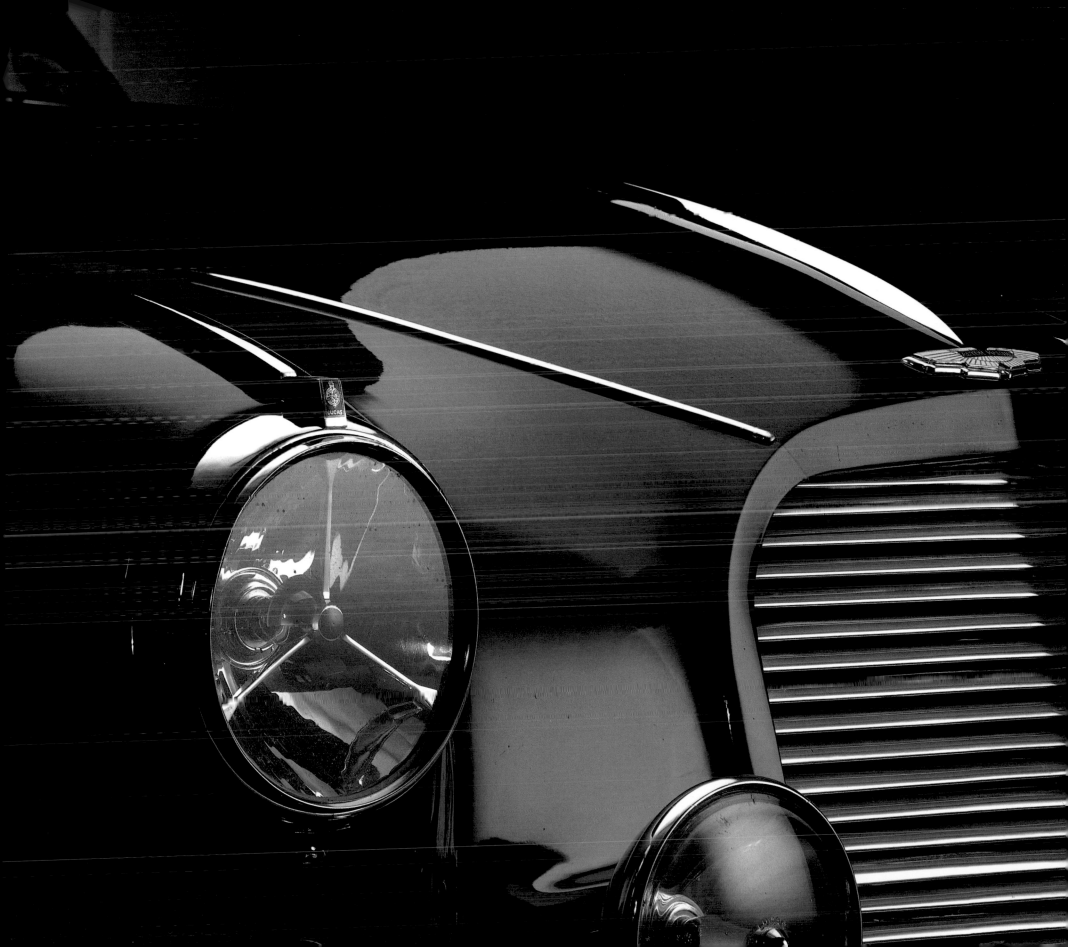

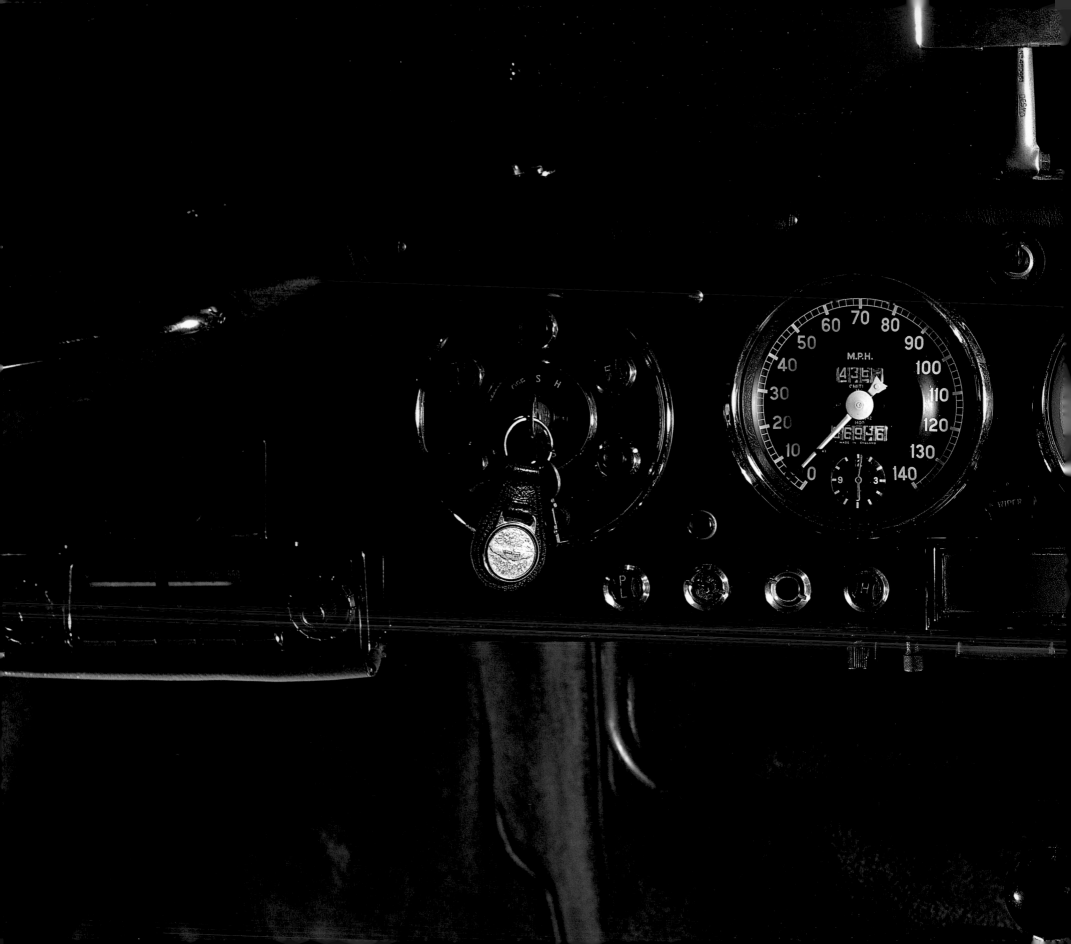

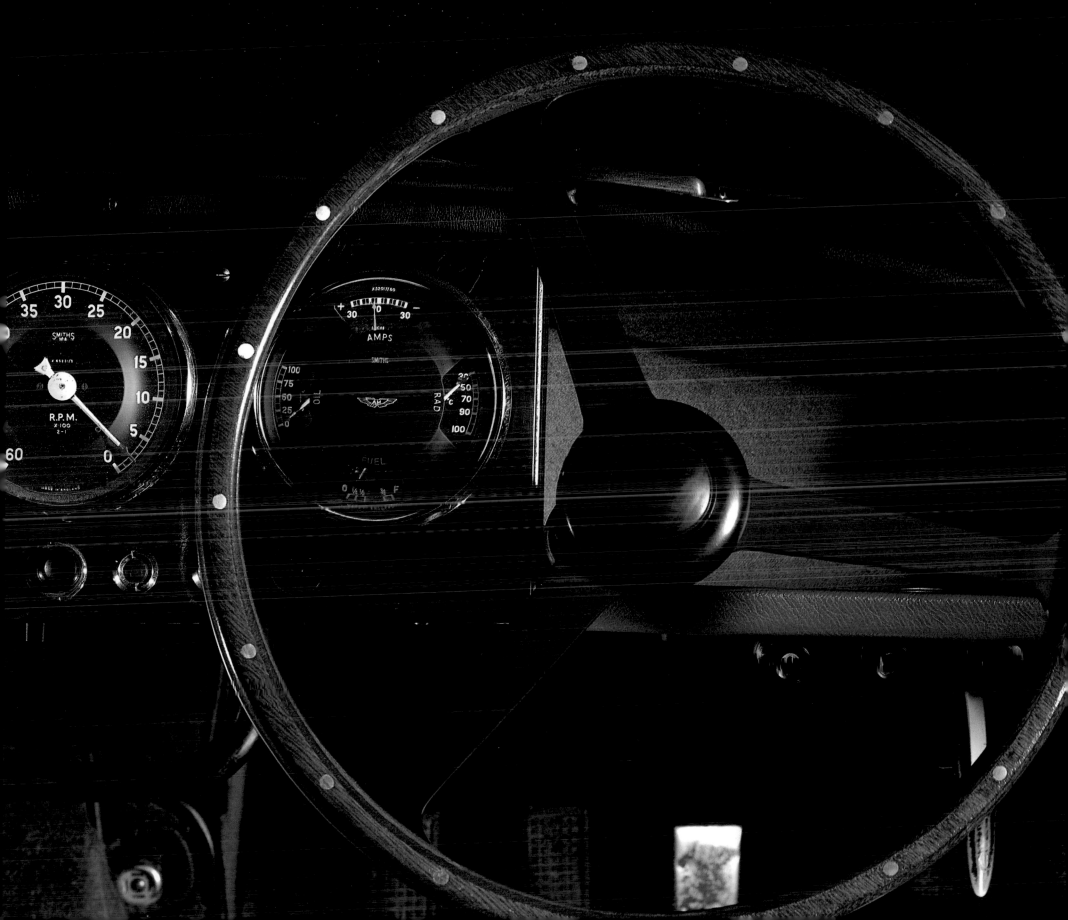

Chevrolet Corvette (1955) USA Zora Arkus-Duntov was the gifted engineer who translated his love of performance into the sporting cars that General Motors produced in the adventurous Fifties to meet young America's quest for home-bred speed and glamour. With the Corvette, he succeeded in combining many attributes in a classic package which stands out now as a true milestone design. Its use of glass-fibre body panels for high volume production was an automotive first. Powerful and nimble with a neat attention to detail, the Corvette had a rounded style that appealed to all, although few were exported. Its cockpit is attractive and practical; the large semi-circular speedometer is matched by a similarly shaped radio speaker on the opposite side, to give a hint of twin racing cowls. On top of the column, a brake warning light is inset within the plastic moulding. Other instruments are scattered across the facia, each with its own 'bulge' on the bottom of the panel. The steering wheel centre emblem of crossed flags reflects the racing heritage, while the automatic transmission is controlled, unusually

for the period, by a small vertical lever nestling by the side of the driver's seat squab. The restrained tail treatment with its twin styled exhaust pipes also shows the embryonic tail-fins beloved by automobile stylists at the time, a fashion future Corvettes did not follow. The neat wrap-round screen was a period General Motors hallmark, although its chrome bright-work could be a nuisance in the sun. A fine example of American automobile art, the Corvette was the country's one and only answer to the European sports car.

This page: Headlight stone guards were a standard feature of the Corvette's first style.

Opposite: Vestigial tail-fins pandered to period style, but were dropped for the 1956 model.

Overleaf: Total symmetry of shapes matches the speedometer with the passenger's speaker for the standard radio; the tachometer in the centre incorporates an unusual revolution counter.

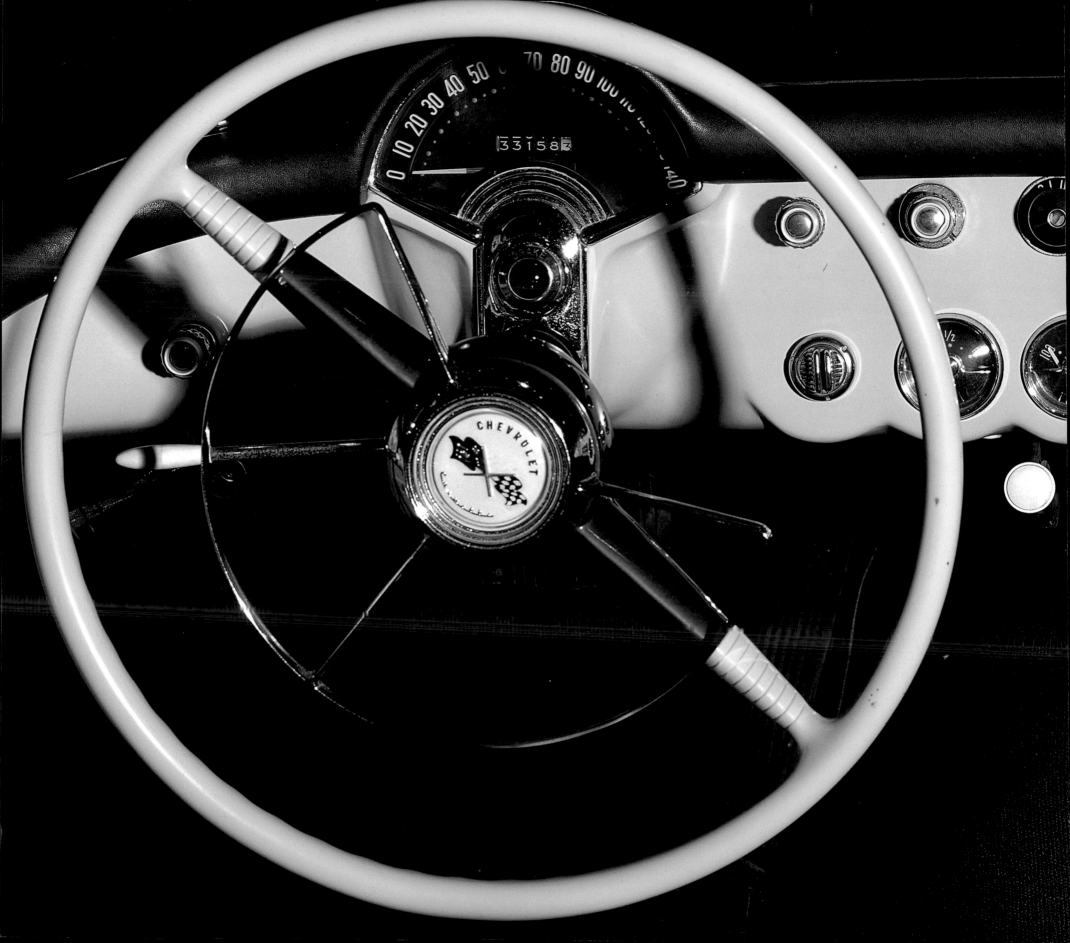

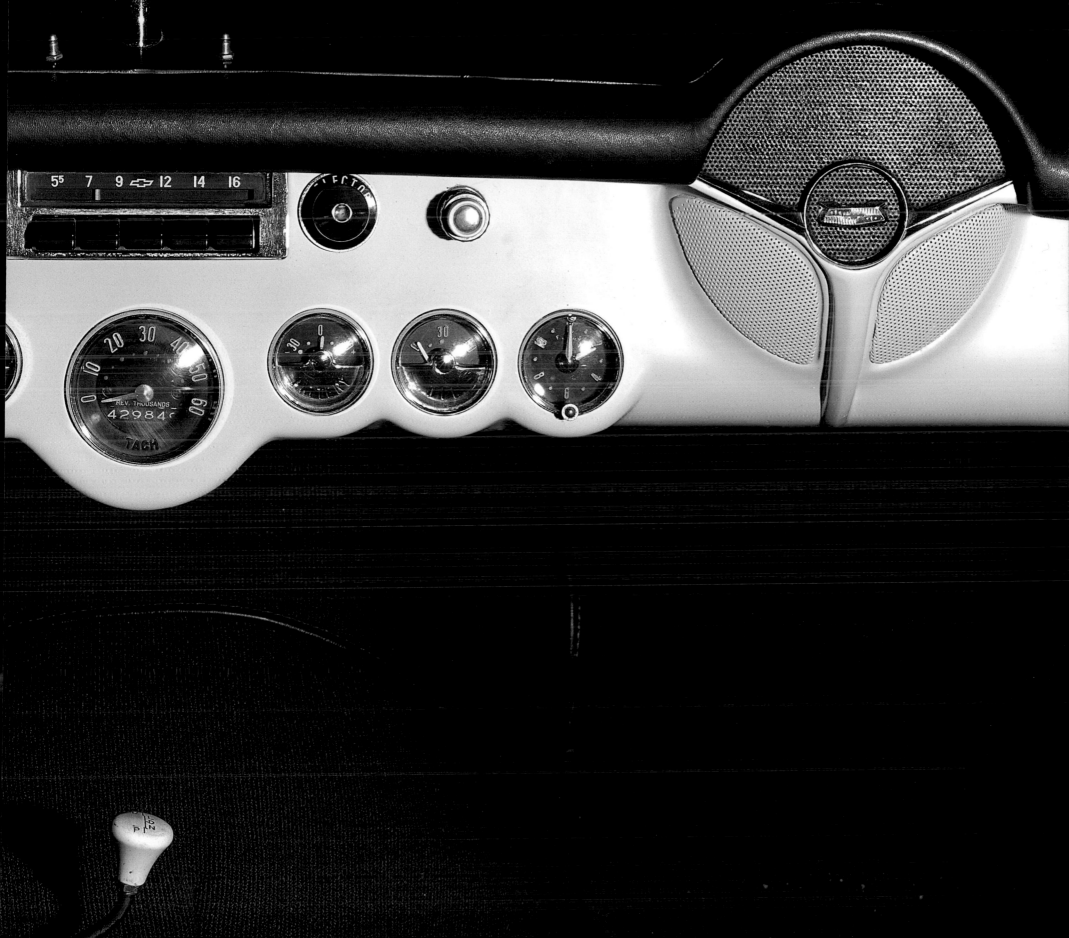

Jaguar Mk VIIM (1955) GB With the XK120 sports car design completed, Jaguar set out to replace the rest of their basically pre-war range. Applying all his innate skill and eye for line, William Lyons created the five-seater Mk VII; imposingly styled, sumptuously comfortable, comprehensively equipped, it was also very fast for 1950 with 160 bhp from the 3.4-litre XK engine. And its selling price astounded rivals whose sales were left trailing in its wake – Bentley

appearance, outside and in, at a little over one-third of the price. The dashboard well reflects Lyons' ability to know how to please his customers. A full complement of handsome white on black instruments and elegant switchgear is set on a hinged central panel, good for left- or right-hand drive, among acres of shiny wood veneer. Less common dash details for that time include a changeover switch for the twin fuel tanks, a clock set in the glove locker lid, twin map reading lights, a warning light for brake fluid and the handbrake, and a handle to wind up the aerial for the standard radio. Unique is the rheostat-controlled indirect infra-red instrument lighting which imparts a blue glow to the dials. With a telescopic section in the column, the typically Jaguar four-spoked steering wheel can be adjusted for reach. Our example is a manual transmission Mk VIIM which incorporated body detail changes and a more powerful engine with 190 bhp. The opulence exuded by the veneered dash was endorsed by the wide expanses of soft leather and real carpet. Grace, space and pace was the apt Jaguar advertising slogan. It was also incredible value for money.

This page: The wheel hub-plate carries vestigial 'ears' that simulate the knock-on hubcaps of earlier wire-wheeled Jaguars.

Opposite: Lucas inserted the 'J' into their headlights. The leaping cat was stylized on this model.

Overleaf: Night driver's view of the Mk VIIM dash shows the instruments uniquely lit by infra-red technology. The central panel hinges down for access to the wiring behind.

Lancia Aurelia B20 GT (1955) Italy In days before ergonomic standardization, dashboards would generally reflect nationality; Italian ones were often quite distinct from those of other countries. Lancia, certainly, applied styling and form to all their dash design, extending this to their steering wheels and minor controls. Always technically interesting, often advanced, Lancia models only joined the competition scene after the last war with Fifties victories in Targa Florio, 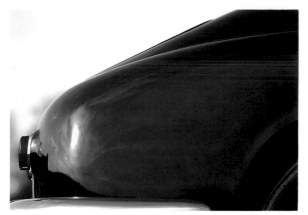 Mille Miglia and Carrera Panamericana. The Aurelia, designed by Vittorio Jano and the founder's son Gianni Lancia, had a superb 1,754 cc V-6, later enlarged up to 2½ litres for this GT version, set in a complex all-independently sprung chassis with huge alloy brakes under an elegantly smooth body in the best Italian tradition. At first sight, the dashboard looks almost utilitarian, but actually has a full range of information and control within its neat and symmetrical form. The large speedometer and tachometer contain subsidiary gauges for oil pressure, coolant temperature, ammeter and hand-throttle warning, and main or auxiliary lights. A row of push-pull switches operates wipers, washers, pass-lamps and lights for dash and interior; small levers below the dash control mixture and throttle settings, and ventilation. Like many grandes marques, Lancia chose right-hand-drive, despite the European rule of the road, until the mid-1950s. This Aurelia has the factory-fitted Nardi wood-rim steering wheel and Nardi's floor-change conversion from the standard steering-column gear lever. Nardi also provided the special inlet manifold with twin Dell'Orto carburettors. Its first owner was competition minded; the model clocked an impressive list of race and rally successes.

This page: Pininfarina's elegant fast-back shape gave GT style to this sporting four-seater saloon.

Opposite: Once proudly independent, Lancia's flag emblem now waves for the FIAT group.

Overleaf: Two Jaeger dials, Italian style, have inset lesser gauges and warning lights. Unlabelled switchgear requires

familiarity. Nardi provided many sporting extras for factory fitment including this wood-rim wheel.

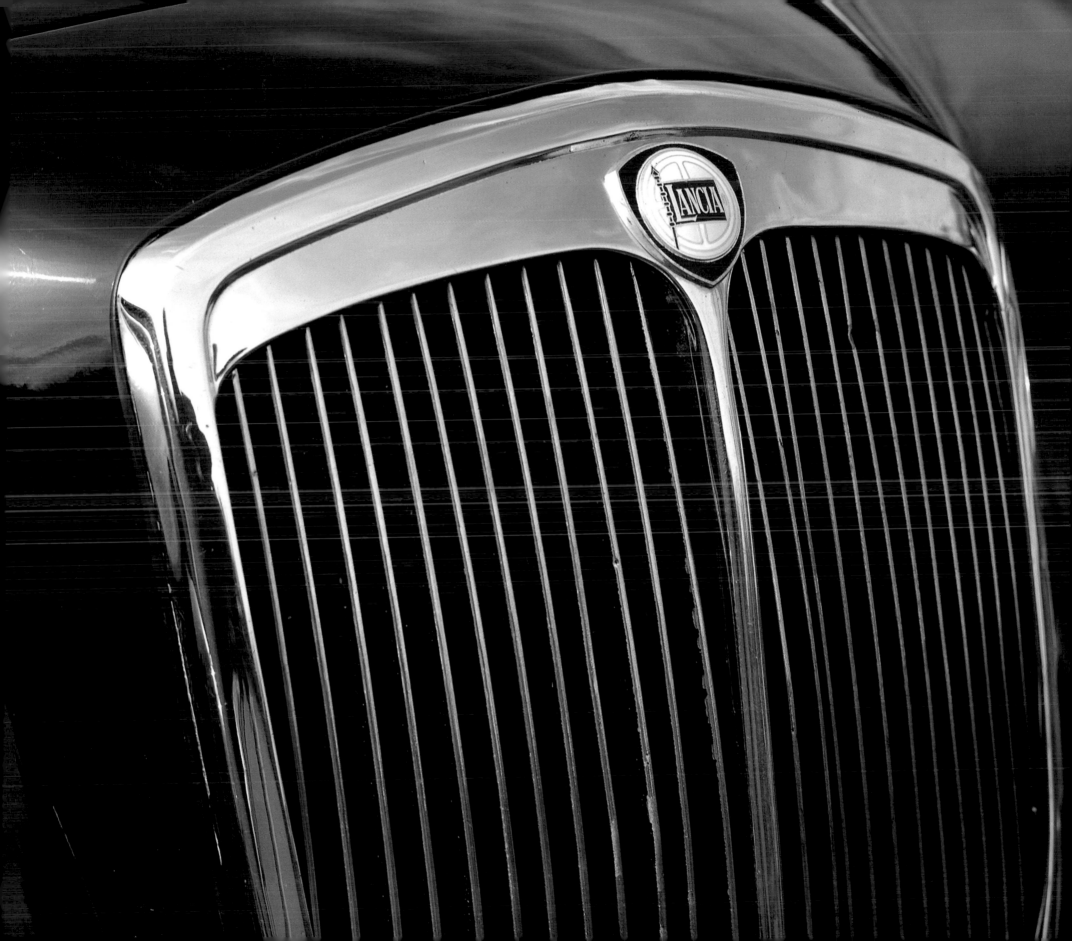

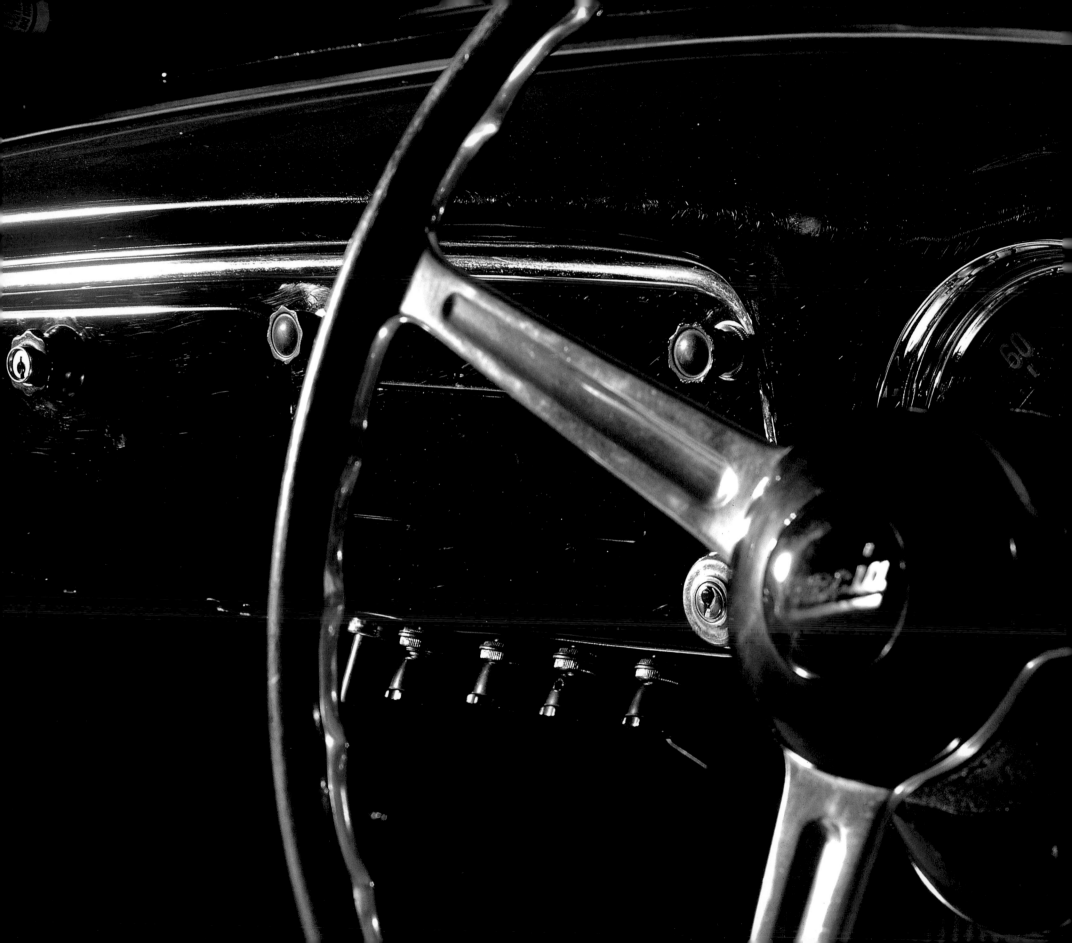

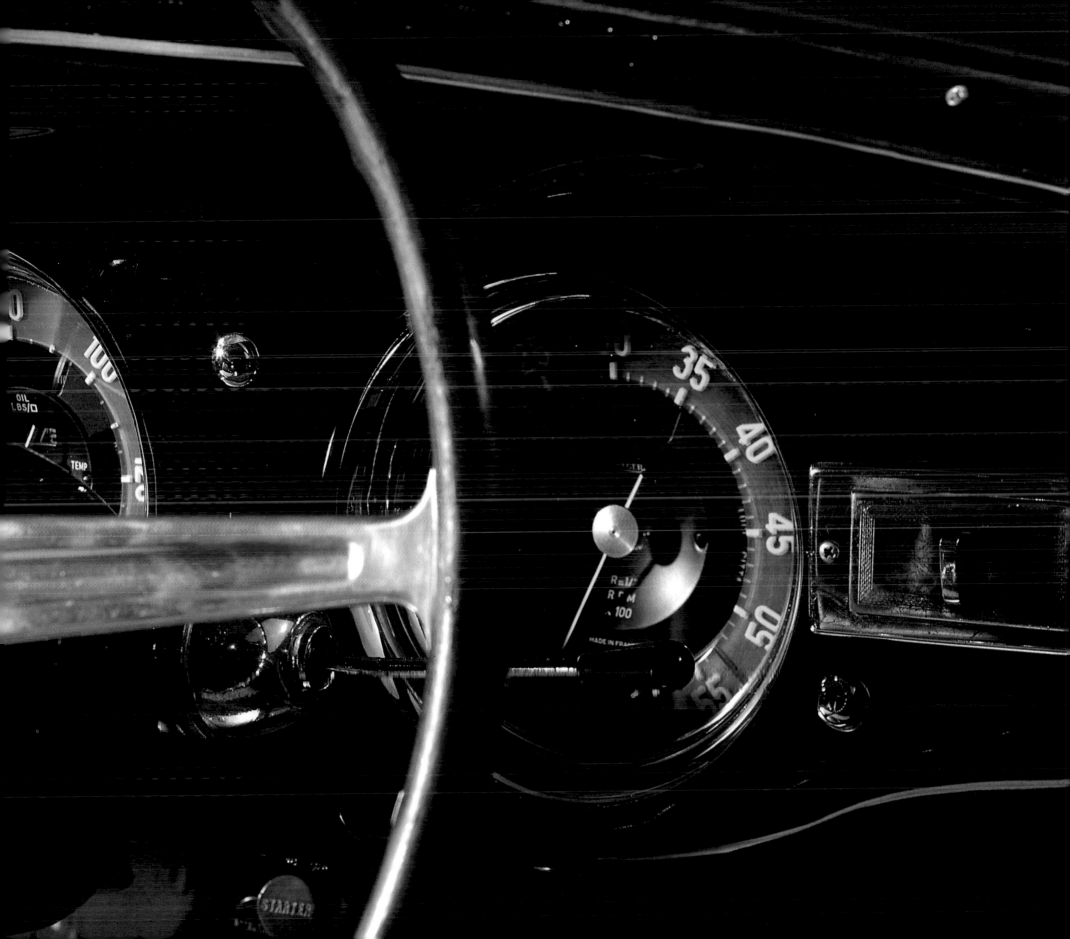

Mercedes-Benz 300SLR (1955) Germany After their post-war return to international competition with the success of the 300SL coupé in winning both Le Mans and the Mexican Carrera Panamericana in 1952, Mercedes-Benz entered the mid-Fifties with a determination to wrest honours from all in both Grand Prix and sports-car racing, and did just that. The 300SLR

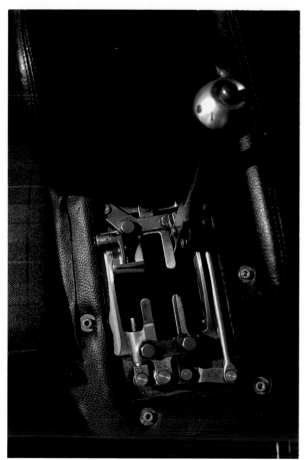

– Sport, Leicht, Rennwagen – was their sports-racing challenger. This car was built for the 1955 Mille Miglia, which the marque won in convincing record-breaking fashion in the hands of Stirling Moss, navigated by former side-car champion and journalist Denis Jenkinson. They had practised the 1,000-mile course several times and compiled a comprehensive set of notes onto a continuous roll of paper that Jenkinson had to read and then make appropriate hand-signals to Moss. Such was their mutual faith that Moss took one hump-backed bridge at 170 mph, flying through the air to land a hundred feet later, confident that the road was straight. So win they did, at 98 mph on public roads. Functional design and tool-room disciplines show at every point in the cockpit; there are just three instruments, two switches, and warning lights set into a single-seater-style dash panel behind the wood-rimmed steering wheel. The gear-lever in the centre sits in an open gate with its complex lock-out mechanisms visible; it was very much an engineer's car. 'The 300SLR was built like a tank, but had the responsiveness of a jungle cat' said American driver John Fitch, after winning the Targa Florio on the appallingly surfaced and tight Sicilian circuit.

This page: Fine engineering is shown in this multi-piece gate with its reverse stop and first gear detent.

Opposite: 722 denoted the 7.22 am Brescia start time for this Mille Miglia winner. A second

headrest, unusually, was provided for Moss's passenger/navigator Denis Jenkinson.

Overleaf: Only three instruments were required: German VDO water temperature and oil pressure, and Italian

Veglia rev counter; 7,800 rpm was the limit for this engine, but the same instrument was also used on the GP car.

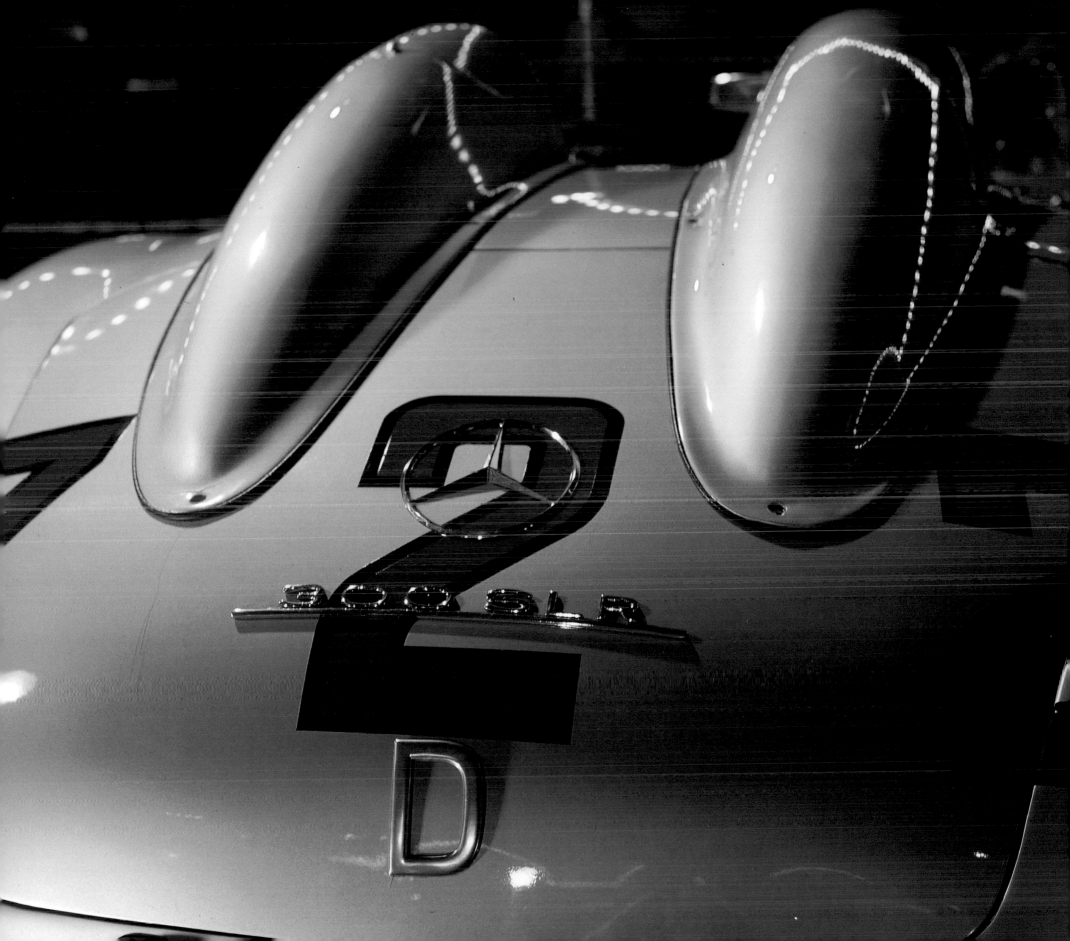

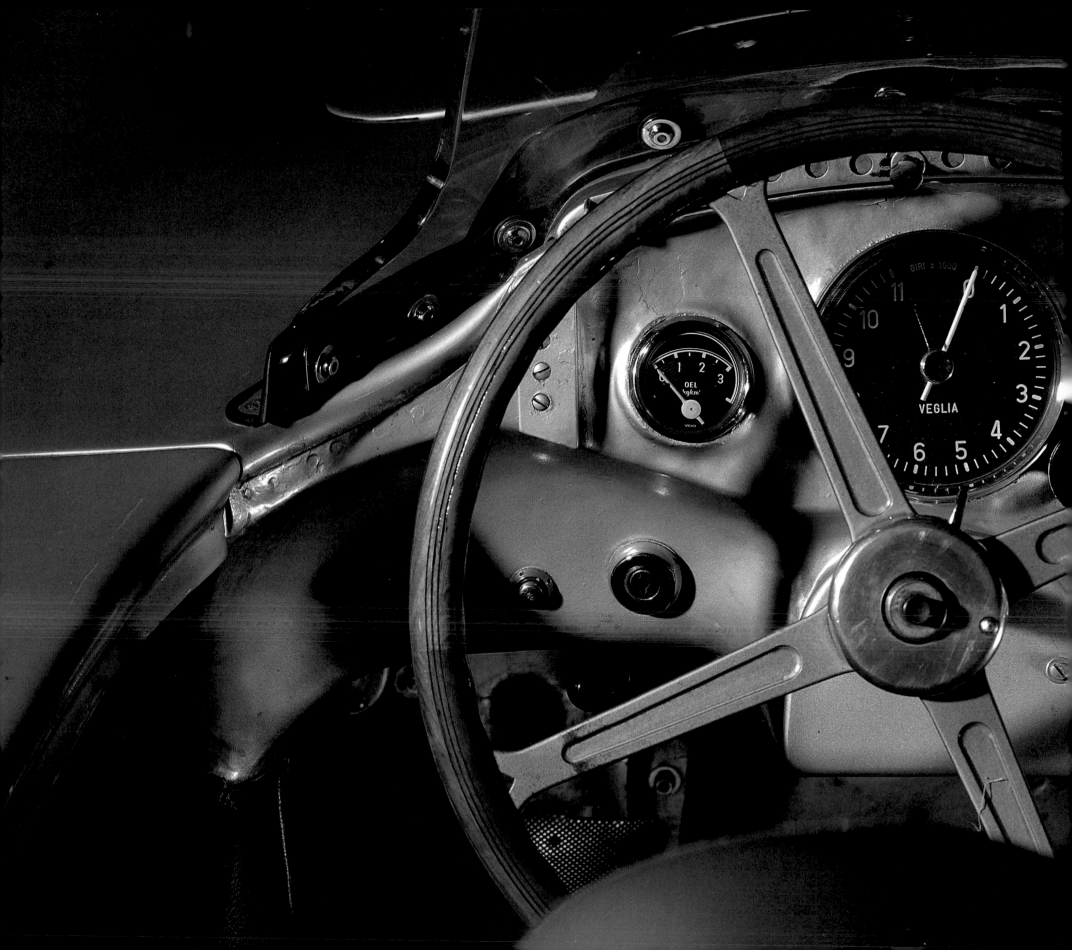

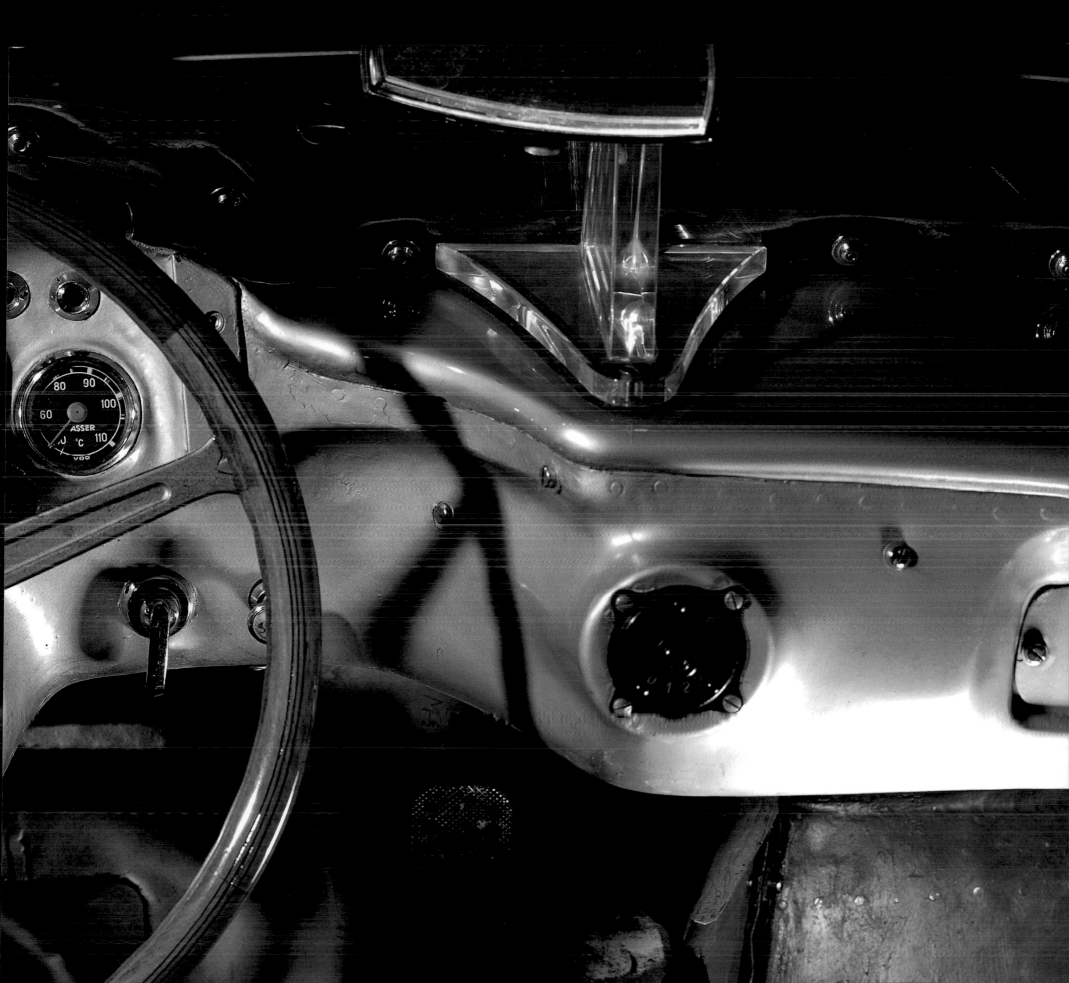

Ford Edsel (1958) USA Named after Henry Ford's gifted but unassuming son, the Ford Edsel was designed some years after his early death. It was remarkable in being the first automobile project to be based entirely upon the results of market research governing the design from

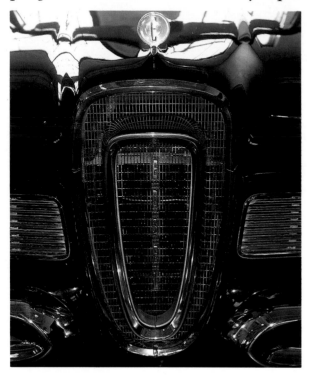

grille to tail pipe. The resultant motor car was, however, a commercial lemon and at $350 million the most costly mistake ever made by the Ford motor company. Man being ever capable of profit from error, however, the Edsel fiasco led directly to the corporate reconstruction that still governs Ford strategy. The radiator grille was unique, being a completely vertical motif; the tail-lights were unkindly likened to ingrowing toenails, while the extent of body overhang was horrendous. But underneath it all lay a strong well-engineered chassis frame in the large American idiom, while the range of engines fitted during the two years of production included some of the most powerful in the USA – up to a claimed 350 bhp. From the driver's seat, the dashboard view included such innovations as a rotating drum speedometer (new in execution if not in American principle) and 'teletouch' buttons recessed into the steering wheel to activate the automatic transmission. The Edsel wasn't the worst automobile in American history, but it will certainly be remembered as an object lesson in how not to design for the market by remote control.

This page: The Edsel trademark was an inverted horse-collar grille containing vertical Edsel lettering.

Opposite: Edsel was to be a marque in its own right, here seen on the rear side panel.

Overleaf: The dashboard follows the period norm, but auto transmission selector buttons in the wheel boss are novel.

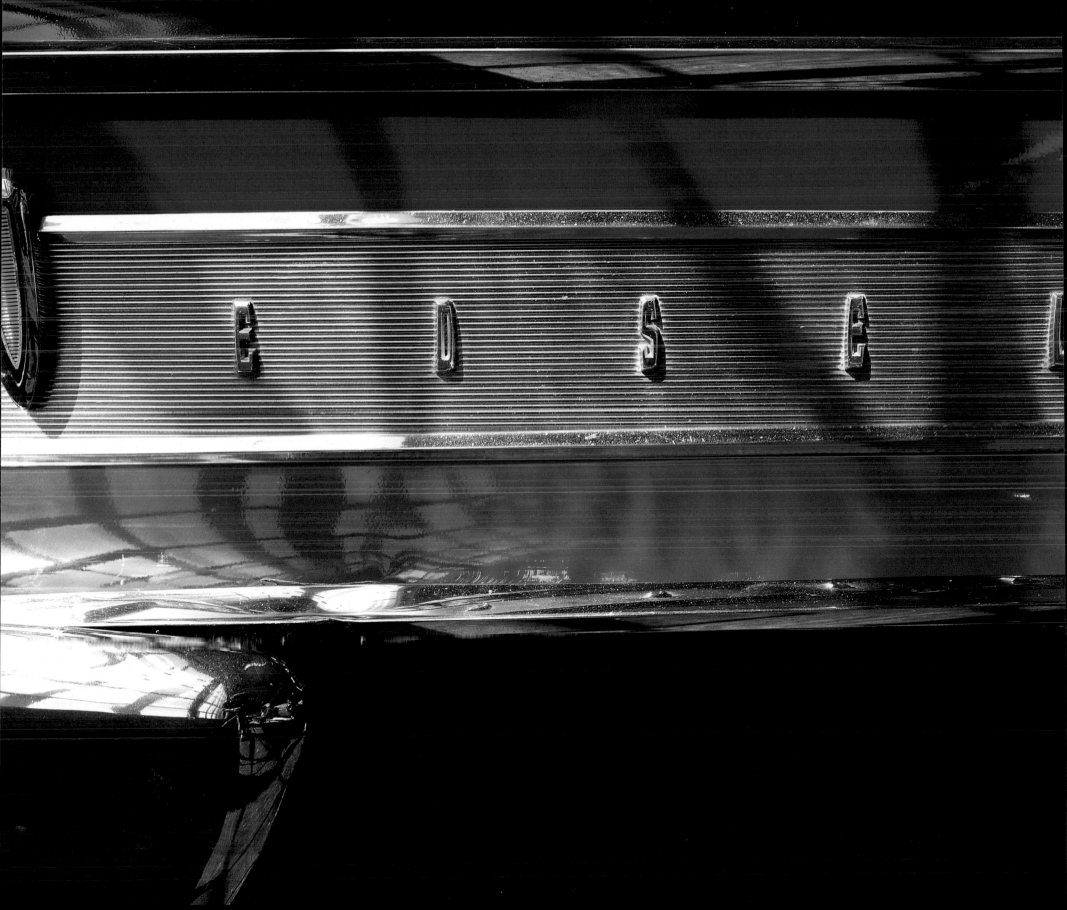

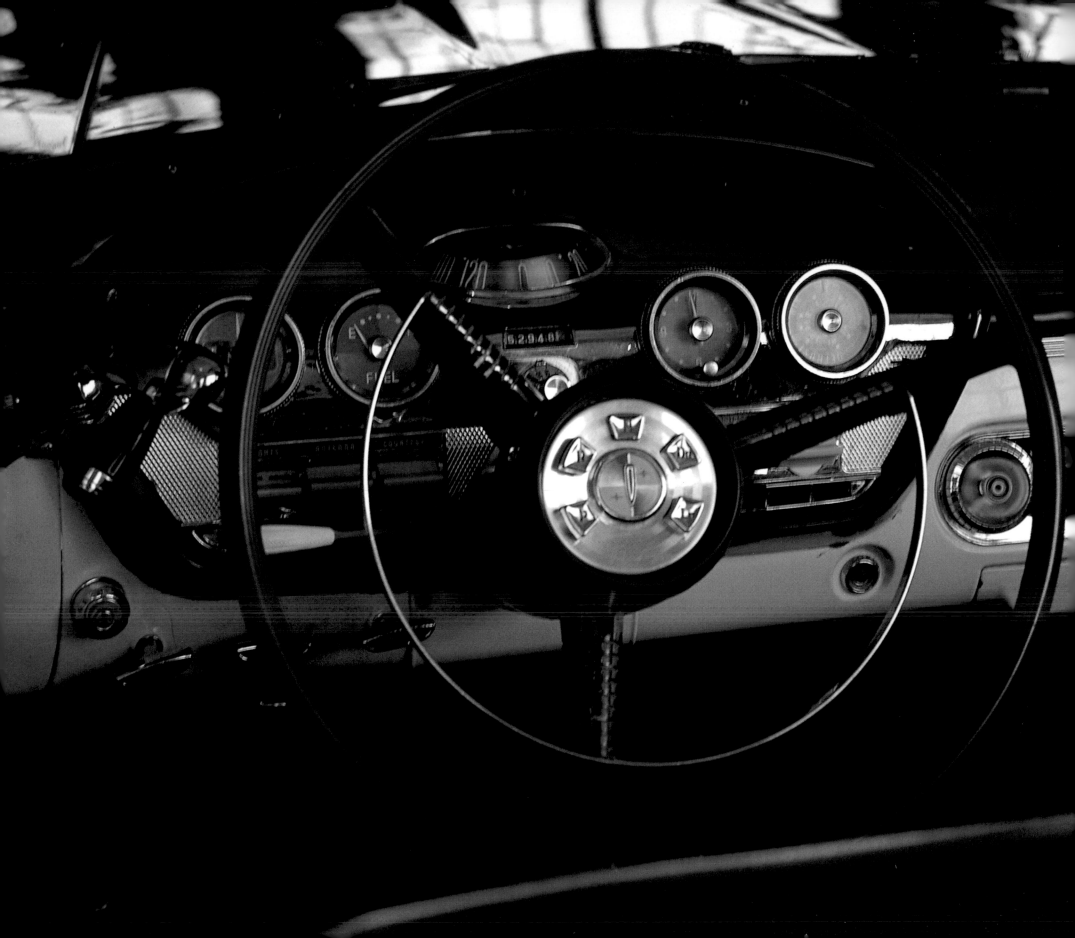

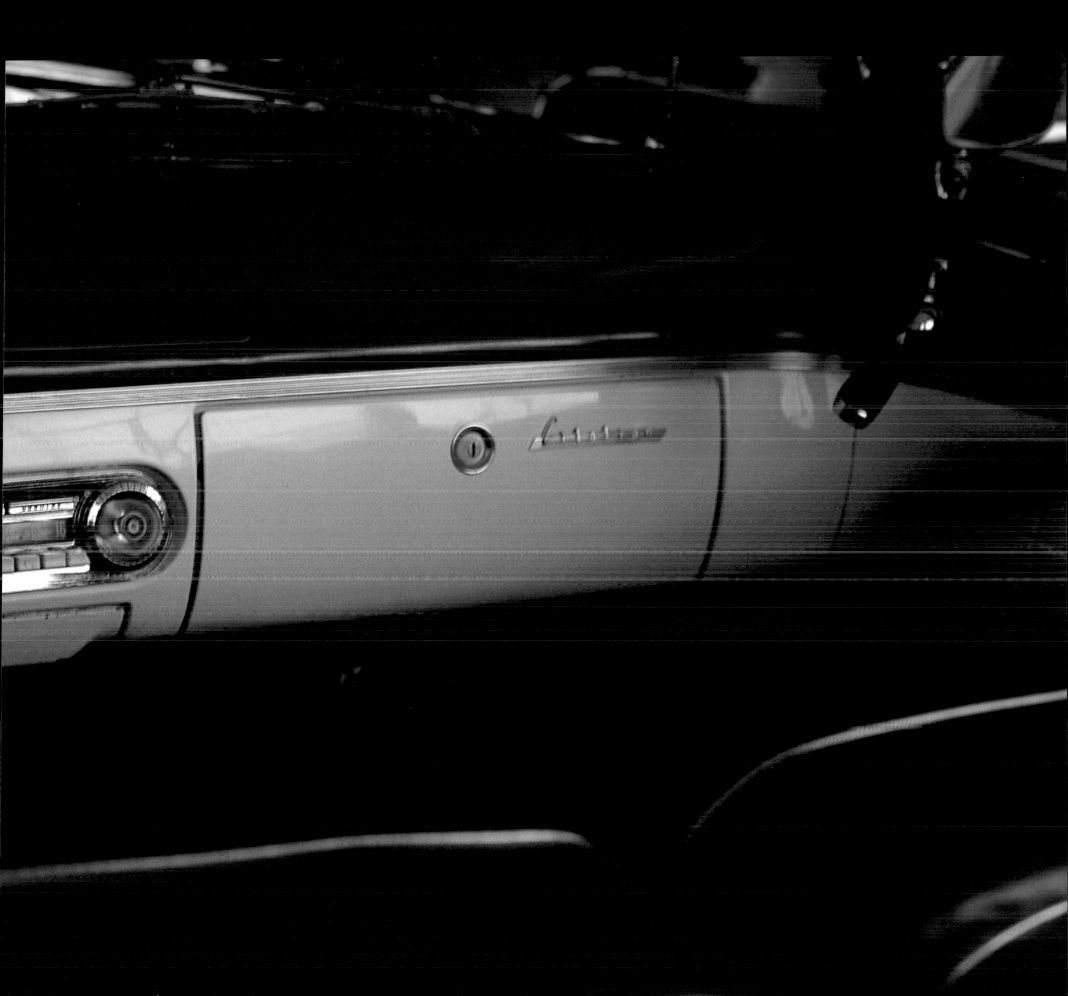

Aston Martin DBR4 GP (1959) GB It had taken a great deal of dogged determination, painstaking development, money and faith for Aston Martin to become the first British manufacturer to win the World Sports Car Championship in 1959 with the DBR1. So Aston's owner David Brown's second ambition of entering Grand Prix racing had to take its place behind the mainstream of road-car development work; thus the single-seater DBR4, originally started in 1956, suffered in priority during the period when the opposition was developing cars with engines behind the driver. Launched eventually for the 1959 season, the DBR4 was the last of a vanishing front-engined breed. It is easy to say 'too little, too

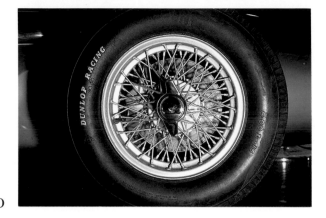

late' but Aston's resources couldn't run to competition in both world championships. Like all Astons this single-seater was beautifully made and the dashboard reflected the style and racing pretensions of its makers. Plain to the eye but functional, it had a minimum of dials: a large tachometer reading to a usable 8,000 rpm flanked by smaller gauges for oil pressure, plus switches for the twin magnetos. In best Aston tradition, the steering wheel is a fine alloy pressing covered in laminated wood, riveted together such that the rivet protrusions on the back provided extra grip for the driver's gloved fingers. Just visible are the two brake hydraulic reservoirs on the right of the close-fitting cockpit. Behind the wire wheels, shod with native Dunlop racing tyres, the powerful disc brakes can be seen. The DBR4 was a wonderful swan song to the end of the front-engined era.

This page: Aston Martin used Dunlop racing tyres for the Grand Prix cars. The Boranni wire wheel has seventy-two spokes.

Opposite: The lightly blued exhaust system groups three cylinders per pipe running high alongside the cockpit.

Overleaf: The typical racing dashboard has the tachometer prominent with its tell-tale red

needle at zero. The panel is removable using the quick-action Dzus fasteners at the top.

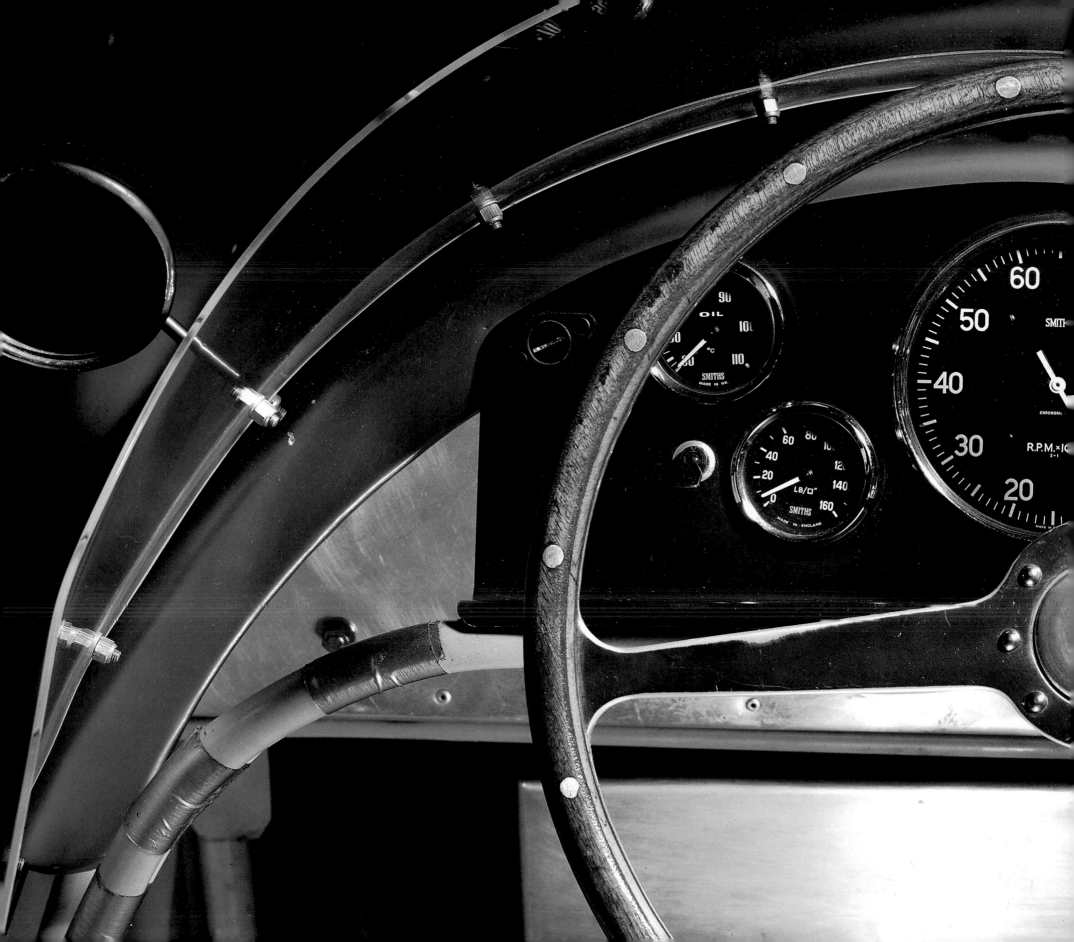

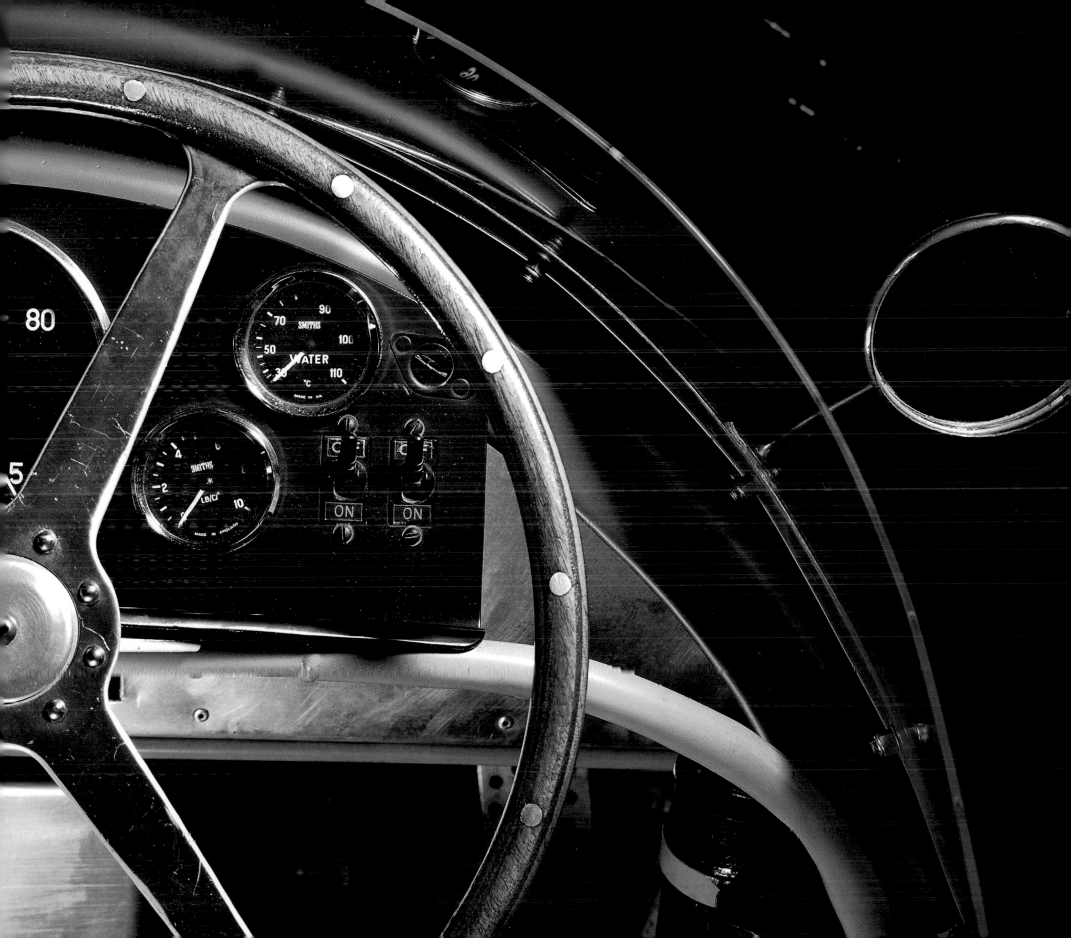

Cadillac Eldorado (1959) USA At the top of the American automobile tree, Lincoln and the Chrysler Imperial fought General Motors' Cadillac for market success; the Eldorado was the extravagant, extrovert model of the General's flagship range. Large, luxurious, lavishly equipped, it was fitted with the biggest V-8, mated to the Dynaflow automatic transmission, and had a power-

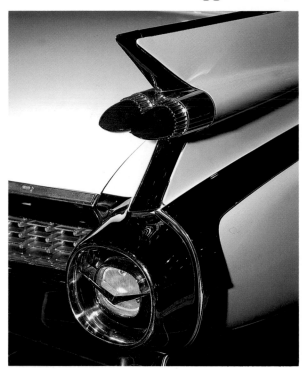

operated roof. Period fashion dictated acres of sheet steel, starship fins, ballistic rear lights and complex chrome-plated shapes. Looking back, it was a dinosaur, but at the time it was the highly regarded style leader in its environment, much envied and much copied. The driving compartment was rather less exotic, but still needed to look the part of range leader, with high quality furnishings and facia design. Behind the large slender steering wheel, and easily visible, are the horizontal speedometer, the gear selection panel and gauges for temperature and fuel level. Beneath these are air-conditioning controls; to the left are the cruise control and light switch; beside the dash panel is a bank of electric window switches. To the right are the ignition/starter switch and a clock, with the radio out towards the passenger. With no clutch, the 'Power Brake' pedal is wide for use with either foot. It wasn't so much the style that impressed, but the extent of the equipment fitted was remarkable to European eyes. The car was inevitably fast in a straight line though somewhat unwieldy, but it was made for wide open spaces and long journeys; it was built to be quiet and comfortable with style. It did just what its market expected of it.

This page: This tail shot is a fine example from the star-ship era of chrome and ever-higher fins.

Opposite: The full-width chip-cutter grille and four lights per side give a very impressive frontal aspect.

Overleaf: An early prelude to modern design, the Eldorado featured cruise control, air conditioning, electric windows and servo brakes surrounding rather minimal instrumentation.

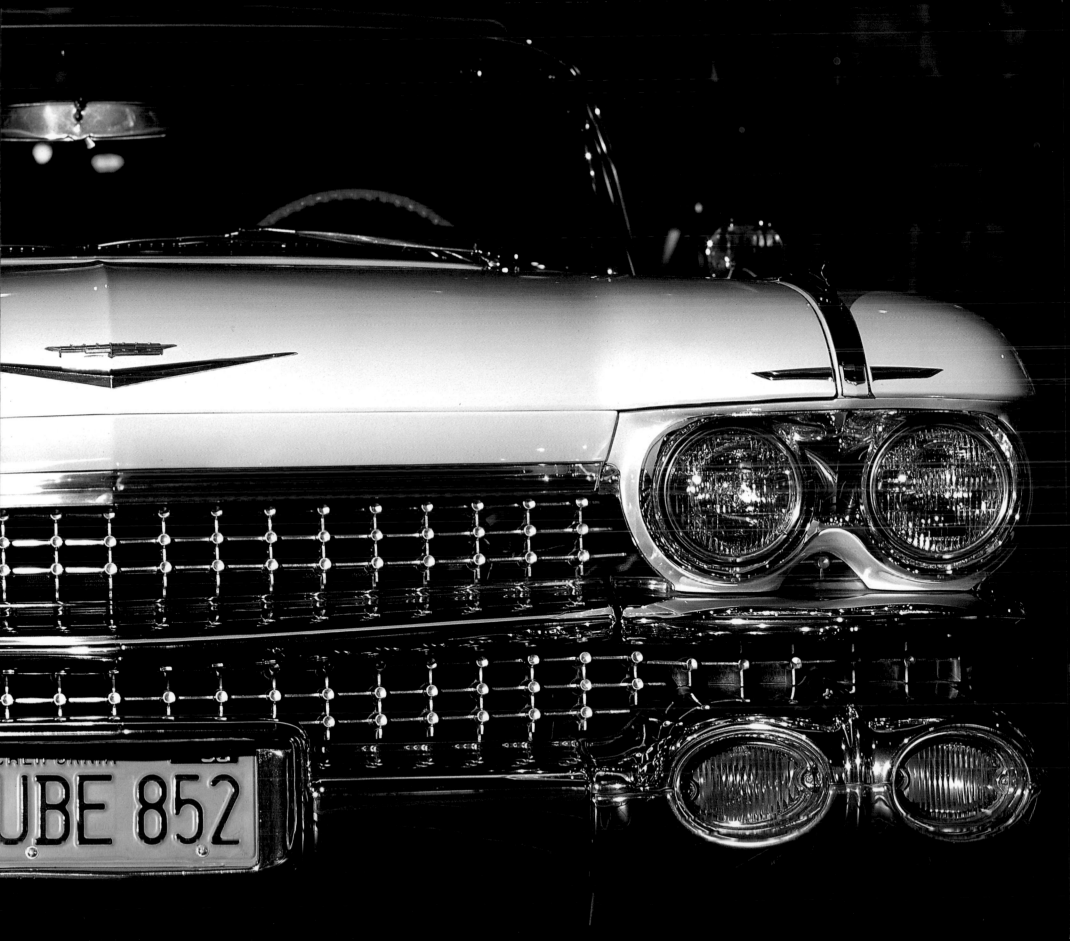

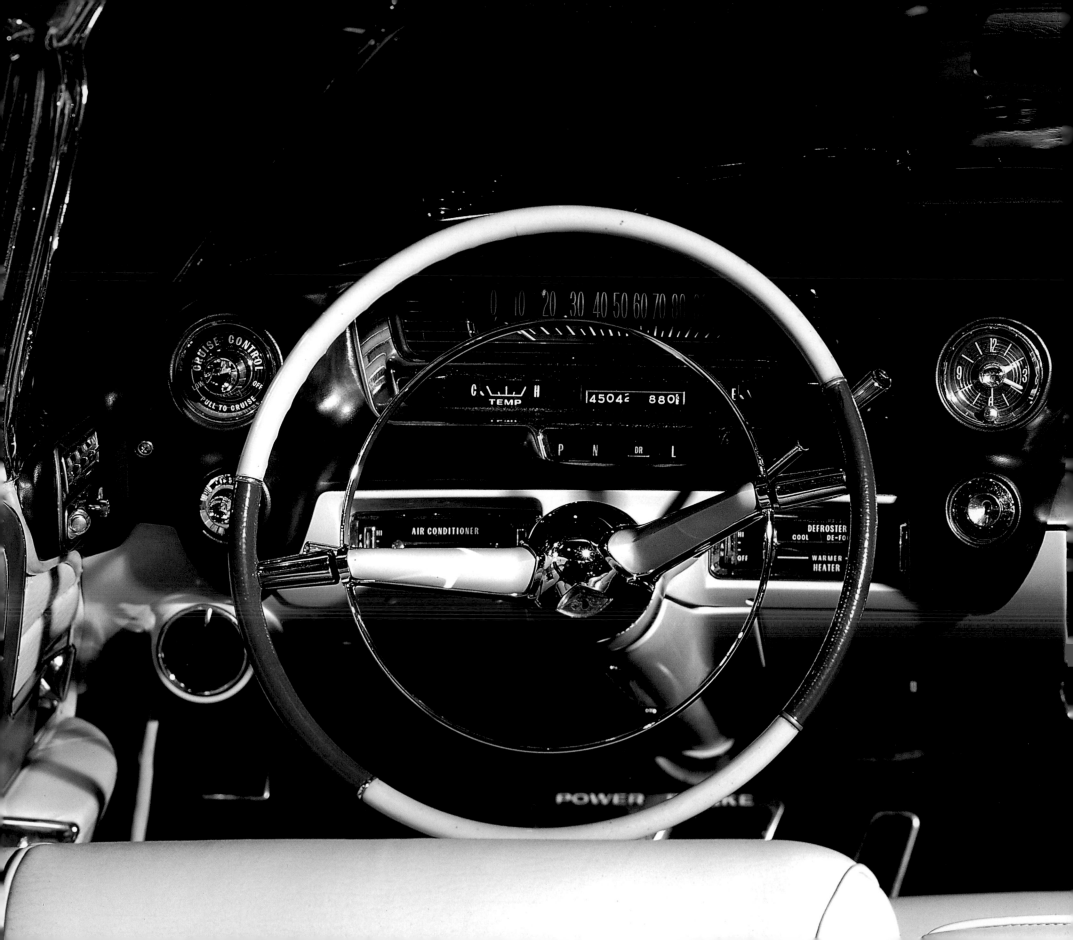

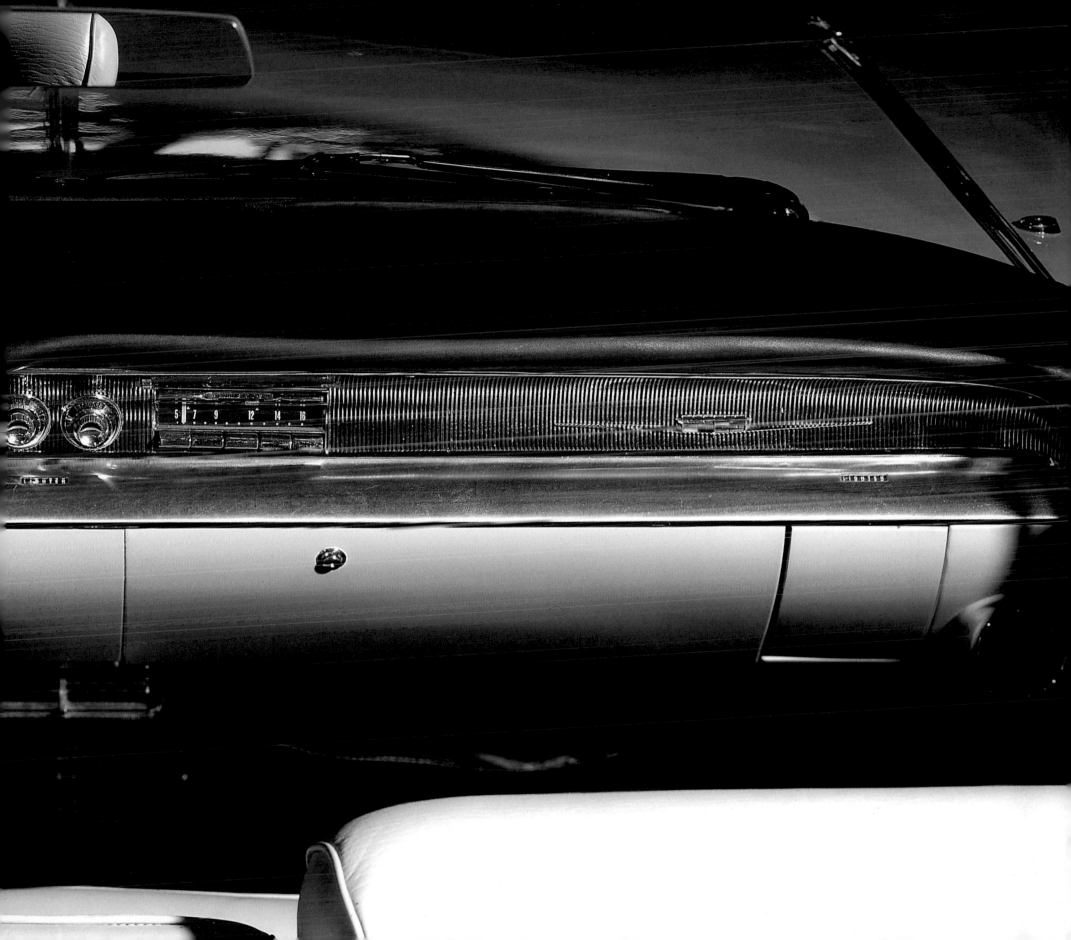

Facel Vega HK500 (1961) France Ava Gardner, Pablo Picasso and Tony Curtis were among the illustrious clientele for the fast, luxurious Franco-American Facel Vegas during their short-lived ten-year production run. Based at Pont-à-Mousson, near Nancy, Facel had previously been coachbuilders for such as Panhard and Simca, but started their own production in 1954 around Chrysler V-8 engines and automatic transmissions, or Facel's own manual box; the beautiful hand-built steel bodies owed nothing to any other manufacturer, and featured much fine detail, from the radiator grille to the unique tail lamps. With opulent leather interior, including the most comprehensive equipment available, the Facel Vega was recognized as one of the best period grand'routières on the market, with a price tag to match. This HK500, selling then at £4,740, could run at 130 mph with its 6½-litre Chrysler unit. Its dashboard is a splendid example of sitting-room baroque applied to a car; a huge expanse of wood veneer (sometimes well simulated on metal) carried every possible gauge, switch and tell-tale lamp, as well as radio, air conditioning, 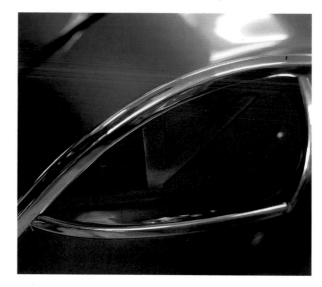 electric windows and more. Only the rev counter was straight ahead, the speedometer being on the angled return to the rearward centre console, which carried five smaller instruments and most of the switches. The large two-spoke wheel is set on a long column protruding through the dashboard, with only a single stalk for indicators. Just below the column are the selector buttons for the automatic transmission fitted to this car. It was an awe-inspiring array for the last of the grand tradition of French high performance voitures de prestige.

This page: Facel Vega created their own styles; these unique tail lights also give good side visibility.

Opposite: Die-cast slats, egg-boxed together, form the chip-cutter grille – the badge shows the parent company.

Overleaf: All instruments in the mock-wood-painted metal facia are marked in French and English, even the heater controls.

Automatic transmission buttons are under the rev counter to the right of the steering column.

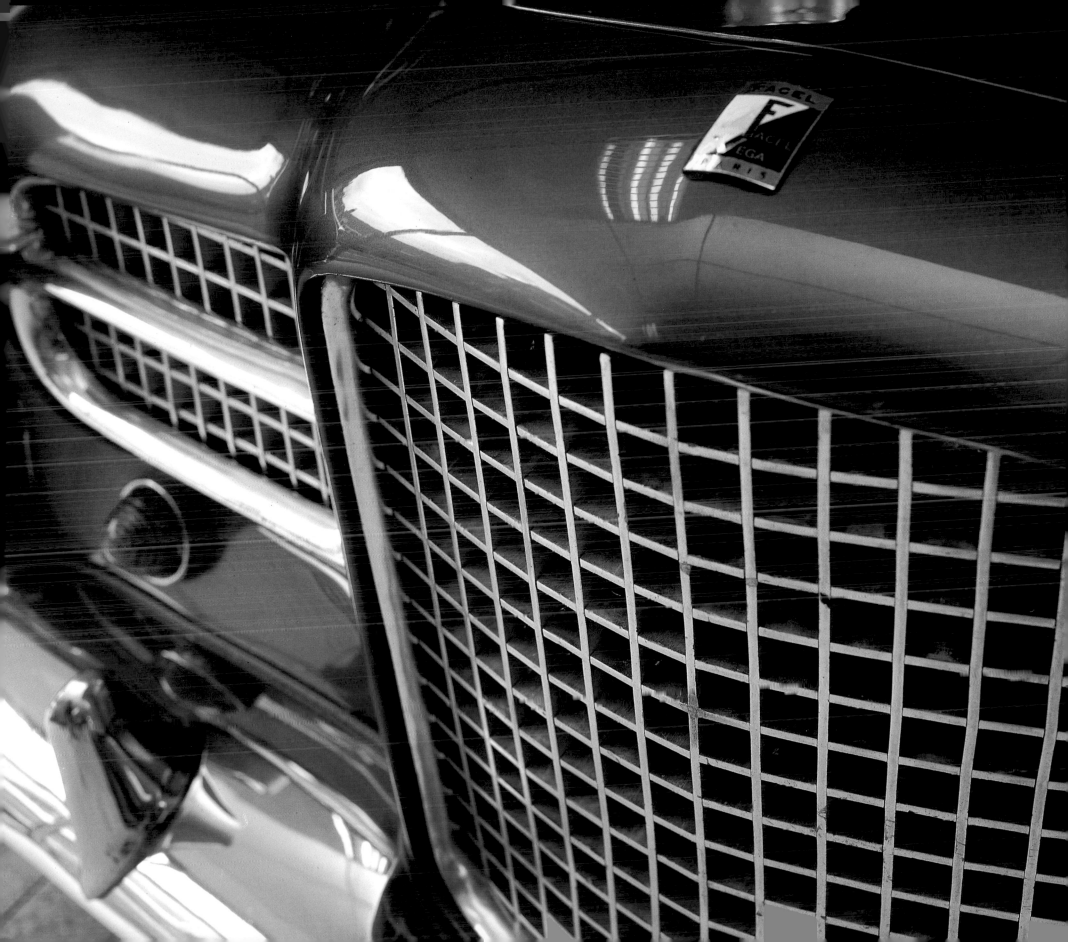

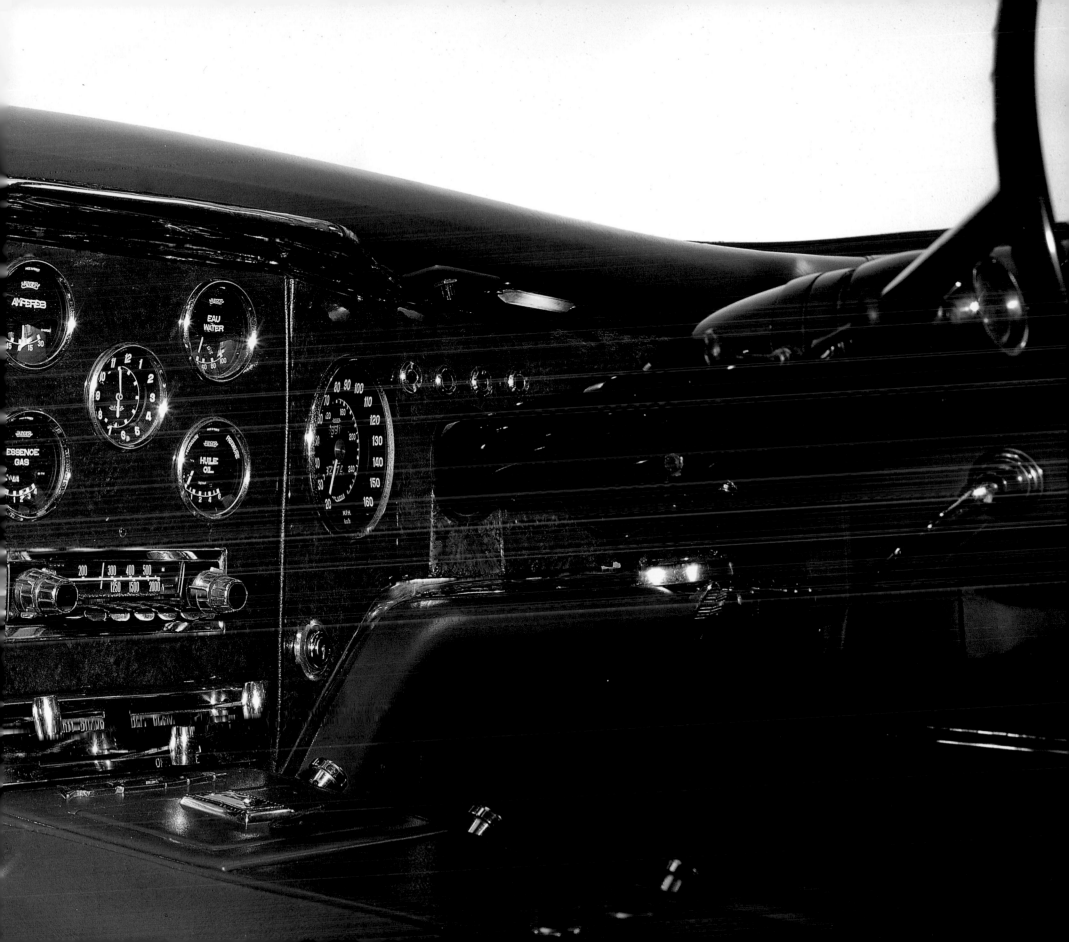

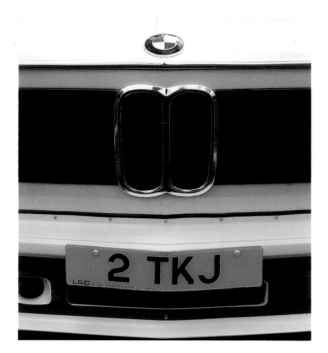

BMW 2002 Turbo (1973) Germany Having struggled to get going again through the Fifties, BMW launched themselves into their modern reputation with the four-door 1500 in 1962; the engine soon grew to 2 litres. Putting the same power units in the smaller 02 series from 1966 produced a lively range of two-door coupés. Fastest of these was the turbocharged 2002, race winner and road-burner. As produced in Germany, it earned Federal criticism for the reversed inscription – 2002 Turbo – on the front air dam designed to intimidate the driver ahead. This was the Europe's first production turbo-charged road car; with some 170 bhp and a top speed around 130 mph, it earned for BMW a tremendous performance reputation with many racing successes. The interior was quite plain by modern standards with no concession to fashion or superfluous gadgetry. For this model only, however, the dash panel was bright red. The tachometer reads to 7,000 rpm with the red sector starting at 6,500 rpm, and is matched by a 150 mph speedometer. In the centre of the car, but easily visible to the driver, is the pressure gauge indicating the amount of turbocharger boost. A well-shaped seat, excellent visibility through the large screen and deep windows, and a slick short-travel gear lever completed the driving environment for this highly effective sporting saloon. It was just as much at home on road or track, but production met an early end due to the fuel crisis.

This page and Opposite: The BMW Motorsport colour striping, and bulging wheel arches, are the only external indications of a special version of the compact 2002 Turbo.

Overleaf: The unusual red dash panel signifies that this is a Turbo, for which a separate boost gauge is added (right).

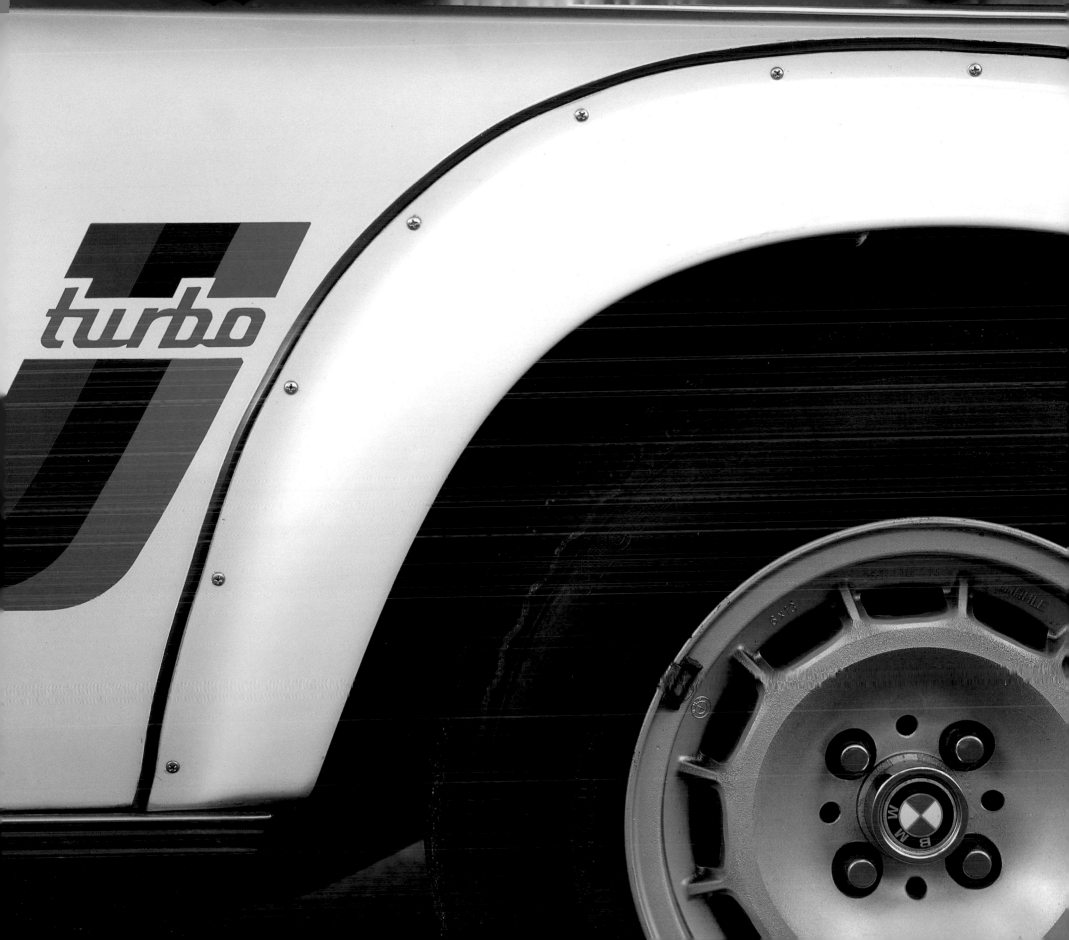

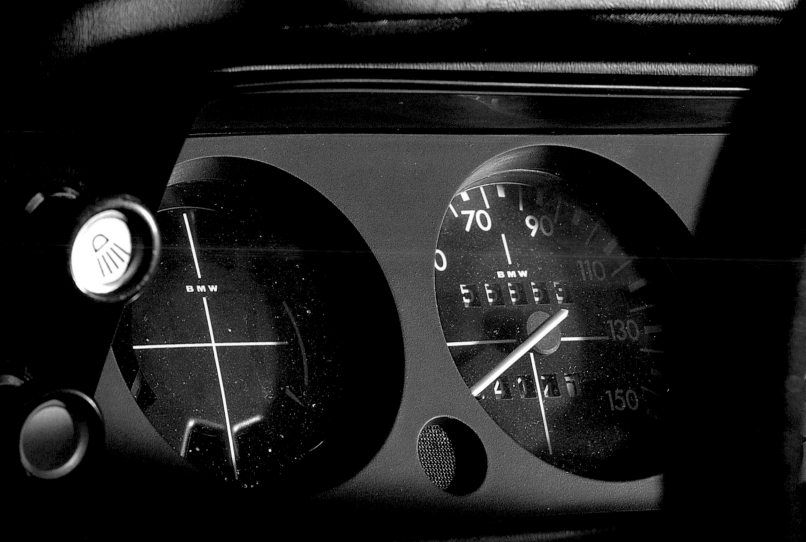

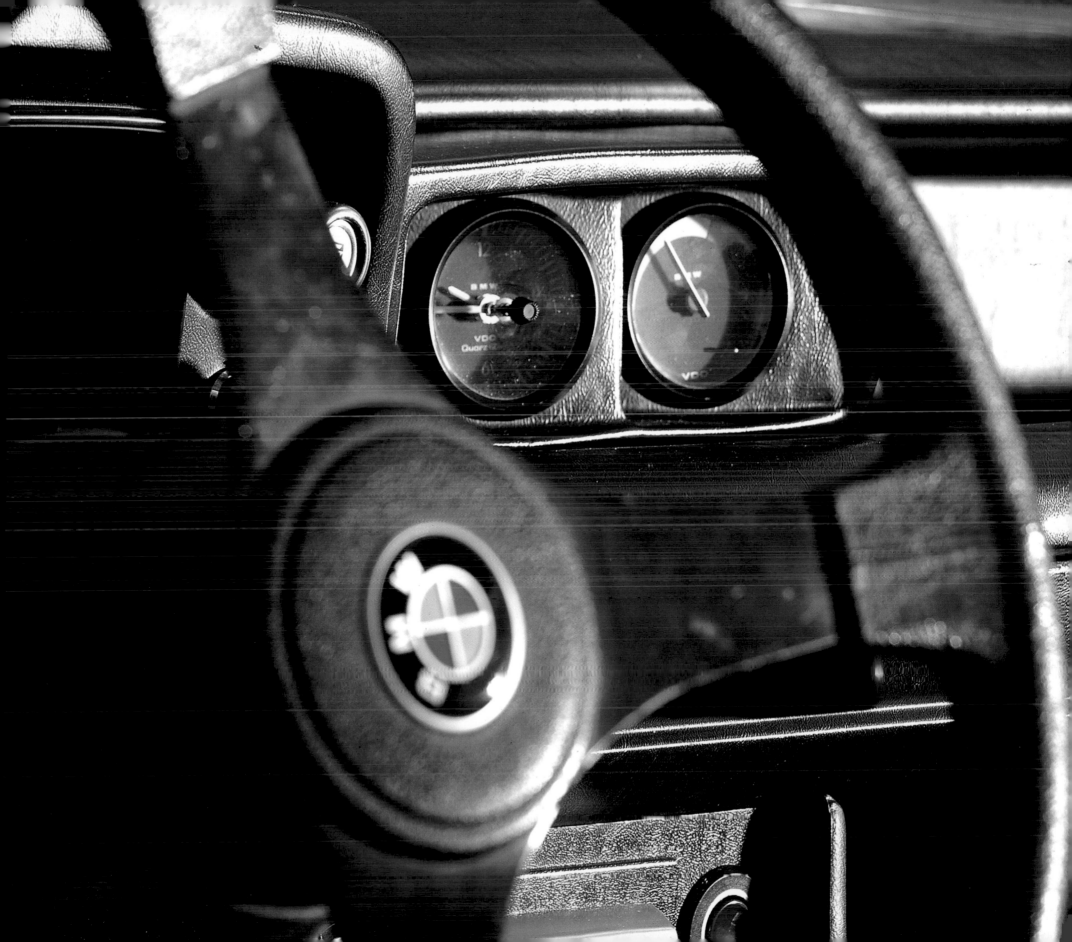

Glossary

Around the cockpit:

Binnacle

A hooded housing for the group of instruments. While the term was derived from the housing for a ship's compass, it now refers to any group of instruments which are separated from the main dashboard within their own housing.

Cowl

A hood over a dash panel. Derived from a monk's cowl, it referred to that part of the bodywork which deflected air around the front occupants. Dual-cowl phaeton bodywork had a second cowl behind the front seats to protect the rear occupants, frequently with a second windscreen.

Cowling

A close-fitting engine cover, as used for aircraft engines fitted within the wing or fuselage. (A hanging engine is housed in a nacelle.) The term is sometimes used as an alternative to **cowl.**

Facia/fascia

A term used to describe the modern integrated dashboard. It derived from the shop front facia-board used to convey information on the owner and his business.

Fairing

A piece of bodywork shaped to reduce aerodynamic wind resistance. In this context, a cockpit fairing covers the passenger space during racing, and a head-fairing blends the outline of the driver's head into the rear bodywork. The shaping of metal around the radiator for streamlining is referred to as a fairing or a **cowl.**

Panel

A piece of metal which is flat, or was flat prior to shaping. Here, it is used with 'electrical' (carrying **ammeter** and switches) or with 'instrument' (that part of the dashboard which carries only instruments and not switches).

Scuttle

The body panel between the back of the engine cover and the top of the dashboard. Originally a removable panel to give access to the back of the dashboard, on the modern car it has disappeared as the panel behind the engine cover now merges into the windscreen.

Instrumentation:

Altimeter

A gauge to indicate the height above sea level. Of more use in an aeroplane than a car, it is a somewhat esoteric adornment for any dashboard.

Ammeter

A gauge to show the amount of current (amperes) charging the battery, after such ancillaries as lights and heater have taken their requirement from the charging dynamo or alternator.

Boost gauge

A gauge to show the amount of extra pressure supplied to the engine's inlet manifold by an engine-driven super-charger or an exhaust-gas-driven turbocharger. It reads in pounds per square inch (psi) or kilograms per square centimetre (kg/cm^2). Atmospheric pressure = 14.7 psi = 1.03 kg/cm^2.

Calormeter

A glass temperature gauge mounted on the radiator cap when such were fitted externally. The driver could easily see this without taking his eyes off the road.

Chronometer

An extremely accurate clock with a finely engineered escapement and compensation for pressure and temperature. Chronometric movements were also used in **speedometers** and **tachometers** in more expensive cars.

Ignition

The point during the engine's cycle at which the sparking plug is ignited to fire the mixture. Depending on the engine speed and required performance, this point needed adjustment to change the ignition timing; manual controls were marked 'Advance/Retard' or 'Early/Late'.

Ki-Gass

Proprietary name for a handpump which was used to squirt a spray of atomized fuel into the inlet manifold for extra enrichment during cold starting. It was necessary when long manifolds were used or where no choke was provided.

Magneto

An engine-driven spark generator used before the arrival of the coil and distributor, or on racing cars where no battery was fitted. Because the magneto generates a spark purely by rotation, it is necessary to 'earth' the spark to stop the engine – hence the magneto earth switch.

Manifold vacuum gauge

A gauge to measure the amount of vacuum in the manifold as the engine draws mixture through it. Small throttle openings produce higher vacuum, so the gauge acts as an accelerator movement monitor or economy gauge.

Mixture control

Adjustment of the fuel:air ratio to provide the correct balance for clean combustion. In modern terms this is a choke control for cold starting and warm-up, but early engines demanded more frequent adjustment between the extremes of Rich and Weak; the French used 'Riche/Pauvre' while American controls were marked 'Gas/Air'.

Nivex fuel gauge

A particularly accurate French fuel tank contents indicator. Most fuel gauges have used some form of float in the tank to give a guide to the fuel remaining; the Nivex gauge was calibrated in litres and worked by measuring the pressure increase from one stroke of its adjacent air handpump.

Odometer

A recorder of distance. As it is driven by the speedometer drive, it is usually set within that face; total and trip recorders are normally provided.

Quadrant

The quarter-circle arc which carries the scale through which such levers as hand-throttle and mixture and ignition controls are moved. It usually carries some form of serrated locking mechanism. Steering column gear levers for automatic or pre-selector transmissions also use marked quadrants.

Rev counter

A counter of engine revolutions. This term is now used to refer to a counter of engine speed

in revolutions per minute (rpm) for which the correct term is a **tachometer.**

Rheostat

A device for adjusting electrical resistance. It is used to vary dashboard lighting levels and windscreen wiper sweep intervals.

Sight-oiler

A mechanism that allowed the rate of engine lubricating oil drips to be adjusted within a glass viewing cylinder. Early engine bearings were fed by such drips before the invention of pressure lubrication.

Solenoid

An auxiliary heavy-duty switch working in tandem with a smaller dashboard switch. Small switches cannot carry the current for such as starter motors, and thus require a solenoid to make the high-current contact.

Speedometer

A gauge to indicate the speed of the vehicle in miles per hour (mph) or kilometres per hour (km/h). As it counts road-wheel revolutions, usually via the gearbox, it is in fact a **tachometer** with another face.

Switchgear

The generic term for all the switches around the dashboard. These can be push/pull knobs, up-down tumblers, or rotary switches as with steering column stalks or ignition switches.

Tachometer

A gauge to indicate the speed of the engine in revolutions per minute (rpm). Its face is usually calibrated in numbers without all the zeros as rpm x 100, or rpm x 1000

Tapley meter

Proprietary name for an instrument that reads fore-and-aft accelerations. It can be calibrated for braking performance (as a percentage of the gravitational unit 'g') or accelerative performance (in pounds per ton).

Voltmeter

A meter to show that the battery is charged to its nominal rating of 6 or 12 volts. The **ammeter** (or now more commonly a warning light) gives an instant indication of charging failure; the voltmeter will show that a battery is not holding its charge even if the ammeter is reading positive.

Transmissions:

Chain drive

The system of driving the rear wheel(s) by chain as on a bicycle or motorcycle. Early cars used this as a simple means of connecting the engine's drive to an axle that was moving up and down.

Countershaft/Cross-shaft

The transverse shaft, ahead of and parallel to the rear axle, on which the front chain-wheels (sprockets) were mounted. Drive from the engine was transmitted through a gearbox and propeller shaft to a crown wheel and pinion which drove the cross-shaft. When the front sprockets were mounted at the ends of the cross-shaft it was relatively easy to change the overall gearing. Chain drive was superseded by using a longer propeller shaft and moving the crown-wheel and pinion to the rear axle line.

Detent

A spring-loaded or mechanical obstruction to the selection of a gear. Automatic transmission levers will have a detent system to avoid

inadvertent selection of Neutral, Park or Reverse. Manual transmission levers will have a detent to obstruct reverse gear selection, while racing cars may even have a mechanical detent to lock out first gear once on the move.

Epicyclic gears

A reduction gear-set that employs planetary gears rotating between a driven sun-wheel and an outer ring gear. Stopping the ring gear by means of clutches or circumferential bands will cause the planetary gear carrier to rotate at a different speed from that of the sun-wheel. The epicyclic gear system is used in automatic and pre-selector transmissions.

Pre-selector gearbox

A gearbox that allows pre-selection of the next gear, which is engaged when required by pressing the 'clutch' pedal. This allowed the driver to keep his hands on the steering wheel when changing gear and was much favoured in racing cars during the Thirties. The selector lever was usually carried on a **quadrant** attached to the steering column.

Speed

The common term for a forward gear ratio. Thus a 4-speed gearbox would have four forward gears and one reverse.

Abbreviations

bhp – brake horse power

A measure of the actual power developed by an engine, as recorded on a dynamometer which uses 'brakes' to absorb the power
1 bhp = 0.746 kW (Kilowatt) = 1.0139 ch (French cheval-vapeur) = 1.0139 PS (German Pferdestärke)

cc – cubic centimetres

A measure of the volume swept by the engine's pistons, thus an indication of the volume of air-fuel mixture inhaled by the engine and therefore its potential power.
1000 cc = 1 litre = 61.02 cu. in. (cubic inches)

CV – cheval-vapeur

The former French-calculated horse-power used for taxation purposes; the Citroën Deux Chevaux was rated as a 2CV. When cheval-vapeur is written as 'ch' it refers to brake horsepower.

dohc – double overhead camshaft

see **ohc**

GT – Gran Turismo

Italian description of a car designed for Grand Touring, which means faster than saloon car touring and was usually only for two people in comfort.

HP – Horse Power

The former British-calculated horse-power used for taxation purposes; the Austin Seven was taxed at 7 HP.

mpg – miles per gallon

The number of miles attained on an Imperial gallon of fuel. The American gallon is 16.7% smaller.
1 Imp. gallon = 1.2009 US gallons = 4.545 litres.
10 mpg (Imp) = 8.33 mpg (US) = 28.24 litres/100 km.

ohc – overhead camshaft

A camshaft mounted on top of the cylinder head to operate overhead valves, either directly or through rockers. With double overhead camshafts, each will act directly, which allows a more efficient engine.

Dedication

To Charles Renaud – Automobilist, Racing Driver, Patron of the Arts and Connoisseur of Life – who has encouraged my interest in the incredible twentieth-century love affair with the motor car, and whose private collection has provided many of the unusual machines depicted in this book.

Author's Acknowledgements

The author's gratitude is due to all the helpful people at the National Motor Museum in Beaulieu, the Donington Collection, the Henry Ford Museum, the Mercedes-Benz Museum, the Museum of British Road Transport, the Auburn-Cord-Duesenberg Museum and Jaguar Cars Limited.

Individuals who gave their time, facilities and influence include Andy Jacobson of Ford Motor Company, Andy Bell of Ecurie Bertelli, Daryll Group of Fullbridge Engineering, Daniel Donovan of Straight Eight, Greg Buttermere and David Turner of Auburn, Indiana, Luke Swetland and James McCabe of the Henry Ford Museum, Tim Hignett and Carl Wilford of L & C Auto Services, Brian Joscelyne, David Burgess-Wise, Mark Beattie, Simon Kidston, Roger Bateman, Debbie Hayes, Sue Childres, Nigel Dawes, Rivers Fletcher, Malcolm Oliver, Ben Redgrove and Laurent Matthey.

Owners who kindly allowed their cars to be photographed include Tom Wheatcroft, Robert Kline, Richard and Linda Kughn, Jim Medcalf, James Cheyne, Richard Schultz, John and Isobel Willis, and Charles Renaud.

In addition to all these, Michael Bowler especially gave invaluable help in all the final stages.

Photographic acknowledgements

Ken Kirkwood: pp 27, 28-29, 56-57, 182, 183
All other photography by Colin Turner

Phaidon Press Limited
Regent's Wharf
All Saints Street
London N1 9PA

First published 1994
Reprinted in paperback 1999
© 1994 Phaidon Press Ltd

A CIP catalogue record for this book is available from the British Library

ISBN 0 7148 3863 2

Printed in Hong Kong